WHITNEY BIENNIAL 2006

DAY FOR NIGHT

Chrissie Iles and Philippe Vergne

with contributions by Toni Burlap, Johanna Burton, Bradley Eros,
Lia Gangitano, Bruce Hainley, Bernard-Henri Lévy, Molly Nesbit,
Siva Vaidhyanathan, and Neville Wakefield

Whitney Museum of American Art, New York
Distributed by Harry N. Abrams, Inc., New York

This book was published on the occasion of the *2006 Whitney Biennial: Day for Night* at the Whitney Museum of American Art, New York, March 2–May 28, 2006.

Lead sponsor

Altria

Major support is provided by

Deutsche Bank

Additional support is provided by

Sotheby's

Significant funding for the 2006 Biennial has been provided by an endowment created by Melva Bucksbaum, Emily Fisher Landau, and Leonard A. Lauder. Research for Museum publications is supported by an endowment established by The Andrew W. Mellon Foundation and other generous donors.

A portion of the proceeds from the sale of this book benefits the Whitney Museum of American Art and its programs.

ISBN 0-87427-152-5
ISSN 1043-3260 (series number)

Defining the NEW for Seventy-Five Years

© 2006 Whitney Museum of American Art
945 Madison Avenue at 75th Street
New York, New York 10021
www.whitney.org

Distributed by:
Harry N. Abrams, Inc.
115 West 18th St., 6th floor
New York, New York 10011
www.abramsbooks.com
Abrams is a subsidiary of La Martinière Group.

ABRAMS

front and back covers and jacket: Marilyn Minter, *Pink Eye*, 2005 (details). Enamel on metal, 60 x 108 in. (152.4 x 274.3 cm). Collection of Vanessa Arelle de Peeters; courtesy Salon 94, New York

WHITNEY BIENNIAL 2006

DAY FOR NIGHT

But it's the

the Terminat

--Chuck D of Public Enemy

The incredib

Public Enemy

Five-O said

and I got nu

Can I tell t

I really nev

SPONSOR'S STATEMENT
Altria

Bold, provocative, and unique, the Whitney Biennial is a compelling exploration of the vision and voices of contemporary artists. The diverse artists and media represented in the Biennial create a vibrant and insightful dialogue that challenges us to question our cultural and artistic values. The 2006 Biennial brings the current art scene into focus and zooms in on the restless and reflective energy of the art world today, offering an important perspective on an ever-changing world.

For the past fifty years, Altria has funded the arts with an emphasis on supporting organizations and exhibitions that take risks and push boundaries, going beyond the conventional. As a global company, we are particularly pleased that the 2006 Biennial reaches beyond the borders of the United States and includes artists from around the world. The Whitney Museum of American Art has been a valued partner of Altria since 1967, and we are proud to continue our long-established relationship with them. We applaud the vision of this year's curatorial team and offer a heartfelt thanks to Adam D. Weinberg for his leadership. We also thank the entire staff of the Whitney for their dedication and commitment as well as all of the artists represented in this powerful and dynamic Biennial.

Jennifer P. Goodale
Vice President, Contributions

 Altria

e D.

number one

"Freeze!"

nb

iem that

r had a gun?

wax that

or X spun

CONTENTS

10 Artists in the Exhibition

12 Introduction to *Draw Me a Sheep*
 Chrissie Iles and Philippe Vergne

14 Foreword
 Adam D. Weinberg

18 Preface and Acknowledgments
 Chrissie Iles and Philippe Vergne

28 *The Euclidean Triangle*
 Toni Burlap

60 *Letter from Berlin*
 Molly Nesbit

72 *Dead Flowers: Oppositional Culture
 and Abandonment*
 Lia Gangitano

92 *Elastic Film, Mercurial Cinema*
 Bradley Eros

108 *Some Found Text and Borrowed
 Ideas (Thanks Leo, Mel, Adrian,
 Jasper, Sherrie, Roland, Dan, Fred,
 and Douglas)*
 Johanna Burton

122 *Dark Album*
 Neville Wakefield

128　*The Technocultural Imagination:*
　　　Life, Art, and Politics in the Age of
　　　Total Connectivity
　　　Siva Vaidhyanathan

140　*In the Footsteps of Tocqueville*
　　　Bernard-Henri Lévy

154　*No Child Left Behind*
　　　Bruce Hainley

165　Artists' Plates

368　Public Art Fund: A Collaboration
　　　with the Whitney Biennial
　　　Susan K. Freedman

370　Works in the Exhibition

386　Screening and Performance Schedule

389　Notes on the Contributors

LUCIFER

A LOVE

BY

KENNET

DISTRIBUTED BY ©BERKELEY BONAPARTE 1967, P.O. BOX 1250, BERKELEY, CALIF.

ARTISTS IN THE EXHIBITION

The page number to the left of the name corresponds to the artist's plate; the number following each name corresponds to the order of the *Draw Me a Sheep* foldouts.

166 Jennifer Allora and
 Guillermo Calzadilla [1]
168 Dawolu Jabari Anderson [2]
170 Kenneth Anger [3]
172 Dominic Angerame [4]
174 Christina Battle [5]
176 James Benning [6]
178 Bernadette Corporation [7]
180 Amy Blakemore [8]
182 Louise Bourque [9]
184 Mark Bradford [10]
186 Troy Brauntuch [11]
188 Anthony Burdin [12]
190 George Butler [13]
192 Carter [14]
194 Carolina Caycedo [15]
196 The Center for Land
 Use Interpretation [16]
198 Paul Chan [17]
200 Lori Cheatle and
 Daisy Wright [18]
202 Ira Cohen [19]
204 Martha Colburn [20]
206 Dan Colen [21]
208 Anne Collier [22]
210 Tony Conrad [23]
212 Critical Art Ensemble [24]

214 Jamal Cyrus [25]
216 Miles Davis
218 Deep Dish Television
 Network [26]
220 Lucas DeGiulio [27]
222 Mark di Suvero and
 Rirkrit Tiravanija [28]
224 Peter Doig [29]
226 Trisha Donnelly [30]
228 Jimmie Durham [31]
230 Kenya Evans [32]
232 Urs Fischer [33]
234 David Gatten [34]
236 Joe Gibbons [35]
238 Robert Gober
240 Deva Graf [36]
242 Dan Graham, with
 Tony Oursler,
 Rodney Graham,
 Laurent P. Berger,
 and Japanther [37]
244 Rodney Graham [38]
246 Hannah Greely [39]
248 Mark Grotjahn [40]
250 Jay Heikes [41]
252 Doug Henry [42]
254 Pierre Huyghe [43]

256 Dorothy Iannone [44]
258 Matthew Day Jackson [45]
260 Cameron Jamie [46]
262 Natalie Jeremijenko / Bureau of Inverse Technology [47]
264 Daniel Johnston [48]
266 Lewis Klahr [49]
268 Jutta Koether [50]
270 Andrew Lampert [51]
272 Lisa Lapinski [52]
274 Liz Larner [53]
276 Hanna Liden [54]
278 Jeanne Liotta [55]
280 Marie Losier [56]
282 Florian Maier-Aichen [57]
284 Monica Majoli [58]
286 Yuri Masnyj [59]
288 T. Kelly Mason and Diana Thater [60]
290 Adam McEwen [61]
292 Taylor Mead [62]
294 Josephine Meckseper [63]
296 Marilyn Minter [64]
298 Momus [65]
300 Matthew Monahan [66]
302 JP Munro [67]
304 Jesús "Bubu" Negrón [68]
306 Kori Newkirk [69]
308 Todd Norsten [70]
310 Jim O'Rourke [71]
312 Otabenga Jones & Associates [72]

314 Steven Parrino [73]
316 Ed Paschke [74]
318 Mathias Poledna [75]
320 Robert A. Pruitt [76]
322 Jennifer Reeves [77]
324 Richard Serra [78]
326 Gedi Sibony [79]
328 Jennie Smith [80]
330 Dash Snow [81]
332 Michael Snow [82]
334 Reena Spaulings [83]
336 Rudolf Stingel [84]
338 Angela Strassheim [85]
340 Zoe Strauss [86]
342 Studio Film Club [87]
344 Sturtevant [88]
346 Billy Sullivan [89]
348 Spencer Sweeney [90]
350 Ryan Trecartin [91]
352 Chris Vasell [92]
354 Francesco Vezzoli [93]
356 Kelley Walker [94]
358 Nari Ward [95]
360 Christopher Williams [96]
362 Jordan Wolfson [97]
364 The Wrong Gallery [98]
366 Aaron Young [99]

INTRODUCTION TO *DRAW ME A SHEEP*
Chrissie Iles and Philippe Vergne

Draw Me a Sheep is a visual essay, consisting of ninety-nine foldout posters, that borrows its title from the second chapter of Antoine de Saint-Exupéry's 1943 book *Le Petit Prince*. The narrator of the book is an aviator whose plane has broken down in the Sahara; one morning, he is awoken by a voice—that of the little prince, who has appeared out of nowhere, asking the aviator to draw him a sheep. "In the face of an overpowering mystery, you don't dare disobey," the narrator recalls. "Absurd as it seemed, a thousand miles from all inhabited regions and in danger of death, I took a scrap of paper and a pen out of my pocket."

In this spirit of irresistible absurdity, each artist has been given a four-panel foldout in which to respond the following question: If you could crystallize the last two years in one image, one word, one piece of text, one object, what would it be? *Draw Me a Sheep* is a collection of images, embedded within the format of the book, that defies the logic of knowledge structure—a succession of snapshots that informs us, or de-informs us, about our present time. *Draw Me a Sheep* is an open-ended narrative whose meaning is to be found between the lines, between the pages. It is an accumulation of images, just images, but eventually, as Jean-Luc Godard once said, "des images justes."

The *Draw Me a Sheep* foldouts begin with the first signature of the book, and run consecutively throughout; a key to their order of appearance can be found on pages 10–11.

FOREWORD
Adam D. Weinberg, Alice Pratt Brown Director

Today's artistic situation is highly complex, contradictory, and confusing. It is an environment few can make sense of. Despite the proliferation of large-scale, comprehensive, international exhibitions—biennials, triennials, and the like—that aspire to reveal trends and meaning, the current state of affairs seems more complicated than ever given the sheer number of working artists and the morass of seemingly conflicting styles, conceptions, and directions. Curators are often at sea as to how to approach the overwhelming task of providing a coherent overview. Frequently, they simply cherry-pick and assemble what is perceived to be the best art of the moment in the hopes that quality alone (however one may define it) will carry the day. This strategy is far more difficult than it might seem on the face of it, if for no other reason than an exhibition of works by a hundred or more artists selected with little or no structural framework will likely be seen as an inchoate mess. Other curators might select a concept or theme that seems emblematic of the moment and sort worthy art into various conceptual baskets. The danger here is a heavy-handed, overly predetermined methodology that precludes a full consideration of the art itself.

The two curators of the 2006 Whitney Biennial, Chrissie Iles and Philippe Vergne, are themselves reflections of the contradictions and heterogeneity of the art world today. Though both were born, trained, and have curated abroad, both have spent nearly a decade working at premiere American arts institutions and have been immersed in the American art community. And though deeply embedded in the particularities of the American context, they are simultaneously active participants in an increasingly fluid, global art community. Both curators have organized exhibitions in a range of media, from film and video to architecture and performance, not to mention painting and sculpture. And, perhaps most important, both have worked extensively with artists on residencies, commissions, and exhibitions as well as through teaching. Their approach to the 2006 Biennial is neither simply descriptive, representing the quality of work being produced, nor proscriptive, as determined in advance by an organizing principle. Rather, their method lies at the intersection of these two methods. Through visits with and consideration of hundreds of artists, they took their cues from the art itself. This exhibition includes not only artists they perceive to be outstanding but also artists who reveal a particular perspicacity. And through consideration of their artworks certain coherences, patterns, and relationships became evident. The curators' metaphor for the exhibition—"Day for Night"—was not premeditated but realized much later in

PRECISION SIGHTING-
100 YARD RIF
457
12 PAC

0 76683 45761 5

10
9
8
7
5

1
2
3
4
5

1 2 3 4 5 6

CHRONOGRAPH: Distance from muzzle		Rounds fired
VELOCITY: High	Low	Average
		2005

NOTES: Wind, etc.

ANACONDA TARGETS

BY DOMINIC ANGERAME

LASKA, WI 54650 • Made in U.S.A. • Printed in U.S.A. • 404174 • 1060 www.outers-guncare.com

4

the process, growing out of engrossment with, and in direct response to, exemplary works and intensive discussions with the artists. In other words, the exhibition is not merely a selection of important works, but important works that reveal overwhelming evidence of certain artistic responses to a broad range of aesthetic, social, political, and cultural phenomena.

The Whitney Museum from its inception has fostered close relationships between curators and artists. Indeed, most of the early directors and curators of the Museum were artists themselves. While there are certain scholarly exhibitions that require distance from the makers, others such as the Biennial not only benefit from this involvement but necessitate (especially given the considerably condensed time period to produce the exhibition and catalogue) a direct and dialectical relationship with artists. Furthermore, given the slippage between the roles of artist and curator, as can be seen in the Biennial representation of artist collectives such as the Wrong Gallery and Reena Spaulings that organize curatorial interventions, it's an unavoidable reality.

At least a passing reference needs to be made in these introductory remarks regarding the political environment from which these artworks emerge. America today is engaged in a tragic and distressing war that has taken thousands of lives. Moreover, recent natural disasters in this country have upended the lives of many thousands. And though these events take place hundreds or even thousands of miles away, they are omnipresent through the media. However, for many Americans such events exist more as the crackle of background static than as a palpable presence, seeing that much of this country lives simultaneously in a bubble of prosperity and security. This schizophrenic situation gives rise to at least two realities that discomfortingly coexist: one of anxiety, exasperation, and despair; and another of exuberance, energy, and wishful thinking. These contradictions are poignantly and disturbingly evidenced in the Biennial itself. How could it be otherwise? Accordingly, the curators have described the museum exhibition as a model for the exploration of the zeitgeist, "where not everything is understood, but everything is questioned." Such risk taking and honest examination are what distinguish the Whitney Biennial and the artists the curators have courageously selected.

We are grateful to the Biennial's corporate sponsors for their unwavering support of the exhibition and are proud to be associated with these exemplary corporate leaders in the arts. Lead sponsor Altria Group, Inc., in particular, has been a long-standing champion of art that takes risks and pushes boundaries. The Whitney is deeply

indebted to Altria for more than forty years of collaboration, encouragement, and support. We would also like to acknowledge major funding for the exhibition from Deutsche Bank and to recognize Deutsche Bank's invaluable role in producing the Pierre Huyghe project in Central Park, in conjunction with the Public Art Fund. We give special thanks to Sotheby's for its commitment to artists by sponsoring the Artists' Opening to launch the 2006 Biennial. We are grateful to Voom and Cineric for their generous in-kind contributions, without which this exhibition would not be possible. I would also like to thank our colleagues at the Public Art Fund, especially Susan K. Freedman, president, and Tom Eccles, former director, for another successful partnership, as well as the Cultural Services of the French Embassy and étant donnés: The French-American Fund for Contemporary Art, a program of FACE, for their support of the project. Finally, the Museum is profoundly grateful for the generous support of Melva Bucksbaum in establishing the Bucksbaum Award, granted to a Biennial artist in recognition of artistic excellence, and for the long-standing and ardent commitment of both Emily Fisher Landau and Leonard A. Lauder in creating an endowment for the Biennial.

As exciting and honorific as it is to curate a Biennial, the attendant risks, time constraints, pressures, and stresses are more than one might imagine. I am especially thankful to Chrissie Iles, the Whitney's Anne and Joel Ehrenkranz Curator of Contemporary Art, who, having co-curated the 2004 Biennial, had full knowledge of what lay ahead and nevertheless charged forward with boundless energy, deep commitment, and great insights to take on this endeavor. Philippe Vergne, the deputy director and chief curator of the Walker Art Center in Minneapolis and Iles's collaborator, although a newcomer to the Biennial gauntlet, was brave enough to perform, in effect, two jobs at once. I am deeply grateful to him for having done so and for having been such a great partner. His spirit of adventurous seeing and his desire to stretch paradigms have helped us to expand our thinking about the Biennial itself. Chrissie and Philippe's acknowledgments follow, and I join them in thanking all the individuals and institutions that made this remarkable project possible. I am especially indebted to the entire Whitney staff, whose names appear on pages 392–93, for their dedication to and enthusiasm for this demanding and rewarding project.

PREFACE AND ACKNOWLEDGMENTS
Chrissie Iles and Philippe Vergne

In the current plethora of biennial and triennial exhibitions, art fairs, and large group shows across the United States and the rest of the world, how can the Whitney Biennial remain relevant? This was one of our first questions as curators of the 2006 Biennial exhibition. The exhibition remains a closely watched barometer of the changing tides of contemporary American art. Yet the current intense pace of the commercial and not-for-profit art world has brought so much art into view at such speed that by the time it reaches the walls of the Whitney in a Biennial exhibition, there is very little that has not already been seen, digested, and critiqued.

At a moment when world opinion of the United States is at its lowest ebb and art students are gaining national press and gallery attention before they have even graduated, there seemed a particular urgency to make a bold curatorial statement about the current zeitgeist. To underline the importance of the exhibition as a model by which this exploration might take place, we gave the Biennial a title for the first time: *Day for Night*, after François Truffaut's classic 1973 film. The film's original French title, *La nuit Américaine*, refers to the cinematic technique by which night-time is shot artificially during the day, using special filters. The curatorial lens of this Biennial aims to capture the artifice of American culture, in all its complexity. The "day for night" that it reveals suggests an impulse that could be termed premodern, or pre-Enlightenment, confirming the sociologist of science Bruno Latour's argument that we have yet to become modern. We are, in other words, in a "post-America," in which America has become more of a nation than an ideal.

It became immediately apparent that the definition of what constitutes "American" is in dramatic flux. Artists, and curators, are moving round the world with an ever-greater fluidity, often living or working between countries, traveling back and forth from New York, Los Angeles, Puerto Rico, and Chicago to Istanbul, Thailand, Zurich, Berlin, Milan, and London. This fluidity has created a complicated network of communication and artistic exchange that refuses to be contained by geographical borders and that creates arcs which traverse vast distances.

This situation evokes a moment at the beginning of the last century when artists moved back and forth between the axes of, among other places, Paris, Berlin, Moscow, New York, and Zurich. Perhaps Duchamp epitomizes the reciprocity between the United States and Europe most clearly, traveling constantly between New York and Paris; by the 1960s, he commented that geographical boundaries had become irrelevant as containers for cultural forms.

Duchamp's geographical fluidity was matched by an osmosis between one identity

or alter ego and another, creating an obfuscation that finds a strong echo in the spirit of this exhibition. In addition to the familiar Rrose Sélavy, Duchamp adopted a number of other occasional alter egos, including R. Mutt, Belle Helaine, Marchand Du Sel, Archy Pen Co, Marsélavy, the wanted criminal Hooke Lyon and Cinquer, Sarah Bernhardt, a monkish ascetic, and a shaving cream–smothered satyr, all of which served to undermine the notion of fixed identity. Several artists in this exhibition have adopted similarly abstruse identities, one choosing to remain completely anonymous. Some artists appear in more than one communal grouping. Others work individually, and, in one case, the artist has chosen to make at least one work anonymous and invisible, encountered only through careful observation.

The swing of the barometer in the exhibition toward obfuscation, darkness, secrecy, and the irrational is, as always, determined by the artists. It could also be said to reflect the mood in the larger world. Running concurrently with this exhibition, for example, the Baltic Triennial of International Art in Lithuania, entitled *BMW: Black Market World*, takes as its theme secrecy, shadows, and the invisible; and a large historical exhibition organized by the Grand Palais in Paris and touring to Berlin at the moment the Whitney Biennial opens addresses the theme of melancholia. *Day for Night*, therefore, not only holds a mirror up to the current cultural moment in America but also reflects America's international relevance as part of a larger cultural moment.

We thank Adam D. Weinberg, Alice Pratt Brown Director, for inviting us to curate the 2006 Whitney Biennial and for his steadfast support throughout the project. His trust in us at every stage gave us the freedom to make decisions that we hope have produced a Biennial that is both unique and consistent in its dedication to the new and the unexplored. Nearly half the exhibition comprises new work, indicating our commitment to the artists and to venturing into the unknown.

We are indebted to our extraordinary biennial coordinator, Lindsay H. Macdonald, whose unwavering support, administrative skills, and creative energy brought the exhibition together in record time. Coordinating a hundred and one artists, two curators on the road, and a checklist of several hundred works is a daunting task, which she accomplished flawlessly. In her role as biennial coordinator, she provided creative input from start to finish, as a sounding board, support, problem solver, and friend.

We are grateful for the hard work and dedication of Jarrett Gregory, biennial assistant, who worked tirelessly on all aspects of the exhibition, especially the

catalogue; and Gary Carrion-Murayari, curatorial assistant, who worked so hard on the exhibition, its installation planning, and the Wrong Gallery's exhibition within the exhibition. Henriette Huldisch, assistant curator, has been an invaluable part of the Biennial team, in particular coordinating the film and video program. We also thank Elizabeth Gwinn, Biennial intern, for her commitment and hard work, as well as interns Nicholas Anderson, Simone Grant, Sarah Norell, Ellen Oh, and Berit Potter, who made important contributions to the project.

Our core Biennial team is part of a larger Whitney team whose collective expertise and dedication have made this complex exhibition possible. We are grateful to Christy Putnam, associate director for exhibitions and collections management, for her wise voice and guiding hand throughout the exhibition. Meg Calvert-Cason, exhibitions manager, provided us with invaluable advice. Carolyn Padwa, manager of touring exhibitions, generously stepped in to manage the Sturtevant installation. We thank Arianne Gelardin, research assistant, for her astute research. We are indebted to Nicholas S. Holmes, legal officer and exhibitions and collections coordinator, for his expertise and wise judgment. Larissa Gentile, administrative project coordinator, provided important advice regarding the challenges posed by artists' projects in relation to the building and its immediate environment.

The key to the success of every exhibition is its presentation, and we are fortunate to work with an exceptional team. We thank Mark Steigelman, manager of design and construction, for his patience, skill, and creative solutions to the challenging issues of space in this large group exhibition. We are grateful to Beverly Parsons, senior registrar, exhibitions, and assistant registrars Melissa Cohen and Emilie Sullivan for coordinating the complex arrangements to bring all the artwork safely into the building. We thank our superb team of art handlers, Filippo Gentile, Susan Griswold, Jan Hoogenboom, Chris Ketchie, Tom Kotik, Kelley Loftus, Graham Miles, David Miller, Matt Moom, Pablo Narvaez, Elisa Proctor, Warfield Samuels, and G. R. Smith who, under the guidance of Joshua Rosenblatt, head preparator, worked tirelessly with us to ensure that the artworks in the exhibition are presented at their very best. We are fortunate to have a highly experienced audiovisual team, and we thank Jeffrey Bergstrom, audiovisual coordinator, and Richard Bloes, Jay Abu-Hamda, and Ronald Bronstein, projectionists, for their expertise in presenting the film program and installing the substantial film and video installation component of the exhibition.

We are particularly grateful to Elisabeth Sussman, curator, for generously allowing us to present the Wrong Gallery's exhibition *Down by Law* in the Sondra Gilman

Gallery. We thank Cecilia Alemani and Jenny Moore, as well as Tina Kukielski, senior curatorial assistant, for their hard work and commitment to the project. The *Down by Law* exhibition includes the following artists (accurate at the time of printing): Dennis Adams, Matthew Antezzo, Edgar Arceneaux, Richard Barnes, Monica Bonvicini, Fernando Bryce, Chris Burden, Paul Cadmus, Paul Chan, Larry Clark, Chivas Clem, Verne Dawson, Jules de Balincourt, Jeremy Deller, Sam Durant, Marcel Dzama, Gardar Eide Einarsson and Oscar Tuazon, Kota Ezawa, Mathias Faldbakken, Leon Golub, Boris Gorelick, Gregory Greene, Karl Haendel, Barkley Hendricks, Jonathan Horowitz, Matthew Day Jackson and Dan Peyton, Sergej Jensen, Mike Kelley, Christopher Knowles, Glenn Ligon, Mark Lombardi, Nate Lowman, Louis Lozowick, Robert Mapplethorpe, Naeem Mohaiemen, Vik Muniz, Henrik Olesen, Raymond Pettibon, Tim Rollins, Ed Ruscha, Dread Scott, David Shrigley, Taryn Simon, Fred Tomaselli, Kerry Tribe, Kara Walker, Andy Warhol, Weegee, David Wojnarowicz, and those who wish to remain anonymous.

We thank Donna De Salvo, associate director for programs and curator, permanent collection, for her invaluable advice and support throughout the exhibition, and Bridget Elias, chief financial officer, for her steady guidance. We also appreciate the contributions of Jan Rothschild, associate director for marketing and communications, Stephen Soba, communications officer, and Meghan Bullock, communications coordinator, who superbly promoted the exhibition to the local, national, and international press and public. We are grateful to Raina Lampkins-Fielder, associate director and Helena Rubenstein Chair of Education, Frank Smigiel, manager of adult programs, and Kathryn Potts, head of museum interpretation, for their enthusiasm and creativity in public programming and visitor education. We are also grateful to Susan Courtemanche, development consultant, Amy Roth, director of corporate partnerships, and Maggie Ress, coordinator of corporate sponsorships, for their hard work securing support for the exhibition through major sponsorship.

We would like to extend a special note of gratitude to Kathy Halbreich, director of the Walker Art Center, for her understanding and collegiality. Her support enabled us to spend extended time together researching the exhibition. Also at the Walker, we are grateful to Lynn Dierks, visual arts administrator, and Eileen Romain, assistant to the chief curator/deputy director, for their support during a particularly demanding schedule.

The unusual format of this Biennial's catalogue, a "book within a book," was the inspiration of Conny Purtill, of Purtill Family Business, whose vision has produced

a uniquely designed publication in which the artists' voices, in the section entitled *Draw Me a Sheep*, play a major role. The book has been designed and bound so that it can be pulled apart to create ninety-nine posters designed by the Biennial artists. We are grateful to all the artists for their superb contributions and for responding to our challenge so enthusiastically and under short deadlines.

Our heartfelt thanks go to the writers who have made such strong contributions to the book. The insightful texts by Toni Burlap, Johanna Burton, Bradley Eros, Lia Gangitano, Bruce Hainley, Bernard-Henri Lévy, Molly Nesbit, Siva Vaidhyanathan, and Neville Wakefield form a critical backdrop for the exhibition, of which the book is a significant part. We also thank writers Max Andrews, Johanna Burton, Gary Carrion-Murayari, Suzanne Hudson, Henriette Huldisch, Nathan Lee, Emily Speers Mears, Jenny Moore, and Lisa Pasquariello for producing the many informative artist entries and extended wall labels.

We are thankful to Rachel de W. Wixom, head of publications and new media, for shepherding the book into being. Such a complex publication is challenging to produce in the short time span of the Biennial, and we are deeply grateful to Mary DelMonico for her skilled supervision as project director. Her energy, professionalism, and unerring eye have been crucial to the book's success at every stage. We are also grateful to Michelle Piranio, editor, for her superb editing skills. And we thank Basem D. Aly, Joe Avery, Shapco Printing, Inc., Kathleen Drummy, Anita Duquette, Richard G. Gallin, Joann Harrah, Karen Hernandez, Thea Hetzner, Anna Knoell, Vickie Leung, Jennifer MacNair, Sheila Schwartz, Lynn Scrabis, and Makiko Ushiba for their hard work and commitment to the publication and exhibition under tight deadlines.

We are proud to celebrate another Biennial partnership with the Public Art Fund. This is our third joint project with the Public Art Fund and Tom Eccles, who first brought the Pierre Huyghe video installation to the table and left the Public Art Fund in the summer of 2005 to become director of the Center for Curatorial Studies at Bard College. We thank him and our current partners at the Public Art Fund, especially Susan K. Freedman, president, Richard Griggs, deputy director, Anne Wehr, communications director, and Yayoi Sakurai, installation coordinator, for their extraordinary commitment and hard work in bringing a complex project to fruition, as both a large-scale performance in the Central Park Wollman Rink and in its final installation form at the Whitney.

We extend our deep gratitude to all the lenders to the exhibition, for their

generous support in making works available to us: Artangel; Valerie Cassel; Castello di Rivoli, Museo d'Arte Contemporanea; China Art Objects; Alberto and Maria de la Cruz; Chris Erck; Pete Franciosa; Estate of Steven Parrino; Estate of Ed Paschke; Danielle and David Ganek; Hort Family Collection; Jedermann Collection, N.A.; Rita Krauss; Judy Ledgerwood and Tony Tasset; Adam Lindemann; Michael and Ninah Lynne; Museum of Contemporary Art, San Diego; The Museum of Modern Art, New York, The Judith Rothschild Foundation Contemporary Drawings Collection; Linda Pace; César and Mima Reyes; Ringier Collection; Saatchi Gallery; Sadie Coles, HQ; Pamela and Arthur Sanders; Nancy and Stanley Singer; Dirk Skreber; Lorelei Stewart and Andreas Fischer; David Teiger; Madalyn and Stephen Tobias; Dean Valentine and Amy Adelson; Walker Art Center; Paul F. Walter; Michael Young; and those lenders who wish to remain anonymous. Without the support and generosity of the following lenders, the Wrong Gallery's exhibition, *Down by Law*, could not have been realized: Galerie Daniel Buchholz; Chris Burden studio; Feigen Contemporary; Zach Feuer Gallery; Galleria Emi Fontana; Eivind Furnesvik, Standard Gallery; Gavin Brown's enterprise; Greene Naftali Gallery; Haines Gallery; Anna Helwing Gallery; Hosfelt Gallery; Erling Kagge Collection; Fawad Kahn; Galerie Kamm; Anton Kern Gallery; Galerie Klosterfelde; maccarone inc.; Andrew McKuin; Murray Guy; Todd Norsten; Morris and Patricia Orden; P.P.O.W.; Rubell Family Collection; Sikkema Jenkins & Co.; Steve Shane; Team Gallery; Galerie Barbara Thumm; Susanne Vielmetter Los Angeles Projects; Estate of David Wojnarowicz; and David Zwirner Gallery.

An exhibition of the size and complexity of the Biennial requires the support and generosity of many galleries. We particularly acknowledge and thank the following: 303 Gallery; Baldwin Gallery; Jean Bernier Gallery; Blum & Poe; Galerie Daniel Buchholz; Canada Gallery; Casey Kaplan Gallery; China Art Objects; Clementine Gallery; Cohan and Leslie; Sadie Coles HQ; Galería Comercial; Contemporary Fine Arts; Paula Cooper Gallery; Galerie Chantal Crousel; Elizabeth Dee; Deitch Projects; Thomas Erben Gallery; Zach Feuer Gallery; David Floria Gallery; MARC FOXX Gallery; Gagosian Gallery; Gavin Brown's enterprise; Marian Goodman Gallery; Greene Naftali Gallery; Jack Hanley Gallery; Hasswellediger & Co.; HOTEL gallery; Inman Gallery; Anton Kern Gallery; Nicole Klagsbrun Gallery; Johann König Gallery; Harris Lieberman Gallery; Lisson Gallery; maccarone inc.; Marvelli Gallery; Matthew Marks Gallery; Metro Pictures; Galerie Meyer Kainer; Victoria Miro; Modern Art, Inc; Peres Projects; Friedrich Petzel Gallery; Postmasters Gallery; Galerie

Eva Presenhuber; The Project; Regen Projects; Rivington Arms; Perry Rubenstein
Gallery; Salon 94; Jack Shainman Gallery; Sikkema Jenkins & Co.; Team Gallery;
Richard Telles Fine Art; Michael Werner Gallery; White Columns; Galerie Barbara
Wien; Donald Young Gallery; and David Zwirner Gallery.

We are also grateful to the following individuals for all their kind help and gen-
erous support: Cecilia Alemani; Sandra Antelo-Suarez, TRANS>; Jean Bernier,
Jean Bernier Gallery; Tim Blum and Jeff Poe, Blum & Poe; Jim Browne; Gavin
Brown, Corinna Durland, and Laura Mitterand, Gavin Brown's enterprise; Bianca
Cabrera; Claudia Carson, Robert Gober Studio; Walter Cassidy; Leslie Cohan and
Andrew Leslie, Cohan and Leslie; Sadie Coles; Paula Cooper and Steve Henry,
Paula Cooper Gallery; Luca Corbetta; Karina Daskalov, Dan Graham Studio;
Elizabeth Dee; Melissa Dubbin; Rebecca Fasman; Frances Garret; Haidy Geismer,
New York University; Leo Goldsmith, White Mountain Films; Ed Greer; Loren
Guinnebaylt; Jack Frank and family; Jose Freire, Team Gallery; Darren Flook,
HOTEL gallery; Marian Goodman and Rose Lord, Marian Goodman Gallery;
Jeanne Greenberg Rohatyn, Salon 94; Jack Hanley; Bob Holman and Matthew
Lydon, Bowery Poetry Club; Ali Hossaini, Voom; Aaron Igler; Dick Johnston;
Anton Kern and Christoph Gerozissis, Anton Kern Gallery; Wynne Kettell; Nicole
Klagsbrun; Elizabeth Linden; Matthew Marks; Trina McKeever and Clara Weyergraf,
Richard Serra Studio; Ivana Mestrovic and all the staff at Spacetime C. C.; Jenny
Moore; Cullen Murphy and Bessmarie Moll, The Atlantic Monthly; Will Murphy,
Random House; Tim Nye; Balasz and Francine Nyeri and all the staff at Cineric, Inc.;
Ana Otero; Tony Oursler Studio; Marc Paschke; Jenelle Porter; Eva Presenhuber;
Katherine Pugh; Roberto Rabin, Fuerte Conde de Mirasol; Shaun Caley Regen
and Lisa Overduin, Regen Projects; Francisco Rovira Rullán, Galería Comercial;
Perry Rubenstein, Sylvia Chivaratonond, Branden Koch, and Amy Davila, Perry
Rubenstein Gallery; Brent Sikkema, Michael Jenkins, and Teka Selman, Sikkema
Jenkins & Co.; Debra Singer, The Kitchen; Larry Gagosian and Robert Shapazian,
Gagosian Gallery; Gavin Smith, Walter Reade Theater; Will Swofford; Blanche
Tannery, Director of Visual Arts and Architecture, Cultural Services of the French
Embassy; Richard Telles and Deborah Hede, Richard Telles Fine Art; Tabatha
Tucker, Weiss Studio; Will Washburn; Michael Werner and Gordon VeneKlasen,
Michael Werner Gallery; Donald Young and Tiffany Stover, Donald Young
Gallery; and David Zwirner, Angela Choon, Bellatrix Cochran-Huber, and Amy
Bauman, David Zwirner Gallery. We would also like to thank all those involved

in the complex *Don't Trust Anyone Over Thirty* project, including all the team and coproducers listed on page 243; David Alexander, Valentin Essrich, and Francesca von Hapsburg should be singled out here.

We are grateful to the many colleagues who offered suggestions, advice, and hospitality during our research for this exhibition. We particularly acknowledge Thomas Bartscherer, doctoral candidate in the Committee on Social Thought, University of Chicago; Ariella Ben-Dov, director, Madcat International Women's Film Festival; Andrea Bowers; Canyon Cinema, San Francisco; Maurizio Cattelan, Massimiliano Gioni, and Ali Subotnick; Amada Cruz, Bridget Murphy, and Christopher Vroom, Artadia; Sam Durant; Electronic Arts Intermix, New York; Okwui Enwezor, dean, San Francisco Art Institute; Marcos Ramirez Erre, director, Gallery Estacion, Tijuana; Sylvie Fortin, Art Papers; Patrick Friel, Chicago Filmmakers; Alison de Lima Greene, curator, Museum of Fine Arts, Houston; Eungie Joo, director and curator, Gallery at REDCAT, Los Angeles; Mary Leclère, director of the Core Residency Program, Glassell School of Art, Houston; Rick Lowe, director, Project Row Houses, Houston; Paula Marincola, director, Philadelphia Exhibitions Initiative; Michael Newman, associate professor in art history, theory, and criticism, School of the Art Institute of Chicago; Madeline M. Nusser, art editor, *Time Out Chicago*; Glenn Phillips, research associate and consulting curator, Getty Research Institute; Scott and Tyson Reeder, General Store, Milwaukee; César and Mima Reyes; James Rondeau, Frances and Thomas Dittmer Curator of Contemporary Art, The Art Institute of Chicago; Ralph Rugoff, director, CCA Wattis Institute for Contemporary Arts, San Francisco; MM Serra, director, Filmmakers' Cooperative, New York; Stephanie Snyder, director, Cooley Art Gallery, Reed College, Portland, Oregon; Fabrice Stroun, Musée d'Art Moderne et Contemporain, Geneva; Hamza Walker, education director, Renaissance Society, Chicago; Suzanne Weaver, associate curator of contemporary art, Dallas Museum of Art; Mark Webber, London-based independent curator; and the folks at Video Databank, Chicago. We would also like to thank all of the artists whom we visited during the course of our research for the exhibition. Studio visits are intimate experiences, not undertaken lightly, and we appreciate the generosity with which the artists opened their studios, and often their private homes, to us. We learned a tremendous amount from the dialogues and exchanges we had with every one of them.

Finally, we thank the Biennial artists. Their talent, energy, enthusiasm, and support have been the inspiration for, and the driving force of, this exhibition.

THE EUCLIDEAN TRIANGLE
Toni Burlap

Herodotus says that Babylonian priests would gather once a year before dawn to watch the sunrise reach a certain pillar deep within the temple; as the sun touched the horizon, a gem inlaid in the pillar would glow for a few moments, indicating that the world still worked.[1]

Since the Salons of nineteenth-century Paris, the exhibition has functioned as an indication that the art world still works. Within each changing cultural paradigm, the exhibition continues to perform "a ritual in which the real and the imaginary join forces to find a concrete, and yet open, final result which could give new meaning to 'humanity.'"[2] The search for meaning is one of the driving forces behind curatorial thinking: a quest for new ways of seeing, even after the end of modernism and the utopian idea of progress.

In extreme close-up, the undercurrent of recent contemporary American art suggests a working through of the endgame of the tired models of modernism. Even as the movement's major figures are receiving renewed recognition, both by institutions and by a younger generation of artists, the underpinnings of its value system are being questioned and transformed. The resulting return of the once-repressed contains a paradox. Conceptual practices, political actions, performance, and nonmaterially based works are reasserting themselves with a new force. At the same time, formal, narrative forms of sculpture and painting are strongly evident, with a focus on objecthood, materiality, and commodity exchange, even as other works appear to be simultaneously critiquing this approach. Since the art market is arguably the purest form of capitalism, it is uncertain whether this criticality is illusory or simply a form of acquiescence in disguise. As Marcel Duchamp observed, "Artists throughout history are like gamblers in Monte Carlo and in the blind lottery some are picked out while others are ruined."[3] The Conceptual, antimaterialist interventions that have emerged in some recent art evoke Duchamp's lithograph *Monte Carlo Bond* (1924), signed by both Duchamp and Rrose Sélavy, in which Man Ray photographed Duchamp covered in shaving cream, with devil-like horns, in the center of a roulette wheel. The profits from the sale of

the "bonds" were meant to provide the artist with funding to research a chess-based system for winning at roulette. Duchamp's desire to transform the random chance of the roulette wheel—to which he, as an artist, was hostage, about to be shaved, or fleeced—into the logical strategy of chess, over whose outcome he had a certain control, demonstrates his desire to be free of a system in which the commodified artist has no control over his or her own production. In this system, everything is for sale, if only you can pay the price; but everything is already sold. We might be facing a situation where art has moved beyond aesthetic pleasure and financial speculation to eventually become the ultimate path to social distinction. Tell me what you bought, where, when, and for how much, and I'll tell you who you are. But the answer might be, as Todd Norsten proclaims in one of his toxic paintings, "Fuck you, I can afford it."

The paradoxical condition we see today might be understood in terms of a Freudian uncanny, in which, as critic Hal Foster points out, the familiar returns, made strange by its repression.[4] This return, Foster argues, "renders the subject anxious and the phenomenon ambiguous, and this anxious ambiguity produces... an indistinction between the real and the imagined... a confusion between the animate and the inanimate, as exemplified in wax figures, dolls, mannequins, and automatons... and a usurpation... of physical reality by psychic reality."[5] This could describe the current state of contemporary art in Western culture, in which Conceptual and material forms are infused with irrationality, obfuscation, desire, disappearance, and ambiguity, embracing the erotic and the abject, the invisible and the hyperreal. This tension between Eros and Thanatos evokes Foster's "convulsive beauty," in which the uncanny "mixes delight and dread, attraction and repulsion" in a form of "negative pleasure."[6]

The desire to possess (and be possessed by) and the power of money are other manifestations of this negative pleasure, whose horror vacui is rooted in an erotic impulse that evokes, in the words of Biennial artist Jutta Koether, quoting philosopher Slavoj Žižek, the "death drive: [an] entropic night of the world... trauma, loss, anxiety, excess... tension and insistence... [a] transcendental condition... threatening to explode."[7]

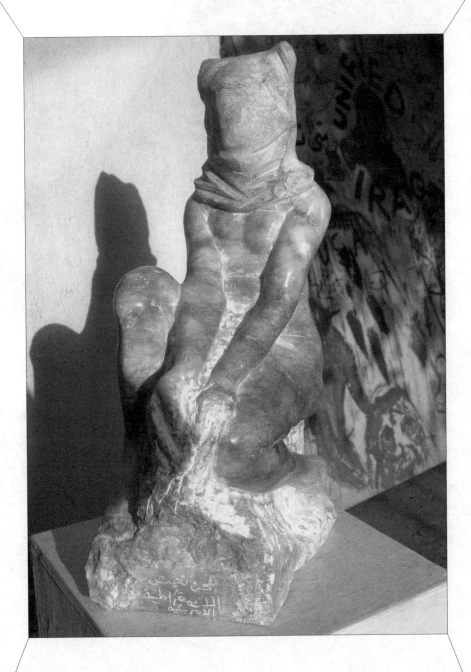

An alabaster sculpture that bears a striking resemblance to shocking photographs from Abu Ghraib prison, made by Iraqi artist Abdul-Kareem Khalil in March 2004, on view at a gallery in Baghdad. The words "We are living in an American democracy" are inscribed on its base. (AP Photo/Karim Kadim)

Borrowing from Foster's explanation for the emergence of Surrealism at the beginning of the twentieth century, it could be suggested that, just as Surrealism's imagery worked through the traumas of the nineteenth century, contemporary art is grappling with those of the twentieth and early twenty-first centuries—from the collective trauma of two world wars, Vietnam, September 11, and the forgotten genocide in the Sudan, for example, to the resulting convulsive changes in the social, political, and cultural life of both the United States and Europe. The current artistic moment reflects a new century reliving the repressed moments of the old in order to leave them behind.

This might help explain the current simultaneous juxtaposition of "space-times"[8] in contemporary American art. In painting, psychedelia—that delirious resurfacing of the unconscious that first appeared at a previous time of war, in the 1960s—rubs shoulders with the languages of Symbolism, 1980s German painting, eighteenth-century portraiture, and the rebirth of religious painting at the end of the nineteenth century. In sculpture, works that embrace the cool, reductive Minimalist and Conceptual forms of the 1970s coexist alongside a fantastic realism in sculpture and installation, where doll-like bodies, puppets, and other surrogates undermine the commodification of the body by confusing its corporeality, representing it as both deathly robotic and uncannily hyperreal, overexposed, and underexperienced.

This slippage creates a space between one reading and another that includes elements of both but is contained by neither. The resulting obfuscation of identity, which permeates contemporary art in many forms, echoes Foster's uncanny "as anxious crossings of contrary states, as hysterical confusings of different identities."[9] In some cases it is manifested through anonymity, in others as a fictitious artistic persona, such as Reena Spaulings or Otabenga Jones, or as a collaborative activity in which no one person's contribution is necessarily identifiable, as in Bernadette Corporation, the Wrong Gallery, Critical Art Ensemble, or Deep Dish Television Network. Anonymity or invisibility might be the condition of absolute freedom today. When artists and the art world collide with the people pages of the celebrity press, not

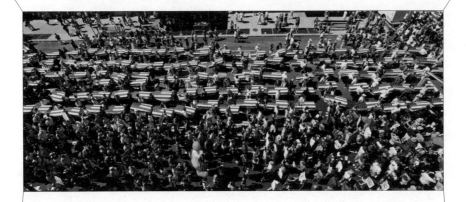

Protesters carry coffins to symbolize American soldiers killed in Iraq, during a protest march, sponsored by United for Peace and Justice, leading up to the Republican National Convention site in New York, August 29, 2004. (AP Photo/Gregory Bull)

There's

to be seen, not to be known, might be the sole guarantee of being able to work, think, and live autonomously. The blurring of the lines of identity, in an attempt not to confuse genres, but to reformulate the format of artistic and cultural production—a necessary attempt if one does not want what was once called the avant-garde to become the arrière-garde—may apply to both the artist and the work. For Bernadette Corporation, a film can also be a performance or an ongoing street activity; a journey might double as a performance and an exhibition, as with the work of Pierre Huyghe and Robert Gober.

Alternatively, the instability of meaning can occur in the reading of the image itself, as seen in Troy Brauntuch's black-and-white canvases, after-images in which delicate specters seem to slip between light and shadow, as though seen through a mist, or in Mark Grotjahn's white paintings, in which layers of creamy white paint cover an image entirely to render it invisible. In Carter's ghostly collages, photographs of faces are drawn over with pen or disguised by layers of cutout paper, through which identity is glimpsed but never ascertained. Such ambiguity acts out a classic trope of the late nineteenth and twentieth centuries: Baudelaire's definition of modernity as "the ephemeral, the fugitive, the contingent."[10]

The revisiting of obfuscation as an echo of a defunct modernity often reveals itself in playful, Duchampian terms. In *Homo Ludens: A Study of the Play Element in Culture*, the historian Johan Huizinga argues that play—as he designates it, the "highest region of the spirit"—performs a significant social function, whose most important characteristic is a spatial or psychological separation from ordinary life. The artist, the ultimate *Homo ludens*, is reconfiguring, through play, a metaphorical representation of the world.

The fictitious artist Otabenga Jones is a kind of collective alter ego, an independent personality who produces writings and installations alongside the four young Houston-based black artists—Dawolu Jabari Anderson, Jamal Cyrus, Kenya Evans, and Robert A. Pruitt—from whose imagination he sprang. Jones is named after Ota Benga, a survivor from a Pygmy community in the Congo who was purchased by Samuel

Phillips Verner and brought to the United States for the 1904 World's Fair in St. Louis and then exhibited in the Bronx Zoo in 1906. Once again, the artist evades attempts to define his production as uniquely his, since Otabenga Jones has facets of all four artists, whose work—comprising an aesthetic language indebted less to a postcolonial logic than to a decolonial one—incorporates elements of Black Power, the Black Panthers, and a strong critique of representations and guilty commodification of fetishized African American culture. A good example of this can be found in Anderson's own drawing *Black History Month—Feel What the Excitement Is All About* (2005), in which we can understand the notion of a "postblack" condition as a lure, a hangover, that barely hides the problems of race and class divisions in America.

It is perhaps no accident that the current self-conscious questioning by artists of conventional ego structure evokes Jean-Paul Sartre's philosophical writings on the removal of the ego from the center of consciousness, such as *Being and Nothingness* (an important counterpoint of Mahayana Buddhist philosophy), a major book of the 1950s. Sartre's arguments regarding nonduality have had a profound influence on Dan Graham, one of the key senior figures in this Biennial. His project *DTAOT: Combine (Don't Trust Anyone Over Thirty, all over again)* (2005), a collaboration with Tony Oursler, Rodney Graham, Laurent P. Berger, and Japanther, resists conventional aesthetic categories and has no vocabulary to describe it: it is neither a film, a concert, a performance, a puppet show, nor an installation in any strict definition of these terms, yet it embraces elements of each.

Masks, mimesis, music, the carnival, the grotesque, esoteric ritual, and paganistic traditions all play an important role in this aspect of social theater, in which conventions are overturned. Cameron Jamie's film performance and installation *Kranky Klaus* (2002–3), for example, analyzes the world as a theater of dysfunctional bodies. He reconnects his subject, the social body, to a sense of performance through the live presence of Los Angeles–based band The Melvins, who play in front of the projected film, thus using live music to suggest the potential of the artist as a cathartic presence confronting an architecture of repression embodied by religion, politics, and morality.

war going on

In discussing the alternative artistic strategies of the 1970s, critic Kathy O'Dell cites philosopher Mikhail Bakhtin's arguments regarding the importance of carnivals and holidays as social levelers that turn hierarchies "inside out."[11] Current contemporary art seems driven by a spirit that recalls what was happening in the 1970s, when artists eschewed the museum for alternative spaces, the streets, and commercial galleries alike. During the 2005 Performa Performance art biennial in New York, for example, artists created performances, actions, and ephemeral artworks on the street, in a Lower East Side club, in museums, and in numerous alternative commercial spaces across the city, both public and private. For one such work at Anthology Film Archives, Koether and Emily Sundblad, along with Ei Arakawa and others, built a structure of silver boards, which was torn apart at the end of the performance to reveal a group of paper images stretched across canvases; these were then carried across the theater and destroyed. Streaming silver curtains hung across the audience space; bread was thrown and soup served to the spectators. Films came and went on the screen, sometimes appearing for no longer than a few seconds, and people shouted statements through megaphones. Koether played live noise music, and Sundblad sang a traditional song with her mother and brother (who were visiting from Sweden), standing together behind the audience, almost invisible in the back row.

The fluidity of form that defines current art also has a direct resonance with what artist Christopher Williams has termed "a kind of Marxist, Situationist minimalism" found in certain artists' work in the late 1970s— that pivotal moment when Conceptual practices were being reworked through an intersection with abstruse narratives. Williams describes being influenced by the collaborative work of New York artist Christopher D'Arcangelo (who chained himself to the door of the Museum of Modern Art, New York, to protest the institutional status quo), whose own constructed walls "would also become the surface on which other work[s] of art would be displayed, on which other artists would perform actions."[12] Likewise, Williams's work refuses precise categorization, reconsidering architectural space by incorporating fragments from the structure within

"First, let me make it very clear, poor people aren't necessarily killers.
Just because you happen to be not rich doesn't mean you're willing to kill."

—Washington, D.C., May 19, 2003

Page from *The George W. Bush Coloring Book*, illustrated by Karen Ocker, published by Garrett Country Press, 2005

which it is housed alongside photographs, objects, and video. Sometimes a parallel film program is curated, bringing together films that have elaborated on the ideas in the installation, and this program is documented as a poster, which in turn becomes a discrete additional element of Williams's elusive yet rigorous critical narrative. His work defies aesthetic categories by altering the logic of production—the production of signs that stratifies, if not neutralizes, sociopolitical reality.

Such an assembly line of images, or economy of empty signs, is at the heart of Pierre Huyghe and Philippe Parreno's 1999–2002 Annlee project, which combined cinematic fiction with a real anime character, creating a bridge from the institutional critique of the late 1970s and 1980s to the current proliferation of obscured meaning. In *A Journey That Wasn't* (2005), Huyghe brings together an actual journey to Antarctica with a theatrically staged filming of Antarctica in darkness, crafted using artificial black icebergs floating on a dark, melting ice rink in the middle of New York's Central Park.

In another twist of the uncanny, a new breed of art fair has infused the traditional commercial marketplace with a sense of carnival, defamiliarizing the mercantile with a critical, performative impulse, creating a shimmerer's dance evocative of Andy Warhol. As the art market has intensified, alternative models of artist-run spaces have appeared in New York, the market's center, some of which, like Reena Spaulings or the Orchard Gallery, are for-profit and not-for-profit hybrids. Within this paradoxical situation, the lines between profit and not-for-profit, commodity and concept, are becoming unprecedentedly blurred. A case in point is the Wrong Gallery (whose members Maurizio Cattelan, Massimiliano Gioni, and Ali Subotnick acted as curators of the 4th Berlin Biennial for Contemporary Art), which has taken on a new role—a critical *détournement*—in the form of a gallery space named Gagosian Berlin, where different curators develop not-for-profit exhibitions. Playing the devil's advocate, one might question whether, through Gagosian Berlin, the notion of subversion has been instantaneously digested and instrumentalized by the very target of such a critical strategy, who gains from it, perhaps, just another public

relations opportunity. What does this reveal as a sign of the times? It might mean that we are all sleeping with the enemy; it might mean that the art community has organized itself in an endless loop of commercial, co-opted spectacle that feeds off its own decay. It might mean that we have become our own worst enemy and that the structure in place has relevance only within its own insular borders.

That the Wrong Gallery collective—two-thirds of whom are European—is included in the Whitney Biennial of American art as artists curating an exhibition within an exhibition and producing a new list of artists whose identity in relation to those selected by the Biennial curators is both equal and independent further indicates the level of complexity that characterizes the current resistance to taxonomic conventions, an impulse which pervades the character of the Biennial exhibition as a whole. What the Wrong Gallery addresses, with a sense of irony, is the need to reassess our parameters, our aesthetic conversations. Thus Jay Heikes's need to put to use his oversized *New Heaven Hook* (2005), based on the hooks used in cabarets to forcibly remove from the stage an especially bad performer. Heikes's sculpture, like much of the work in the Biennial, attempts to reconsider artistic practice in a postspectacle arena. It takes as its target not the popular culture, entertainment model of spectacle, but the spectacle that modernity and art have created for themselves. It is time to burn our idols, to push them from the pedestal, even if we end up admiring only the debris.

Other alternative spaces in New York, such as Participant Inc. or A Gathering of the Tribes, coexist, at a cautious but necessary distance, alongside institutions rather than positioning themselves against them. In Los Angeles, the complex structure of art schools continues to provide a connective tissue between generations of Los Angeles–based artists, drawing young artists from all over the country, and from abroad, to the city, where many settle after graduation. The resulting communality, like the Ariadne thread, echoes media culture guru Marshall McLuhan's prediction in 1967 that "too many people know too much about each other. Our new environment compels commitment and participation. We have become

irrevocably involved with, and responsible for, each other."[13]

Unparalleled social interconnectedness, which might just be interdependence, also has eased the flow of the language of pornography and the erotic into both mainstream culture and the artist's studio. Pornography first appeared as a concept at the end of the eighteenth century, as a rebellious criticism of church and state during a period of revolution and dramatic social change. As critic Lynn Hunt argues, pornography is part of radical politics and inextricably linked to democracy. It initially became an issue as the balance between public and private shifted in a newly modern social structure in which religious values were eroded by secular ideas of the Enlightenment. Originally restricted to the private, sophisticated tastes of the social elite, the erotic was unleashed into the larger world through literacy, broadening the potential threat to the social order and triggering a need to control its availability. Pornography "was the name for a cultural battle zone….[It] names an argument, not a thing."[14]

Francesco Vezzoli explores the political facets of pornography in *Trailer for a Remake of Gore Vidal's "Caligula"* (2005), creating a false trailer for a remake of the notorious film about the decadent government of Roman Emperor Gaius Germanicus, known as Caligula, who gave his horse political office and hosted scandalous orgies in the imperial palace, centuries before the concept of pornography existed. Vezzoli's film, an implicit critique, made using a complicit aesthetic, of the innate corruption of government and of the decadence of the Western historical narrative as formalized and manipulated, if not edited, by the American (and ultimately provincial) Hollywood cinema, achieves its aim by seduction, depicting a fictional moment of high pornographic elitism.

The proliferation of pornographic and erotic imagery in contemporary art arguably signals not only the degree to which it has entered the commercial visual environment—dispersed through billboards, magazines, cable TV, the internet, and fashion—but also, in some cases, an inverted political elitism, through which its original rebellious role is being reclaimed by artists. In the eighteenth century, women were participants in the secret world of erotica, both as consumers and producers. As Hunt points out,

"if all bodies were interchangeable—a dominant trope in pornographic writing—then social and gender ... differences would effectively lose their meaning. Early modern pornographers['] ... portrayal of women, at least until the 1790s, often valorized female sexual activity and determination."[15] The assertive portrayal of erotic desire in the work of Marilyn Minter, Dorothy Iannone, and Monica Majoli has consistently provoked anxiety, even hostility, especially when it involves explicit images of their own bodies. It is no accident that many have trouble uttering painting titles by Iannone, such as *Suck My Breasts I Am Your Most Beautiful Mother* (1972), out loud. Reversing the traditional relationship between male painter and commodified female subject, all three artists counter the Duchampian eroticized model of visuality in which the female body is defined as a dangerous machine. The resistance to the erotic charge contained within, and owned by, each artist's painted surfaces betrays a lingering puritanical value system, one that accepts commercial pornography as part of the machinery of the social unconscious but refuses to acknowledge its transformative possibilities for fear of social disorder. The ecstatic body, the body that "comes," is a source of such disorder. If you touch it, you shake a structure built upon associations with family values, religion, and social status quo. *Nole me tangere* (Do not touch me): Jesus's words to Mary Magdalene (John 20:17) are still strangely operative. The deviancy of the contemporary moment is its striving for normality. Depictions of emotional intimacy, as in the work of Angela Strassheim and Amy Blakemore, can be more disruptive and subversive than almost any form of representation. They actually defy the literalness of pornographic codes of representation and take us back to the uncontrollable force that is the power of intimacy, a force as compelling, and unavoidable, as gravity. Kenneth Anger uncovers a similarly repressed social impulse in his film *Mouse Heaven* (2005), in which Mickey Mouse, described by film critic Jim Hoberman as "this insolent, lowlife, magically animated creature [who] exhibited a commendable disregard for bourgeois propriety,"[16] is returned to his original mischievous, sadistic persona. Anger's film confirms that the Mickey Mouse cartoons' "sadism [and] violence, their very

two-dimensionality, served as a diagram for the mechanisms of social oppression: 'The public recognizes their own lives in them.'"

This sinister portrayal of the cartoon icon confirms the futility of literary critic Walter Benjamin's utopian hope in the 1930s that film—including Mickey Mouse cartoons—could, as Miriam Hansen writes, act as a playful political tool by which "'to establish equilibrium' between humans and technology…an ameliorative strategy [following the failure to do so in World War I] in the face of another, even more devastating military catastrophe."[17]

Hansen notes the covering up of a large tapestry reproduction of Pablo Picasso's *Guernica* in the United Nations Headquarters in New York on February 5, 2003, when U.S. Secretary of State Colin Powell went there to make his case for invading Iraq (this event was an exhibition in its own right, one we won't call art, but one, nonetheless, which no artist, no curator, no institution has yet overpowered). Hansen quotes Maureen Dowd, who wrote in the *New York Times* that, according to diplomats, the picture would have sent "[t]oo much of a mixed message…. Mr. Powell can't very well seduce the world into bombing Iraq surrounded on camera by shrieking and mutilated women, men, children, bulls and horses."[18] Dowd's point underlines the power of the image within a globalized media culture, which contemporary artists have recognized. Richard Serra's *Stop Bush* (2004) reworks one of the most iconic media images from the war in Iraq—a globally broadcast photograph of a hooded Iraqi prisoner at the notorious Abu Ghraib prison, forced to stand on a box, naked except for a blanket, his hands outstretched, apparently wired, in front of his American captors. The image, one of several that revolted the nation and marked a turning point in opinion of the war, was transformed by Serra into a poster and banner that became a symbol of antiwar demonstrations and activities by artists across the country in 2004. The level of political protest activities by artists that year— including through posters, artworks, marches, actions, an *Artforum* issue devoted to political protest, and various fund-raising events—exceeded that during the conflict with Vietnam. The Iraq war continues to be

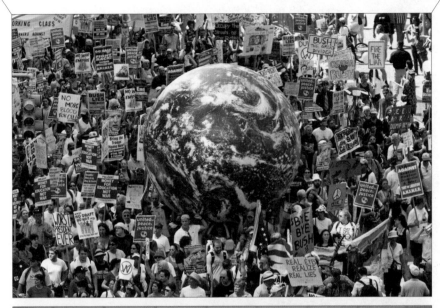

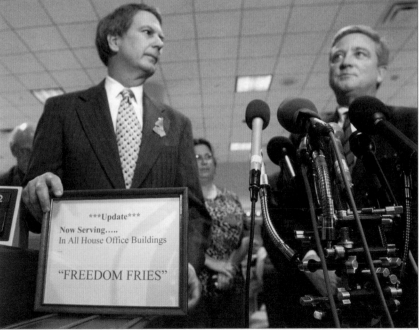

Top: Protest march, sponsored by United for Peace and Justice, leading up to the Republican National Convention site in New York, August 29, 2004. (AP Photo/Joe Cavaretta)

Bottom: Rep. Bob Ney, R-Ohio, chairman of the House Administration Committee, right, and Rep. Walter Jones, R-N.C., meet reporters at the Longworth House Office Building cafeteria on Capitol Hill, March 11, 2003, to announce that House cafeterias will no longer serve french fries, replacing the "French" cuisine with "freedom fries." (AP Photo/Lisa Nipp)

an issue for artists. For the 2006 Biennial, Mark di Suvero and Rirkrit Tiravanija have reconceived the 1966 *Artists' Tower for Peace* in the Sculpture Court of the Whitney Museum. The nearly 60-foot-high original tower, designed by di Suvero, was erected on the corner of La Cienega and Sunset boulevards in Los Angeles by a group of artists protesting the Vietnam War. The tower was affixed with hundreds of small panels made by the artists, who included Donald Judd, Mark Rothko, Roy Lichtenstein, Nancy Spero, Judy Chicago, and many others. For their *Peace Tower* (2006), di Suvero and Tiravanija have invited as many of the original artists who could be found to take part, as well as the 150 artists who participated in the 2003 Venice Biennale's *Utopia Station* project, co-curated by Tiravanija, Molly Nesbit, and Hans Ulrich Obrist. It may not be an exaggeration to state that the new *Peace Tower* marks the first time a large-scale political artwork, made spontaneously in reaction to war, has been installed in an American museum since *Guernica* was placed at the Museum of Modern Art for safekeeping in 1939.

Hansen's argument against Benjamin's vision of an equitable relationship between society and technology, in the face of technology's overwhelming presence, is played out in activist terms by Deep Dish Television Network (DDTV). A collaborative alternative satellite network, their latest programs include *Fallujah* (2005), a documentary by Iraqi and American filmmakers on the community of Fallujah after the Iraqi city's near-destruction in November 2004, and *Shocking and Awful: A Grassroots Response to War and Occupation* (2003–5), a series of twelve short programs on the impact of the Iraq war, including interviews with soldiers and their families and footage of the destruction of the cultural artifacts immediately following the invasion, the global protests against the war, and the World Tribunal on Iraq. DDTV's initiative demonstrates technology's paradoxical legacy: the media's global influence has simultaneously triggered a McLuhanesque dispersion of voices, through web blogs, alternative television and radio broadcasts, and internet reporting, that undermines the very hegemony it seeks.

At issue is not nostalgia or memory without pain, but a genuine desire to reassess history in order to better understand the present. In such an

attempt, Matthew Day Jackson has developed an "amateur historian" practice, based on a fundamental belief that art can make a difference, to reclaim a confiscated history. Similarly, in the work of Jennifer Allora and Guillermo Calzadilla notions of aesthetics and activism collide to identify, ultimately, another category altogether. Such work suggests a multi-, inter-, or transdisciplinary understanding of artistic practice that encompasses not only art and culture but also science, technology, economics, and environmentalism. In such a practice—embodied by, for example, the research and experimentations of Natalie Jeremijenko—the protagonists are not artists anymore but something we have yet to name.

The outsider's voice against the establishment has been at the core of America's identity since the country's founding. The negotiation of the territory between institutional power and marginal voices has played itself out through the figure of the bandit or outlaw, whom the Wrong Gallery has described as one of the "dark heroes of the American Dream. From the dusty days of the Wild West to the current fear of the Middle East, American culture has been hypnotized by the adventures of lonesome warriors and legendary outlaws."[19] *Down by Law*, curated by the Wrong Gallery with Cecilia Alemani and Jenny Moore for the 2006 Biennial as an exhibition within an exhibition, focuses on the Whitney's parameters as a museum of American art by addressing one of America's founding myths. Work by artists such as Chris Burden, Chivas Clem, Jeremy Deller, Nate Lowman, Kara Walker, and Weegee, among many others, demonstrates the boundary between legal and illegal, between order and disobedience, as a negotiable, moving target.

The current character of this negotiated territory, in both an unpopular war and the unsettling state of international geopolitics, has produced a special intensity in present artmaking. The speed with which information about people, artworks, and ideas moves across the globe has given rise to a mixed reaction, one somewhere between panic, indigestion, and exhilaration. Just as protest produces spontaneous action, the impetus of Thanatos is giving rise to Eros, as well as to the expunging of the past. A certain bad-boy aggression, in the end a rather conventional one, has been

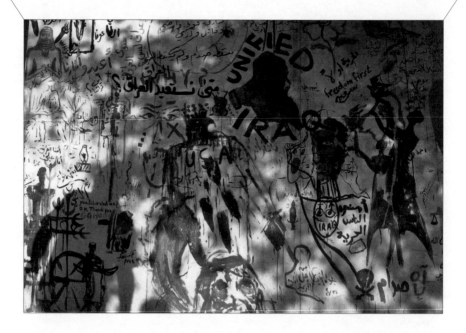

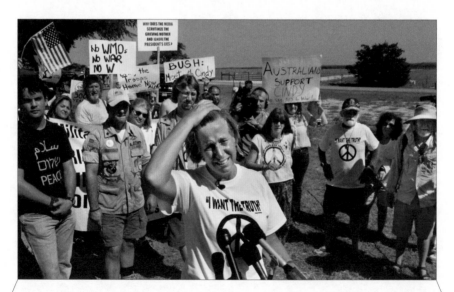

Top: Iraqi painter Qasim al-Sabati, not pictured, invited artists to write or paint their impressions of the occupation on a 2-by-3-meter (6½ x 9¾ feet) wood rectangle, displayed here in a Baghdad gallery, May 8, 2004. Forty artists and writers participated. (AP Photo/Karim Kadim)

Bottom: "Peace mom" Cindy Sheehan, president of Gold Star Families for Peace, began a vigil near President George W. Bush's ranch in Crawford, Texas, August 6, 2005. Sheehan has accused President Bush of lying about the war in Iraq, which claimed the life of her son, Army Spc. Casey Sheehan. (AP Photo/J. Scott Applewhite)

noted in the recent work of some young male artists, for whom exhibition titles such as *Drunk versus Stoned* are merely the tip of the iceberg. In the present environment of war, despite the absence of the draft, an underlying militarism exerts an intangible pressure on the male social body to conform. War is the best context within which to iron out the conflicted impulses of the young male, "for there, all at once, this subject can be defined, defended, and discharged—as if he were a weapon ... this configuration of the subject as weapon is fundamental to fascist aggression, for it allows 'desiring production' to be expressed as 'murdering production.'"[20] Further, Foster's depiction of Hans Bellmer's dolls as a contestation of Nazi masculinity could also be borrowed to consider the current cultural climate, in which sprawling sculptural installations, described by Jerry Saltz as "the New Cacophony or the Old Cacophony, Agglomerationism, Disorientationism, the Anti Dia, or just a raging bile duct,"[21] arguably manifest a rebellion of the body against the ideology of a militaristically constructed male self.

Rebellion against prevailing ideological norms can also take the form of a contingency of materials, used in ways that might be described, if not as feminine, then as a refusal of sculptural monumentality. In a performative action, Urs Fischer cuts large holes out of the white walls of a space, opening it up into layered perspectival vistas and rupturing the familiar boundary between the self and the outside world. Inside the space, two large cast-aluminum branches rotate slowly, bearing a lit candle balanced at each end. As the melting wax drips onto the floor, it traces two overlapping circles; as the candles disappear, the circles become more distinct, creating a form that simultaneously ebbs and flows over time, the branches' rotations forming a calm center of autodestruction within the fluidity of the now-transparent architectural space.

Lucas DeGiulio's small sculptures, such as a barnacle-covered drink can or a construction made of twigs, are similarly fugitive: organic, uncanny objects, pedestal-bound yet modest. The language of Deva Graf's sculptures fuses formalism with a bizarre poetry, in which half-human, half-animal forms appear as though from a dream, as half-remembered objects.

Dan Colen's three large, upright stones, apparently graffitied, stand on bases, one of which is carved out to spell the words *Vete al Diablo* (Go to hell). However, their papier-mâché surfaces undermine any sense of weight or solid form; furthermore, any mystical associations of standing stones and, more obliquely, the purism of land art are undermined by their resemblance to stage props, Hollywood film sets, and aspects of the urban environment.

In Yuri Masnjy's new sculpture, objects and planes of wood appear to tumble across the wall, as though emerging from the two-dimensional realm of drawing into the gallery space. Gedi Sibony's antimonumental work has a comparable delicacy of form, lying in fragile balance between a piece of wood, a fragment of carpet, a large plywood panel leaning against a wall, and a shard of black plastic trailing on the floor. The play of light occurs in the shades of each material set in relation to the others. As Elizabeth Schambelan observes, Sibony's sculpture, like others in the Biennial, registers "the inherently quixotic nature of contemporary sculpture, saddled as it is with the task of asserting actuality, or objecthood, in the face of ever-proliferating virtuality."[22]

By contrast, the paintings of Steven Parrino assert the surface of the canvas in no uncertain terms, slashing, "demolishing ... contorting ... [and] crumpling" it, to use the words of Joe Fyfe,[23] who likens Parrino's treatment of his large, nonperpendicular canvases, made stiff by layers of black gloss enamel paint and white gesso, to Bernini's *Ecstasy of Saint Teresa*, "where excess drapery seems to extrude from the relatively frontal sculptural composition to create an aggressive new foreground."[24] Parrino's collapsing Deleuzian folds evoke the aesthetic of punk on the one hand and the darkness of Kenneth Anger, an important influence, on the other, exerting a sculptural presence that transforms the language of painting.

The paintings of Koether, who often collaborated musically with Parrino before his untimely death in 2005, operate as both distinct works and as part of larger installation environments that recently have incorporated, among other materials, gold lamé, shimmering silver curtains, mylar walls, and a disco ball. Some of Koether's disciplines as a painter, writer, critic,

musician, and performance artist inform each other. In a text written for a 2005 performance, she writes about her paintings as "some witnesses of non-belief, demonic options of the Glimmering Down, that unrest of Becoming. Yes, there it is always the danger of obsession and madness. Yes, their stare might touch you. The self-reflexive tension becoming a burning mirror. There is a wild exuberance. There is overwhelming sadness. At top volume. In eerie silence-holes....Hail to the mental underground!"[25] This brink of madness echoes the fragility and contingency of materials in much of the work in the exhibition. Her "unrest of becoming" describes the space in which many artists are working, a liminal space located somewhere between pre- and postmodernist parameters, between the history of forms and the forms of history—in other words, a twilight zone of uncertainty, between the day and the night, in which much is either called into question or obscured.

A sense of existential ennui in the face of such uncertainty irradiates from two large, black-and-white self-portraits by Rudolf Stingel. His pensive images, depicting the artist in creative crisis, demonstrate the use of a classical model of painting to address profound doubts about the validity of such notions as the future and historical progress. By contrast, Rodney Graham's 35mm film installation *Torqued Chandelier Release* (2005) conjures disorientation through hypnotism: a large crystal chandelier spins around in the darkness, its glass ornaments flying, until it eventually comes to rest. Based on Isaac Newton's experiment with relative motion, in which Newton spun a bucket of water round and round, Graham's "thought experiment" destabilizes the viewer's sense of space and time, overlaying the rationality of scientific experiment with a postpsychedelic reverie.

The paintings of Peter Doig, JP Munro, and Chris Vasell express an equally reverie-laden, almost Symbolist mood. Doig's paintings evoke a sense of magical realism, while Vasell's large faces loom out of the canvas, barely visible through layers of thinly applied paint. Munro's depictions of art historical subjects are romantic, decadent, mythological, and sometimes macabre. In his turn, Adam McEwen, who was once an obituary writer for the *Daily Telegraph* in London, dreams up the fictional deaths of celebrities

in his *Obituaries*, printing them on the pink paper identified with *The Financial Times*. Since most obituaries of the famous are written before their deaths and continually updated, McEwen brings the hidden into the open, revealing the mechanism by which the media feeds society's appetite for death and fame by plucking the inevitable moment from the future and inserting it into the present, in an unsettling, time-warped fusion of fact and fiction.

If this widespread ambiguity marks a last revisiting of a now-defunct modernity, it is perhaps not surprising that many of the artists, including Williams, Huyghe, the Wrong Gallery, Sturtevant, Dan Graham, and di Suvero and Tiravanija, have created exhibitions within the exhibition, in an attempt to engage their own critique of what an exhibition should be and whether it is still a viable model or just the memory of a model. The Biennial was entitled *Day for Night* after François Truffaut's classic 1973 film for the same reason, since the film uses the process of its own making to critique itself. This collaborative inquiry on the part of the two curators and the artists alike suggests that passive spectatorship might be modified by an epistemological activism, with the exhibition acting as a kind of micromodel for an everyday, inquiring behavior—"a safe place for unsafe ideas,"[26] in which accessibility and easy absorption are replaced by alternative, anomalous ways of thinking and seeing, and where not everything is understood, but everything is questioned.

Perhaps the Wrong Gallery's strategy provides the clearest demonstration of this possibility. According to the curators of this Biennial, "The opposite of 'right' is not 'left,' but 'wrong.' Since the world seems to be moving inextricably toward the right—an impulse repressed since the ground zero of the end of World War II—to be wrong is to be the opposition. An institution should, however, by its nature be wrong, in the sense that it should be writing the future rather than echoing its own time. In this case, to be successful, an exhibition of the zeitgeist should be wrong." Wrong is, therefore, ultimately right, completing a loop of communicative thinking that unfolds across history and time like an endless Möbius strip.

Top: A building explodes during heavy bombardment by U.S.–led forces in Baghdad, March 21, 2003. (AP Photo/Jerome Delay)

Bottom: A fire burning on the east side of New Orleans, September 2, 2005. (AP Photo/Eric Gay)

Notes

1. Thomas McEvilley, "Exhibitions—Real and Imaginary," in *L'exposition imaginaire: The Art of Exhibiting in the Eighties/De kunst van het tentoonstellen in de jaren tachtig* (The Hague, Netherlands: SDU Uitgeverij, 1989), 182.

2. Evelyn Beer and Riet de Leeuw, "Introduction," in ibid., 22.

3. Marcel Duchamp, quoted in Dalia Judovitz, *Unpacking Duchamp: Art in Transit* (Berkeley: University of California Press, 1998), 182.

4. Hal Foster, *Compulsive Beauty* (1993; 4th ed. Boston: MIT Press, 2000), 7.

5. Ibid.

6. Ibid., 28.

7. Jutta Koether, text recited for performance on April 27, 2005, in conjunction with the *Afterall* exhibition, Apex Art, New York, April 27–May 21, 2005, n.p.

8. Foster, *Compulsive Beauty*, xx.

9. Ibid., xix.

10. Ibid., 165.

11. Kathy O'Dell, "Performance, Video, and Trouble in the Home," in *Illuminating Video: An Essential Guide to Video Art*, ed. Doug Hall and Sally Jo Fifer (New York: Aperture Foundation, 1990), 143.

12. Christopher Williams, "Rework Everything," artist's statement, 2005, n.p.

13. Marshall McLuhan and Quentin Fiore, *The Medium Is the Massage: An Inventory of Effects* (Corte Madera, Calif.: Gingko Press, 1967), 24.

14. Lynn Hunt, *The Invention of Pornography: Obscenity and the Origins of Modernity, 1500–1800* (New York: Zone Books, 1993), 13.

15. Ibid., 44.

16. Jim Hoberman, "Donald Duck Gets a Cuffing," *London Review of Books*, July 24, 2003, 27.

17. Miriam Hansen, "Why Media Aesthetics?" *Critical Inquiry* 30 (Winter 2004): 393.

18. Ibid., 391.

19. The Wrong Gallery, "Down by Law," exhibition proposal statement, 2005, n.p.

20. Foster, *Compulsive Beauty*, 120.

21. Jerry Saltz, "Clusterfuck Aesthetics," *Village Voice*, December 7–13, 2005, 78.

22. Elizabeth Schambelan, "Gedi Sibony: Canada," *Artforum* 43, no. 1 (September 2004): 270.

23. Joe Fyfe, "Steven Parrino at Team," *Art in America* 89, no. 9 (September 2001): 150.

24. Ibid.

25. Koether, text recited for Apex Art performance, April 27, 2005, n.p.

26. Thanks to Kathy Halbreich for this phrase.

THE RAVEN
By Edgar Allan Poe
1849

Once upon a midnight dreary, while I pondered, weak and weary,
Over many a quaint and curious volume of forgotten lore—
While I nodded, nearly napping, suddenly there came a tapping,
As of some one gently rapping, rapping at my chamber door—
"'Tis some visiter," I muttered, "tapping at my chamber door—
 Only this, and nothing more."

Ah, distinctly I remember it was in the bleak December;
And each separate dying ember wrought its ghost upon the floor.
Eagerly I wished the morrow;—vainly I had sought to borrow
From my books surcease of sorrow—sorrow for the lost Lenore—
For the rare and radiant maiden whom the angels name Lenore—
 Nameless *here* for evermore.

And the silken, sad, uncertain rustling of each purple curtain
Thrilled me—filled me with fantastic terrors never felt before;
So that now, to still the beating of my heart, I stood repeating
"'Tis some visiter entreating entrance at my chamber door—
Some late visiter entreating entrance at my chamber door;—
 This it is and nothing more."

Presently my soul grew stronger; hesitating then no longer,
"Sir," said I, "or Madam, truly your forgiveness I implore;
But the fact is I was napping, and so gently you came rapping,
And so faintly you came tapping, tapping at my chamber door,
That I scarce was sure I heard you"—here I opened wide the door;——
 Darkness there and nothing more.

Deep into that darkness peering, long I stood there wondering, fearing,
Doubting, dreaming dreams no mortal ever dared to dream before;
But the silence was unbroken, and the stillness gave no token,
And the only word there spoken was the whispered word, "Lenore?"
This I whispered, and an echo murmured back the word, "Lenore!"
 Merely this and nothing more.

Back into the chamber turning, all my soul within me burning,
Soon again I heard a tapping somewhat louder than before.
"Surely," said I, "surely that is something at my window lattice;
Let me see then, what thereat is, and this mystery explore—
Let my heart be still a moment and this mystery explore;—
 'Tis the wind and nothing more!"

Open here I flung the shutter, when, with many a flirt and flutter,
In there stepped a stately Raven of the saintly days of yore;
Not the least obeisance made he; not a minute stopped or stayed he;
But, with mien of lord or lady, perched above my chamber door—
Perched upon a bust of Pallas just above my chamber door—
 Perched, and sat, and nothing more.

Then this ebony bird beguiling my sad fancy into smiling,
By the grave and stern decorum of the countenance it wore,
"Though thy crest be shorn and shaven, thou," I said, "art sure no craven,
Ghastly grim and ancient Raven wandering from the Nightly shore—
Tell me what thy lordly name is on the Night's Plutonian shore!"
 Quoth the Raven "Nevermore."

Much I marvelled this ungainly fowl to hear discourse so plainly,
Though its answer little meaning—little relevancy bore;
For we cannot help agreeing that no living human being
Ever yet was blessed with seeing bird above his chamber door—
Bird or beast upon the sculptured bust above his chamber door,
With such name as "Nevermore."

But the Raven, sitting lonely on the placid bust, spoke only
That one word, as if his soul in that one word he did outpour.
Nothing farther then he uttered—not a feather then he fluttered—
Till I scarcely more than muttered "Other friends have flown before—
On the morrow *he* will leave me, as my Hopes have flown before."
 Then the bird said "Nevermore."

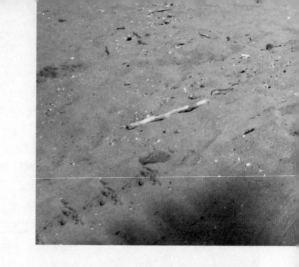

POZA DE L

Startled at the stillness broken by reply so aptly spoken,
"Doubtless," said I, "what it utters is its only stock and store
Caught from some unhappy master whom unmerciful Disaster
Followed fast and followed faster till his songs one burden bore—
Till the dirges of his Hope that melancholy burden bore
 Of 'Never—nevermore.'"

But the Raven still beguiling my sad fancy into smiling,
Straight I wheeled a cushioned seat in front of bird, and bust and door;
Then, upon the velvet sinking, I betook myself to linking
Fancy unto fancy, thinking what this ominous bird of yore—
What this grim, ungainly, ghastly, gaunt, and ominous bird of yore
 Meant in croaking "Nevermore."

This I sat engaged in guessing, but no syllable expressing
To the fowl whose fiery eyes now burned into my bosom's core;
This and more I sat divining, with my head at ease reclining
On the cushion's velvet lining that the lamp-light gloated o'er,
But whose velvet-violet lining with the lamp-light gloating o'er,
 She shall press, ah, nevermore!

Then, methought, the air grew denser, perfumed from an unseen censer
Swung by seraphim whose foot-falls tinkled on the tufted floor.
"Wretch," I cried, "thy God hath lent thee—by these angels he has sent thee
Respite—respite and nepenthe from thy memories of Lenore;
Quaff, oh quaff this kind nepenthe and forget this lost Lenore!"
 Quoth the Raven "Nevermore."

"Prophet!" said I, "thing of evil!—prophet still, if bird or devil!—
Whether Tempter sent, or whether tempest tossed thee here ashore,
Desolate yet all undaunted, on this desert land enchanted—
On this home by Horror haunted—tell me truly, I implore—
Is there—*is* there balm in Gilead?—tell me—tell me, I implore!"
 Quoth the Raven "Nevermore."

"Prophet!" said I, "thing of evil!—prophet still, if bird or devil!
By that Heaven that bends above us—by that God we both adore—
Tell this soul with sorrow laden if, within the distant Aidenn,
It shall clasp a sainted maiden whom the angels name Lenore—
Clasp a rare and radiant maiden whom the angels name Lenore."
 Quoth the raven "Nevermore."

"Be that word our sign of parting, bird or fiend!" I shrieked, upstarting—
"Get thee back into the tempest and the Night's Plutonian shore!
Leave no black plume as a token of that lie thy soul hath spoken!
Leave my loneliness unbroken!—quit the bust above my door!
Take thy beak from out my heart, and take thy form from off my door!"
 Quoth the raven "Nevermore."

And the Raven, never flitting, still is sitting, *still* is sitting
On the pallid bust of Pallas just above my chamber door;
And his eyes have all the seeming of a demon's that is dreaming,
And the lamp-light o'er him streaming throws his shadow on the floor;
And my soul from out that shadow that lies floating on the floor
 Shall be lifted—nevermore!

[1844–1849]

"The Raven" reprinted by permission of the publisher from *The Collected Works of Edgar Allan Poe: Volume 1–Poems*, edited by Thomas Ollive Mabbott (Cambridge, Mass.: The Belknap Press of Harvard University Press, 1969), 364–69. Copyright © 1969, 1980 by the President and Fellows of Harvard College

S MUJERES - PUERTO RICO

LETTER FROM BERLIN
Molly Nesbit

I am reminded of India, of Bharatpur's pink water, its marshes where the birds of the world gather to winter—pipits, buntings and oriental turtledoves, short-eared owls, greater short-toed larks, black-capped kingfishers, Siberian cranes, and flamingos, not to mention the babblers, warblers, parakeets, robins, bee-eaters, egrets, eagles, and ducks who live there year-round. They mingle. They dive. They call. Deep in this tapestry, back with the python and the antelope, a tigress prowls. I'm not sure why she has come to this place in Rajasthan alone. But no one is alone here.

In Berlin it is fall. Crows swirl and storm. Works of art have been forgathered here, forced to winter forever in the Bahnhof, the great northern rail station where it is no longer possible to leave for Hamburg or anywhere else. A long room holds the work of Joseph Beuys, the composer of the *Siberian Symphony*, the son of Kleve who dared extend *Ulysses*, the artist who hoped for social sculpture, meaning that society itself would become artwork. With that, he entered politics. He founded the German Student Party in 1967, the Organization for Direct Democracy in 1970, and became a founding member of the German Green Party in 1979. The sound of the crow's caw snaps us back. The museum holds the work of this Beuys too tightly. It would like to hold itself completely away from politics. The blackboards Beuys used for his lectures have been carefully preserved, installed behind glass, the white chalk pressed to the point where the forces it diagrams seem lifeless too. Draw all the arrows you like. Active becomes passive. The separations become so extreme that even his famous "Art = Kapital" looks more like Titian's *Man with a Glove*. Every man for himself here, by himself.

I am reminded of a crowd in Mumbai. At the fourth annual assembly of the World Social Forum, in 2004, upward of 100,000 people met in India for a week of panels, discussions, presentations, parades, screenings, and political inspiration. These are people with migratory patterns, antiglobalists and activists of all stripes ignited in 1999 by the late fall demonstrations in Seattle against the World Trade Organization and

spreading under the banner "Another World Is Possible." There being no political party at the heart or at the end of this, it is called, simply and descriptively, a movement of movements.[1] These movements bear individual attention.

On the first night of the Forum, the writer Arundhati Roy addressed the crowd.[2] She spoke of turkeys. She was seeking to clarify certain aspects of American policy and so came up with a strange image, the Thanksgiving turkey that each year is spared in a White House ceremony (call it lyric theater) performed by the president of the United States. She did not sing "We Gather Together," the traditional holiday hymn. She compared the lucky lyric turkey to herself—someone whom the New Imperialism welcomed in, while leaving out "the remaining millions [who] lose their jobs, are evicted from their homes, have their water and electricity connections cut, and die of AIDS. Basically," she continued, those others, "they're for the pot." The rest of the world served without ceremony, like soup.

She gave many examples of the New Imperialism's not-so-new neoliberal malfeasance. Take just one. Take this one: "In Iraq the sanctions outdid Saddam Hussein's best efforts by claiming more than half a million children's lives." She cited the international trade agreements that weave new disadvantage for the poor, agreements that made apartheid as a formal policy seem antiquated. Radical change, she told everyone, will not be negotiated by governments. Weekend holiday protests, she chided, will not stop wars. The ten million people on five continents marching against war in mid-February 2003, however magnificent, did not stop the United States government from invading Iraq. All this from a woman who could write sentences pulsating with Maytime in Ayemenem, but here she would not say "the river shrinks and black crows gorge on bright mangoes in still, dustgreen trees."[3] In Mumbai that winter, in the heavy, warm night, she instead sketched a plan for global resistance to the occupation of Iraq. Why not turn two of the corporations profiting from the war into targets themselves, she proposed? This was met with roars of approval.

Mustafa Barghouti, representing the Palestinian National Initiative, also spoke that evening to the crowd. He put the Palestinian struggle for statehood and peace into a long perspective. Nobody present could be neutral in this struggle, he argued, any more than one could be neutral about the right of India to become an independent state in the 1940s, or Algeria in the 1960s, or Vietnam in the 1970s, or be neutral in face of the apartheid policies that held until the 1990s in South Africa. For her part, Shirin Ebadi, the Iranian jurist and winner of the Nobel Peace Prize, stepped forward to say, "We are here to announce our commitment to human dignity. We are here to announce that human suffering from war has no dignity and no future."[4]

What becomes the civilization of question and resistance? In the days that followed, the crowd listened and spoke. It flowed into the parades and across the paths; it obeyed its own pull of gravity. At any one time there was a choice of at least fifty organized discussions. Bright handbills, banners, posters, flags, drums, chants, and pale tents all made their claims. There was no single center of attention and this was deliberate. Something else was building. Shuddhabrata Sengupta, a member of Raqs Media Collective, described it as a caravan mode of politics. "There is clearly a journey under way all over the world," he wrote afterward, "and different kinds of people are pitching their tents in the clearing that marks the zone of intersections between their respective journeys as people navigate their own tracks, and plan the trajectories of the immediate future." The route ahead is not clear, he explained, "but the gathering together of the tents, the directions the people have come from and the directions that they are going to, together, suggest the contours of the journey."[5] Three distinct art spaces had been cleared in the tents, yet they were not separate from these words and activities. One came upon them suddenly. They had names: the Ana Mendieta Fabrik, the Nasreen Mohamedi Lobby, and the Joseph Beuys Corridor.

The Joseph Beuys Corridor was a long low aisle bisecting a high, shady hall otherwise filled with various organizations' booths and the day's wet

Joseph Beuys Corridor at the World Social Forum, Mumbai, India, 2004, photographed by Elizabeth Linden

heat. Its walls were covered in metal sheets lit to make them shine with unspecified reflection. The walls seemed possessed of a curious magnetism that sent the installation flying. Three projects were positioned around and above them.

1. *Baghdad! Baghdad!* began with a poem:

> i will hold vigil
> with you…
> your name my own my own my own

It gathered together art from around the world, some of it from the demonstrations, some of it from exhibitions in galleries, all of it protesting the United States–led invasion of Iraq in 2003. Protesting reports and protest art were shown side by side. Among the groups participating were the Anti-War Coalitions of Africa and Thailand, World March of Women, Stop the War, Greece and UK, Marcha Mundial de Mulheres, Brazil, and the Becker Foundation from Canada.

2. *Dear World Social Forum* collected silent video letters from people unable to be present in Mumbai. It was an open call for letters of no more than five minutes. Answers from thirty-five different countries were screened nonstop on monitors.

3. The rest of the Corridor received the work arriving in response to an *Open Call* for art of any kind.

Who speaks? Sengupta gave a talk at the Forum that was actually a response to this age-old modern question. "Apocalypse is a signature," he began. It was dramatic. But could this really be called theater? He recommended combating the forces of censorship, surveillance, and the

resulting anxieties by making all forms of cultural activity absolutely transparent. What to say in return? When you see through forms so well that everything appears in a new state of absolute realism, do heroes disappear? Out in the light-struck Corridor, there was no sign of Beuys—no basalt, no blackboards, no live coyote, no dead hare, no felt, no fat, no hat. Beuys was nonetheless present as an example taken to heart, not a form, not soup. His idea of social sculpture survived as a corridor's transparent frame. That was everything and all. A transvaluation of the work of Joseph Beuys was taking place. Wasn't he being honored with an aesthetic of silence? You remember Beuys's Teutonic noise, remember him in New York staging his entrance in a blaring ambulance, and so this will make you laugh.

You also remember when Susan Sontag set out "The Aesthetics of Silence" in 1967. The times were just as fraught with questions about the wars in the Middle East and Vietnam, though they figured less in her discussion of transvaluation. Silence then was an artist's strategy for the transvaluation of art; she was thinking especially of the work of John Cage, Marcel Duchamp, Ludwig Wittgenstein, and Jasper Johns, but art itself being what she called "the herald of an anticipated radical transvaluation of human values," its success would mean that art would eventually be left behind. This was something said often in the years after the First World War. Mondrian had said it, as had Léger, the Constructivists, and Moholy-Nagy, but none of them invented the logic—it was something Marxists had long liked to say about the bourgeois state. An avant-garde left behind—for what? By the same, though more technically Nietzschean move, Sontag supposed the wheel of transvaluation would move silence into speech one day.[6] It is almost forty years later. That day has now come. In her last book, *Regarding the Pain of Others*, she herself gives that speech.

Have you read this yet? She chose to write about photography, particularly war photography. She did not treat the Joseph Beuys Corridor, for it was still in the future, but she was writing about the kind of picture

that would hang from its rafters and sides, pictures of violence and its effects on people. She was imagining the needs and uses of such pictures, imagining their different communities. As usual, she wrote with her gloves off. She addressed her peers. "Reports of the death of reality—like the death of reason, the death of the intellectual, the death of serious literature—seem to have been accepted without much reflection," she charged, meaning accepted by readers living in the wealthy nations of the world and trying "to understand what feels wrong, or empty, or idiotically triumphant in contemporary politics and culture." To others these realities will be material and political, just as they should be everywhere. "To speak of reality becoming a spectacle," she went on, "is a breath-taking provincialism."[7] So much for yesterday's Society of the Spectacle. So much for the simulacrum. Existence *is* elsewhere in the world. The earth does not orbit around the question of the self or you or me or art. But you know that.

Art exists, just like the heroes, right along with everything else, the war and the antiwar, in the Joseph Beuys Corridor, but this Corridor is a microcosm of movements and worlds. It is an unlikely microcosm of what used to be called the art world, but there, too, transvaluations are rolling through, opening up passages where art allows itself to be crossed by forces larger than itself, allows itself to be overcome, to explode into a new existence that is more than a sight. Beuys presides at the side, silent, and his silence, not to be overrated, is full of realities. Can these realities ever be grasped by aesthetics, even an aesthetics of immersion? Can art live and move with the new and newly lethal historical forces that tell us our time? Like it or not, we are all extending *Ulysses*. What to say after *its* last word, which was "Yes"? As art moves further afield, where will it live? How will it grow? How will it take the changes through which we are perpetually passing wherever we are? Will it ever find peace? These are the deepwater, Berlin winter questions.

I am writing this too slowly, these questions are not simple like chocolate, or answerable. Still, they need not be drunk or frozen, they can stay. I

don't know when you'll read this, since I now must post it from New York, but when you do, the temperature will not have stopped falling. In New York, the paper is also reporting a drop in immigration, only 90,000 people come each year, though now 6 in 10 babies born in this city have a foreign-born parent.[8] What this means for the corridors of power remains to be seen. If fate has a conscience, they should swell. Meantime, there is hope for the birds.

Five million birds migrate through New York each year, most of them little songbirds. Nature never prepared them for cities. Birds cannot see that glass is a barrier, so they mistake its transparency or mirroring for sky. This leads them to crash unsuspecting into the gleaming, many-windowed skyscrapers. It is not much better for them at night because the blanket of electric city lights interferes with the stars and the moon, the points from which birds chart the route south. They flounder like poor fish out of water in the canyons of Lower Manhattan's grid. But this year the lights in the tall buildings, like the Empire State, the Chrysler, and Rockefeller Center, will dim or switch off completely at midnight.[9] The birds can thread through the dark and fly on. We go with the birds.

> To be continued.
> Write back, like the wind.
> A refrain for a song?
> Write like the wind.

great whe

conservati

00:49:10

JH: yup, ok

possibility in

liberalism. If

door of 1331 w

mother were an

say a pollster…a

a conservative. B

But he'd say to me, everybody c

better. That's what's missing to

people know it's missing. And t

and that's a powerful political e

surge in civic participation, in d

Everybody does better, when ev

that's as good a bumper sticker

LC: sometimes I think…even d

00:48:00

Notes

1. See Bernard Cassen, *Tout a commencé à Porto Alegre… Mille forums sociaux!* (Paris: Mille et une nuits, 2003); *The Movement of Movements: A Reader*, ed. Tom Mertes, José Bové, et al. (New York: Verso, 2004); Alexander Cockburn, Jeffrey St. Clair, and Allan Sekula, *Five Days That Shook the World: Seattle and Beyond* (New York: Verso, 2000).

2. Arundhati Roy's speech at the opening of the World Social Forum's meeting in Mumbai on January 16, 2004, is given on the evaluations page at www.wsfindia.org. A longer, expanded version of its argument was given as a speech at the American Sociological Association's annual meeting that summer in San Francisco, broadcast over the radio and published as *Public Power in the Age of Empire* (New York: Seven Stories Press, 2004). It is included in her collection *An Ordinary Person's Guide to Empire* (Cambridge, Mass.: South End Press, 2004), 83–94.

3. Arundhati Roy, *The God of Small Things* (New York: HarperCollins, 1997), 3.

4. Barghouti and Ebadi are quoted in Saleem Samad, "Activists Slam Third World for Supporting U.S. Policies," *Daily Times* (Pakistan), January 19, 2004. Portions of the opening speeches are included in the video *Rumble in Mumbai*, directed by Jawad Metni (Pinhole Pictures, 2004).

5. Shuddhabrata Sengupta, "WSF—another report is possible!" posted January 30, 2004, on Makeworlds Paper #4 (http://www.makeworlds.org/node/82).

6. Susan Sontag, "The Aesthetics of Silence," in *Styles of Radical Will* (New York: Farrar, Straus and Giroux, 1969), 18.

7. Susan Sontag, *Regarding the Pain of Others* (New York: Farrar, Straus and Giroux, 2003), 110.

8. Nina Bernstein, "Decline Is Seen in Immigration," *New York Times*, September 28, 2005, sec. A.

9. Jennifer 8. Lee, "Kill the Light, Save a Bird," *New York Times*, September 23, 2005, sec. B.

Tape 013

es better when everybody does

y and I think the American

y want to get back to that notion

c that could rally a major new

ocracy in this country.

ybody does better and I believe

we're going to find.

public sense of good.

ng this film, and reading y

ay

ive?

own as

...talked to them about the power

DEAD FLOWERS:
OPPOSITIONAL CULTURE AND ABANDONMENT
Lia Gangitano

Well, when you're sitting there/In your silk upholstered chair/Talking to some rich folks that you know/Well I hope you won't see me/In my ragged company/You know I could never be alone.
—Rolling Stones, "Dead Flowers"[1]

I learned about Boston's underground when it was already over, so I can only describe my orientation as something like a ten-year lag. Around 1994, I was looking slightly back in time to find a reason to believe in its existence, to understand how a social scene of artists—punk and rebellious in nature, consisting of communities forged by such alliances as shared drug dealers, favorite drag bars, and an increasing sense of obsolescence owing to the rise of AIDS—could emerge to make a significant impact on the very institutions they sought to frustrate. What I found was Mark Morrisroe and a group of artists whom we referred to as the Boston School, which started as a joke, became the focus of an exhibition, and has since become synonymous with a form of diaristic photography produced in Boston in the late 1970s and early 1980s.[2] The long-standing importance, to me, of this acknowledgment of an underground lay not in the premature historicizing of a movement, but in the recognition that the ideological legacy of such a group of artists continues to overlap with the present.

Moving to downtown New York in the late 1990s, I guess I arrived here about ten years too late as well. The legendary undergrounds of the 1960s, and their subsequent reincarnations in the 1980s, had already receded. I took a crappy tenement apartment on Ludlow Street, where I secretly cherished late-night cocktails with my neighbor Taylor Mead, and indulged in an occasional sycophantic coffee with Rene Ricard, who had told me, years before, as he declined to write for our catalogue, "Boston eats its young." I preferred looking at my increasingly sanitized neighborhood through the videos of covert documentarian and voyeur Michel Auder and thought, although dramatically changed, it sometimes felt familiar because the cast of characters still included some of its original members.

as if HI▨▨s ▨▨▨▨
in the dust of vaporized
we offer in communion
in the name of compassi
let us sing the teeming
without the one there
we are the miracle ri

HOW TO DRAW SHEEP

listening to the Cantarelle Roos
calling out the dawn the twin
I order a mirror for the twin
who has lost his brother
I try to open my heart to le
the spirits in the clouds of
I try to dispense the ignora
the little human treacheri
I thank you for your beauty
bowing down in a field of
I celebrate your celebration
life. I submit to my desti
ponder the meaning of this
this harbor without outle

SPRACHSALZ Incantation
Sept. 16, 2005 austrian Tyrol
I join the Sprachsalz Festiva
I who am you Salty Dog
take my place in a new co
for this day in the middle
where the planet spins t
can our voices united al
condemn as we levy

As I look back now at the history of alternative space movements in the United States, it seems their periodic resurgences, redefinitions, and co-optation by the mainstream occurred, in previous decades, in tandem with political necessities and potential dreams of progress. These models (whether failed, outmoded, or just grown up) relied on the social character of artmaking and the familial bonding, however dysfunctional, that occurs among artists who continue to work in ways that directly draw from their experiences in alternative culture, whether it be radical feminist politics, AIDS activism, or the club performance scene.

Guided initially by the feminist movement and at times supported by government agencies, alternative art activities in the 1970s raised awareness about inequalities of race, class, and gender; omissions from art historical canons; and exclusionary practices in the art world. Artists as cultural activists addressed societal problems and, in some cases, instigated change. In a sense, progress was signaled by the assimilation of "alternative" practices by more mainstream institutions, including

Michel Auder, still from *Chasing the Dragon*, 1984. Video, black-and-white and color, sound; 48 min.

universities, museums, and art magazines. Critic Michael Brenson notes that among the idealistic principles that shaped the formation of the National Endowment for the Arts in the 1960s was an understanding of the artist as "incorruptible outsider"—one who would protect "against popular culture, against the corrupting influences of rampant American materialism."[3]

In the late 1980s and early 1990s, a subsequent generation experienced the resurgence of alternative art practices linked to political themes—at times, in opposition to the steady withdrawal of public funding that heralded the onset of the culture wars. This can be seen in the continued work of artists and collectives such as Group Material and Tim Rollins and KOS as well as in the formation of activist groups, such as ACT UP and Gran Fury, whose sophisticated methodologies looked like art. Political art and activism were briefly in vogue, and they actually accomplished things. At this moment, "identity politics" was considered a necessary phase in the development of contemporary art, constituting an effort to expand the field across boundaries tied to ethnicity, class, race, and gender—mainly through the disclosures of individual artists whose work found its way more and more into museums and galleries. It was a phase many assumed would naturally continue and lead to further change: political art would not necessarily have to be solely about one's self but could address even broader concerns. However, as museum exhibitions such as *Bad Girls*, for example, demonstrated, the transgressive potential of such work could easily be depoliticized by contentious marketing (together with an exclusion of its originators from the market that it spawned) to deliver a domesticated and diffused form, stripped of its radical foundations.[4]

Today, the accelerated slippage between alternative and mass culture seems more a matter of economic power—the vast corporatization of culture that implies, as Andrea Fraser points out, that "museum and market have grown into an all-encompassing apparatus of cultural reification."[5] This necessarily narrows the criteria of artistic value to market worth

...stellation
of our era
the brink of nightmare
...ed the flood of human...
...or song for the protection.

(Soft speech)
for everyone everywhere

...t flame in our hearts?
(Amsterdam, July 1, 1986)
...states under stars

kulll
collective invocation
n & reason
tars on their way —
s no other
ling + the dust.

✱ Ira Cohen 雹

STES LAO
1986
a africana africana
2k

41

LA ROSA

Kathe Burkhart, *Eat Shit* from the *Liz Taylor Series (after Weegee)*, 1985. Acrylic, plastic chicken, and composition leaf on canvas, 61 x 41 in. (155 x 104.1 cm). Private collection

(with its mandates of legibility and mass appeal) and excludes certain "other" values (such as challenging content and experimentation) that insinuate an exteriority to art's established center and insist that art has a critical use value. One would think, given this situation and the near disappearance in the past decade of what was known as independent media, independent film, and independent music, that the very need for noncommercial, noninstitutional spaces for art would also come into question. But some of us are stubborn.

In an address given to a group of nonprofit arts professionals assembled in Los Angeles in 2005, Brenson described an evolution of the noninstitutional space as one of "engaged possibility and unpredictability" in which artists and groups seek to undo the categories set up by domineering corporate-style hierarchies.[6] The increasing complicity today of cultural institutions in maintaining such hierarchies is yet another mirror of the "radical estrangement"[7] and ineffectuality of oppositional culture that is deliberately engineered within the current political climate in the United States. These draining effects—the byproducts of which are being felt in all areas of cultural production—are not even that heatedly discussed in the public realm anymore: the culture wars deemed art bad for us; we stopped teaching art in public schools; and a new kind of artist as businessperson emerged with the support of various institutions (art schools, galleries, and museums) to appease the distrustful tastes of mainstream culture. This is an oversimplification, of course. But as Dave Hickey has observed, both sides of the political spectrum have contributed to the situation:

> The left wing suspects that art is opium; the right suspects it's PCP.... [F]or the past thirty years the left and the right wings of American culture have urgently conspired to mitigate art's ability to civilize us by striving to "civilize" art itself. They have conspired to limit our freedom to construct new meanings and values for works of art: the right wing by seeking to censor any art

that might generate healthy anxiety; the left by explaining away art's ability to challenge us individually, by presenting art to us in perfectly controlled, explained, and contextualized packages.[8]

The various and recurring slow deaths of "alternativity"[9] and its movements are well considered and astutely documented in such publications as Diana Crane's *The Transformation of the Avant-Garde: The New York Art World, 1940–1985* and Julie Ault's *Alternative Art New York, 1965–1985*. The processes whereby dominant culture accepts and assimilates its fringes, or renders obsolete its opposers, are largely attributed to the mechanisms of cultural power, including the availability of public funding, collecting trends in museums and the private sector, and the cost of real estate. The concept of "the underground," though generously borrowed by all manner of artistic practitioners, has historically been located in the field of cinema, where dominant factors of fundability and mainstream acceptability are more clearly understood. Underground actors and filmmakers serve as illuminating, perhaps more persistent, gauges of alternativity, as the object of their resistance (Hollywood) has always remained somewhat transparent despite social, political, and economic shifts in the cultural terrain—meaning, underground film can remain underground, even if shown in museums. While some of us continue (perhaps out of respect) to use terms such as "alternative space" and "underground film festival," it's not clear anymore what, exactly, we mean. Because the meanings of "alternative" and its elusive companion "the underground" are not fixed but are ever variable in relation to a changing dominant culture, we can perhaps believe that they do not cease to exist. In looking for evidence of their life, I have observed a few, perhaps obvious, things.

Money changes everything.

As a longtime art worker in the not-for-profit sector, I often look to my favorite underground heroes for guidelines. I've found that certain film practitioners offer the most blunt insights into the complicated business of art—insights that would seem a little embarrassing, almost unspeakable, in the pages of an art magazine today. In the current market-driven climate, it was provocative to read actor-director-underground-legend Timothy Carey's rationale for sabotaging his potentially lucrative break into the mainstream in order to preserve his integrity as an artist:

> We slip. We bleed. Cassavetes taught me that. The truth is, I never really cared about conventional success…. I was offered a spot in both *The Godfather* and *The Godfather Part II*…. But I didn't do either show, because if I had, I woulda been just like any other actor—out for the money.[10]

For both Carey and director John Cassavetes, working in the mainstream, mostly as secondary character actors, was just a means to their idealistic ends. All proceeds gathered on the inside served to fuel their independent projects—projects they resolutely considered to be art. Though both critiqued middle-class America and society in general, neither considered himself as part of an underground; in fact, they both rejected the cynical figuration of the modern "anti-artist."[11] Cassavetes joked:

> Q: What is your relationship to underground film?
> A: … If your films have no chance of being shown everywhere, if you don't have enough money, you show them in basements; then they're underground films.[12]

20

The underground doesn't think it's transgressive.

Like certain of their European counterparts, Carey and Cassavetes expressed ambivalence toward the distinctions of art that would necessarily alienate them from their desired audience and seemed to imply no doubt that the public would comprehend their innovative approach as driven by ideological as well as economic necessities—not by underground "style." Stylistic innovation, or experimentation, in this sense, was viewed as a margin they did not seek to occupy. As Patrick Rumble notes, writing about Pier Paolo Pasolini:

> All along the history of cinema there have been filmmakers who have contested any "hardening" of cinematic language.... [O]thers show a long history of "countercinema," with one of its principal aims being the rejection of any standardization of filmic language. Unfortunately, their relegation to avant-garde positions in culture (by art-business institutions) has often functioned to neutralize their impact on cinema.... [Pasolini] would reject much of the avant-garde forms of contestation insofar as their absolute rejection of established conventions (*qua* conventions), and thus their illegibility, situate them securely within an avant-garde "ghetto."[13]

Even the uncompromising Rainer Werner Fassbinder did not really fashion himself as an artist at all, let alone an alternative one, but sought to make popular films specifically geared toward his own generation. Like Cassavetes, he worked with an ensemble cast that functioned much like a dysfunctional family, whose hierarchies of love and alienation served as "radical self-critique" while also commenting on contemporary society in general. In *Beware of a Holy Whore* (1970), "a group of people want to make a film and believe—or believe that they believe—they can change the world with their work."[14] Highly disillusioned by the potential futility

Lovett/Codagnone, *P.P.P. ("Heretical Empiricism")*, 2005. Slide projection on handmade leather jacket, 19 x 24 in. (48.3 x 61 cm). Collection of the artist; courtesy Galleria Emi Fontana, Milan

of such a project, *Beware of a Holy Whore* is the ultimate "making of" film: "In this almost hermetically closed film, social and political reality is turned into sex and drunkenness and into hypocritical dreams about the films one would like to make.... [I]t draws a grotesque picture of the relationships within a group that idealistically confronts a society that at the same time dictates the conditions of its functioning."[15]

> JEFF: You really are the most brutal and contemptible filthy pig I've ever come across. You lousy little conformist pig.
> EDDIE: What did he say?
> HANNA: He said he loves you.[16]

What Pasolini described as "the moment of conflict," which he believed could not be attained through fetishized avant-garde cinematic forms, is played out narratively by Fassbinder in yet another potential ghetto of misdirected utopian energies. That *Beware of a Holy Whore* is a stylish cautionary tale regarding the trappings of creative communities and their unrealizable dreams may be a stretch, but I find it a useful visualization of how prior oppositional moments might have come to unglamorous ends within a larger cultural arena that no longer found them entertaining.

Solitary genius is not alternative.

For an indication of how important social networks are to "the underground," we need only look to the sheer presence (pre- and post internet) of flyers, communiqués, manifestos, and artists' magazines. The idea of the autonomous individual mastermind is prematurely fostered by competitive academic pedigree, traditionally historicized by institutions, and currently preferred by the commercial sector, but I think it's safe to say that recently inducted art stars have little direct impact on their peers. And even though Andy Warhol, through his Factory, was an iconic producer of underground film and magazines, and elevated socializing to an art form, his transformation of the alienated artist into someone who embraces mainstream values of fame, glamour, and commercial success forever changed "the rules of the game." As Catherine Liu explains:

> Warhol understood the dilemma of the Subject under late capitalism and he acted this dilemma out. Žižek has more recently described the situation as being one distinguished by "the arrival of the 'pathological narcissist.'" ... Instead of the integration of

Editorial page from *Dirt Magazine*, edited by Mark Morrisroe and Lynelle White, c. 1977. Courtesy the Estate of Mark Morrisroe

a symbolic law, we have a multitude of rules to follow — rules of accommodation telling us "how to succeed." The narcissistic subject knows only the "rules of the (social) game" enabling him to manipulate others; social relations constitute for him a "playing field" in which he assumes "roles," not proper symbolic mandates; he stays clear of any kind of binding commitment that would imply a proper symbolic identification. *He is a radical conformist who paradoxically experiences himself as an outlaw.*[17]

And sometimes, real outlaws just want to be famous. These opposing goals of the underground artist have taken various forms, and as Parker Tyler wrote in his 1967 article "Dragtime and Drugtime," on the films of Warhol: "Narcotizing is very close to Narcissizing.... The formal restrictions super-exploited by [Warhol's] primitive style (the dragtime) imply an almost puritanical detachment from life: reality's fabulous deadpan dream."[18] Warhol's celebrity, although prompted by radical aesthetics, also challenged the construction of the socially engaged underground artist, as he appeared to be someone who, though perpetually surrounded by people, was alone.

The various permutations of the detached artist continue to play out, mainly outside of alternative contexts, which require increasing levels of intimate collaboration to achieve even the most modest goals. As one veteran of the underground has noted, "the most transgressive thing right now is intimacy."[19] Perhaps the alternative space movement, in its current incarnation as an unlikely family, slightly out of touch with the numbing attributes of "success" (as defined by market value alone), is a locus of resistance.

Genesis "Breyer" P-Orridge, *An English Breakfast* or *High Tea*, 1979. Mail art from collaged souvenir British postcards, original 1960s playing cards, and Polaroids, 28 x 22 in. (71.1 x 55.9 cm). Collection of the artist

The underground thinks it's beautiful.

Inside social groups, unconditional affirmation and aggression exist side by side. However intrusive, the records of such relations (from the now iconic *Ballad of Sexual Dependency* by Nan Goldin to lesser known photographs by Morrisroe) usually stem from intimate appreciation of their subjects' (and their own) bewildering elegance. Jack Pierson described his confusion upon reading a reviewer's description of Morrisroe's work: "…and it said, like, 'the ravaged faces of these pathetic tenement dwellers.' I was like …'What do you mean?!' I thought they were very glamorous, like beautiful dresses."[20] When the ragged "beauty" of the underground—with its, at times, strong insinuations of class—reaches a larger audience, it's possible that the perspective afforded by distance to those not living in these conditions grows freakish, ranging from a complete inability to identify to overidentification with "grittiness" and placing certain disadvantages (poverty, drug addiction, destitute surroundings) in a strange light. Finding abject beauty in one's lower-rung economic and social condition is not a deliberate glamorization of poverty so much as a need to evaluate aesthetic worth on one's own terms—which is, perhaps, exactly why the underground, in its truest forms, is unacceptable to the mainstream.

The alternative can't be retrograde.

Charles Atlas's film *Hail the New Puritan* (1985–86) features scenes of friends in London hanging out, drinking, primping, changing and checking their outrageous outfits—all the rituals involved in going out clubbing that were such important components of "a day in the life of a punk ballerino." Considering the length of these scenes and our doubts that the friends would ever leave the apartment, their eventual arrival at a club is raised to operatic proportions. Like Warhol's 1966 film *The Chelsea Girls, Hail the New Puritan* fully describes a particular generation's subsistence in an underground moment that they defined. In 2003, when approached with the idea of a retrospective that would include this and other influential video works from his career, Atlas chose instead to mount an exhibition that contained no existing work at all—just a

Charles Atlas, still from *Hail the New Puritan*, 1985–86. 16mm film, color, sound; 84:47 min.

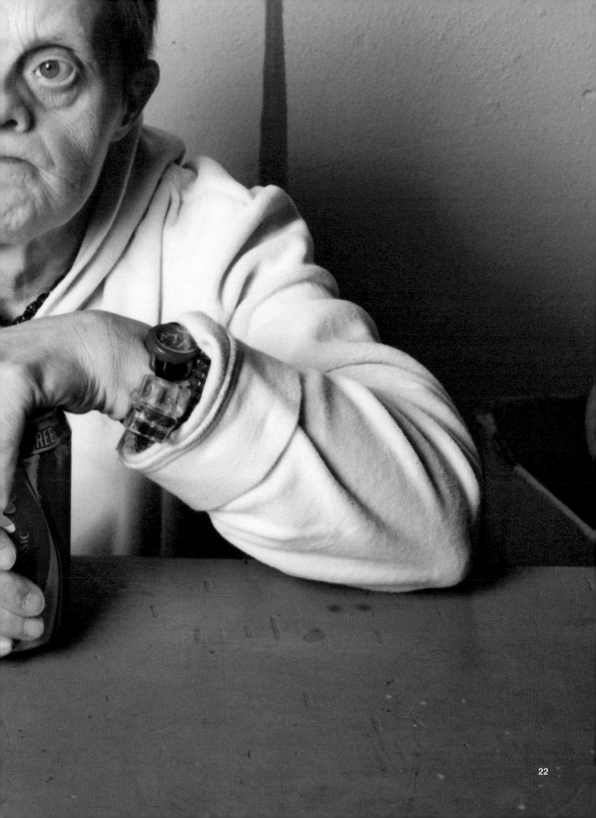

video studio in which he created live portraits each day, remaining adamantly in the impetuous present. I've learned again and again that the underground does not emulate the past (not even its own). References to it may be made to advance or explode certain ideas, but the point is to keep moving forward. The petrifying effects of adopting styles of the past are evidenced by popular culture: retro-everything looks good when drained of its prior content, class associations, and political context. As Dan Graham has stated, in reference to such works as his 1982–84 video *Rock My Religion*:

> My intention is in opposition to the historicist idea that everything we know about the past is dependent upon the interpretation of the fashion of the present. In historicism there is no real past, only an overlay of interpretations or a simulation of the past. In opposition to this notion of history as a simulation, there is possible the idea of an actual, although hidden, past, mostly eradicated from consciousness but briefly available in moments not obscured by the dominant ideology of newness. This myth of evernew is linked to the role of the commodity. Commodities produce a dream of eternal newness—which devalues and makes antiaphrodisiacal and amnesiacal the period of time just prior to the newest present. It devalues and cuts off connection with the implications (of unfinished ideas and projects) associated with the commodities of this just-past period.[21]

In closing, "Remain poor, stay up late."[22]

This sentiment seems as apt a mandate as any other that compelled me to start an alternative space in 2001. Considering the economic obsolescence and self-critical idealism of such an experiment, it seemed like the most political thing to do—testing whether the values associated with these perhaps historical constructs of alternative culture can survive in New York's current cultural economy. Now presumably devoid of overt political incentives (correcting wrongs or filling voids), even the alternative space and its mission have become increasingly characterized within the construct of the contemporary artist's career trajectory from alternative space to commercial gallery to museum. But such a model does not necessarily apply any more, given the commercial sector's current youth obsession, which allows for bypassing the "alternative space" phase altogether. Of course, there are "worlds within worlds," and passing from one to another is entirely possible—it's knowing where you belong that is more difficult.[23] Not unlike the impetus behind Fassbinder's "making of" film, the dynamics of dreams, however thwarted by potential futility and material realities, still holds the promise of restaging a relevant alternative.

Notes

1. Addressed to a self-proclaimed "queen of the underground," "Dead Flowers" (M. Jagger/K. Richards, 1971) describes remembrance, death, and drugs in the wake of class disconnection.

2. *Boston School* (The Institute of Contemporary Art, Boston, 1995) was co-curated by Lia Gangitano and Milena Kalinovska, in collaboration with Pat Hearn and the Estate of Mark Morrisroe, and included the works of David Armstrong, Philip-Lorca diCorcia, Nan Goldin, Mark Morrisroe, Jack Pierson, Tabboo! (Stephen Tashjian), and Shellburne Thurber.

3. Michael Brenson, "The Authority of the Critic," keynote address for the symposium "Criticism: History, and Power," Elvehjem Museum of Art, Madison, Wisconsin, November 11–12, 2004, transcript, 16.

4. See Marcia Tucker et al., *Bad Girls* (exhibition catalogue) (New York: New Museum of Contemporary Art, New York; Cambridge, Mass.: MIT Press, 1994.

5. Andrea Fraser, "From the Critique of Institutions to an Institution of Critique," *Artforum* 44, no. 1 (September 2005): 278–79.

6. Michael Brenson, lecture at the Warhol Initiative Retreat, organized by the Andy Warhol Foundation and held in Los Angeles, June 24, 2005.

7. Ibid.

8. Dave Hickey, "A World Like Santa Barbara," *Art Issues*, no. 63 (Summer 2000): 21.

9. See Carlo McCormick, "Alternativity: or the Final Flight of Franklin's Kite," in *The Alternative to What? Thread Waxing Space and the '90s* (New York: Thread Waxing Space, forthcoming 2006).

10. From "Cracked Actor: Grover Lewis Interviews Timothy Carey, One of Hollywood's Most Feared—and Fired—Character Actors of All Time," *Film Comment* (January–February 2004): 59.

11. Jeff Wall describes the practice of anti-art as follows: "The pure appropriation of the anaesthetic, the imagined completion of the gesture of passing over into anti-art, or non-art, is the act of internalization of

society's indifference to the happiness and seriousness of art. It is also, therefore, an expression of the artist's own identification with baleful social forces." Jeff Wall, "Marks of Indifference: Aspects of Photography in, or as, Conceptual Art," in Ann Goldstein and Anne Rorimer, eds., *Reconsidering the Object of Art, 1965–1975* (exhibition catalogue) (Los Angeles: Museum of Contemporary Art; Cambridge, Mass.: MIT Press, 1995), 262.

12. From André S. Labarthe, "A Way of Life: An Interview with John Cassavetes," *Evergreen*, no. 64 (March 1969): 47.

13. Patrick Rumble, *Allegories of Contamination: Pier Paolo Pasolini's Trilogy of Life* (Toronto: University of Toronto Press, 1996), 18–19.

14. Christian Braad Thomsen, "Self-Criticism," in *Fassbinder: The Life and Work of a Provocative Genius*, trans. Martin Chalmers (Minneapolis: University of Minnesota Press, 1991), 90.

15. Ibid., 91, 94.

16. Dialogue from *Beware of a Holy Whore*, in ibid., 93.

17. Catherine Liu, "Diary of the Pop Body," *Flash Art*, no. 166 (October 1992): 76 (Liu's italics).

18. Parker Tyler, "Dragtime and Drugtime; or, Film à la Warhol," *Evergreen*, no. 46 (April 1967): 87, 88.

19. Genesis P-Orridge, conversation with the author, August 2005.

20. Anne Wilson Lloyd, "The Sadness of Abstract Art: An Interview with Jack Pierson," *Provincetown Arts* (1994): 49.

21. Dan Graham, "Video in Relation to Architecture," in *Dan Graham: Public/Private* (exhibition catalogue) (Philadelphia: The Galleries at Moore, 1993).

22. Thanks to Antony Hegarty for his instructions on how to stay "underground," among other thoughts on this topic; conversation with the author, August 2005.

23. Thanks to Stephen Hepworth for his insights; conversation with the author, August 2005.

ELASTIC FILM, MERCURIAL CINEMA
Bradley Eros

A LASCO C2 "running difference" image showing a "halo" CME blast beginning its journey toward Earth. Courtesy SOHO/LASCO C2 consortium. SOHO is a project of international cooperation between the European Space Agency and NASA.

The cinema involves a total reversal of values, a complete revolution in optics, perspective, and logic. It is more exciting than phosphorus, more captivating than love.
—Antonin Artaud, *Questions and Answers on the Cinema*

Ancient Persian possessed more than eighty words for *love*, denoting different qualities and valences of communal and erotic feeling.[1] In today's culture, the same word is often used, with little distinction, for everything from profound connection to superfluous whim. *Film*, too, is an elastic word, applied to myriad aspects of a cultural object/concept/activity/cinematic phenomenon. *Cinema*, however, is now on the threshold of stretching and morphing beyond recognition, of becoming a different medium entirely—"mercurial"—characterized by rapid and unpredictable change. Film and cinema may soon permanently part ways as we enter a postmedium condition (to use Rosalind Krauss's term) or a postfilmic cinema, as the former retains its status as a mechanically projected celluloid object and the latter transforms into a digital technology, exhibiting mercury's other qualities as a quicksilver messenger: ingenuity, eloquence, and thievishness.

Technology is neither a devil nor an angel. But neither is it simply a "tool," a neutral extension of some rock-solid human nature. Technology is a trickster and it has been so since the first culture hero taught the human tribe how to spin wool before he pulled it over our eyes.
—Erik Davis, *Techgnosis*

LAMIC EXTREMISTS THE FRENCH FOREIGN FIGHTERS WELFARE MOTHER
NTHRAX WMD PANDEMIC AVIAN FLU DIRTY BOMB PLAGUE GAY MARRIAGE T
OMB PLAGUE THE FRENCH FOREIGN FIGHTERS WELFARE MOTHERS INTELL
JDGES EVOLUTION EBOLA CUBA THE AXIS OF EVIL ILLEGAL IMMIGRANTS
L-QAEDA VENEZUELA IMPROVISED EXPLOSIVE DEVICES NUCLEAR ATTACK
HE INTERNAL ENEMY RADICAL ISLAMIC EXTREMISTS THE FRENCH FORE
NTHRAX WMD CORPORATION FOR PUBLIC BROADCASTING TERRORISTS
LAGUE GAY MARRIAGE WAR LORDS ILLEGAL IMMIGRANTS SUICIDE BOMBERS
ELFARE MOTHERS INTELLECTUALS CORPORATION FOR PUBLIC BROADCA
VIL VENEZUELA IMPROVISED EXPLOSIVE DEVICES NUCLEAR ATTACK SOCI
EXUAL PREDATORS THE INTERNAL ENEMY ANARCHISTS RADICAL ISLA
ITELLECTUALS CORPORATION FOR PUBLIC BROADCASTING DRUG LORDS
ERRORISTS BIOLOGICAL WEAPONS ANTHRAX WMD PANDEMIC AVIAN FLU
ITELLECTUALS CORPORATION FOR PUBLIC BROADCASTING DRUG LORD
IMIGRANTS SUICIDE BOMBERS ANARCHISTS RADICAL ISLAMIC EXTREMISTS
TTACK SOCIAL SECURITY ENEMY COMBATANTS ARTISTS LIBYA SEXUAL PR
OREIGN FIGHTERS WELFARE MOTHERS INTELLECTUALS BIOLOGICAL WEAP
IOLOGICAL WEAPONS ANTHRAX WMD PANDEMIC AVIAN FLU DIRTY BOMB F
NARCHISTS RADICAL ISLAMIC EXTREMISTS THE FRENCH FOREIGN FIC
ROADCASTING DRUG LORDS ACTIVIST JUDGES EVOLUTION EBOLA CUBA TH
OCIAL SECURITY SYRIA LOOTERS AL-QAEDA ENEMY COMBATANTS ARTIS
LAMIC EXTREMISTS THE FRENCH FOREIGN FIGHTERS WELFARE MOTHER
NTHRAX WMD PANDEMIC AVIAN FLU DIRTY BOMB PLAGUE GAY MARRIAGE TE
OMB PLAGUE THE FRENCH FOREIGN FIGHTERS WELFARE MOTHERS INTELL
JDGES EVOLUTION EBOLA CUBA THE AXIS OF EVIL ILLEGAL IMMIGRANTS
L-QAEDA VENEZUELA IMPROVISED EXPLOSIVE DEVICES NUCLEAR ATTACK
HE INTERNAL ENEMY RADICAL ISLAMIC EXTREMISTS THE FRENCH FORE
NTHRAX WMD CORPORATION FOR PUBLIC BROADCASTING TERRORISTS
LAGUE GAY MARRIAGE WAR LORDS ILLEGAL IMMIGRANTS SUICIDE BOMBERS
ELFARE MOTHERS INTELLECTUALS CORPORATION FOR PUBLIC BROADCA
VIL VENEZUELA IMPROVISED EXPLOSIVE DEVICES NUCLEAR ATTACK SOCI
EXUAL PREDATORS THE INTERNAL ENEMY ANARCHISTS RADICAL ISLA
TELLECTUALS CORPORATION FOR PUBLIC BROADCASTING DRUG LORDS
ERRORISTS BIOLOGICAL WEAPONS ANTHRAX WMD PANDEMIC AVIAN FLU
TELLECTUALS CORPORATION FOR PUBLIC BROADCASTING DRUG LORD
IMIGRANTS SUICIDE BOMBERS ANARCHISTS RADICAL ISLAMIC EXTREMISTS
TTACK SOCIAL SECURITY ENEMY COMBATANTS ARTISTS LIBYA SEXUAL PR
OREIGN FIGHTERS WELFARE MOTHERS INTELLECTUALS BIOLOGICAL WEAP
OLOGICAL WEAPONS ANTHRAX WMD PANDEMIC AVIAN FLU DIRTY BOMB F
NARCHISTS RADICAL ISLAMIC EXTREMISTS THE FRENCH FOREIGN FIC
ROADCASTING DRUG LORDS ACTIVIST JUDGES EVOLUTION EBOLA CUBA TH
OCIAL SECURITY SYRIA LOOTERS AL-QAEDA ENEMY COMBATANTS ARTIS
AMIC EXTREMISTS THE FRENCH FOREIGN FIGHTERS WELFARE MOTH

BIOLOGICAL WEAPONS ANTHRAX WMD PANDEMIC AVIAN FLU DIRTY BOMB
FIGHTERS WELFARE MOTHERS INTELLECTUALS BIOLOGICAL WEAP
SOCIAL SECURITY ENEMY COMBATANTS ARTISTS LIBYA SEXUAL
SUICIDE BOMBERS ANARCHISTS RADICAL ISLAMIC EXTREMISTS
CORPORATION FOR PUBLIC BROADCASTING DRUG LOR
BIOLOGICAL WEAPONS ANTHRAX WMD PANDEMIC AVIAN FLU
CORPORATION FOR PUBLIC BROADCASTING DRUG LORDS
PREDATORS THE INTERNAL ENEMY ANARCHISTS RADICAL ISLA
VENEZUELA IMPROVISED EXPLOSIVE DEVICES NUCLEAR ATTACK SOCI
MOTHERS INTELLECTUALS CORPORATION FOR PUBLIC BROADCA
GAY MARRIAGE WAR LORDS ILLEGAL IMMIGRANTS SUICIDE BOMBERS
WMD CORPORATION FOR PUBLIC BROADCASTING TERRORISTS
THE INTERNAL ENEMY RADICAL ISLAMIC EXTREMISTS THE FRENCH FORE
AL-QAEDA VENEZUELA IMPROVISED EXPLOSIVE DEVICES NUCLEAR ATTACK
JUDGES EVOLUTION EBOLA CUBA THE AXIS OF EVIL ILLEGAL IMMIGRANTS
BOMB PLAGUE THE FRENCH FOREIGN FIGHTERS WELFARE MOTHERS INTELL
ANTHRAX WMD PANDEMIC AVIAN FLU DIRTY BOMB PLAGUE GAY MARRIAGE TE
EXTREMISTS THE FRENCH FOREIGN FIGHTERS WELFARE MOTHERS
SOCIAL SECURITY SYRIA LOOTERS AL-QAEDA ENEMY COMBATANTS ARTIS
BROADCASTING DRUG LORDS ACTIVIST JUDGES EVOLUTION EBOLA CUBA TH
ANARCHISTS RADICAL ISLAMIC EXTREMISTS THE FRENCH FOREIGN FIG
BIOLOGICAL WEAPONS ANTHRAX WMD PANDEMIC AVIAN FLU DIRTY BOMB F
FOREIGN FIGHTERS WELFARE MOTHERS INTELLECTUALS BIOLOGICAL WEAP
SOCIAL SECURITY ENEMY COMBATANTS ARTISTS LIBYA SEXUAL
SUICIDE BOMBERS ANARCHISTS RADICAL ISLAMIC EXTREMISTS
CORPORATION FOR PUBLIC BROADCASTING DRUG LOR
BIOLOGICAL WEAPONS ANTHRAX WMD PANDEMIC AVIAN FLU
CORPORATION FOR PUBLIC BROADCASTING DRUG LORDS
PREDATORS THE INTERNAL ENEMY ANARCHISTS RADICAL ISLA
VENEZUELA IMPROVISED EXPLOSIVE DEVICES NUCLEAR ATTACK SOCI
MOTHERS INTELLECTUALS CORPORATION FOR PUBLIC BROADCA
GAY MARRIAGE WAR LORDS ILLEGAL IMMIGRANTS SUICIDE BOMBERS
WMD CORPORATION FOR PUBLIC BROADCASTING TERRORISTS
THE INTERNAL ENEMY RADICAL ISLAMIC EXTREMISTS THE FRENCH FORE
AL-QAEDA VENEZUELA IMPROVISED EXPLOSIVE DEVICES NUCLEAR ATTACK
JUDGES EVOLUTION EBOLA CUBA THE AXIS OF EVIL ILLEGAL IMMIGRANTS
BOMB PLAGUE THE FRENCH FOREIGN FIGHTERS WELFARE MOTHERS INTELL
ANTHRAX WMD PANDEMIC AVIAN FLU DIRTY BOMB PLAGUE GAY MARRIAGE TE
EXTREMISTS THE FRENCH FOREIGN FIGHTERS WELFARE MOTHERS
SOCIAL SECURITY SYRIA LOOTERS AL-QAEDA ENEMY COMBATANTS ARTIS
BROADCASTING DRUG LORDS ACTIVIST JUDGES EVOLUTION EBOLA CUBA TH
BOMBERS ANARCHISTS RADICAL ISLAMIC EXTREMISTS THE FRENCH FOREIG

The Trickle-up Theory

Cinema's viral commutability of images infests the next technology of the social body with a genetic and mimetic ability to replicate, sometimes unconsciously. A rarely seen history "trickles up" through cultural osmosis from the experimental laboratory or the artistic hothouse of the avant-garde(n). Often without direct knowledge or awareness of the sources, new forms and ideas are "borrowed" and transmitted by daisy chain or travel up by social spore from the "cinema of the worm"—to some, this is a contemptuous source, abject, reviled, low; to others, fertile, underground, culture. From here, adaptations are fashioned into stylistic tropes, severed from the formal or conceptual roots from which they germinated, diluting the rich DNA of their deep structure or contextual gene, but spreading widely amid the cultural landscape through sporadic distribution.

However, this is the life cycle of the cultural meme—the conceptual mirror of the bio gene—developing into new forms, in some cases quite unlike the source. Creations and inventions incubated under the radar often twist into pilfered versions when filtered by dispersion and diluted by replication. These shards and fractures are grafted into new mutations, metamorphosing into hybrids through creative misunderstandings and misinterpretations that produce fresh translations. Whether flowers of evil or songs of innocence and experience, that's how culture often thrives, through piracy, accident, and mistaken identity. The imperfect is alive!

Expanding & Contracting
(Rubbery Positions)

It appears as if film could mean almost everything, a metaphor for the whole world. A metaphor for what happened in Plato's cave and equally for the birth of the universe in creation myths. The question What is film? *generally assumes contraction as a consequence—a journey into the core in search of film's essence. In contrast, the answer suggested here is that* Film is more than Film.

—Alexander Horwath, on Gustav Deutsch's *Film ist.*[2]

An artistic debate arises pinpointing tensions between hybridists and purists, between those who favor expanded cinema, a maximal approach of heterogeneous compositions inclusive of multiple media and additional "extra-filmic" elements, and those who prefer what I would call "contracted cinema," reducing forms and materials to the essential by subtracting elements to reach the exclusively "filmic."

Both views derive from an artisan approach to the material nature of film and to the objectness of the whole apparatus of cinema. This plunges us into the "handmade," where film is treated as a sculptural, "plastic," or painterly material, suited for manual manipulations of the filmstrip and its surfaces. In addition, the entire mechanics emphasizes an operational performance: an active machine generating visual or aural effects.

These positions are often bracketed as irreconcilable differences: "synesthetic cinema" or "intermedia" on the one hand versus "film as film" or "absolute essence" on the other, although some, myself included, embrace the entire trajectory, or at least favor the extremes. I believe the primary difference lies in the individual artist's approach to the investigation he or she is focused on at a given time, as the parameters seem to shift with the specific inquiry.

WELFARE MOTHERS INTELLECTUALS CORPORATION FOR PUBLI
GAY MARRIAGE WAR LORDS ILLEGAL IMMIGRANTS SUICIDE BOMBER
ANTHRAX WMD CORPORATION FOR PUBLIC BROADCASTING TERRORIST
THE INTERNAL ENEMY RADICAL ISLAMIC EXTREMISTS THE FRENC
AL-QAEDA VENEZUELA IMPROVISED EXPLOSIVE DEVICES NUCLEAR
ACTIVIST JUDGES EVOLUTION EBOLA CUBA THE AXIS OF EVIL ILLEGA
BOMB PLAGUE THE FRENCH FOREIGN FIGHTERS WELFARE MOTHER
ANTHRAX WMD PANDEMIC AVIAN FLU DIRTY BOMB PLAGUE GAY MARRIAG
EXTREMISTS THE FRENCH FOREIGN FIGHTERS WELFARE MOTHER
SECURITY SYRIA LOOTERS AL-QAEDA ENEMY COMBATANTS ARTISTS LIBY
DRUG LORDS ACTIVIST JUDGES EVOLUTION EBOLA CUBA THE AXIS O
ANARCHISTS RADICAL ISLAMIC EXTREMISTS THE FRENCH FOREIGN FIGHTER
BIOLOGICAL WEAPONS ANTHRAX WMD PANDEMIC AVIAN FLU DIRTY BOM
FIGHTERS WELFARE MOTHERS INTELLECTUALS BIOLOGICAL WEAPON
SOCIAL SECURITY ENEMY COMBATANTS ARTISTS LIBYA SEXUAL PREDATOR
SUICIDE BOMBERS ANARCHISTS RADICAL ISLAMIC EXTREMISTS LOOTER
INTELLECTUALS CORPORATION FOR PUBLIC BROADCASTING DRUG LORDS ACTIVIS
TERRORISTS BIOLOGICAL WEAPONS ANTHRAX WMD PANDEMIC AVIAN FLU DIRT
INTELLECTUALS CORPORATION FOR PUBLIC BROADCASTING DRUG LORD
LIBYA SEXUAL PREDATORS THE INTERNAL ENEMY ANARCHISTS RADICA
AXIS OF EVIL VENEZUELA IMPROVISED EXPLOSIVE DEVICES NUCLEAR ATTAC
FIGHTERS WELFARE MOTHERS INTELLECTUALS CORPORATION FOR PUBLI
GAY MARRIAGE WAR LORDS ILLEGAL IMMIGRANTS SUICIDE BOMBER
ANTHRAX WMD CORPORATION FOR PUBLIC BROADCASTING TERRORIST
THE INTERNAL ENEMY RADICAL ISLAMIC EXTREMISTS THE FRENC
AL-QAEDA VENEZUELA IMPROVISED EXPLOSIVE DEVICES NUCLEAR
ACTIVIST JUDGES EVOLUTION EBOLA CUBA THE AXIS OF EVIL ILLEGA
BOMB PLAGUE THE FRENCH FOREIGN FIGHTERS WELFARE MOTHER
ANTHRAX WMD PANDEMIC AVIAN FLU DIRTY BOMB PLAGUE GAY MARRIAG
EXTREMISTS THE FRENCH FOREIGN FIGHTERS WELFARE MOTHER
SECURITY SYRIA LOOTERS AL-QAEDA ENEMY COMBATANTS ARTISTS LIBY
DRUG LORDS ACTIVIST JUDGES EVOLUTION EBOLA CUBA THE AXIS O
ANARCHISTS RADICAL ISLAMIC EXTREMISTS THE FRENCH FOREIGN FIGHTER
BIOLOGICAL WEAPONS ANTHRAX WMD PANDEMIC AVIAN FLU DIRTY BOM
FIGHTERS WELFARE MOTHERS INTELLECTUALS BIOLOGICAL WEAPON
SOCIAL SECURITY ENEMY COMBATANTS ARTISTS LIBYA SEXUAL PREDATOR
SUICIDE BOMBERS ANARCHISTS RADICAL ISLAMIC EXTREMISTS LOOTER
INTELLECTUALS CORPORATION FOR PUBLIC BROADCASTING DRUG LORDS ACTIVIS
TERRORISTS BIOLOGICAL WEAPONS ANTHRAX WMD PANDEMIC AVIAN FLU DIRT
INTELLECTUALS CORPORATION FOR PUBLIC BROADCASTING DRUG LORD
LIBYA SEXUAL PREDATORS THE INTERNAL ENEMY ANARCHISTS RADICA
AXIS OF EVIL VENEZUELA IMPROVISED EXPLOSIVE DEVICES NUCLEAR ATTAC
FIGHTERS WELFARE MOTHERS INTELLECTUALS CORPORATION FOR PUBLI

NTELLECTUALS CORPORATION FOR PUBLIC BROADCASTING DRUG LORD
RORISTS BIOLOGICAL WEAPONS ANTHRAX WMD PANDEMIC AVIAN FLU DIRT
CTUALS CORPORATION FOR PUBLIC BROADCASTING DRUG LORDS ACTIVIS
SUICIDE BOMBERS ANARCHISTS RADICAL ISLAMIC EXTREMISTS LOOTER
OCIAL SECURITY ENEMY COMBATANTS ARTISTS LIBYA SEXUAL PREDATOR
N FIGHTERS WELFARE MOTHERS INTELLECTUALS BIOLOGICAL WEAPON
BIOLOGICAL WEAPONS ANTHRAX WMD PANDEMIC AVIAN FLU DIRTY BOM
NARCHISTS RADICAL ISLAMIC EXTREMISTS THE FRENCH FOREIGN FIGHTER
ING DRUG LORDS ACTIVIST JUDGES EVOLUTION EBOLA CUBA THE AXIS O
SECURITY SYRIA LOOTERS AL-QAEDA ENEMY COMBATANTS ARTISTS LIBY
C EXTREMISTS THE FRENCH FOREIGN FIGHTERS WELFARE MOTHER
NTHRAX WMD PANDEMIC AVIAN FLU DIRTY BOMB PLAGUE GAY MARRIAG
IRTY BOMB PLAGUE THE FRENCH FOREIGN FIGHTERS WELFARE MOTHER
ACTIVIST JUDGES EVOLUTION EBOLA CUBA THE AXIS OF EVIL ILLEGA
OOTERS AL-QAEDA VENEZUELA IMPROVISED EXPLOSIVE DEVICES NUCLEA
ATORS THE INTERNAL ENEMY RADICAL ISLAMIC EXTREMISTS THE FRENCH
IS ANTHRAX WMD CORPORATION FOR PUBLIC BROADCASTING TERRORIST
AGUE GAY MARRIAGE WAR LORDS ILLEGAL IMMIGRANTS SUICIDE BOMBER
TERS WELFARE MOTHERS INTELLECTUALS CORPORATION FOR PUBLIC
AXIS OF EVIL VENEZUELA IMPROVISED EXPLOSIVE DEVICES NUCLEAR ATTAC
LIBYA SEXUAL PREDATORS THE INTERNAL ENEMY ANARCHISTS RADICA
NTELLECTUALS CORPORATION FOR PUBLIC BROADCASTING DRUG LORD
RORISTS BIOLOGICAL WEAPONS ANTHRAX WMD PANDEMIC AVIAN FLU DIRT
CTUALS CORPORATION FOR PUBLIC BROADCASTING DRUG LORDS ACTIVIS
SUICIDE BOMBERS ANARCHISTS RADICAL ISLAMIC EXTREMISTS LOOTER
OCIAL SECURITY ENEMY COMBATANTS ARTISTS LIBYA SEXUAL PREDATOR
N FIGHTERS WELFARE MOTHERS INTELLECTUALS BIOLOGICAL WEAPON
BIOLOGICAL WEAPONS ANTHRAX WMD PANDEMIC AVIAN FLU DIRTY BOMI
NARCHISTS RADICAL ISLAMIC EXTREMISTS THE FRENCH FOREIGN FIGHTER
ING DRUG LORDS ACTIVIST JUDGES EVOLUTION EBOLA CUBA THE AXIS O
SECURITY SYRIA LOOTERS AL-QAEDA ENEMY COMBATANTS ARTISTS LIBY
C EXTREMISTS THE FRENCH FOREIGN FIGHTERS WELFARE MOTHER
NTHRAX WMD PANDEMIC AVIAN FLU DIRTY BOMB PLAGUE GAY MARRIAG
IRTY BOMB PLAGUE THE FRENCH FOREIGN FIGHTERS WELFARE MOTHER
ACTIVIST JUDGES EVOLUTION EBOLA CUBA THE AXIS OF EVIL ILLEGA
OOTERS AL-QAEDA VENEZUELA IMPROVISED EXPLOSIVE DEVICES NUCLEA
ATORS THE INTERNAL ENEMY RADICAL ISLAMIC EXTREMISTS THE FRENCI
IS ANTHRAX WMD CORPORATION FOR PUBLIC BROADCASTING TERRORIST
AGUE GAY MARRIAGE WAR LORDS ILLEGAL IMMIGRANTS SUICIDE BOMBER
TERS WELFARE MOTHERS INTELLECTUALS CORPORATION FOR PUBLIC
AXIS OF EVIL VENEZUELA IMPROVISED EXPLOSIVE DEVICES NUCLEAR ATTAC
LIBYA SEXUAL PREDATORS THE INTERNAL ENEMY ANARCHISTS RADICA

Prying History Loose, Not Nailing It Down

Some of the best films I have experienced will most likely *never be seen
again.* These celluloid projections—performative, ephemeral, expanded,
paracinema works—have often vanished with time. In some cases, the
artist has simply moved on, superseded by shifting interests or inspira-
tion. In other cases, the works were abandoned or retired. Some works
and artists have disappeared entirely, and some works have died with
their makers. There is no document of them, no studio version or live
recording, no film or tape of the performance or screening, only experi-
ences, memories, reports, if that.

In a few cases, instructions, notations, and materials exist for possible
reconstruction. But often only the maker can properly execute the work
with the necessary finesse and subtlety. Though they are often rehearsed
and perfected by their creators, they are usually songs without scores,
dances without choreography, buildings without blueprints, theater with-
out a script, poems in space. They are certainly films without scenarios,
meant to be live. But they are not less for being unrepeatable—only rare,
unique, resonant, but often lost. Shining examples are unfixed works
by Harry Smith, Jack Smith, Ken Jacobs, Valie Export, Guy Sherwin,
Mediamystics, Schmelzdahin, and silt.

Ars Moriendi
(The Mortality of Art)

Some would argue that these are not films at all because they are not
fixed. Because they are not objects or reproducible as copies, they do not
count in the history of the media. It is hard enough for films with prints
to remain in cultural view—with fragile originals or negatives in need of
temperature-controlled storage vaults and preservation care, and prints
that fade, scratch, break, or deteriorate. Phantom film performances and
flickering operations made all the more transparent by being difficult to
grasp and contain—live versions using recorded materials or a playback
apparatus with unfixed elements—make for strange, unwieldy, and un-
likely artifacts in the archive department or among the documents of
art history; but digital capture may change all that, at least for traces of
the seemingly untraceable.

*The false immortality of the film gives the viewer an illusion of control
over eternity.*
—Robert Smithson, "A Tour of the Monuments of Passaic, New Jersey"

In the year of his death, Marcel Duchamp enunciated this thought:

> I believe that a picture, a work of art, lives and dies just as we
> do.... That is, it lives from the time it's conceived and created,
> for some fifty or sixty years, it varies, and then the work dies....
> Art history begins only after the death of the work....In that
> sense, I believe that the history of art is extremely random....I
> am convinced that the works on view in museums and those we
> consider to be exceptional, do not represent the finest achieve-
> ments in the world.[3]

AVGERAGE LIFE
SPAN= 68 YEARS

AVG. GRAVE DEPTH
= 7 ft. = 84 in.
RATE OF DESCENSION
FOR EACH YEAR+= 1.25 in.
SUBJECTS AGE = 32 YEARS

TO DATE SUBJECT HAS DESCENDE
APPROXIMATELY 40 in.
REMAINING DEPTH BEFORE SUBJE
REACHES THE ALL OF EVERYTHII

1) IF YOU COULD SUM UP OR C
YEARS IN ONE IMAGE, ONE WOR
OBJECT, WHAT WOULD IT BE?

2.5 INCHES
ANSWER:

Meta-Utopian

The survival, as object and practice, of the artisan film, especially performative and expanded cinema, requires an infrastructure of protection, or, at least, resistance to assimilation—a preserve, as it were, facilitated by critical, financial, and viewer support—a kind of spectral greenhouse for the experimental growth of optical orchids and other visual fungi.

Self-Determination

> *The belief in what you are doing is in the form.*
> —Donald Judd

The point is there is a danger that more selective histories will be written, as to date within the various histories of the experimental avant-garde there has been a gradual writing-out of an enormous body of narrative, expanded, technological and interactive moving image work that does not fit easily into categories. Perhaps it is the fault of the artists, who should have written their own histories. For future consideration we should start to challenge the way that the writing up of practice takes place.
—Jackie Hatfield[4]

I have never felt that any institution is wholly dependable for the proper preservation or contextualization of our artwork—though some occasionally are—so I have always embraced the initiative to curate, exhibit, organize, distribute, write about, and exchange—to place in context as an artistic process—my own works and others I cherish and support, as a radical gesture of self-determination. I feel a deep affiliation with other artists/activists who practice this in our temporary autonomous zones and a maverick resistance to co-optation or reification. There is much to be learned from the wolf, the owl, and the octopus.

> *The surest way of making useful discoveries is to diverge in every way from the paths followed by the uncertain sciences.*
> —Charles Fourier

...REASED DUE TO
...EX. GUNSHOT

SUBJECT

T...
= 44 in.

...STALLIZE THE LAST TWO
...ONE PIECE OF TEXT, ONE

Paradigm Shift
(from hands to digits)

> *Films have a certain place in a certain time period. Technology is forever.*
> —Hedy Lamarr, actress and co-inventor of the model for wireless communication

Here the question of film's elasticity is magnified, emphasizing which properties make it film qua film and which formal and material qualities translate cinema into the coming medium. It is especially significant at a moment of major cultural media transformation—a paradigm shift. In the last decade, the massive growth of computer and digital technology has affected film at all levels, engendering the discontinuity of film stocks and processing as well as shooting, editing, and projecting equipment and techniques. Though both television in the 1950s and video in the 1970s greatly influenced filmmaking and distribution, neither seemed to signal the demise of "cinema as film" quite like today's threshold of high-definition digital developments.

Hidden Operations

The digital realm is a hidden operation, a literal sleight of hand, whereby all tricks are now concealed in a truly encrypted language. Though film may have once had elements of the veiled, compared to the latest technologies, it now seems absolutely lapidarian. (Perhaps to its solid advantage.) Though it may be another decade before the popular world converts to a new medium of cinema, the film material as we know it—optical images of emulsive chemistry on thermoplastic celluloid—may soon be nothing but a rare archival medium for exhibition in historical museums, alongside other artifacts and relics of the cultural past (much as we experience it today in museums, galleries, archives, festivals, and revival cinemas—*but only there*).

Will the ones and zeros of the digital obliterate film's preservation or extend it? Has digital technology nailed the ephemerality of cinema's fragile material to an eternal code, stretching from zero to infinity? Will it be the mummy's resurrection machine of longevity or the spike in film's coffin?

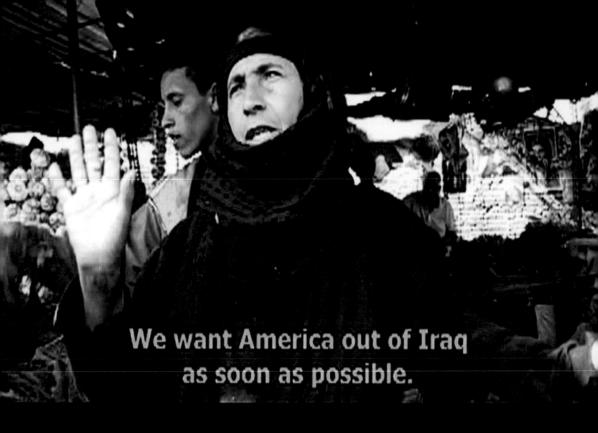

We want America out of Iraq
as soon as possible.

SHOCKing

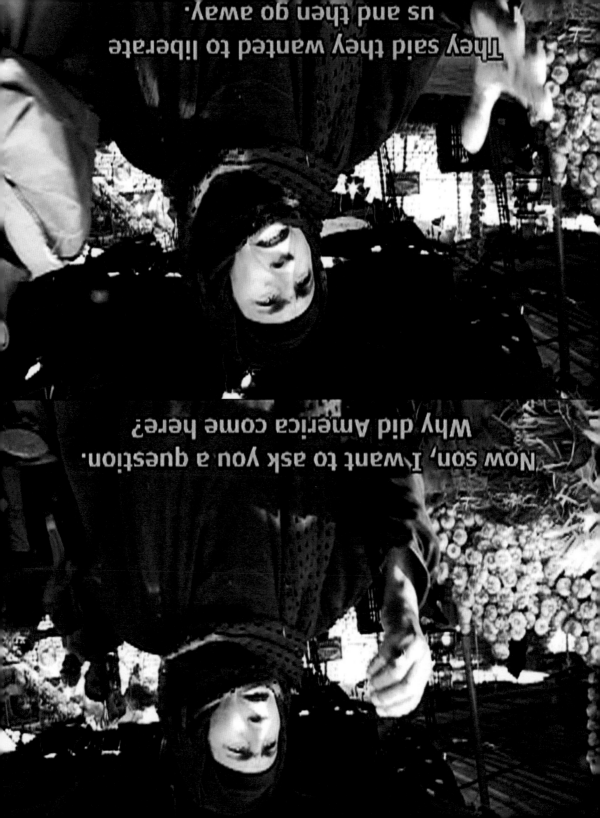

Hijack the Inquiries

Artists should hijack forms, then subvert the conversation. Whether playing pirate or vampire—always keep your hosts on their toes.

Systematic investigations by contemporary film detectives.

Inquiries being made:

1. Modifications to the mechanisms that produce distillations of phenomena experienced in both nature and the city

2. Magnification of the materials to mirror cognitive as well as perceptual processes

3. Hybrid experiments with obsolete and advancing media to question aesthetic purity and conceptual rigidity

4. Dismantling of codes: social, gender, and visual

5. Shifting the context for reception to revitalize the structural/materialist debate

6. Initiating screening venues and situations to pry up history, disarm the canon, and provoke dialogue among makers, supporters, and dissenters

7. Constructing site and context for sculptural and architectural emphasis

8. Isolating chroma and velocity to emphasize kinetic and graphic qualities

9. Renewing light modulations to focus and fracture luminosity

10. Disjunctions and synchronisms of sound and image interfaces

11. Displacing lenses, gates, apertures, and shutters to reconfigure apparatus assumptions

12. Narratives: untold stories and untelling stories

13. Analog amplifications and questions of digital permanence: zeros and ones to infinity?

Art should raise questions.
—Bruce Nauman

I went. I saw him lying there,
shot in his chest, his stomach,
his legs, his hands...

& AWful

Sins of the Cinenaut

In the tension between the object and the idea, obsession is formed.

Where no obsessions are to be discerned, I have no reason to linger.
—Harald Szeemann

Deep veins of celluloid continue to be mined by devotional artisans seeking a captured quality of light unequaled in the spectrum of sublime chroma and textured luminosity, though the true sine qua non of cinema may be the silver halide of the "lyrical" nitrate now all but lost to the combustion of history.

A specter is haunting cinema: the spectra of light and color that only transparency and flicker can bring.

An "aesthetic tragedy" is played out in Tomorrow's Memorial Cinemas: A perfumed ghost will frequent the digital theaters of the near future, its fragrant emulsion lingering like an afterimage in the mind of those who have cine'd in the past.

The plastic arts do not lament.
—Johan Huizinga, *The Autumn of the Middle Ages*

What proves that cinema ever existed? The night is still here and the shadows are even deeper after the pain and promise of the twentieth century, inhabited by a clairvoyance only the dreaming can fully know. Intuitions about what film might have become, or any art for that matter, had it developed in a less cruel, insidious, or carnivorous sphere, where few have extended beyond the larval stage, and if success were measured not by agreement, but by divergence or, even better, that open exchange, expressed in Malcolm de Chazal's "Declaration," which "makes the mechanism of *correspondences* operate as far as the eye can see."[5]

spider of the eyes

light traces caught in retina's web
membrane of capture
the brain's optic net at work

*The spectator in the cinema reacts to the screen as if his brain was attached
to an inverted retina at a distance.*
—Edgar Morin, *The Cinema, or The Imaginary Man*

Film is plastic thought. A resilient form that thinks. It is light that touches
the mind. A material vessel of immateriality.

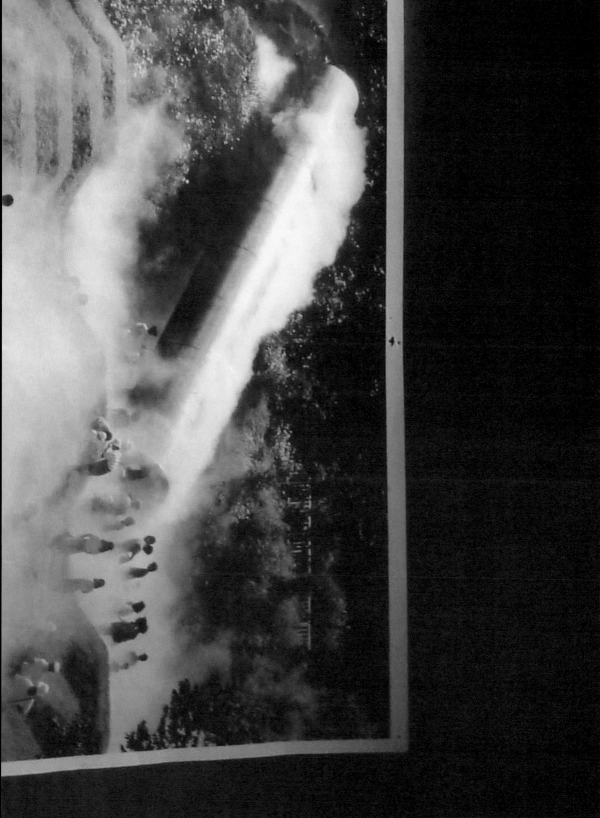

Elasticity Generator

Stretching from the nineteenth to the twenty-first, it is a skein that envelops the century, an elasticity of consciousness and play. But what exactly made cinema the reigning philosophical toy? What urgency, what chance? What drive and circumstance? And to what lost experiments, overtaken by the flood of the narrative of economics and its vice (versa), will we finally return, now that obsolescence opens the gateway to the unexplored?

I think that what we valued most in cinema was its power to disorient.
—André Breton, "As in a Wood"

> a. What radiation permits this?

> b. What experience directs it?

> c. What links it to the night?

… it casts light on the premonition that no other knowledge generating process is so alive, so open and capable of thought as film is.
—Alexander Horwath, "Flash"

What the black of the shutter carves into the white of the screen.

The cinema is solar in creation, but lunar in reception; for it needs the sun to generate, but its reflective light is selenographic in nature, related to transparent crystals. So, much as we absorb the moon's hypnotic glow nocturnally, film's flickering works best in darkness, for as de Chazal states: "only the Night has this power." To which Breton adds: "the cinema is the first great open bridge which links the 'day' to this Night." To which I add: "the elastic day to this mercurial Night. Your work is often completed in the mind of the spectator after she's gone to sleep."

Notes

1. See Daniel Pinchbeck, "Skeleton Women and Fisher Kings," *Arthur* 1, no. 18 (September 2005): 11.

2. Alexander Horwath, "Flash," essay in a booklet accompanying the DVD of Gustav Deutsch's *Film ist.* (1998), published by Sixpack Film, Vienna.

3. Marcel Duchamp, filmed interview by Jean Antoine (1968), translated transcript published in *Art Newspaper* (April 1993): 16–17.

4. Jackie Hatfield, "Expanded Cinema and Its Relationship to the Avant-Garde," *Millennium Film Journal*, nos. 39–40 (Winter 2003): 63–64.

5. Malcolm de Chazal, "Declaration," printed in Curepipe, Mauritius, September 25, 1951, quoted by André Breton in "As in a Wood," reprinted in *The Shadow and Its Shadow: Surrealist Writings on Cinema*, ed. Paul Hammond (London: British Film Institute, 1978), 42–45.

SOME FOUND TEXT AND BORROWED IDEAS (THANKS LEO, MEL, ADRIAN, JASPER, SHERRIE, ROLAND, DAN, FRED, AND DOUGLAS)

Johanna Burton

One observes in order to see what one would not see if one did not observe.
—Mel Bochner, borrowing from Ludwig Wittgenstein[1]

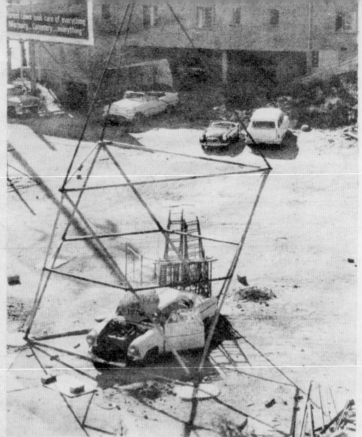

After a we
dals wrecked
the Artist's
continued wi
their 33 foot
Sunset and La
vandalism fol
pattern estab
board erecte
knocked dow
night raids.

The tower,
Mark di Suver
of the welding
Eric Orr, is
hour a day
war in Vietn
no demonstra
advertisemen
speak in the
as artists." (T
a large post
from the Artis

Hundreds c
mitted by ar
world, will be
by February
is planning a d
that day at l
whole commun

The photogr
shows a car h
ture in prepa

COUNCIL GIVES LAND AWAY
AFTER PLANNERS SAY NO

Ridgely Cummings

By a 12 to 1 vote the City Council last week started proceedings to give away 12,000 square feet of City property to the Taverner and Fricke Paper Co. at 1461 East Fourth Street.

Councilman Marvin Braude cast the sole "no" vote against instituting vacation proceedings on the 400 foot long strip of East Fourth Street.

Braude said he objected to the City surrendering a big block of land in the central core of the City, especially after the City Planning Department recommended against the vacation.

Councilman Gil Lindsay, who represents the East side area, urged approval and said, "It will be good for the great 9th Council district."

The majority of the council went along with the Councilman of the district, as they frequently do on matters of a local nature.

During the discussion there was no mention of the name of the petitioner who will benefit from the proposed vacation. The Council file showed that the proceedings started April 30, 1965 with a letter from W. H. Taverner of the Taverner and Fricke Paper Co.

Taverner wrote that the 30 foot wide strip of property 400 feet

long is a side
primarily by
boring firm,
Fabrics. He s
pany needs m
the warehouse
City to give u

The City En
the land cou
number of pr
were first c
the Planning
Council disap

"Fourth St
way which ser
to the central
is granted, ve
petitioner's p
Painted Fabr
park along Fo

Karl Curst
planner, told

(continu

LOS ANGELES FREE PRESS

BOOTS

COUNC

A HAP

153 PL

Policemanship:

VOL. 3, #7 (ISSUE #83)

COPYRIGHT, 1966
THE LOS ANGELES FREE PRESS

FEBRU.

KAY STARR
GAYLORD & HO'IDAY
NOW THRU FEB 20

I. Bad Risks Are Good

Jasper Johns, *Three Flags*, 1958. Encaustic on canvas, 30⅞ x 45½ x 5 in. (78.4 x 115.6 x 12.7 cm). Whitney Museum of American Art, New York; 50th Anniversary Gift of the Gilman Foundation, Inc., The Lauder Foundation, A. Alfred Taubman, Laura-Lee Whittier Woods, and purchase 80.32

Jasper Johns once wrote a handful of haiku-like statements that seem connected to his working method. One of these reads:

> Take an object.
> Do something to it.
> Do something else to it.
> " " " " " 2

I take this to mean that, in Johns's view at least, an artist should per-form a series of functions on an object ("do" something to it and then something else and then something else again) in order to render that object unstable and, thus, different from what it originally was. (In an interview, Johns once said, "I prefer work that appears to come out of a changing focus—not just one relationship or even a number of them but constantly changing and shifting relationships to things in terms of focus."3) I also take it to mean that to simply mimic, mirror, or magnify preexisting things (rather than altering their terms) is to do only that—to engage in mimicry, mirroring, or magnification. To place an object into some kind of productive existential crisis requires its potential oblitera-tion. To place an object into some kind of productive existential crisis also pretty much ensures the same will happen, for a time, to its maker and maybe even to its audience.

Sherrie Levine once wrote a handful of "comments" (laced throughout with overtly plagiarized phrases) that seem connected to her working method. A segment of one of these reads:

> The world is filled to suffocating. Man has placed his token on every stone. Every word, every image, is leased and mortgaged. We know that a picture is but a space in which a variety of images, none of them original, blend and clash. A picture is a tissue of quotations drawn from the innumerable centers of culture.4

RAP FOR WATTS

GIVES LAND AWAY

NING THIS FRIDAY-SEE AD

10¢

CES TO GO THIS WEEK -PAGE 12

A Guide SEE PAGE 7

Y 18, 1966 654-4618 **10¢**
(15c OUTSIDE OF LOS ANGELES)

nd in which van-
-lding generator,
-test Committee
construction of
-ptural tower on
-nega. The latest
-ed the senseless
-ed when the bill-
- the artists was
-everal times in

-gned by sculptor
' o is doing much
g with scul r
-ied to be 4
st against e
as no del ,
no newsp r

-ner native to us
quotation is from

u. sub-
s all o..
-ng on the towe.
The committee
-ation ceremon:
m to wh'
-ic

test by a county inspector whi
the well designed tower easi
passed. The photograph on the
lower left, taken several day
later from the adjoining hillsid
shows another section welded
the top. As this paper goes to th
printers, a large crane is bei
used to hoist a pre-fabricat
twenty foot section of the scul
ture to its apex.

The photograph on the uppe
right sho some of the art pane.
in the wa use of the committee.
In the ir committee memb
Irving P n is seen examinir
some of submissions.

Amon contributing artis
-on, Rudolph Arani
Larry Bell, Paul Brach, Hele
Breger, Arnaldo Coen, Kar
Appel, Allan D'arcangelo, Elaine
Dijon Dillon, Ken
Dillon, Mark Di Duvero, Bella
T. Feldman, Hassel Smith, Joh
Adja Yunkers, and Piet
Ca l.

-onel
Gongora, Liyn Poulos, Sam Fran-
cis, Judy Gerowitz, Leon Golub,
Lloyd Hamrol, Hardy Hanson,
Francisco Icaza, Donald Judd,
Wolf Kahn, Howie Kanowitz, Matta
Arthur Secunda. Charles White,

Also Richard Klix, Max Koz-
loff, Roy Lichtenstein, Ivan Maj-
drakoff, Phil Lieder, Robert Mal-
lory, Charles Mattox, Robert Mc-
Chesney, Arnold Mesches, Robert
Motherwell, Lee Mullig Rolf
Nelson, C r, George S , Jim
Wines, Er o Baj and T chi.

Also F k O'Hara, ques
Overhoff, ia Pearl, Irv Pet-
-.. .. - C. By-
- ctor,
Ad Reinhardt, Maria Orozco Ri-
vera, Larry Rivers, Jim Rosen-
st, Mark tella,
-temio Sept da, George rar-
man, Mauric uchman a ean
Helion.

OPERATION OOTSTRAP'
ANOTHER ANS FOR TTS

on for a stress
d whic'
i-

u Painted
-ie paper com-
land to enlarge
-ce and asked the
' land.

' reported that
'-d if a

-tiv.
-lied with white
-artment urged
eporting:
-s a busy high-
as an approach
-r. If the request
-es serving the
-ty and Mission
-'d have to

principa..
Council that the
-n Page 2)

Clay Carson

n the people of South Los
Ang are effectively subdued
last Au by the National Guar
and the L Angeles police forc
the burden finding lasting so'
tions to th problems has fall
to the po ians, the communi
leader u the civil rights wor
-n, in their own way, ac-
-s the task with the knowledge
that their ineffectiveness played
an im tant part in the outbre
of vio nd that much of the
present s rt comes from thos
who seek t se them as buffers
postpone mollify radic
change

Of th l rights groups in th
Non-Violent Actic
-.tee is the most militan
and this week one of its leader
initiated a project called Oper-
ation Bootstrap. The leader is

Robert Hall, a veteran civil rights
worker who recognizes some of
the ineffective-
pas. proj. he L. A.
-vil rights movement ends
to use his experience in -ing
a private, Negro-run job r in-
ing center in the heart of So Los
Angeles. He and Lou Sm the
-o coordinators of ' strap,
-. nter at
41.. d a ro parts
building.

As I talked with Robert amidst
the varied equipment that was be-
ginning to fill the buildi g, it was
quick to point out that Bootstrap is
-oot-
-gan-
ization." He does not intend to give
up the militancy that led him and
other CORE members to break
away and form N-VAC in April of
1964. The basic premise of

(Continued on Page 3)

I take this to mean that Levine probably is interested, like Johns, in the shifting relationships between things. Yet, she further tweaks Johns's notion by insisting that relationships between things are really *all there is*. With Levine, there is no longer a conception of an object as it "originally" was but, instead, only countless relays and recitations of it and about it. (Johns's formulation above would need to be rewritten with the first line altered to reflect a phantasmic object always already in some process of "being done to." Perhaps ellipses before the first line would signify this ostensibly "postmodern" *mise en abîme*?) I also take Levine's statement to mean that we should consider, in looking and listening, the ways and means by which "every word, every image" is "leased and mortgaged." Levine asserts, "Man has placed his token on every stone," and she really does mean every *man*. She also means that the majority of these (unmarked) mortgages and leases are held by the upper class, the white, the heterosexual, and the otherwise arbitrarily privileged. Levine's appropriations shake things up without "doing" a thing to them. Exacerbating the notion of an object (and perhaps a corresponding subject) in existential crisis, Levine suggests that this is the natural state of modern things. Of the anxiety produced by her baldly pilfered wares, she has written, "The birth of the viewer must be at the cost of the painter." (A quotation that, even altered, surely sounds familiar, yes, out-and-out stolen and then turned against itself.[5])

In 1962, the art historian and critic Leo Steinberg admitted that he liked Johns's work. Or that he had recently come to like it after first not really liking it at all. I'm not sure what, if any, opinion he holds of Levine's oeuvre, though his delicious proclamation that "it is in the nature of original contemporary art to present itself as a bad risk" could surely be seen as applying to Levine in the 1980s as it had to Johns twenty years prior. (Steinberg, by the way, meant "bad risk" as a very high compliment. More on this in a moment.)

II. Please Despair

More often than I care to admit, I find myself wondering, "What would Leo Steinberg think?" I suppose I could write him a letter asking his expert opinion of various artworks or artists, but the pleasure of the question is likely partially born of its being strictly hypothetical. Besides, it was Steinberg who insisted that we come up with our own innovative (as he put it, "other") criteria with which to approach new art and destabilize calcified or teleological models of critique and analysis.[6] So many of his theoretical cogitations—the earliest of them posed a half century ago—are now asserting themselves with an urgency typical of prescience coming to term. To take the example most ready-at-hand for which I'd like to bend Leo's ear: Just what are we to make of this Biennial? When I say "we," I mean all of us—artists, writers, curators, hobbyists, connoisseurs (do these still exist?), academics, laypeople; the believers and the non-; the raw and the cooked.

I use the word "we" here in the way Steinberg used the word "public" in his 1962 essay "Contemporary Art and the Plight of Its Public."[7] Arguing that, when it comes to contemporary art, the distinction between the initiated and the uninitiated is ultimately a case of pure semantics and good (or bad, depending on how you see things) timing, Steinberg proceeded to define the public not as an exterior-to-art position occupied by, say, cultural tourists on their rare weekend outings to museums, but rather as a *function*, one occupied from time to time by everyone.[8] In Steinberg's telling, even the biggest of the big "avants" unhappily took up the mantle for spates of time: Matisse dipped his toe into "public" occupation when he saw and was enraged by Picasso's work; Picasso did the same in the face of Duchamp's *Nude Descending a Staircase*. For to operate in and as a member of the public, one need only experience—in the face of some work of art (and couldn't we argue in the face of other things as well?)—"the shock of discomfort or the bewilderment or the anger or the boredom which some people always feel, and all people

G AUTHORITY

sometimes feel, when confronted with an unfamiliar new style."[9] In other words, when unable to immediately account for that which stands before you or to understand it purely in relation to all you think you already know, then you are—in that moment—functioning in the mode of the public. It's hard to stress enough that this is, in fact, a *good* thing, nothing to be embarrassed about. Or, better, good *because* embarrassing. This just means all your naturalized, lazy assumptions are being put to the test. (The etymology for "embarrass" is literally "to block, bar, or obstruct." To be embarrassed is to encounter a roadblock, be thrown a curve: metaphors that make it clear it's important to change direction from time to time.)

The question is, in exploring this Biennial (maybe your first, your fifteenth, your last), have you found yourself unexpectedly bewildered, beleaguered, embarrassed? (Surely you are bored in some instances, but I think Steinberg's invocation of productive boredom suggests that it only counts as a "public" function when mounted—however unconsciously—as a defense mechanism against change, not as merely unadulterated tedium or, worse and far more common, apathy. In other words, are you bored because you've seen it all before or, very differently, because you're fending off the unfamiliar? And why am I boring you with terms borrowed from an essay written more than forty years ago by somebody else?)

Following Steinberg, we should hope to become depressed or anxious—these were his initial reactions to Johns—as we walk from floor to floor through the Whitney. Judging from the heterogeneity of content, form, and concept here—the expanded field of *everything*—how could there *not* be a moment of immanent uncertainty lying in wait for each of us? But will we be disappointed—meaning, and this sounds strange, will we walk away simply satisfied? Not because this Biennial isn't filled with provocative and, in numerous cases, truly important art, but because it's more and more rare, and for shorter and shorter periods of time (despite what pharmaceutical companies would have us believe) that we find ourselves plummeted into the depths of ideology-shaking

despair. I don't mean that a work of art has to knock the wind out of us or bring us to our knees. Not so. It's more the effect of a persistent, nagging whisper, equal parts pleasure and discombobulation. It's more the effect of a question hovering in the air. (A painting can murmur just as suggestively as an experimental film, though it will have a different accent, as all forms of art can't help but refer to their own histories.) Indeed, what Steinberg admired about Johns's work wasn't its content (or contentlessness, depending on how you see things) or its *far-out* flair, but the way it revealed the critic's own reliance on — and faith in — a set of preestablished, predetermined beliefs by placing their assumptions and normalizing procedures in question. What Steinberg admired about Johns's work was that it paraded as a "bad risk," snubbing its nose at a lineage of tradition that it simultaneously took so seriously as to do battle with. What Steinberg admired about Johns's work was that it made him — and perhaps its own context — deeply insecure. And while our current moment evinces a thorough understanding of the "snub" (as has every transformational moment in which the just-previous history asserts itself as a force to be reckoned with), today that reckoning too often has been reduced to low-stakes, tongue-in-cheek "sampling," diffusing the insecurity generally attending the "next generation" as it grapples with lineage. When the snub is no longer attended by (indeed driven by) real anxiety, one could argue, in deference to Barthes, that it's time to "change the object itself." [10]

29

III. Change the Object Itself

In 2006, it is no longer a "bad risk" to cast a beer can in bronze or take the American flag as a purely structural painterly template. And it would seem, given the thorough omnipotence of appropriative methods by artists today, that Levine's radical mode of "taking" images to reveal their contextual armatures has itself been appropriated so fully as to have flatlined into simply the most efficient mode of regurgitative commercial practice. Deploying "found objects" or utilizing "appropriation" is now a matter of course, to the point that such practices, alone, can hardly be considered "critical" any longer. (Levine, I should add, continues to be a "bad risk" since questions of gender and class are more crucial—if less popular—today than ever before.) Indeed, one finds that the once-shocking revelation that originality is merely a construct has become a modus operandi of our own moment (ironically, its own brand of originality) and galleries are glutted with images we are seeing-again-for-the-first-time. The immanent criticism attributed in the 1980s to gestures of appropriation has itself been largely emptied out and retooled into a sexy-cynical style. (This is not to say there are no "critical practices" today, but only that those which are self-consciously recognizable as such are sometimes handily modeled on, rather than generated by, previous ventures, rendering the radical reified.)

Fredric Jameson saw this danger on the postmodern horizon as early as 1982. Interpreting contemporary society's compulsion to repeat the already existent, he wrote,

> [In] a world in which stylistic innovation is no longer possible, all that is left is to imitate dead styles, to speak through the masks and with the voices of the styles in the imaginary museum; even more, it means that one of its essential messages will involve the necessary failure of art and the aesthetic, the failure of the new, the imprisonment in the past.[11]

Sherrie Levine, *After Walker Evans: 4*, 1981. Gelatin silver print, 10 x 8 in. (25.4 x 20.3 cm). Whitney Museum of American Art, New York; Purchase, with funds from the Photography Committee 96.2

S.P.R.

HAIL FIRE AND FLOW!

AND THE BOREDOM OF THE FAL

Ironically, for Jameson, such imprisonment in the past *disallows* access to history, and, of course, to a future. Indeed, he argues that if modernism can be cursorily defined by language and time, then postmodernism is the effect of a schizophrenic breakdown into image and space. There can be no past where there is no time, nothing but the horizontal sprawl of endlessly repeated, emptied, and pastiched images.[12] Such a transformation of reality into images, and of time into fragmented, perpetual presents, mirrors, says Jameson, the logic of consumer capitalism. He leaves as a less-than-hopeful open question whether the capacity for resistance—and not simply exacerbation—can reside in such mimesis.

But today (when "postmodernism" is no longer used as a description of the times, though it's unclear just what term has come to replace it), repetition, appropriation, and the redeployment of found objects are not the problem. Nor are they the answer. They are, instead, simply everywhere. (I tend to agree with Barthes that there never *was* a time when every sentence, every word, wasn't already delivered as "anonymous, untraceable, and yet *already read*: they are quotations without inverted commas."[13]) Perhaps everything has already always been seen, been said. But that hardly means everything has been fully observed, which is something else altogether. I want neither to denounce nor to pronounce strategies of appropriation and found objects in today's art, but to insist on what is, admittedly, an idea that's certainly not even mine and not even very new. In looking at today's art, risk feeling embarrassment, depression, lack of conviction. Look at things not because you know what they are but because you might not, after all. In his notebook, Johns wrote himself a reminder that says it best of all: "Processes of which one 'knows the results.' Avoid them."

Notes

1. The text comes from a 2001 series of paintings by Bochner, in which it appears, superimposed upon itself, in English and German. The citation is taken from Wittgenstein's *Remarks on Colour*, ed. G. E. M. Anscombe, trans. Linda L. McAlister and Margaret Schättle (Oxford, England: Blackwell Publishers, 1977), 62. One can read Wittgenstein's statement (and Bochner's subsequent "reframing" of it) as a description of a metapractice, a method of utter self-reflexivity. I take every such metainvestigation as the bedrock of critical politics. For a beautiful read of the meta with regard to art practices, see Adrian Piper's seminal essay "In Support of Meta-Art," *Artforum* 12, no. 2 (October 1973): 79–81. My own essay is a simple exercise in detailing the importance of the meta at what is arguably a non-meta political moment.

2. Jasper Johns, "Sketchbook Notes," *Art and Literature* 4 (Spring 1965): 191–92.

3. Jasper Johns, interviewed by G. R. Swenson, in "What Is Pop Art? Interviews with Eight Painters," part 2, *Art News* 62, no. 10 (February 1964); reprinted in *Theories and Documents of Contemporary Art: A Sourcebook of Artists' Writings*, ed. Kristine Stiles and Peter Selz (Berkeley and Los Angeles: University of California Press, 1996), 323.

4. Sherrie Levine, "Five Comments" (1980–85), in Brian Wallis, ed., *Blasted Allegories: An Anthology of Writings by Contemporary Artists* (New York: New Museum of Contemporary Art; Cambridge, Mass.: MIT Press, 1987), 92–93.

5. The quotation plays on (and plays up) Roland Barthes's famous 1968 assertion that "the birth of the reader must be at the cost of the death of the Author." See his "The Death of the Author," in *Image-Music-Text*, trans. Stephen Heath (New York: Hill and Wang, 1977), 142–48.

6. See Leo Steinberg, "Other Criteria," in his *Other Criteria: Confrontations with Twentieth-Century Art* (New York: Oxford University Press, 1972), 55–91.

R.J.63

7. Leo Steinberg, "Contemporary Art and the Plight of Its Public," in *Other Criteria*, 2–16.

8. Dan Graham, presenting a series of comments at the Art Workers' Coalition "Open Hearing" in 1969, offered the following succinct description of the shared field of art: "What does the artist have in common with his friends, his public, his society? Information about himself, themselves and all ourselves—which is not reduced to ideas or material, but shares in both categories as it has a past, present and future time/space. It is neither subjective nor objective 'truth'; it simply is—it is both a residue 'object' and neutral 'ethereal' media transcribed—transcribed upon/translation—translating the content of single and collective man's internal and external position, work, ideas, activities." Published in *An Open Hearing on the Subject: What Should Be the Program of the Art Workers Regarding Museum Reform and to Establish the Program of an Open Art Workers' Coalition* (New York: Art Workers' Coalition, 1969), unpaginated; reprinted in *Conceptual Art: A Critical Anthology*, ed. Alexander Alberro and Blake Stimson (Cambridge, Mass.: MIT Press, 1999), 94.

9. Steinberg, "Contemporary Art and the Plight of Its Public," 5.

10. "Change the Object Itself" is the title of a 1971 essay by Barthes in which he discusses "mythology today." He writes, "a mythological doxa has been created: denunciation, demystification (or demythification), has itself become discourse, stock of phrases, catechistic declaration… the problem is not to reveal the (latent) meaning of an utterance, of a trait, of a narrative, but to fissure the very representation of meaning, is not to change or purify the symbols but to challenge the symbolic itself." Barthes, *Image-Music-Text*, 166–67.

11. Fredric Jameson, "Postmodernism and Consumer Society," in *The Anti-Aesthetic: Essays on Postmodern Culture*, ed. Hal Foster (New York: The New Press, 1983), 133–34.

12. Interestingly, Douglas Crimp, in his seminal essay "Pictures" (a revised version of the catalogue essay for his 1977 exhibition of the

same name), argues nearly the opposite when it comes to those post-modern practices he regards as critical. In works by artists such as Troy Brauntuch, Sherrie Levine, Cindy Sherman, and Jack Goldstein, Crimp sees a kind of theatrical temporality—which introduces not only a felt duration but also a kind of distance or semiotic framing device. Though Crimp, like Jameson, acknowledges that postmodernity may be seen to exist in a kind of perpetual *present*, he sees this as potentially radical, even liberatory—not cut off from history but freed from its demands. Speaking of Goldstein's work specifically (but this applies to his notion of *pictures* more generally), the critic implores that representation not be "conceived as the *re*-presentation of that which is prior, but as the unavoidable condition of intelligibility of even that which is present." Everything is always already a picture. Douglas Crimp, "Pictures," *October* 8 (Spring 1979); reprinted in *Art after Modernism: Rethinking Representation*, ed. Brian Wallis (New York: New Museum of Contemporary Art, 1984), 177.

13. Roland Barthes, "From Work to Text," in *Image-Music-Text*, 160.

DARK ALBUM
Neville Wakefield

Make of this what you may: We tell ourselves stories in order to live, or so, at least, I have been told. The princess is caged in the consulate. The dog barks and the sybarite sleeps on the sixteenth floor, dreaming perhaps of empty deserts from which the smoothened boulders of history have recently rolled. The landscape of this dream is level like the ocean, which it is not. Its surface bears the record of existences other than our own. It is the vacant lot into which all dreams of final theories, departure countdowns, sermons, and suicides have been decanted. Its geology is the sand of Borges and the rock of Smithson. Its presence is the non-site of the unrealized idea, the dark matter of excerpted testimony, of lip syncs and Park Hyatts, of shooting stars and narrative trails. It is where we go to transcribe our beliefs.

But this is a place that doesn't necessarily exist except in the mind of the self-described woman with long straight hair who wears a migraine and a bikini to every eruption of zeitgeist, waiting, perhaps, for the tidal wave that will not come. Next to the bright rictus of her social ring flash is the man who wears headphones and darkness tuned to the residues of silence, of drum trigger and distortion. A skeleton attached by earpods to an iPod, he is the librarian of his own metal congress. Choosing loneliness over vulgarity has become a national pastime for those who live, like him, with an apprehension of what it might be like to open the door to a stranger and find that the stranger does indeed have a knife. And now it seems that stranger is all around us in the malevolent conga line of images and events, of hooded prisoners and un-Genevered conventions, suicide bombers and sex videos, Tinkerbells and mink-lined mukluk boots. These are the narratives that couldn't be dreamt because they have indeed come to pass.

Joan Didion described a time, around 1971, when she began to doubt the premise of all the stories she had ever told herself; a common condition, but one she nonetheless found troubling. Different sounds now fill the empty lots and the angle of those daylight political shadows may have changed. But now, more than ever, we seek to find the narrative line

that strings together ever more disparate experiences, that makes sense of worlds where it is possible to watch porn and preach religion at the same time. For the man with the basement headphones and the woman on the sixteenth floor, that sense may be one of competing theories, the most workable of multiple choices drawn from the offerings of creationism, intelligent design, bad gurus, and the policy voodoo otherwise known as government rule. Some, if not all, of this abiding uncertainty inevitably seeps into the things we make.

In this view, the groundwater from which we drink has already been contaminated, and perhaps Victor Hugo was right all along to claim the sewer as the resting place of all failure and effort. And as far as I'm concerned, any choice carries the potential for abandonment and betrayal, not just those of the political sermonizers, whose dreamworks are devised to obscure any intelligence that might trouble the dreamer, but also those of common neurasthenics, like myself, who rub themselves up on a daily basis against nameless derelictions of personal conscience, dubious sexual conducts, inexplicable bereavements, jackknifed relationships, and other proteins of normalcy and fear.

And so we look out from places like these, places of personal moral scrutiny, into the cloudy imperium of national conscience. In an effort to discover senses greater than our own, we turn from local malfeasance to primal decree, hoping, perhaps, that in the interrogation of notions about how we came into being might also be found the template of our own creative aspiration. But the turn from the sewer to the wellspring offers few reassurances. After all, the view that we, along with the rest of the earth's plants and animals, have evolved via the accumulation of the tiny fraction of random mutations that proved useful—a view that commands solid majorities in most of the developed world and has the near-unanimous support of scientists everywhere—turns out to be just one option in an equal opportunity buffet that has science and superstition served up side by side.

And, as our least privileged die in crusades conducted against the infidels

of progress abroad, faith-driven antirationalism at home unravels the premise of social evolution, dumping it without regard like the secular fuel of an airliner bound to go down. On this, the bad-weather channel, we learn that science is marginalized precisely because it now lies outside the interests of the governing conservative coalition. That's why the White House—sometimes in the service of political Christianism or ideological fetishism, more often in obeisance to the baser motivations of the petroleum, pharmaceutical, and defense industries—has altered, suppressed, or overridden scientific findings on global warming; pollution from industrial farming; forest management and endangered species; environmental health, including lead and mercury poisoning in children and safety standards in drinking water; missile defense; HIV/AIDS; and nonabstinence methods of birth control and sexually transmitted disease prevention. That may also be why, in contemplating the abduction of American democracy, I can only understand it in terms of a loss of faith in my own method and powers of narration. At once seduced and abandoned by those narratives that supported the endeavor of finding and making images that can adequately reflect the mendacity of our sad and frightened times, it's easy to understand why Gitmo has become a verb as much as a place, why blindness in faith and in war has cast its shadow across all descriptive effort.

Let me go further. I do not know why I did or did not do anything at all. Perhaps it's because fighting for peace is indeed like fucking for virginity. Wrong means to a right end. Perfect anodyne solution to a situation where nothing is true and everything is permitted. The Situationists, at least, got that much right. Ours is indeed a culture of palindromes that achieves its full despair-producing effect through the recognition that our sense of the beginning is arrived at only through our knowledge of the end. In foreign as in personal policy, we have become accustomed to graduating through all rituals of self-annihilation in similarly unseemly haste, as if hesitation of any sort would be to open oneself up to the objections of rationality, or to expose a lack of steel for this premature confrontation

with the end. In this cultural mosh pit, boredom and violence find their perfect détente. Slamming quickly through homegrown pleasures to the importation of other more threatening species of blankness, we create out of circumstances and predilection our own self-styled laboratories for testing death. Hence the prevailing darkness, the litter of broken pixels, the preference for black paint on top of embroidery, gnomic haikus, and SMS exchanges over rhetorical dialectics. These are the cultural products of the good-faith inroads we made toward the extinction of personality as sought by adolescence and clung to in adulthood as a hope unfulfilled. They are also the fatalities of ignorance and innocence, the collateral damage of our personal wars.

Honking helps, and war in this case seems to be the answer. Militarizing against evil, terror, and drugs gives local cant to global abstractions. In foreign and domestic policy, the caricature of the evil-doer has become a one-size-fits-all boogie man as effective in the mobilization of American might against one-eyed Muslim clerics—our version of Rambo versus the Hobbit—as it has been at home, where the rural fabric is being torn apart not by the consolidations of corporate farming but by high school kids freelancing as chemists. But in truth it's not the meth-lab aneurisms that darken the CAT scan of rural North America. Rather, it is a more insidi-ous, subaudible Armageddon that leaches out from the prescription pads of the pharmaceutical interests and into the heads of those for whom the Esperanto of Xanax has created a language of pain management, a muffled syntax of absent subjects and late-in-the day verbs. Everything around has the soft, disinterested feel of conversations belonging to others.

As with our heads so we furnish our homes. In the vicinity of airports and other spaces recognizable by the failed prevalence of any history, we buy into flat-pack socialism turned to a profit—sensible Scandinavian furniture that measures in the metric system and suggests the region's famous long winters and high suicide rate. Dave Hickey may have been right when he described his personal Vegas as "the only indigenous visual culture on the North American continent, a town bereft of white carpets,

ficus plants and Barcelona chairs—where there is everything to see and not a single pretentious object to be scrutinized."[1] From such a lack the isolation of substance can itself become a state of interest.

And if we have become used to a type of art that speaks in ad hoc responses to the driving forces of the market and taste, we have also become accustomed to the platitudes that seek to make sense of the senseless by incorporating the things we know among the things we don't and perhaps never can. Here our art is served as seismograph, alert on the fault lines of culture to every tremor of the fashion plate. And while it would be not only curious but wrong for the texture of now not to reflect these uncertainties, it is also hard not to think of the dark troika of dislocation, dreaming, and dread as narratives told only in self-defense. The woman on the sixteenth floor and the man whose world is drowned in distortion have in common the intuition that these stories we tell ourselves in order to live may yet be inadequate. Their descriptions fall short in ways not fully understood. They leave me consulting menus of strange choices and calamitous consequences. Meanwhile, I receive emails and texts like nighttime companions, each with its insinuation of personal literature. I see typed passages in my sleep, underwater texts, almost decipherable. Looking at this carnival of unnecessary ideas, it's easy to imagine them as the portents of other, better-rehearsed ends. At the same time, each local refusal of the narrative overview allows the bad disjunctive idea to breathe its own air. And with the inhalation of this ambivalence comes the exhalation of contradiction. And so we recognize ourselves encoded in the rhythm of these minor graces, and what, after all, is there not to like about that? Man, these antidepressants really are strong.

Notes

1. Dave Hickey, *Air Guitar: Essays on Art and Democracy* (Los Angeles: Art Issues Press, 1997), 23.

THE TECHNOCULTURAL IMAGINATION: LIFE, ART, AND POLITICS IN THE AGE OF TOTAL CONNECTIVITY
Siva Vaidhyanathan

When Alexis de Tocqueville toured the western edges of the American Republic in the 1830s, he considered the state of American cultural production. His thoughts on art, literature, and the American publishing industry have not received as much analysis as his account of civic culture and its relationship to the young democratic republic. Nonetheless, his observations were significant and prescient.[1]

For Americans, Tocqueville observed, books didn't matter much. Or, rather, they didn't matter for their own sake. Civic engagement was everything. Knowledge, history, and culture were tangential and trivial. The books that mattered were those that could function as instruction manuals, such as Benjamin Franklin's autobiography or the Bible. American artistic expression, Tocqueville wrote, was practical and functional rather than decorative or contemplative. There seemed to be no profound value in art for art's sake or in art as a higher calling. Yet Tocqueville was careful to explain that there was a strong connection between democratic culture and democratic politics.

Because there has been a long-standing assumption that cultural habits are somehow divorced from political matters, that "soft power"—an account of the power of ideas and the process of global cultural politics—is more soft than powerful, few since Tocqueville have adequately considered the impact that habits of cultural production and distribution have on matters of material power.[2]

Tocqueville meant his observations to seem complimentary of the American spirit. But for more than 150 years, American artists and writers have tried to prove Tocqueville wrong. They have struggled against the perceived inferiority complex of American cultural figures in relationship to Europe. American cultural institutions struggled to establish elite status while trying to avoid betraying the democratic mission of the nation. By the second half of the twentieth century, American artists, writers, philosophers, journalists, critics, museums, universities, and foundations had established their power and relevance beyond a doubt. Their status had risen along with the power of their native nation-state.

These institutions and communities had by the 1980s become elite and, despite their intentions, elitist. Their unbridled optimism and faith in progress had fostered great growth and arrogance.[3]

Yet in recent years, an interesting phenomenon has emerged. Just when the United States established itself as the loudest—if not the most important—source of sounds, sentences, ideas, and images in the world, our cultural foundations have shifted under our feet, unbalancing industries and institutions. Established producers and arbiters of cultural products and practices have found themselves off-balance, anxious, and panicked. American cultural policy has seemed confused and contradictory. Artists are experiencing both a strong sense of anxiety and unimagined opportunity in the new creative environments.[4] Consumers and citizens have found cultural menus so full and materials so abundant and inexpensive that they have become overwhelmed and dazed by the "data smog" around them.[5]

Tocqueville's observations about cultural production—being grounded in the tangible, the practical, the technological, and the democratic spirit of the times—are more true now than when he wrote them. And his explicit connection between the practical arts and democratic practice is central to the moment. Much to the dismay of conservative arbiters of culture, the processes of creativity, meaning-making, and criticism have been democratized. Thanks to the proliferation of cheap video cameras, recording technology, editing software, and peer-to-peer networks, most Americans can be a creator, a producer, and a distributor. Anyone with access to the internet can set up a zine or a blog to engage in passionate and informed criticism. For many millions and for more every day, everything is punk rock, everything is hip-hop. And everything seems cheap and easy, malleable and alloyed.

For the past twenty years, the United States has been experiencing a significant cultural, social, and political shift of which we are only now taking account. The very presence of powerful personal computers, loaded with easy-to-use editing and production software, connected to millions

of others at high speed at all times of the day has changed the cultural and political environment radically and irreversibly. Distributive information and communication technologies have enabled this shift by amplifying the effects and possibilities of long-established practices.

Clearly, Americans have experienced a radical change in expectations when it comes to culture and information. I call this change the rise of "technocultural imagination."[6] We are on the cusp of a truly democratic cultural moment. But all is not open and free. Nor should we celebrate this technologically enabled, radical cultural democracy for its own sake. It's messy and troublesome. It's risky and disruptive. But it's also exciting and fascinating.

The technocultural imagination is a state of expectation and assumption. It's an ideology of desire. We expect to be able to create our own sounds and images using inexpensive tools. We assume we can communicate in real time with collaborators and critics around the world for relatively little cost. We get frustrated and annoyed when systems break down or powerful interests interfere with such collaboration or communication. The habits and desires of humans to connect and collaborate with one another are not new. They are ancient. Only the awareness of possibilities and expectations of results have changed in recent years, facilitated and amplified to a large degree by new communicative technologies such as the personal computer, the internet, and the mobile phone.

For those infused with the technocultural imagination, tangled, multi-valent, often collaborative or collective authorship is the norm, not the exception. The technocultural imagination is a global phenomenon fueled by particular American experiences and ideologies—techno-optimism, civil libertarianism, and, to a lesser extent, neoliberalism—that are no longer provincial or national. And despite decades of worrying about the "two cultures" of art and science, the technocultural imagination demands engagement with, rather than repugnance for, science and technology.[7]

The technocultural imagination also generates an awareness of the possibility of real global connections, movements, and idea flows. This

awareness has political potential. Although it has never been fully realized, politics informed by the technological imagination would resist authority by swarming and confusing it.[8] The technocultural imagination ensures that membranes between and among authorities (academics, critics), cultural producers (authors, artists, coders, hackers), and audiences (publics, citizens, consumers) are permeable. Hierarchies can be tumbled and overturned.

Overall, an immersion in or engagement with the technological imagination leads one to think in terms of circuits of feedback and emergent systems, cultures of openness and revision, horizontal organizations, dynamic and temporal expression rather than fixed or static icons, and a global or at least portable sensibility. It's about the multiplayer online video game rather than Jean Renoir's *Rules of the Game*.[9]

Let me be clear. The technocultural imagination is not utopian in nature or in direction. It does not lead us to a better, richer, more just way of life. It will not necessarily topple tyrants or even defeat Republicans at the polls.[10] It is not so attractive and seductive that everyone will subscribe to it. In fact, it has encountered significant resistance.

There is heavy blowback against the assumptions and the effects of the technocultural imagination. As the processes of cultural production and distribution become democratized, authorities suffer from status anxiety. They are motivated to deny, resist, or capture the phenomenon. Authority hardens and struggles to monitor everything and everybody. We can see these dynamics play out in the struggles to rein in the internet. As authorities worry about how kids sharing music (or worse: making their own new music out of pieces of the old) will undermine established institutions and hierarchies, they generate "moral panics" about immoral expression, ethical crises, and security threats all incubated by the anarchistic environment of digital culture and technology.[11]

How did we get to this point? This phenomenon was not a sudden revolution sparked by the availability of personal computers and cheap, powerful software. Such technological innovations were necessary but

not sufficient conditions for this shift. The rise of the technocultural imagination took more than the entire twentieth century to emerge. We can trace the steady awareness of a global, mediated, anarchist sensibility by focusing on the work of some insightful artists and a general democratization of the archive of human knowledge and creativity.

As with most big ideas, artists led the way. The 2005 exhibition *Open Systems: Rethinking Art c. 1970* at the Tate Modern in London took as its subject an antimovement in the visual arts, a disorganized and diverse set of reactions to the annoyingly elitist bent of Abstract Expressionism and the market-ready naked populism of Pop art that immediately preceded the 1970s. In addition, the thirty-some artists in the exhibition formed a global collective of influences without resorting to the cliché of a localized salon or scene. As curator Donna De Salvo notes in the exhibition catalogue, quoting gallerist Seth Siegellaub, "Prior to this, artistic movements were very localized with all the leaders living in the same city (and usually the same neighborhood).... Conceptual art, which is an inappropriate name, was probably the first artistic movement which did not have a geographic center."[12] De Salvo also describes this antimovement as one that shifted emphasis from the static object to the dynamic, from the fixed to the responsive and interactive. And it was overwhelmingly politically engaged. This "open systems" trend was multimedia before multimedia was cool. It was "new media" before old media was old. And it served as an ideal source of inspiration and raw material for the torrent of such tropes that would flood us from the late 1990s through the present day.

Soon after the open systems movement in the professional art world, this sensibility was further democratized in the field of popular music. Punk rock rose as a powerful force when its champions declared the power of simplicity: three chords and three minutes per song; shouted, direct lyrics; distribution via cassette tape; criticism via photocopied zines. Simultaneously, hip-hop grew along similar patterns: spoken-word poetry over a bed of borrowed "samples" and hooks of other pop

And we are on our way, shrugging off coincidence and making up the story
From the story's *hitherto*
The outcomes must be several and unknown
They must be exchanged like accuracies
With you taking your aim and I taking mine

Two figures in a figure drawing present at different times
Time now is the element of invisibility
In a tendered exchange
Between a blown boy and a planted girl
Love is a violence that compels thinking

—— Lyn Hejinian, <u>A Border Comedy</u>

songs; distribution via cassette tape; low-cost production technologies, including turntables, portable public address systems, and cassette decks. Within twenty years of the rise of punk and hip-hop, both forms stood at the center of styles for global youth culture. The last two decades of the twentieth century saw a torrent of malleable media products—often commercial but sometimes anticommercial—that competed for our precious and frenetic attention.

The torrent was also a culmination of a century-long process of private mastery of personal media space. At the beginning of the twentieth century, a personal library was a rare and desirable thing. To own books signified a certain status as a cultural citizen. As American publishers lowered the cost of producing and distributing large sets of the complete works of authors such as Thomas Hardy and Charles Dickens, more Americans could build libraries in their parlors. As publishers such as Harper and Brothers busted printers' unions, employed cheaper labor, and used cheaper materials on more efficient presses and binding machines, the American book industry took off as a mass-market phenomenon in the first few decades of the twentieth century.[13]

Soon it became important not only to own books (because more people could, thus inflating the social status of having a library); one had to have the *right* books. Thus publishers produced American editions of almost unreadable modernist fiction, leveraging the highbrow reputation of the author as a marketing tool. Random House, for example, embarked on an advertising campaign in 1934 in which full-page magazine ads helped guide readers through the plot and, for many, the impenetrable prose of James Joyce's *Ulysses*. The ad was titled "How to Enjoy James Joyce's Great Novel *Ulysses*." It was clear that to be an elite cultural citizen in the 1930s, while other Americans were building their own libraries of "classics," one had to at least display a rudimentary understanding of modernist work.[14]

As the American home grew in size, so did the American cultural menu. The motion picture and radio industry programmed sites and sounds

that could contribute to a common and cohesive experience and ideology through mid-century. By the 1960s, Americans had come to appreciate programming their own soundtracks on home stereos. By the 1970s, the cassette tape allowed people to program soundtracks for home, office, or car, disengaged from the common loudspeaker. People discovered ways to use this powerful recording technology to create and mix their own sounds for local distribution. The subcultures of punk and hip-hop were carried forth on cassette culture.[15] The 1980s saw the rise of personal media platforms, best exemplified by the Sony Walkman and the video cassette recorder. Now everyone could be Shaft, walking through streets and malls with a personal soundtrack that no one else needed to share. Everyone could be a video librarian or film historian. An entire generation of filmmakers, including such suburban-grown talents as Robert Rodriguez and Quentin Tarantino, could build on the traditions of mid-century film through their video collections, whereas directors of the previous generation, such as Martin Scorsese and Steven Spielberg, had relied on small urban revival theaters or film schools for their educations. By the 1980s, young filmmakers could experiment with inexpensive portable videotape cameras and editing machines as well. By the 1990s, the personal computer facilitated new forms of creativity and collaboration.[16] And the video game industry emerged as the fastest growing segment of the cultural industries.

In the first decade of the twenty-first century, the processes of archiving and preserving have been distributed and democratized. So has the ability to remix and mash up sounds and images. With limited investment, people can generate powerful new forms of communication and cultural expression and distribute them globally at no marginal cost. The long-term effects of this power are unclear. There is much boasting and bombast about what might happen, both good and bad. But one thing is undeniable: we have a different sense of possibility now. We can do what was unimaginable just two decades ago. And we must harness this radical democratic power for the best, before the powerful and anxious capture and kill it.

ilar details." Is he or she supposed to compile a set of authoritative texts that can withstand the charge of forgery, the test of time, the timeliness of libraries?

A bibliography is "the history, identification, or analytical and systematic description or classification of writings or publications considered as material objects." Can we ever really discover the original text? Was there ever an original poem? What is a pure text invented by an author? Is such a conception possible? Only by going back to the pre-scriptive level of thought process can "authorial intention" finally be located, and then the material object has become immaterial.

• • •

Pierre Macherey's description of the discourse in a fiction applies to the discourse in this bibliography: "sealed and interminably completed or endlessly beginning again, diffuse and dense, coiled about an absent centre which it can neither conceal nor reveal."

—— Susan Howe, <u>The Nonconformist's Memorial</u>

Notes

1. Alexis de Tocqueville, *Democracy in America*, trans. and ed. Harvey Claflin Mansfield and Delba Winthrop (Chicago: University of Chicago Press, 2000).
2. An exception is Joseph S. Nye, *The Paradox of American Power: Why the World's Only Superpower Can't Go It Alone* (New York: Oxford University Press, 2002).
3. See Robert Morse Crunden, *American Salons: Encounters with European Modernism, 1885–1917* (New York: Oxford University Press, 1993); and Richard H. Pells, *Not Like Us: How Europeans Have Loved, Hated, and Transformed American Culture since World War II* (New York: Basic Books, 1997).
4. For more on this topic, see Siva Vaidhyanathan, *The Anarchist in the Library: How the Clash between Freedom and Control Is Hacking the Real World and Crashing the System* (New York: Basic Books, 2004).
5. David Shenk, *Data Smog: Surviving the Information Glut* (San Francisco: HarperEdge, 1997).
6. The concept of "technoculture" has been explored in a variety of places. See Stanley Aronowitz, *The Last Good Job in America: Work and Education in the New Global Technoculture* (Lanham, Md.: Rowman & Littlefield Publishers, 2001); John Thornton Caldwell, *Electronic Media and Technoculture* (New Brunswick, N.J.: Rutgers University Press, 2000); Simon Cooper, *Technoculture and Critical Theory: In the Service of the Machine?* (London and New York: Routledge, 2002); Jodi Dean, *Publicity's Secret: How Technoculture Capitalizes on Democracy* (Ithaca, N.Y.: Cornell University Press, 2002); Matthew Fuller, *Media Ecologies: Materialist Energies in Art and Technoculture* (Cambridge, Mass.: MIT Press, 2005); René T. A. Lysloff and Leslie C. Gay, *Music and Technoculture* (Middletown, Conn.: Wesleyan University Press, 2003); Constance Penley and Andrew Ross, *Technoculture* (Minneapolis: University of Minnesota Press, 1991); Kevin Robins

and Frank Webster, *Times of the Technoculture: From the Information Society to the Virtual Life* (London and New York: Routledge, 1999); and Geoff Waite, *Nietzsche's Corps/e: Aesthetics, Politics, Prophecy, or, The Spectacular Technoculture of Everyday Life* (Durham, N.C.: Duke University Press, 1996). For an account of how the "technocultural imagination" affects the creative and compositional process, see David Sanjek, "Don't Have to DJ No More: Sampling and the Autonomous Creator," in *The Construction of Authorship: Textual Appropriation in Law and Literature*, ed. Martha Woodmansee and Peter Jaszi (Durham, N.C.: Duke University Press, 1994).

7. C. P. Snow, *The Two Cultures and a Second Look: An Expanded Version of "The Two Cultures and the Scientific Revolution"* (London: Cambridge University Press, 1969); Snow's *The Two Cultures and the Scientific Revolution* was first published in 1959.

8. See Vaidhyanathan, *The Anarchist in the Library*.

9. The terms of this sensibility resemble Lev Manovich's description and definition of "new media." See Lev Manovich, *The Language of New Media* (Cambridge, Mass.: MIT Press, 2001).

10. Accounts of the flaws and fallacies in the idealization of cultural politics as they affect real politics are well founded and have been explained at length. See Thomas Frank, *New Consensus for Old: Cultural Studies from Left to Right* (Chicago: Prickly Paradigm Press, 2002); and Todd Gitlin, "The Anti-Political Populism of Cultural Studies," in *Cultural Studies in Question*, ed. Marjorie Ferguson and Peter Golding (London and Thousand Oaks, Calif.: Sage Publications, 1997).

11. See Lawrence Lessig, *Free Culture* (New York: Penguin Press, 2004); and Vaidhyanathan, *The Anarchist in the Library*.

12. Donna De Salvo, *Open Systems: Rethinking Art c. 1970* (exhibition catalogue) (London: Tate Gallery, 2005), 12–13.

13. For more on this topic, see Siva Vaidhyanathan, *Copyrights and Copywrongs: The Rise of Intellectual Property and How It Threatens Creativity* (New York: New York University Press, 2001).

14. See Catherine Turner, *Marketing Modernism between the Two World Wars: Studies in Print Culture and the History of the Book* (Amherst: University of Massachusetts Press, 2003).

15. See Kembrew McLeod, *Freedom of Expression®: Overzealous Copyright Bozos and Other Enemies of Creativity* (New York: Doubleday, 2005); and Vaidhyanathan, *Copyrights and Copywrongs*.

16. Manovich, *The Language of New Media.*

IN THE FOOTSTEPS OF TOCQUEVILLE
Bernard-Henri Lévy

The following are excerpts from "In the Footsteps of Tocqueville" by Bernard-Henri Lévy (translated by Charlotte Mandell), first published in serial form by *The Atlantic Monthly* (Part One: May 2005, pp. 54–89; Part Three: July–August 2005, pp. 71–94). The complete series, plus new material, is available in the book *American Vertigo: Traveling American in the Footsteps of Tocqueville* by Bernard-Henri Lévy, published by Random House in January 2006.

A People and Its Flag

It was here, a little south of Boston, on this East Coast that still bears the mark of Europe so clearly, that Alexis de Tocqueville came ashore: Newport, Rhode Island. Its well-kept Easton's Beach. Its yachts. Its Palladian mansions and painted wooden houses that remind me of the beach towns of Normandy. A naval museum. An athenaeum library. Bed-and-breakfasts with a picture of the owner displayed instead of a sign. Gorgeous trees. Tennis courts. A Georgian-style synagogue, exhibited as the oldest in the United States, but which, with its well-polished pale wood, its fluted columns, its spotless black rattan chairs, its large candelabra, its plaque engraved with clear-cut letters in memory of Isaac Touro and the six or seven great spiritual leaders who succeeded him, its American flag standing next to the Torah scroll under glass, seems to me, on the contrary, strangely modern.

And then, of course, the flags—a riot of American flags, at crossroads, on building fronts, on car hoods, on pay phones, on the furniture displayed in the windows along Thames Street, on the boats tied to the dock and on the moorings with no boats, on beach umbrellas, on parasols, on bicycle saddlebags—everywhere, in every form, flapping in the wind or on stickers, an epidemic of flags that has spread throughout the city. There are also, as it happens, a lot of Japanese flags. A Japanese cultural festival is opening, with exhibitions of prints, sushi samples on the boardwalk, sumo wrestling in the street, barkers enticing passersby to come look at these wonders, these monsters: "Come on! Look at them—all white and powdered! Three hundred pounds! Legs like hams! So fat they can't even walk! They needed three seats in the airplane! Step right up!" White flags with a red ball, symbol of the Land of the Rising Sun, hang from the balconies on this street of jewelers near the harbor, where I'm searching for a restaurant to have lunch in.

In the end, though, it's the American flag that dominates. One is struck by the omnipresence of the Star-Spangled Banner, even on the T-shirts of the kids who come to watch the sumo wrestlers as the little crowd cheers them on. It's the flag of the American cavalry in westerns. It's the flag of Frank Capra movies. It's the fetish that is there, in the frame, every time the American president appears. It's the beloved flag, almost a living being, the use of which I understand is subject to rules—not just rules but an extremely precise code of flag behavior: Don't get it dirty, don't copy it, don't tattoo it onto your body, never let it fall on the ground, never hang it upside down, don't insult it, don't burn it. On the other hand, if it gets too old, if it can no longer be used, if it can't be flown, then you *must* burn it. Instead of throwing it out or bundling it up, it's better to burn it than abandon it in the trash. It's the flag that was offended by Kid Rock at the Super Bowl, and it's the flag of Michael W. Smith in his song "There She Stands," written just after September 11, in which "she" is none other than "it," the flag, the American symbol that was targeted, defiled, attacked, scorned by the barbarians, but is always proudly unfurled.

It's a little strange, this obsession with the flag. It's incomprehensible for someone who, like me, comes from a country without a flag—where the flag has, so to speak, disappeared, where you see it flying only in front of official buildings, and where any nostalgia and concern for it, any evocation of it, is a sign of an attachment to the past that has become almost ridiculous. Is this flag obsession a result of September 11? A response to that trauma whose violence we Europeans persist in underestimating but which, three years later, haunts American minds as much as ever? Should we re-read those pages in Tocqueville on the good fortune of being sheltered by geography from violations of the nation's territorial space, and come to see in this return to the flag a neurotic abreaction to the astonishment that the violation actually occurred? Or is it something else entirely? An older, more conflicted relationship of America with itself and with its national existence? A difficulty in being

a nation, more severe than in the flagless countries of old Europe, that produces this compensatory effect?

Leafed through the first few pages of *One Nation, After All*, which the author, the sociologist Alan Wolfe, gave me last night. Maybe the secret lies in this "after all." Maybe American patriotism is more complex, more painful, than it seems at first glance, and perhaps its apparent excessiveness comes from that. Or perhaps it has to do, as Tocqueville saw it, with a kind of "reflective patriotism" that, unlike the "instinctive love" that reigned during the regimes of times past, is forced to exaggerate when it comes to emblems and symbols. To be continued…

But it's a good question to ask oneself, in any case, at the beginning of this journey that will lead me for almost a year from large cities to small towns, on highways and back roads, from one end to the other of this country I really know so little. Lord knows I've come here time and again in the past. Of course I have always loved it, and been molded, from boyhood on, by its literature, its movies, its culture. Anti-Americanism, that strange passion that acts, in my country, like a giant magnet attracting all the most disagreeable qualities that national ideology can produce, has had no adversaries more resolute than I. But there it is. A few flags in the windows, a slight whiff of patriotic celebration—and suddenly I have the feeling I'm approaching terra incognita.

[…]

A Jewish Model for Arab Americans

How can one be an Arab—I mean, Arab and American? How can one in post-9/11 America remain loyal to one's Muslim faith and not be taken for a bad citizen? For the inhabitants of Dearborn, Michigan, a few miles west of Detroit, the question doesn't even arise. This town is a little special, of course. Its McDonald's, for instance, is halal. A supermarket is called Al Jazeera. There are mosques. I spot an old Ford with one of those personalized license plates that Americans love; it reads TALIBAN. And I quickly see that around River Rouge—the old Ford factory, parts of which are now reduced, like the Bethlehem Steel plant in Lackawanna, to rusted steel carcasses, useless pipes, empty silos, and half-destroyed warehouses in the middle of which trees are growing—conversations switch easily from Arabic to English and back. But all the people I meet, all the businessmen, politicians, community leaders, when I ask them how, in these times of al Qaeda, these two interlinked identities can be combined, reply that actually everything is for the best in the best of all possible worlds. The question of twofold allegiance that is poisoning the debate in France about where one belongs does not arise here. Ahmed, wearing a turban like a Sikh, who sells utterly American sodas on Warren Avenue, says, "Of course there were problems; of course there was a backlash; of course the FBI agents came here to look for terrorists. But they didn't find any; we are exemplary American citizens, and they couldn't find any." Nasser M. Beydoun is a high-spirited young businessman, married to a Frenchwoman; it takes me a while to pick up that when he says "we," he means not "we Arabs" but "we Americans." He tells me, in the large conference room of the American Arab Chamber of Commerce, of which he is a board member, "I was against the war in Iraq, but less for them, the Arabs, than for us, the Americans, this great nation with its fine culture, this exemplary democracy that's preparing a fate for itself as an occupying power."

And then there's Abed Hammoud, of the Arab American Political

Action Committee, a small organization whose role, he tells me, is to interview, review, and, eventually, endorse candidates at all levels of local or national power. When Bush wrote him, in 2000, a beautiful page-and-a-half personal letter beginning with "Dear Abed"; when Kerry asked him what procedure he should follow to get the support of the Arabs in Detroit, and he sent Kerry a copy of the letter to inspire him; when, last January, he organized a series of telephone interviews for Kerry and for Wesley Clark and a representative of Howard Dean; when he had one of his teams follow around a candidate for the Illinois legislature and be present at all his appearances and press conferences, even the smallest ones; when he finished off, this very morning, the information letter he sends to all his members—in all this, do I know what his example is? The Jews, obviously: the incredible success story that is the power of the Jewish community—what they succeeded in creating, this power they knew how to buy, to earn with the sweat of their brows, this path they made that led them to bring together all influences. "How can one not be inspired by that?" he asks. "We are fifty years late, I'll grant that; today they are ten times stronger than us. But you'll see, we'll get there; one day we'll be equal."

I'm not saying this little speech was without ulterior motives. Maybe the restraint of this statement was purely tactical and the idea is still, in the end, to do not just as well as but better than a Jewish community that is identified, without its being said, as the very face of the enemy. And I also felt in him a strong reticence about Israel, whose existence he is careful not to question, but where it is "out of the question" for him to travel as long as the "Palestinian resistance" hasn't been granted its rights by the "occupation."

But finally, the fact still remains. We are far from Islamberg, in the heart of the Catskills, that fundamentalist phalanstery I discovered during my investigation into the death of Daniel Pearl, where the terrorist ideologue Ali Shah Gilani is venerated. And we are even farther from those French suburbs where they shit on the flag and hiss at the national anthem, and

where hatred for the country that has taken them in is equaled only by an anti-Semitism eager to go into action. My great American lesson. A fine lesson of democracy at work—that is, of integration and compromise. There are 115,000 Arab Americans in the metropolitan Detroit area. There are about 1.2 million scattered through Michigan, Ohio, Illinois, and the rest of America. And despite Iraq, despite Bush, despite the hawks of the so-called clash of civilizations, these two traits dominate: the American dream, neither more nor less alive than in all the generations of Irish, Polish, German, or Italian immigrants who came before them; and, linked to that, a passion, an obsession, a mimetic rivalry, with a Jewish community that is regarded as an example and, at bottom, an obscure object of desire—a yearning to be, if I may say so, parodying the famous motto of the French Jews before the Dreyfus affair, *as happy as Jews in America.*

EXCERPTS FROM PART THREE

The Prison Business

Death row in the Southern Nevada Women's Correctional Center, in North Las Vegas, has only one inmate when I visit: Priscilla Ford, a seventy-five-year-old black woman found guilty of having deliberately run over twenty-nine pedestrians twenty-four years ago in Reno, killing seven, as she drove her Lincoln at full speed.

Be careful, the state's director of prisons told me. She is sick. Very sick. Emphysema. Can't get up or talk to you.

But in fact, that's not how it is. She is tired, of course. Short of breath. Wearing a dirty jogging suit. Shaggy gray hair, with a bald spot at the back of her skull. She is standing up, pretty straight. Welcomes me gravely into her tiny cell, plastered with photos of Prince William, Lady Di, President Bush, Pope John Paul II, Mel Gibson. A book on children's education near her bed. *The Da Vinci Code* and a Bible on a shelf. A television set. A sign that says GOD FIRST. Family photos she doesn't appear in, except by means of a rough and clumsy paste-up.

"I hope my girlfriends didn't scare you too much," she begins, alluding to the hundred or so women, almost all of them black, in the "segregation" section you need to go through to get to her cell—genuine raging beasts, all dressed in the same brightly colored jumpers, and shouting behind their bars that they haven't done anything, that they can't bear it anymore, that they want to be allowed to exercise, that they screw visitors, that I should go to hell.

Then, shaken by strange bursts of laughter, a hiccup of sorts, that double her over every time, cut off her breath, and make me think that the expert psychiatric opinion given at her trial that she was suffering from paranoid schizophrenia wasn't completely without foundation, Priscilla continues, "I was wrong to confess. I didn't do anything. I was charged because I had a terrible lawyer who couldn't convince the jury that I'm

the reincarnation of Christ himself. The real guilty one, here she is [she shows me a photo pinned upside down, all by itself on a gold-painted cork board]: she's the real guilty one. She's my sister. She's still on the run, and that's why there are still crimes being committed in Reno."

And then, finally, in response to my questions about the ordeal it must be to wake up every morning for twenty years and tell yourself that this could be the last day, she makes a remark whose sudden brilliance settles in three sentences the debate on the merits of the network of private prisons that this penitentiary had belonged to since its creation, as against the "normal" public system that it has just joined *in the past few days*, after a controversy that inflamed passions throughout the state: "For me, there's a before and an after. Before, I was living like a dog, no one cared about me, but the advantage was that they no longer thought about executing me. Today the food is better, the cell is cleaner, but I think they're going to come looking for me…"

In a few words she expressed the core idea.

Priscilla Ford is cut off from everything, and, in the twenty years since she was condemned, has received almost no visits.

But she has summarized one of the crucial issues that divide the country today, about which the Nobel Prize–winning economist Joseph Stiglitz talked with me at length in New York—she is expressing the advantages and inconveniences of the privatization of American prisons as I had been able to glimpse them myself, in a visit that preceded my meeting with her.

The positive side: An apathy in the behavior of the prison guards, which I imagine is an offspring of this culture of private enterprise that was the rule until last month. A certain casualness, almost freedom, in the way the prisoners (except, of course, the ones in the segregation sector) walk around in the hallways, talking, pausing if they want, and in the way they are dressed. Mini stereo systems in some cells, and sometimes television sets; beauty parlors with posters of different hairstyles, just as in provincial hair salons; even the color on the walls of the common

rooms—pink or mauve or blue—whose affected cheerfulness could be that of a kindergarten. Behind all this you can imagine the shareholders of Corrections Corporation of America, which had run the prison, coolly calculating that feeding and entertaining the human animal, loosening the bit a little, offering a less sinister environment than the punitive cells of a state prison, is an affordable way—less costly, at any rate, than armies of prison guards—to keep a prisoner quiet and tame.

The negative side: The abandonment, when the state resigns and the law of profit reigns, of any kind of reform project. These outcast men—or in this case women—whom the body politic, and thus the community of citizens, may forget to punish, but with whom, at the same time, they have utterly lost contact. This is the height of abandonment, the most absolute dereliction. Bodies are fed but morally beaten; souls are suspended and literally lost in the bright shadows of these sweetish dungeons. Snuffing of human light; residual subhumanity; fundamentally, the completion of the gesture of exclusion and elimination that began at Rikers Island, that I sensed yet again at Alcatraz, but that finds here, in this withdrawal of public authority, in this programmed indifference of the community to its delinquents and monsters, probably its most complete form.

Between the plague and cholera it's never easy to choose. And it's clear that when we contemplate the horror of Priscilla Ford's case, when we're faced with this hopeless scandal—the fact that thirty-eight states, including Nevada, maintain the death penalty—all other debates over the American prison system seem almost frivolous. Still, there are, at times, degrees of evil. And I fear that with this debate about privatization, with the very existence of prisons subject only to the logic of money, we have taken one more decisive step on the path to civilized barbarism.

[…]

Armed Like Nazis

"You won't understand anything about this country if you choose to overlook the question of weapons," the vivacious Carole Keeton Strayhorn, the Texas comptroller of public accounts, had told me in her Austin office. Here carrying a weapon is a right, people explained to me, a right inspired by the English Bill of Rights of 1689, which was explicitly linked with the right to resist tyranny. And what you Europeans don't want to see is that it is guaranteed as such by the Second Amendment of the Constitution. Are you going to Dallas after you leave here? Yes? In that case you should keep on going to Fort Worth, where there's a major gun fair. You'll see what the mood's like. You'll see all the people there. And you'll understand that it's the heart of Texas, and of America, that's beating in that kind of place.

No sooner said than done. Just after reaching Dallas, I take Route 30, the Tom Landry Highway, named after the former coach of the Dallas Cowboys football team. And here I am, in the midst of a most puzzling city, all parks, deserted hotels, highway overpasses with very few cars—here I am at the center of this empty city where neither the admirable Kimball Art Museum, by Louis Kahn, nor the famous Hotel Texas, where John and Jackie Kennedy spent their last night together, seems to attract anyone, and where everything looks as if it's actually been constructed around a Mussolini-style building with a white facade, where a sign reads GREAT WESTERN GUN SHOW.

In the lobby I see a fat couple, both carrying new rifles. I see a gray-haired fellow with pinched features carrying an oversized package in the shape of a weapon. I give my identity card to a group of policemen who make sure—absurd, but true—that I'm unarmed. I pass a table covered with worn-out felt where the National Rifle Association is recruiting new members. And I enter the showroom.

Hundreds of stands. Thousands of buyers and window-shoppers wandering with concentrated gazes from stand to stand. Groups of people.

Families. Overexcited mothers pushing strollers. Old men, young men, eyes shining. Tattooed people and middle-class people. People dressed as Confederate soldiers, looking for guns from the Civil War period. A stand displaying rifles from the Korean War. Another one where people come to caress daggers whose certificates of origin bluntly specify how many "Viets" they've stabbed. Competition Bushmaster AR-15s like the one used by the snipers who killed thirteen people near Washington, D.C., in 2002. A guy who says his name is Yoda, like the *Star Wars* character, who's selling a "sport version" of the Barrett 82 A-1 .50-caliber rifle. The price? Eight thousand dollars. The procedure? Hold an American passport and carry a valid driver's license. That's it? That's it. No need for any authorization from the FBI? Yeah—a phone call. The agent at the other end takes note; he doesn't take down the serial number, he just takes note. Still, don't you sometimes have to turn someone down? Sometimes, yes. Suppose someone comes to you saying "I've just been robbed. I want a weapon to get revenge." In that case I'd hesitate; you don't sell to a guy who's out of control. What about me, for instance? If I weren't French, would you sell me one of your marvels? He hesitates, looks me up and down. Not sure. I don't sell to just anyone, and you don't know anything about this stuff, it's pretty obvious...

And then, next to Yoda's stand, another one I linger at. The seller is about sixty, brick-red complexion, white hairpiece. A sign says COLLECTOR PAYING TOP PRICES. And I notice that the objects of his "collection" are "German war relics"—in other words, Nazi weapons and souvenirs. A jumble of pilots' badges. Goebbels dolls. Swastikas. Lugers priced at $18,000. Himmler's personal revolver. Göring's sword. A piece of the door to Nazi headquarters in Munich. A fragment of what is said to be the Führer's actual helmet. One of thirty-one armbands—"Limited series! Numbered!"—that belonged to his first bodyguards. And, exhibited like the most precious art book, a catalogue containing photographs of the rarest pieces of the seller's collection: life-size wax statues of Nazi officers; helmets in a library; a silver bowl, gift from Hitler to Eva Braun;

dishes, engraved with a skull, from which the couple is supposed to have eaten; and the star attraction—an immense painting, almost a mural, showing Hitler in uniform, a coat draped over his shoulders, fist on his hip, quite feminine. Doesn't it bother you to sell this stuff? "Since there are people who want to buy it, someone's got to sell it." Are you aware that this is absolutely forbidden in Europe? "Makes sense. You were occupied; we conquered them!" No misgivings, then? "No misgivings; the Reich killed fewer people than Genghis Khan." Would you sell objects that had belonged to bin Laden? "Oh, no! [outraged] That's completely different! Those things sure wouldn't have the aesthetic quality of these Nazi artifacts."

As I burrow deeper into the show, I'll get to see a half dozen other antiques dealers—good Americans who happen to have a bent for the Nazi aesthetic. Here's another display, advertising some of the most prejudicial, controversial films ever made: cassettes of Leni Riefenstahl, Nazi marches and songs, and a film titled *The Glory Years: Ruins of the Reich, Vol. III.* Seeing what is for sale, I cannot help asking if the emotional power of the defense of gun ownership is fully explained by the fact that it is a constitutional right. Maybe something else is also at work, something uglier. I take to the road again, headed for Louisiana, more skeptical than ever—part of me wondering if the real story isn't here, in this terrible, grotesque fascination. Of course there are all the fine speeches about the right to bear arms. The grandstanding. The campaign arguments. The pompous professions of faith of the NRA and its CEO, Wayne LaPierre, whom I saw the other week in Virginia. But in the end, the unformulated thought of all these gun-toting adherents, the possible horizon to their logorrhea, perhaps its ultimate truth, the secret which, although usually unconscious, seems mutely active in some people's minds, could lie in something else, something evoked by the Hitlerian kitsch, the morbid flirtation with horror.

NO CHILD LEFT BEHIND
Bruce Hainley

1. We crave from art

 a. pleasure
 b. thinking or critique
 c. political motivation
 d. a mainline to power
 e. psychosis
 f. an illustration of how we live now

2. Art should

 a. be a solution to a problem
 b. be a problem to a solution
 c. experiment in contingency
 d. be faggier
 e. cause a crisis, ecstatically carrying anyone out of him-
 or herself
 f. destroy itself, be its own undoing

3. How much of the contemporary art you encounter would you
categorize as "unquestionably great" or "important"?

 a. 43%
 b. 77%
 c. 9%
 d. 25%
 e. 61%
 f. 33.5%

4. To get a handle on the art of today, it would be best to

 a. go shopping
 b. watch TV
 c. question art history
 d. websurf
 e. meet "Tina"
 f. go off-grid for at least a month

5. Pornography should be analyzed and studied as a sign system influencing, influenced by, and analogous to that of art. True or false? (circle one)

6. The art—as well as the mood—of "the zeitgeist" is

 a. madcap
 b. without parameters
 c. thoughtful but with a frisson of complacency
 d. displaying a renewed interest in collective work and activities
 e. neoformalist
 f. I don't believe in zeitgeists

7. Which of the following best describes what new formalism means to you:

 a. I own a tux and am into formals.
 b. Formula, not breastfed.
 c. "Clem" was like a grandfather to me.
 d. After the Formula One Grand Prix, Gordon over
 Schumacher in the sack.
 e. Dude, there's a *new* formalism?
 f. Formalize this!

8. To consider form and how it requires attention to the medium as potentially distinguishable from meaning, it would be good to

 a. read all the books mentioned in question 15
 b. rewatch *The Aristocrats*
 c. reread Paul de Man
 d. study *Team America*
 e. compare Oscar Wilde's essays to those of Clement Greenberg
 f. see Liza Minnelli perform "live"

9. New formalism is a spruced-up version of old formalism. Both are more readily applied to abstract and nonrepresentational art than to figurative and representational works, and serve as a way to stabilize modes of interrogation but often end in quarantining or corralling the kinds of questions that might be asked. True or false? (circle one)

10. Design : Art ::

 a. mind : body
 b. client : collector
 c. virus : inoculation
 d. pencil : finger
 e. Rashid : Eames
 f. "anonymous" : signature

11. The most cogent representation of the artist and his or her artistic process in a Hollywood film is

 a. Vincent Price in *House of Wax*
 b. Patty Duke in *The Miracle Worker*
 c. Johnny Depp in *Ed Wood*
 d. Nicolas Cage in *Adaptation*
 e. Diana Ross in *Mahogany*
 f. Lana Turner in *Imitation of Life*

12. Jasper Johns is the only American artist to lend his voice to his cartoon representation on *The Simpsons*. True or false? (circle one)

13. There should be a big-budget biopic about Marcel Duchamp starring

 a. Jimmy Stewart
 b. Ethan Hawke
 c. Jackie Chan
 d. Stanley Tucci
 e. Denzel Washington
 f. Amy Sedaris

14. Rank the following artists in descending order (1 = most dynamic, 6 = least), then make a second list ranking the same artists in terms of who has (had) the best hairdo. Compare lists, and write what you have learned from the rankings.

 John Armleder, Matthew Barney, Mary Kelly, Yayoi Kusama, Louise Nevelson, Andy Warhol

15. "Just what is it that makes today's theory so different, so appealing?" applies most accurately to

 a. *The Man Without Content* by Giorgio Agamben
 b. *Stupidity* by Avital Ronell
 c. *Decreation* by Anne Carson
 d. *Their Common Sense* by Molly Nesbit
 e. *Moira Orfei in Aigues-Mortes* by Wayne Koestenbaum
 f. *The Sluts* by Dennis Cooper

16. Art/Artists : Art Fairs ::

 a. writers : readings
 b. Judy Garland : Carnegie Hall
 c. pigs : slaughter
 d. Duchamp's *Fountain* : 20th century
 e. heroin : crack
 f. art fairs : biennials

17. Sprouting everywhere they can, frequently like mushrooms after a good rain, biennials are

 a. good for art
 b. bad for art, but good for artists
 c. good for art, but not so good for artists
 d. good for neither art nor artists, but great for marketing
 (cities, institutions) and public relations in general
 e. none of the above
 f. all of the above

18. Who of the following was never in a Whitney Biennial:

 a. Lee Lozano
 b. John Waters
 c. Peter Hujar
 d. Maureen Gallace
 e. Olivier Mosset
 f. Betty Tompkins

19. Go through the last fifteen Whitney Biennial catalogues and make lists based on the following:

> a. select artists whose names you recognize who have succeeded / survived, noting your criteria of "success."
>> What is the percentage of all the artists, according to said criteria, who have "succeeded" compared to those who "haven't"?
> b. delineate various critical modes (fashions) and what is still / is no longer viable.

20–22. There are three essay questions. Please choose one from each of the following three pairs. Each of the three responses should be 500 to 600 words long.

20. While ours is an increasingly visual culture—some (notably Guy Debord) would argue that we moved long ago from a visual society to a society of the spectacle—funding for arts education, not to mention a sustained training in how images operate, has never registered as a relevant concern among the American polis. Argue why you think this is so (e.g., there is an unfounded but deeply held belief that images are "transparent"; art is about "feelings" ["I don't know nothin' about art but I know what I like"] and "uplift," therefore, having no system or rules, visual culture cannot be objectively tested [case in point: there is no GRE for art history]) and hypothesize ways of changing the situation. Discuss.
or
Prepossessing contemporary art challenges and/or questions what "art" was before it, moving toward its destruction or decreation—toward an ever new artlessness. (The history of art is the history of following how artists seek not antiart so much as an art that experiments with confounding any previous notion of what art has been or has looked like.) One strange thing to say about this situation is that the discourses

(art history, philosophy, criticism) within which art is considered have rarely questioned their own form, have not usually allowed themselves an analogous drive toward disarticulation, nonrepresentation, blankness, a thwarting of sense—even though some artists (most cogently, Robert Smithson) have availed themselves of all these means when they have chosen to write about the endeavor, the experiment, calling into question art's *being, the potential and the contingency of it all.* Discuss.

21. The art world is interested in two kinds of artists: hot new kids and eminences. Most artists spend much of their time being neither. One solution would be to experiment with a "40 to 60" age mandate for curators, editors, collectors, and corporate sponsors for, respectively, all exhibitions, magazine features, art fairs, and highfalutin prizes: meaning that the focus would be on men and women artists no younger than forty and no older than sixty. Consider how different what's considered *au courant* would be. Discuss.

or

Consider the following relation of art and politics: When the dominant discourse implements politics, start thinking about aesthetics; when the discourse strives only for beauty, stress an interrogation of the politic. Explain the validity or invalidity of such a strategy. Is there a way to move beyond the dialectical?

22. American art has no equivalent to Michael Krebber. Even if Krebber never called himself a "painter" or an "artist" (he may claim "actor"), the dynamics of his project depend on a superstructure of painting (its history, instantiations, etc.), on his deployment of "painting" or its absence. True or false? If true, explain why. If false, name his equivalent and explain how.

or

No artwork in any media has ever been auctioned for a higher price than a painting. Why should this still be so?

23. Percy Bysshe Shelley pronounced that poets are "the unacknowledged legislators of the world." Correlatively, artists are the (unacknowledged) _____ of the world.

 a. aristocrats
 b. bums
 c. antibourgeois bourgeoisie
 d. legislators
 e. freaks
 f. none of the above

24. Looking at people looking at art _____ looking at art.

 a. is usually better than
 b. (especially artists) is sexier than
 c. ruins
 d. with Acoustiguides makes for a comedy of errors more than
 e. is more or less the same as
 f. complicates

25. For any opening, I should be wearing

 a. Comme des Garçons "Lumps"
 b. Zoran, great jeans, and Louboutins
 c. anything other than Imitation of Christ
 d. Martin Margiela
 e. a homemade uniform but a great scent (maybe Jicky?)
 f. a vintage YSL "smoking"

26. The 2005 *ArtReview* "Power 100" list included not a single person identified as "writer," "art historian," "editor," or "critic" (not to mention "theorist" or "philosopher"). This list, as a symptom, says what about the value (or lack thereof) placed on critical writing or thinking, relative to other valuations in the art world?

 a. The only current parameter is pecuniary.
 b. Writing is a mutha.
 c. To détourne this situation, discourse itself must be détourned.
 d. Judgment schmudgment.
 e. Nothing.
 d. Everything.

27. Art for art's sake

 a. has outlived its validity
 b. is the translation of the motto of MGM
 c. becomes me
 d. makes redundant any other sake of art
 e. has a politic
 f. is its truth

28. How does it feel to treat me like you do when

 a. you've laid your hands upon me and told me who you are
 b. I thought I was mistaken
 c. I thought I heard your words
 d. I see a ship in the harbor
 e. I can and shall obey
 f. I'd be a heavenly person today

JENNIFER ALLORA AND GUILLERMO CALZADILLA

Allora: Born 1974, Philadelphia, Pennsylvania; lives in San Juan, Puerto Rico
Calzadilla: Born 1971, Havana, Cuba; lives in San Juan, Puerto Rico

Jennifer Allora and Guillermo Calzadilla's collaborative installations, photographs, sculptures, videos, and public projects contest the seemingly incontestable power of official norms and values. Their work puts forth an understanding of protest in a broader context of what artist Krzysztof Wodiczko has termed "proactive testing." As they have articulated, "For us the political dimension in a work of art lies in its endless propulsion of given norms and terminologies into a space of crisis. This happens through a state of permanent questioning.... [A]rt has much to offer to this task, in its potential to create a space of individual questioning about a particular subject, about preconceived notions of truth, about forms of representation, participation, identification, etc. At that point it is up to each individual to decide how this self-questioning will play itself out: at a political level, at a union level, at an aesthetic level, cultural level, and so on."

Several of their recent works developed alongside the popular resistance movement on the Puerto Rican island of Vieques. In 1941, the U.S. Navy took over about 70% of the territory on this tiny island and for sixty years, until 2003, conducted war games and bomb testing that resulted in toxic pollution and environmental damage. As documented in the photographs of *Land Mark (Footprints)* (2001–2), Allora and Calzadilla worked in collaboration with various individuals and activist groups to make customized shoe soles etched with personalized images and messages. The shoes were worn by the participants as they walked in the off-limits militarized zone as an act of civil disobedience, leaving impressions in the sand. Yet the photographs also serve to document the competing interests and motivations of the diverse group of individuals who united for the common goal of stopping the bombing on the island. The images depict a "composite of individual traces," each one effacing the next in the collective aim to mark their presence in this contested territory, which, though still contaminated and still debated, has since become a wildlife refuge under the protection of the U.S. Fish and Wildlife Service.

Hope Hippo (2005), exhibited at the Fifty-first Venice Biennale, also deals with the volatility of land, commemoration, and questions of justice. This life-size sculpture of a hippopotamus ("river horse")—a slovenly riposte to Venice's martial equestrian statuary—was made from mud from the notoriously unstable Venetian lagoon and served as a seat for a "whistleblower": a changing roster of people who read the daily newspaper and sounded a referee's whistle every time he or she came across a report of perceived injustice, from sports to world events.

MA

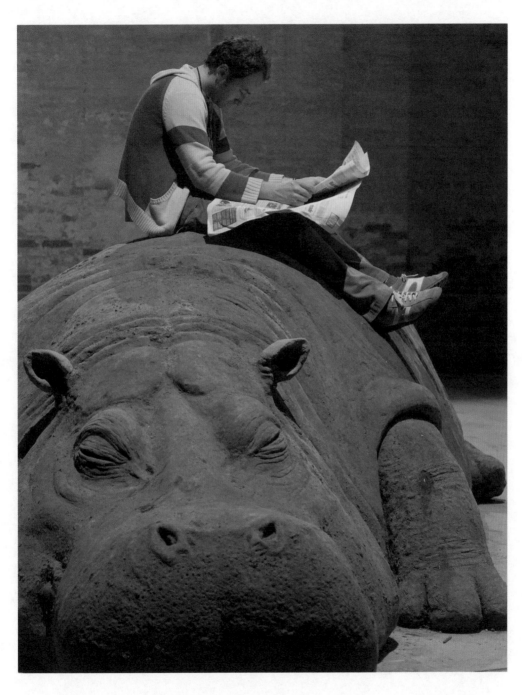

Hope Hippo, 2005 (installation view, Venice Biennale, 2005). Mud, whistle, daily newspaper, and live person, dimensions variable. Collection of the artist; courtesy Lisson Gallery, London

DAWOLU JABARI ANDERSON
Born 1973, Houston, Texas; lives in Houston, Texas

In his large-scale drawings, Dawolu Jabari Anderson co-opts the vernacular of graphic design and advertising in order to present ironic critiques of how black history in the United States is oversimplified and commodified. His drawings are made with acrylic paint on top of which he applies stained-brown, brittle (yet hardy) paper that has been "chocolate-baked" using a technique of the artist's own invention. The paper's ocher tint and semblance of aging reinforce the drawings' invocation of the historicization, monumentalization, and subsequent corporatization of heroicist narratives.

Black History Month—Feel What the Excitement Is All About (2005) depicts three girls—one Asian, one Caucasian, and one Hispanic, with mouths agape in an expression of awe—huddled around the apparition, cradled in the hands of the white girl, of a black basketball player aiming for an imaginary hoop. The girls' faces, especially their excited expressions, are carefully detailed, but their bodies and their flowery dresses are only roughly outlined, emphasizing their own token status. The picture, with its "Black History Month!" banner at the top, plays off stereotypes that heroicize African Americans for their supreme athleticism—which for many black youth still seems to offer the only way out of the cycle of poverty. It also articulates the inadequacy and unequal power dynamic of officially celebrating and commodifying black history, every February, while so many African Americans remain permanently disadvantaged in American society.

Anderson presents an alternative to this potted version of black history with his 2005 *Frederick Douglass Self-Defense Manual* series. In the manual, a black slave, his eyes and face partially erased as if to highlight his "everyman" status, demonstrates self-defense moves such as "8 Diagram Shovel Counter Whip Technique" and "Infinite Step Escape Technique," many of which mimic kung fu poses. Like many artists of his generation, Anderson was influenced by classic kung fu films such as *Five Deadly Venoms* (1978) and *Return to the 36th Chamber* (1980). Anderson's clean, clear graphics and liberationist message echo the "tough on institutionalized corruption" rhetoric of these films.

ESM

Anderson is a member of Otabenga Jones & Associates, also in the 2006 Biennial.

Frederick Douglass Self-Defense Manual Series, Infinite Step Escape Technique #1: Hand Seeks Cotton, 2005. Ink and acrylic on chocolate, butter paper, builder's paper, and craft paper, 43½ x 33½ in. (110.5 x 85.1 cm). Collection of the artist

KENNETH ANGER
Born 1927, Santa Monica, California; lives in Hollywood, California

The films of Kenneth Anger, one of the seminal figures of the American avant-garde cinema, have had a pervasive and profound impact on postwar visual culture. Beginning with *Fireworks* (1947), his first acknowledged film, he forged a hallucinatory, daringly erotic style of nonnarrative filmmaking that evokes an eclectic range of influences, from the poetic films of Jean Cocteau to prosaic Hollywood movies, from the occult teachings of Aleister Crowley and the ceremonies of ancient Egypt to the allures of popular culture and the iconography of the gay underground. Filmmaking for Anger is literally a form of magic, and in works such as *Puce Moment* (1949), *Scorpio Rising* (1963), and *Invocation of My Demon Brother* (1969), he sought a ritualistic fusion of "dreams, desire, myth, and vision." He has recently culled a suite of Ultrachrome frame enlargements from the latter film, permitting a detailed appreciation of his visionary compositions and private occultism, with imagery that includes an autumnal equinox ritual, rock concert fantasias, the artist's tattoos of magic seals, hieroglyphic superimpositions, naked torsos, goldfish bowls, and owl heads.

Mouse Heaven (2005) continues the filmmaker's enduring fascination with Hollywood as "matrix and adversary," in the words of historian P. Adams Sitney—a fascination explored at great length in *Hollywood Babylon*, Anger's infamous exposé of scandal in the dream factory (first published in France in 1959). *Mouse Heaven* celebrates and critiques that most recognizable of Hollywood icons: Mickey Mouse. Anger animates a collection of rare Mickey memorabilia using a repertoire of editing techniques (wipes, irises, dissolves) and numerous digital effects that manipulate—one might say *enchant*—the objects to life. The film is divided into movements separated by a fade, each with its own dominant color scheme and thematic focus, and the soundtrack consists of a string of pop songs carefully chosen for their structural and suggestive capacities. On the surface, this is a playful typology of an American icon in all its many forms (cartoon, toy, souvenir, appliance, tattoo) and materials (plastic, wood, ceramic, cardboard, tin, fabric, rubber). But on a deeper level, *Mouse Heaven* lays bare the social, cultural, and sexual implications of what Anger calls this "demon 'fetish' figure." In one sequence, backed by the 1966 pop song "I'm Your Puppet," Anger contemplates Mickey as robot, automaton, simulacrum—an object manipulated by invisible forces. The idea of control is established in the very first image, which shows a real mouse in a cage, and throughout the film, Mickey is exposed as a commodity: the last iteration of the shape is made from a quarter and two dimes.

NL

Still from *Mouse Heaven*, 2005. Video, color, sound; 10 min. Collection of the artist

DOMINIC ANGERAME
Born 1949, Albany, New York; lives in San Francisco, California

As a filmmaker and longtime director of Canyon Cinema in San Francisco, Dominic Angerame has been an influential figure in experimental film for more than twenty years. From 1987 to 1997, he made a group of five films collectively titled *City Symphony* (an homage to such pioneering filmmakers as Walter Ruttmann and Dziga Vertov working in the 1920s and 1930s) that focused on the constructed human environment, industrial decay, and the dehumanizing aspects of technological mechanization. *Deconstruction Sight* (1990), for example, shows workers on contemporary construction sites as diminutive drones that vanish behind heavy tools and giant machinery.

In his most recent work *Anaconda Targets* (2004), Angerame presents chilling footage of a 2002 military operation in the arid mountains of northeastern Afghanistan. Over the course of twelve minutes, crackly audio and pixelated black-and-white images recorded aboard a United States gunship helicopter describe an air strike against a suspected al Qaeda hideout. From the vantage point of the cockpit, the camera zooms in as the soldiers take aim at a small cluster of buildings and moving vehicles. "Engaging" their targets, the operatives fire so-called smart bombs, which detonate with uncanny precision on the ground. Several times, the aircraft targets fleeing individuals, visible as small white dots against the blurry gray and black of the video.

The appropriated images are not unlike a sequence that might be shown in the context of a news broadcast (the audio is even subtitled in Spanish), but Angerame chooses to present them accompanied by the soldiers' own voices and without editing or commentary. Although the details of the operation remain unclear, viewers will likely infer that they are witnessing a relatively recent operation in the Middle East (one of the buildings is identified as a mosque, and the soldiers target the entrance to a cave). Lacking auxiliary information, the images do not serve as a demonstration of modern warfare's exactitude and efficiency. Rather, they represent a disturbing testimony to the dehumanizing effects of aggressive military intervention and a poignant critique of the United States' current involvement in Afghanistan and Iraq.

HH

Still from *Anaconda Targets*, 2004. Digital video, black-and-white, sound; 12 min.

GOING ON WITH THE JOURNEY T
BUT NOW, BELOVED, NO LONGER SEEK
WHERE ECSTATIC UNITY WITH YOU
UNDEPENDABLY AND WAS, FOR ONE REA
IMPOSSIBLE TO MAINTAIN, SO THA
THAT WAY WOULD NOT RESULT
I BEGAN TO LOOK FOR YOU

The Unexpected Continuation of the Long Neglected

The last two years began with the abandonment of a completely uncharacteristic attempt to achieve a certain level of security in my life, at least in regard to my dwelling. My various proposals to obtain an apartment where I would have the right to live and work for the rest of my life, in exchange for art, had come to nothing. And because the deadline for leaving my old place, where I had lived for twenty years, was perilously close, I had no choice but to admit defeat on the security front to completely change course and to concentrate all my energy on finding a place to rent. Considering that, ideally, this would be my last apartment, and since it is my way to make my apartments a sort of extension of my art, I would really have to like the new place very much. Amazingly, a few months later, the perfect apartment (not particularly undervalued by the landlord, either) presented itself. After many months of renovation and preparation, and with the help of a sympathetic team of four movers, all of us working eight hours a day, for ten days, I moved in about a year ago. Perhaps because I do not appear especially robust, the boss thoughtfully warned me that people my age sometimes did not survive moving day. But then, he couldn't have known about my stamina, and my will, and let's call it, my lucky star. They just managed to carry me through, but for weeks after, I had to go into zombie mode to recover. Then began the wonderful task, which still continues, of making the space my own, and where, as long as I pay the rent, I can presumably stay for the rest of my life! Anyway, moving is, as they say, not an option, anymore. (Part II continues above.)

activity, renewal, completio[n] last two years. Everything /a interviews, contributions to suddenly to have increased project of making installat[ion] audio recordings which I've

CHRISTINA BATTLE
Born 1975, Edmonton, Canada; lives in Toronto, Canada

Christina Battle takes a physical, painterly approach to her medium: shooting on 16mm film stock, she processes the works by hand using custom-made chemicals and subsequently continues to alter the developed film by color toning, painting, or dunking it in solution. Interested in evoking a charged emotional register, she treats the celluloid strip as though applying layers of paint to canvas until the texture and surface of the original photographic imagery are profoundly transformed by the traces of her manual manipulations.

The films *oil wells: sturgeon road & 97th street* (2002) and *buffalo lifts* (2004) depict two facets of Battle's fascination with the prairie landscapes of her native Canada (the filmmaker completed a degree in biology before studying film). The eponymous pumps in *oil wells*, iconic markers of industrial wealth, form sharp silhouettes against backgrounds of white, red, and yellow. Although Battle finds a kind of beauty in the industrialized landscape, she also subtly alludes, in the second film, to the ecological toll of western expansion. A short sequence of running buffalo, once almost completely extinct, is treated to near-abstraction: the animals' dark forms move horizontally through the frame, emerging and disappearing against abstract shapes of cascading color. To make *following the line of the web* (2004), Battle used a photogram process, laying the image of a spider web directly on the unexposed stock. In the edited, projected film, the filigree threads move on the screen in crisscross patterns or are magnified to the point where they disintegrate, providing, as Battle notes, "the opportunity to travel through the space of a spider's web."

In *nostalgia (april 2001 to present)* (2005), the artist appropriates a series of photographs and picture-book drawings of wholesome 1950s Americana. Images of middle-class suburban homes, a family seated in a convertible, and a perfectly coiffed housewife, for example, have been altered to affect a scratchy, raggedly worn surface. "[The] picture of the world that's presented to the public has only the remotest relation to reality," she writes, quoting Noam Chomsky, in her description of the film. By layering a painterly patina onto the images, which are accompanied by an abstract rumbling soundtrack, Battle inverts their nostalgic charm and highlights their sugarcoated datedness.

HH

paradise falls, new mexico, 2004. Dual projection 16mm film, black-and-white, sound; 5 min.

These words represent my
oys used to do — exhibitions,
blications and films — seem
vefold. Recently, I began the
s for the many videos, films, and
er released and which have

not yet been given their final form, and of collecting those autobiographical writings and drawings which still remain to be published. The new works which will result from these activities are meant, in some way, to complete the story I have been creating for the last forty or fifty years. And even if the possibility of completion is unlikely, it is anyway always delayed by the intrusion of irresistible new projects such as, for instance, the "Draw me a Sheep" page. I'm very fond of this photo of myself which was taken in 2004, with a painting from 1972 (not only because it is exceptionally flattering, but also) because my presence as part of the work is aesthetically acceptable. And if it is still true that "I Begin to Feel Free," then the reason for that rel(ease) is completely different now than it was when I was forty. Perhaps the extended title of the painting, "Going On With the Journey Toward Ultimate Union," which was made in 1990, and a reproduction of which I have kept close to me for the last few years, will elucidate the nature of that not quite only aspirational new feeling of freedom: "Going on with the Journey toward ultimate union, but now, Beloved, no longer seeking you outside of myself where ecstatic union with you used to take place, sporadically, undependably, and which was, for one reason or another, enough times impossible to maintain, so that, forced finally to realize that way would not result in completion, I began to look for you in my own heart. Perhaps I should mention that on the continuing journey toward the shore which this title describes, the distance sometimes seems even to increase and the recognition that this will be a solitary way to grow stronger. But not to go on now is, like moving house again, not an option, anymore.

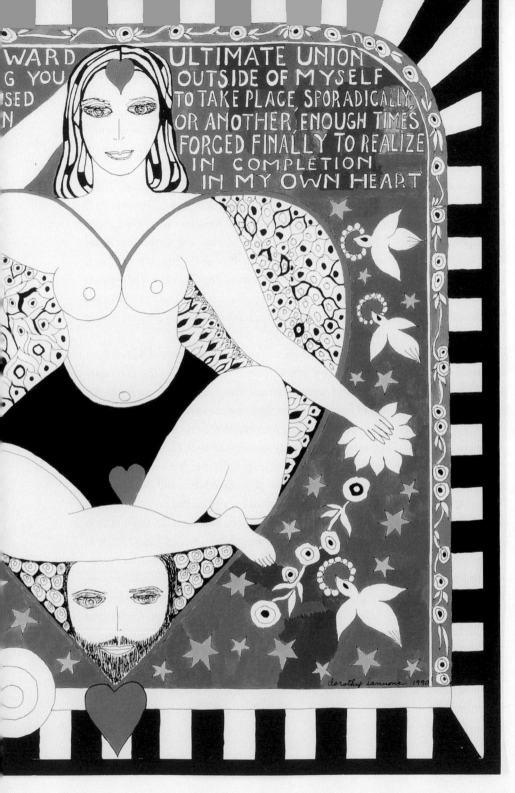

WARD ULTIMATE UNION
G YOU OUTSIDE OF MYSELF
SED TO TAKE PLACE, SPORADICALLY,
N OR ANOTHER, ENOUGH TIMES
FORCED FINALLY TO REALIZE
IN COMPLETION
IN MY OWN HEART

dorothy iannone 1990

JAMES BENNING
Born 1942, Milwaukee, Wisconsin; lives in Val Verde, California

A critical and contemplative engagement with landscape informs the work of filmmaker James Benning. His films are often labeled structuralist and Minimalist, terms that fail to account for the breadth of ideas and emotions to be gleaned from his meticulous studies of geography. "Landscape," Benning has said, "is actually a function of time," and for more than thirty years, he has fixed his 16mm camera on American spaces to excavate strata of form, feeling, history, and culture.

Mixing dramatic re-creation with uninflected documentary, *Landscape Suicide* (1986) contemplates the unremarkable sites of sensational murders. *Four Corners* (1997) develops an essayistic meditation on art, politics, and identity out of the famous geographic nexus shared by Arizona, Colorado, New Mexico, and Utah. In *El Valley Centro* (1999), *Los* (2001), and *Sogobi* (2001), the flux of landscape is mediated through strict formal parameters. Collectively known as *The California Trilogy*, each 90-minute film consists of exactly thirty-five fixed-position images lasting 150 seconds each, a rigorously circumscribed framework through which Benning presents an epic study of the Golden State's genius loci.

One Way Boogie Woogie (1978), a meditation on the one-way streets of Milwaukee's industrial districts, is conceived along similarly strict lines. Each of the film's sixty shots lasts 60 seconds and ends with a physical event that punctures the static tableau: a playfulness and economy of form worthy of the reference to Mondrian's *Broadway Boogie Woogie* (1942–43). In 2004, Benning returned to the sites of *One Way Boogie Woogie* for a shot-by-shot remake transparently subtitled *27 Years Later*. The cityscape is much changed, with buildings in shambles or gone altogether. Viewed in sequence, the two films reinforce a haunting examination of temporal drift and spatial flux.

Trained as a mathematician, Benning has described his analytically designed films as akin to theoretic proofs, "elegant solutions" to aesthetic problems. By instinct he is an artist of the tableau and has referred to *Ten Skies* (2005) and *13 Lakes* (2005) as "found paintings." The subjects of *13 Lakes* are framed with the horizon line bisecting the image, allowing for a mesmerizing interplay of shape and shadow between the zones of earth and sky. Indebted to the serialism and transcendent duration of Warhol's early films, *13 Lakes* may also be understood in the luminous tradition of Monet's late cycles of haystack and cathedral paintings.

Ten Skies consists of ten upward-looking views, each 10 minutes in length, filmed from Benning's backyard. As he has described, "Each sky is a detail selected from the whole, sometimes filled with drama, sometimes a metaphor for peace.... I think of my landscape works now as antiwar artworks—they're about the antithesis of war, the kind of beauty we're destroying."

NL

Still from *13 Lakes*, 2005. 16mm film, color, sound; 135 min.

BERNADETTE CORPORATION
Founded 1994; based in New York, New York, and Berlin, Germany

Bernadette Corporation produces films, publications, and interventions that pose the question of how to defect from modern living within the capitalist system. Through the shifting nature of the group's composition and their diverse modes of production—and, paradoxically, by branding themselves as a corporation—they elude any definitive, image-based identity.

Responding to the seductive glamour of a society inexorably bombarded by images, the corporation wrote a novel, *Reena Spaulings* (2005), which is dedicated to New York, the ultimate city of spectacle. Reena is an "it girl" without qualities whose travails are compiled by the novel's authors from outrageous events both real and concocted, recounted interchangeably in the breathless tone of a gossip column and in lyric prose. *Reena Spaulings* was written by 150 anonymous members of the collective in the assembly-line style of a Hollywood script, thus preemptively—yet only with partial success—superseding any individual subjectivity or style. In a further rebuke to the traditional novel's format and composition, and mimicking contemporary society's too fast and too furious culture, Reena herself fades in and out of the pages like the many voices that narrate the story.

Bernadette Corporation's intentional use of unstable process and strategy is also evident in the video tract *Get Rid of Yourself* (2002), which takes as its starting point, though not its focus, the guerilla techniques of the anarchist black bloc that disrupted the heavily policed 2001 G8 conference in Genoa. Footage of the riots themselves is intercut with musings on the events by the philosopher Werner von Delmont, sunset shots of Calabrian beaches, and the actress Chloë Sevigny, in a sunlit kitchen in Paris, attempting to memorize transcripts of interviews with the anarchists, to aggressively disorientating effect.

Pedestrian Cinema (begun in 2005), the corporation's current yearlong project, is a temporary underground film studio operating out of Berlin. Members write, shoot, edit, and present digital films, though not necessarily in that order; the films are also screened as fragments or as trailers for films that may or may not ever be produced, and are exhibited alongside their raw materials. Bernadette Corporation sees cinema as "another way of assembling a rhythmic confrontation with the programmed desert of the contemporary metropolis"; their impromptu style of work rejects the notion of a finished product in favor of an atemporal, aproductive, and destabilizing logic.

ESM

Reena Spaulings

A novel by
BERNADETTE CORPORATION

Cover of *Reena Spaulings*, published by Semiotext(e), 2005

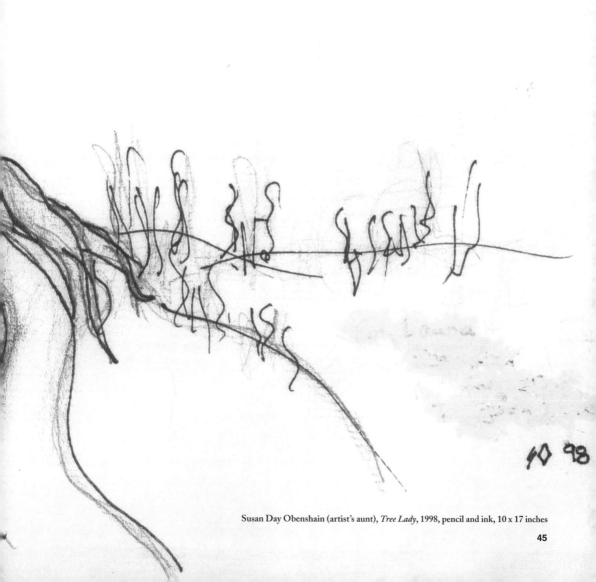

Susan Day Obenshain (artist's aunt), *Tree Lady*, 1998, pencil and ink, 10 x 17 inches

AMY BLAKEMORE
Born 1958, Tulsa, Oklahoma; lives in Houston, Texas

In his seminal theorization of photography, *Camera Lucida* (1980), Roland Barthes isolated an intractable "truth" of the photograph, namely, that its temporality is not grounded in the present tense but in the future anterior of that which will have been. This means that every presence captured by a photograph already implies its absence too. Amy Blakemore's small-scale photographs, with their evocation of memory and longing, amplify such a conceit, through both their technical peculiarities and their hauntingly ephemeral subjects.

Blakemore uses a Diana, a plastic toy camera from the 1950s and 1960s that was once given away as a premium to customers when buying gas or subscribing to a magazine. It is known for its wildly unpredictable and idiosyncratic effects born of a single shutter speed and for its ubiquitous light leaks. The lens's focus is often sharpest at the center, falling off toward darkening, fuzzy edges. She favors this camera for the chance encounters it produces as well as for the lack of control its mechanistic foibles entail. Mining this obsolete technology, Blakemore, as a modern-day flâneur, moves through public spaces to capture, however imperfectly and fleetingly, what she sees. Her blurry black-and-white snapshots—whether of children in parks or mystics and pilgrims at Lourdes or architecture in suburban Tulsa—are rife with distortions that both mediate and veil what they fugitively apprehend.

In the mid-1990s, Blakemore started to make color photographs that render ordinary subjects—mundane but not banal—exquisitely. In *Glowing Tree* (1997), she captures a fiery mass of leaves, seemingly incandescent from within, while in portraits such as *Patrick* (1997), *Duncan* (2002), and *Laura* (2003), she depicts sitters who, despite their often-occluded features, still manage an elusive presence. And in *Jill in Woods* (2005), a young woman in profile is framed by a backdrop of dissolving foliage, part of a story we will never know but are nonetheless seduced by. These stolen glimpses are meditations on fragility and transience; nebulous in appearance and incomplete in narrative, they appear for a moment and then quietly recede into the past.

SH

Jill in Woods, 2005. Chromogenic color print, 19 x 19 in. (48.3 x 48.3 cm). Collection of the artist; courtesy Inman Gallery, Houston

LOUISE BOURQUE
Born 1963, Edmundston, New Brunswick, Canada; lives in Malden, Massachusetts

Process is both meaning and method for filmmaker Louise Bourque. Her films reckon with the instabilities of identity, family, and home. Traces of the past (home movies, found footage, childhood memories, dream imagery) are processed in every sense of the word. Though she has worked in a more traditional mode of production (involving actors, set lighting and design, mise-en-scène, and narrative structures), for the past ten years Bourque has focused on a process-oriented approach. Manipulation of materials is the essence of her technique, whereby filmstrips are scratched, bleached, buried, punctured, soaked, solarized, and specially printed, resulting in rich layers of abstraction and ambiguity.

"All the techniques I use," Bourque has explained, "are about finding ways to imbue the materiality of film with a metaphorical quality." *Self Portrait Post Mortem* (2002), constructed from an outtake from Bourque's first film, shows traces of decay effected by a three-year burial of the image in the Bourque family backyard. The floral and arboreal imagery in *Jours en fleurs* (2003) was chemically altered by several months' immersion in the artist's menstrual blood. *Imprint* (1997) and *Fissures* (1999) assault the surface of home movies with everything from hole punching to the use of lip balm as a stopping agent in a multicolor toning process akin to batik. Through such treatments Bourque seeks to "tease out new meanings and … call attention to image-making as manipulation and construct. In doing so," she writes, "I hope to prompt a questioning of representation (inherent to the vernacular material I appropriate as well as in my own images) and claim a space for other expression wherein the poetical and political meet."

Home, war, and the dark truth of the unconscious fuse in Bourque's new film, *L'éclat du mal/The Bleeding Heart of It* (2005). "In my dream there's a war going on," the artist gently intones over faint images of members of her family gathered outside their house. Shot by Bourque's father before she was born, this archival memento is submerged in thick, painterly blotches of color and shadow that reflect the anxious lyricism of the voice-over: "There are all kinds of obstacles … there's debris everywhere, and bombing …"

NL

Still from *Self Portrait Post Mortem*, 2002. 35mm film, color, sound; 2:30 min.

MARK BRADFORD

Born 1961, Los Angeles, California; lives in Los Angeles, California

Mark Bradford makes sculptures, installations, videos, prints, and vast paintings that explore the aesthetics and the economics of informal urban transactions. His multilayered and vibrant paintings are built up using commonplace materials such as translucent paper, string, magazine pages, tape, and colored stationery and often incorporate remnants of "street spam" advertisements for workers "living under the radar of formal business." This collage practice might recall the torn-poster works of French *affichiste* artists such as Raymond Hains and Jacques de la Villeglé working in Paris in the 1950s and 1960s. Yet in the 'hood that is Bradford's paintings, the strata of paper and stains are mimicked rather than appropriated, and in works such as *Method Man* (2004), it accumulates a radically different expression of urban pop culture that resonates with the scarified sidewalk culture of South Los Angeles. "Like those tagged up, repainted, tagged up, sanded, and repainted walls you pass everyday on the street, my process is both reductive and additive."

The diverse demographics of Los Angeles create juxtapositions where one might find, as Bradford has noted, the "Mexican taqueria next to the black wig shop across the street from the Korean nail shop." Aside from reflecting the mosaic of renovation and degradation that is his neighborhood, the artist's embedding of hybridity, multiplicity, and community into his practice functions as more than just a metaphor for demographics. This is evident in Bradford's *Maleteros* project (2005), in which he collaborated with informal networks of porters operating on the U.S.–Mexican border at San Ysidro, California. Seeking to disrupt the familiar reading of this port of entry as a highly formal site, replete with mechanisms of control and surveillance, Bradford co-created, through an extended process of conversations, a visual "porter identity" at their work locations. Designing a logo and uniform for these unrecognized workers, encouraging them to customize their carts, and mapping their whereabouts in a wall drawing made on-site, Bradford honored their intermediary status and highlighted their half-lit trajectories of commerce.

Bradford's most recent canvases, such as *Temporary* (2005), with its intersecting maplike forms and colorful slabs, suggest a city seen from the air. *Los Moscos* (2004) distantly recalls Piet Mondrian's allusion to Manhattan in his late painting *Broadway Boogie Woogie* (1942–43). Yet Bradford's paintings, like the topography of South LA, are far less rectilinear. Evoking impermanence, they appear scattered, as if punctuated by vacant lots and plots awaiting development, making a grittily beautiful and dynamically sensual exchange between the studio and the street.

MA

Temporary, 2005. Mixed-media collage and string on paper, 130 x 196 in. (330.2 x 497.8 cm). Collection of James Patterson; courtesy Sikkema Jenkins & Co., New York

if you see

say so

TROY BRAUNTUCH
Born 1954, Jersey City, New Jersey; lives in Austin, Texas

A member of the so-called Pictures Generation, Troy Brauntuch—whose career spans some three decades—has often been discussed as taking a particularly post-modern tack when it comes to representation. Yet his works, as much as they can be seen as performing a deconstructive function, are equally compelling for their subtle insistence on subjective experience. Long interested in contextual opera-tions, Brauntuch produces various kinds of interruptions between images and their presumed meanings. On first glance, nearly all his works exert a whisperlike banality, but what appears to be commonplace yields unexpected layers. Unlike the rapidity inherent in so much of the imagery surrounding us today, Brauntuch's photo-based works enact a slow burn. Sometimes it literally takes time to acclimate one's eyes to *see* them at all or, in other cases, to penetrate the sheer ordinariness of the images offered.

Well known for early works in which he decontextualized what would otherwise be hyperbolically charged content, Brauntuch has long been concerned with revealing the kinds of cultural knowledge we unwittingly rely on in our everyday decipher-ing of images. A 1977 series of photographic screenprints with the simple title *1 2 3* was made using borrowed imagery: unremarkable sketches of a tank, a vestibule, and a stage set. There is no accompanying caption or other text with which to site these fragmentary clues, whose immediate capacity to signify has been temporar-ily tampered with. The appropriated sketches were, it turns out, penned by Adolf Hitler, whose name, of course, once divulged, imparts overwhelming significance to otherwise rather insignificant images. Brauntuch highlights the strange effect such alienation and then reuniting of form and content can have on a viewer.

In his most recent work, Brauntuch investigates that infrathin space between a thing and our idea of it. Continuing to lean on the photographic as such even while utilizing a variety of media, he is able to play with yet another layer of mediation. In his conté crayon works on black cotton, the images feel as though they were conjured from the deep recesses of phantasmic space. What appear at first to be monochromatic canvases reveal photo-derived images (a woman's polka-dotted coat, the supine form of a cat) that coagulate and rise to the surface, barely there. In his photographs, everyday objects assert their ephemerality, and a tangible, intimate silence seems as much a part of the pictures as the simple domestic scenes they convey.

JB

Untitled (Shirts 2), 2005. Conté crayon on cotton, 63 x 51 in. (160 x 129.5 cm). Collection of Alberto and Maria de la Cruz; courtesy Friedrich Petzel Gallery, New York

ANTHONY BURDIN
Born Encino, California; lives in California

Numerous modern and contemporary artists have used the automobile as an icono-graphic source, but few as literally as Anthony Burdin: the nomadic California-based artist has reputedly lived in a 1973 Chevy Nova for most of the past decade. Many of his *Voodoo Vocals* videos, which he began making in the early 1990s, are shot from the car's interior. Burdin, who calls himself a "recording artist," drives around with a handheld camera, singing along to songs playing on the radio or on a paint-spattered boom box resting on the passenger seat. His eclectic musical tastes range from Blue Öyster Cult to the James Bond theme, and his voice moves from whimpering to screeching in an atonal farrago that parallels the jerky move-ments of his camera as it tracks the passing urban landscape. In *Desert Mix*, a video series from the early 1990s, the artist meanders through the parched topography of Southern California, muttering, grunting, and breathing heavily as he traverses barren expanses littered with brush and old car parts.

All of Burdin's videos are raw and unedited, and he often accompanies his multi-channel installations with drawings, sculptures, and performances in which he plays drums or guitar. His gritty sculptural objects are usually made from the detritus of everyday life, including cardboard boxes, bound with U.S. Customs packing tape or covered with single words or rock song lyrics, which he scatters on the floor or piles in stacks. Some drawings, covered edge-to-edge with Burdin's spindly, Gothic handwriting, depict prospective album covers and tour posters for the mysteriously titled *Most Famous Witchy Revival*; others are wholly abstract washes of paint, the splotched paper crumpled to further accentuate their motley surfaces.

Unlike some contemporary work in film and video that lends itself to detached viewing, Burdin's art demands our immersion: active engagement is necessary to make sense of his abrasive sounds and haunting references, and to piece together his shaggy-dog narratives. He recoups outmoded recording technologies and seventies music not for nostalgic purposes but to effect a raw psychological zone that seems—in the mediated age of the iPod, photographic digitalization, and pristine exhibition spaces—refreshingly contemporary. One image, of a guitar half-embedded in drywall, consolidates the usually distinct spaces of the artwork and the gallery and suggests Burdin's achievement of one of the age-old goals of the avant-garde: the coincidence of art and life.

LP

Scum Strat II, 2005. Ink, enamel, and etching on guitar, dimensions variable. Collection of the artist; courtesy maccarone inc., New York

North Wall
(garage door behind shelves)

door to house

GEORGE BUTLER
Born 1943, Chester, England; lives in Holderness, New Hampshire

In 1964, at a party hosted by a mutual friend, photographer and filmmaker George Butler met a political science student from Yale named John Kerry. Bonding over their similar backgrounds, they became close friends, though their lives would soon radically diverge. Kerry enlisted and went to Vietnam, serving as a lieutenant in the U.S. Navy until 1970, at which time he returned home and became active in the antiwar movement. Butler applied for a military deferment, joined VISTA, and found himself working in inner-city Detroit. It was here, in 1971, that Butler accompanied Kerry, now a leading figure of Vietnam Veterans Against the War, to the famous Winter Soldier Investigation, a series of public forums for the discussion of crimes and atrocities committed by U.S. forces during the war. Butler's photographs of the event were published later that year in *The New Soldier* (a book for which Kerry wrote the introduction) and are among the various archival materials edited into his feature-length documentary *Going Upriver: The Long War of John Kerry* (2004).

Deftly mixing period photographs and film clips with contemporary talking-head interviews, *Going Upriver* recounts Kerry's journey from student to soldier to antiwar activist, climaxing with his extraordinary testimony before the Senate Foreign Relations Committee on April 22, 1971. Released in the final months of the contentious 2004 presidential campaign between incumbent George W. Bush and Senator Kerry, *Going Upriver* was immediately embraced and attacked along ideological lines. Now that the dust has settled, Butler's achievement can be appreciated for the skill of its montage, the tenderness of its address, and the sincerity with which it posits the values of sacrifice, contrition, and patriotism.

Butler's career as a documentary filmmaker began in 1977 with the release of *Pumping Iron*, a critical and popular success that launched the career of an obscure Austrian athlete (and future California governor) named Arnold Schwarzenegger. Butler followed with a sequel, *Pumping Iron II: The Women* (1985), and *In the Blood* (1989), a controversial film that presents, in the words of critic Janet Maslin, "an ennobling view" of big-game hunting in Africa. Butler's next project would take him to the wilds of the Antarctic to film a series of television and theatrical documentaries based on Caroline Alexander's book *The Endurance: Shackleton's Legendary Antarctic Expedition*, and in 2006 he released *Roving Mars*, further establishing his interest in extremes of human trial and endeavor.

NL

Going Upriver: The Long War of John Kerry, 2004. 35mm film, black-and-white and color, sound; 89 min.

65

t these this
not really
ns. I know
nterpret, so
show you
le that the

shot

48

CARTER
Born 1970, Norwich, Connecticut; lives in New York, New York

In his drawings, photographs, sculptural installations, and videos, Carter collages and overlaps clipped images of body parts and facial features—noses, eyes, ears, hands, clumps of hair—to create what he calls "anonymous portraits." Although these images derive from photographs taken of the artist himself, they are combined in a way that obscures the identity of the figure. Carter is interested in challenging notions of self-portraiture by making work that acts as a stand-in for an *idea* of someone. The subsequent second-generation rendering of a person who is already disguised compels us to question our own identity and the many devices we might use to conceal or transform it.

An untitled work of 2005, one among a large series of such works, features an outline of a man's head filled in with patches of hair drawn with blue and black ink. Several triangular forms, stacked one atop the other, suggest a nose. The whole image is mounted on to a sheet of handmade marbleized paper, which, for the artist, signifies abstract painting and allows for an area of creative reflection in the work. The generic man's profile, which serves as the centerpiece of this series, takes on a variety of identities as mustaches, hair, and facial features are endlessly reconfigured on the surface.

Carter's densely layered ink drawings come about through a multistep process whereby he takes a Polaroid image of himself, using the kind of Polaroid "Big Shot" camera favored by Andy Warhol, manipulates it using Photoshop, and then translates the image into an ink drawing. The act of using an outmoded technology to create something contemporary, as well as using sophisticated computer technology to make something as seemingly straightforward as a line drawing, carries conceptual significance for Carter and embodies the play of contradictions he strives for in his art.

His most recent work includes collaged photographic images of eyes peering out from a wall or from the back of someone's head and of the artist wearing a blond wig backward to conceal his face, as well as an androgynous plastic dummy situated in a sculptural environment—recalling a retro domestic setting—the walls of which are papered with the artist's drawings. All is suspended in a transitional moment, where past and present converge, gender eludes us, and three-dimensional objects and two-dimensional images engage in an open-ended dialogue about the possibility for transformation and change.

JM

prosopopoeia / stasis / landscape, 2005. Blue acrylic ink, hand-marbleized paper, graphite and paper on paper, 37 x 31 in. (94 x 78.7 cm). Collection of Saatchi Gallery, London; courtesy HOTEL gallery, London

CAROLINA CAYCEDO
Born 1978, London, England; lives in New York, New York, and San Juan, Puerto Rico

Carolina Caycedo responds to the effects of global capitalism with a practice rooted in processes of communication, movement, and exchange. Her varied projects—from street actions and itinerant markets to public marches—all germinate in dialogues with communities outside of the art world, and her works invariably refer back to the culture and economy of the street.

Caycedo resists the commodification of art by turning to an economy based on bartering. In 1999, as a member of the Colombian artists' group Colectivo Cambalache, she helped initiate the ambulatory *Museo de la calle* (Museum of the street), which began in a single neighborhood of Bogotá and revolved around a street cart as a site of exchange. The cart held a constantly changing inventory of objects, ranging from the functional to the illicit, that could be swapped with other objects by passersby on the street. As members of the collective transported and exhibited the cart across the globe, it continued its function as a mobile marketplace, while also existing as an ever-evolving artifact of community intervention.

Caycedo extended her use of bartering as a basis for communication during a two-month exhibition in Vienna in 2002. During this time, she traveled the city in a van subsisting only on what she could obtain from people she encountered on the street. In exchange for food or a place to shower and cook, Caycedo offered any number of goods or services that she was able to provide. The written inscription on the side of the van summarized the structuring principle of the work: "I give, I need. You give, you need."

For Caycedo, the site of artistic experience extends beyond the studio or the exhibition space into the wider world in which the artist lives and moves. Additionally, she considers her audience to be not just the typical museum- or gallery-goer but *anyone* she may encounter in daily life. The result is an art that consists in the creation not of objects for passive aesthetic contemplation but of opportunities for cooperation and conversation among a broad array of individuals and communities.

GCM

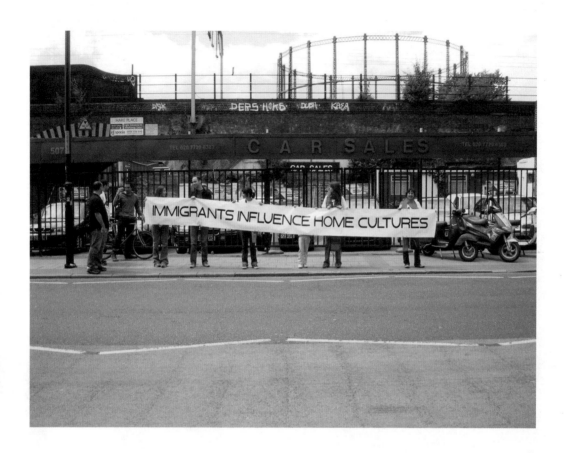

Immigrants Influence Home Cultures, public march, June 20, 2004, Hackney, London

THE CENTER FOR LAND USE INTERPRETATION
Founded 1994; based in Culver City, California

The Center for Land Use Interpretation (CLUI) is an organization "dedicated to the increase and diffusion of information about how the nation's lands are apportioned, utilized, and perceived." Formed in 1994 by director Matthew Coolidge, the center is run out of a small office/gallery in greater Los Angeles but also incorporates residency and exhibition facilities at an abandoned airbase in Wendover, Utah; a desert research station halfway between Las Vegas and Los Angeles; a northeast regional office in Troy, New York; and an ever-expanding "infospace" on the internet. The remote Wendover complex (on a site built to train World War II bomber crews, including that of the Enola Gay, and used more recently as a filming location for Hollywood movies) is home to, among other programs, the Target Museum, whose collection includes paper targets used in firing ranges and ground-based bull's-eye bombing targets. Locations, research, and information are the core of CLUI's interests, and through its multimedia tours, exhibitions, publications, lectures, artist residencies, and extensive photographic archive, it gathers, processes, and presents the residues and territorial histories of humans' impact on the land.

CLUI analyzes extraordinary places—from chemical weapons incinerators, gigantic open-pit mines, aerospace complexes, and hydroelectric power plants to clandestine training facilities and abandoned shopping malls—and the group's practice reads like an alternative tourist brochure of scarred topology, contemporary archaeology, and industrial aesthetics. "In some ways," Coolidge has explained, "the Center is a reconciliation of geography and art." Global politics are never far from the equation. A recent project, for example, focused on the abandoned copper company town of Playas, New Mexico, which has been converted into the nation's primary counterterrorism training facility thanks to a grant from the U.S. Department of Homeland Security.

In fact, a significant proportion of CLUI's research relates to the documentation of military installations, reflecting how much of the U.S. economy and culture is founded in defense. One example is the 4,700-square-mile Nellis Range Complex in Nevada, one of the most secretive sites in the world. The ammunition silos, bunkers, mock airfields, and mysterious geometric forms of this terra incognita, resembling Mayan architecture or Egyptian tombs, have all been objectively analyzed by the Center. CLUI prefers to operate from the standpoint that "fact is often just a more widely believed form of fiction." The lay of the land, to borrow the title of CLUI's newsletter, is a multilayered and often bewildering experience of place.

MA

Pilot Peak Viewing Area, Nevada. Courtesy The Center for Land Use Interpretation

PAUL CHAN
Born 1973, Hong Kong; lives in New York, New York

Paul Chan keeps his art and his politics separate, or at least he claims to. He has been involved in the aid group Voices in the Wilderness (with whom he spent an unsanctioned month in Iraq) and participated in creating *The People's Guide to the Republican National Convention* (an agitprop map of New York City for use by protesters in 2004). Yet while such activities may not appear to directly inform his art practice, they tie into his general insistence on "hallucinating" repressed relationships in contemporary society: between the sacred and the secular, the high and the low, the poetic and the pornographic.

Best known for his digital projection installations, Chan unites traditional techniques and subjects (such as drawing and religion) with altogether new modes of representing and contextualizing them. In *Happiness (finally) after 35,000 years of civilization—after Henry Darger and Charles Fourier* (2003), he presents his fantasized merging of the world inhabited by outsider artist Henry Darger's "Vivian girls" (a group of frolicking, übersexualized preadolescent girls) with the philosophies of the nineteenth-century philosopher Charles Fourier. The result is a lush graphic work in which sex, violence, and considerations of utopia are made strangely present, albeit in animated, fictionalized form. Similarly, in *My Birds … trash … the future* (2004), the artist brings together seemingly unrelated references to tease unexpected meaning from them: set in a contemporary Beckettian landscape, Pier Paolo Pasolini and Biggie Smalls rub shoulders with an assorted cast of characters as hints of the apocalypse bear down upon them.

In *1ˢᵗ Light* (2005), Chan invokes religion as he speculates on the mechanisms of faith and belief. Here, a silent digital animation is projected onto the gallery floor. Simulating the kind of diffused and schematic imagery that might be cast—in light and shadow—through a glass window, the work offers a post-9/11 version of the Rapture. An electrical pole invokes both the everyday and the transcendent, its tangle of wires thwarting our reading of it solely as a crucifix yet insisting on the ubiquity of that form. As the rapturous ascension appears to take hold, a number of items are loosed from gravity's grip: cell phones, cars, sunglasses suddenly float upward and outward. Yet, impossibly, as these signifiers of material possession are rendered buoyant, human bodies begin to fall toward the ground in poses we know all too well from recent events, as though in pointed opposition to any dream of salvation.

JB

1st Light, 2005. Digital animated projection onto floor, dimensions variable. The Institute of Contemporary Art, Boston

LORI CHEATLE AND DAISY WRIGHT

Cheatle: Born 1959, Niagara Falls, New York; lives in Brooklyn, New York
Wright: Born 1969, New York, New York; lives in New York, New York

In their profoundly humanist documentary film *This Land Is Your Land* (2004), Lori Cheatle and Daisy Wright explore the pervasive influence corporations are exerting on life in America. In archival footage and recorded testimonies (the filmmakers traveled across the country interviewing people for more than three years), they trace the impact of corporate power on individual lives, the social fabric, and the very principles of democracy. In the first part of the film, Cheatle and Wright document the ubiquitous presence of corporate logos as well as our susceptibility to branding and the extent to which such forces are internalized: one interviewee declares that she is going to be herself, "not this walking, talking billboard," all the while wearing an Old Navy T-shirt and a Nike baseball cap.

Gradually moving on to graver issues, the filmmakers address the consequences of foreign outsourcing, the dwindling resources of the middle class, and the increasing gap between rich and poor. A former paper mill worker and union leader testifies to the dramatic consequences of losing his job a few years shy of retirement and the subsequent struggle to make ends meet by juggling multiple low-paying jobs with no health-care benefits. In their historical examination of corporate power, Cheatle and Wright contend that the founding of the United States actually sprang from anticorporate sentiment: colonial merchants launched the Boston Tea Party as a protest not only against British taxation policies but also against the unfair trade advantages granted to Britain's East India Company.

At the heart of Cheatle and Wright's film are the stories of individual people who have beaten the odds in their battles against corporate dominion. Father Tryphon, abbot of a Russian Orthodox monastery in Washington State, recounts his battle with Starbucks over the monks' production of a "Christmas Blend" coffee roast (the term had been trademarked to the corporation). San Francisco resident Marc Kasky won a case against Nike on charges of false advertising, which the company tried to defend by claiming protection under the First Amendment right of free speech. Essentially optimistic in their viewpoint, Cheatle and Wright fall squarely on the side of David taking on the corporate Goliath, issuing a celebratory acknowledgment of small acts of resistance and an impassioned call to action.

HH

Still from *This Land Is Your Land*, 2004. Video, color, sound; 87 min.

1192,1193,1194,1195,1196,1197,1198,1199,1200,1201,1202,1203,1
1217,1218,1219,1220,1221,1222,1223,1224,1225,1226,1227,1228,1
1242,1243,1244,1245,1246,1247,1248,1249,1250,1251,1252,1253,1
1267,1268,1269,1270,1271,1272,1273,1274,1275,1276,1277,1278,1
1292,1293,1294,1295,1296,1297,1298,1299,1300,1301,1302,1303,1
1317,1318,1319,1320,1321,1322,1323,1324,1325,1326,1327,1328,1
1342,1343,1344,1345,1346,1347,1348,1349,1350,1351,1352,1353,1
1367,1368,1369,1370,1371,1372,1373,1374,1375,1376,1377,1378,1
1392,1393,1394,1395,1396,1397,1398,1399,1400,1401,1402,1403,1
1417,1418,1419,1420,1421,1422,1423,1424,1425,1426,1427,1428,1
1446,1447,1448,1449,1450,1451,1452,1453,1454,1455,1456,1457,1
1471,1472,1473,1474,1475,1476,1477,1478,1479,1480,1481,1482,1
1496,1497,1498,1499,1500,1501,1502,1503,1504,1505,1506,1507,1
1521,1522,1523,1524,1525,1526,1527,1528,1529,1530,1531,1532,1
1546,1547,1548,1549,1550,1551,1552,1553,1554,1555,1556,1557,1
1571,1572,1573,1574,1575,1576,1577,1578,1579,1580,1581,1582,1
1596,1597,1598,1599,1600,1601,1602,1603,1604,1605,1606,1607,1
1621,1622,1623,1624,1625,1626,1627,1628,1269,1630,1631,1632,1
1646,1647,1648,1649,1650,1651,1652,1653,1654,1655,1656,1657,1
1671,1672,1673,1674,1675,1676,1677,1678,1679,1680,1681,1682,1
1696,1697,1698,1699,1700,1701,1702,1703,1704,1705,1706,1707,1
1721,1722,1723,1724,1725,1726,1727,1728,1729,1730,1731,1732,1
1746,1747,1748,1749,1750,1751,1752,1753,1754,1755,1756,1757,1
1771,1772,1773,1774,1775,1776,1777,1778,1778,1779,1780,1781,1
1795,1796,1797,1798,1799,1800,1801,1802,1803,1804,1805,1806,1
1820,1821,1822,1823,1824,1825,1826,1827,1828,1829,1830,1831,1
1845,1846,1847,1848,1849,1850,1851,1852,1853,1854,1855,1856,1
1870,1871,1872,1873,1874,1875,1876,1877,1878,1879,1880,1881,1
1893,1894,1895,1896,1897,1898,1899,1900,1901,1902,1903,1904,1
1918,1919,1920,1921,1922,1923,1924,1925,1926,1927,1928,1929,1
1943,1944,1945,1946,1947,1948,1949,1950,1951,1952,1953,1954,1
1968,1969,1970,1971,1972,1973,1974,1975,1976,1977,1978,1979,1
1993,1994,1995,1996,1997,1998,1999,2000,2001,2002,2003,2006.

The last two years never happened.

Proof:

B.C.,0,1,2,3,4,5,6,7,8,9,10,11,12,13,14,15,16,17,18,19,20,21,22,23,2
47,48,49,50,51,52,53,54,55,56,57,58,59,60,61,62,63,64,65,66,67,68,
92,93,94,95,96,97,98,99,100,101,102,103,104,105,106,107,108,109,
126,127,128,129,130,131,132,133,134,135,136,137,138,139,140,141
158,159,160,161,162,163,164,165,166,167,168,169,170,171,172,173
190,191,192,193,194,195,196,197,198,199,200,201,202,203,204,205
222,223,224,225,226,227,228,229,230,231,232,233,234,235,236,237
254,255,256,257,258,259,260,261,262,263,264,265,266,267,268,269
286,287,288,289,290,291,292,293,294,295,296,297,298,299,300,301
318,319,320,321,322,323,324,325,326,327,328,329,330,331,332,333
350,351,352,353,354,355,356,357,358,359,360,361,362,363,364,365
382,383,384,385,386,387,388,389,390,391,392,393,394,395,396,397
414,415,416,417,418,419,420,421,422,423,424,425,426,427,428
445,446,447,448,449,450,451,452,453,454,455,456,457,458,459,460
477,478,479,480,481,482,483,484,485,486,487,488,489,490,491,492
509,510,511,512,513,514,515,516,517,518,519,520,521,522,523,524
541,542,543,544,545,546,547,548,549,550,551,552,553,554,555,556
573,574,575,576,577,578,579,580,581,582,583,584,585,586,587,58
605,606,607,608,609,610,611,612,613,614,615,616,617,618,619,620
637,638,639,640,641,642,643,644,645,646,647,648,649,650,651,652
669,670,671,672,673,674,675,676,677,678,679,680,681,682,683,684
701,702,703,704,705,706,707,708,709,710,711,712,713,714,715,716
733,734,735,736,737,738,739,740,741,742,743,744,745,746,747,748
765,766,767,768,769,770,771,772,773,774,775,776,777,778,779,780
798,799,800,801,802,803,804,805,806,807,808,809,810,811,812,813
830,831,832,833,834,835,836,837,838,839,840,841,842,843,844,845
862,863,864,865,866,867,868,869,870,871,872,873,874,875,876,877
894,895,896,897,898,899,900,901,902,903,904,905,906,907,908,909
926,927,928,929,930,931,932,933,934,935,936,937,938,939,940,941
958,959,960,961,962,963,964,965,966,967,968,969,970,971,972,973
990,991,992,993,994,995,996,997,998,999,1000,1001,1002,1003,100
1117,1118,1119,1120,1121,1122,1123,1124,1125,1126,1127,1128,1

IRA COHEN
Born 1935, New York, New York; lives in New York, New York

Ira Cohen is a seminal figure in the consciousness-raising, mind-altering counter-culture movement that began in the 1960s. Over the past five decades, he has produced a wide-ranging body of work that includes poetry, audio recordings, photographs, and experimental and documentary films. Influenced by the many years he spent in North Africa, India, and Nepal with several other key figures of the counterculture, Cohen captures in his work transcendent moments filled with potential and being, embodiments of the Sanskrit word *Akash*, meaning "ether" or "timeless thoughts."

In New York in the late 1960s, Cohen created his Mylar Chamber, a room covered with bendable, distorting mirrors in which he produced psychedelic photographs of shamans, divas, the rock stars Jimi Hendrix and Noel Redding, and the legendary filmmaker Jack Smith. These melting, vibrant images are featured in his film *The Invasion of Thunderbolt Pagoda* (1968). An extraordinary visual trip into a mythical land populated by wizards, sorcerers, dreaming plants, and magical animals, with an accompanying soundtrack by Velvet Underground drummer Angus McLise, the film epitomizes the hallucinogenic experiences of the psychedelic era, melding image with sound, color, movement, and light.

In his poetry, Cohen shies away from ornamentation, favoring a style more akin to collage, in which fragments are brought together to create a unified whole. For Cohen, the most important aspect of his poetry remains the subject matter, which is taken from lived experience, not from the imagination. In "Something I've Been Thinking a Lot About" (2005), he ruminates on the possible exploitation of tsunami victims, the uncounted dead in Iraq, and the rapidity with which these events can be glossed over and forgotten. In "Cornucopion" (2004), he reflects, after discovering long-forgotten flower petals embedded in the last pages of his notebook, on the passage of time.

Cohen's engagement with poetry is not limited to the written word, for, following in the tradition of Dylan Thomas and others, he remains deeply invested in the power of reading his poetry out loud. Through this performative act, he gains a deeper connection to the poem and to his audience, a connection that reaffirms a universal consciousness of being as conveyed through image and word.

JM

Ira Cohen, photographed by Marco Bakker

5,26,27,28,29,30,31,32,33,34,35,36,37,38,39,40,41,42,43,44,45,46,
70,71,72,73,74,75,76,77,78,79,80,81,82,83,84,85,86,87,88,89,90,91,
0,111,112,113,114,115,116,117,118,119,120,121,122,123,124,125,
42,143,144,145,146,147,148,149,150,151,152,153,154,155,156,157,
74,175,176,177,178,179,180,181,182,183,184,185,186,187,188,189,
06,207,208,209,210,211,212,213,214,215,216,217,218,219,220,221,
38,239,240,241,242,243,244,245,246,247,248,249,250,251,252,253,
70,271,272,273,274,275,276,277,278,279,280,281,282,283,284,285,
02,303,304,305,306,307,308,309,310,311,312,313,314,315,316,317,
34,335,336,337,338,339,340,341,342,343,344,345,346,347,348,349,
56,367,368,369,370,371,372,373,374,375,376,377,378,379,380,381,
98,399,400,401,402,403,404,405,406,407,408,409,410,411,412,413,
29,430,431,432,433,434,435,436,437,438,439,440,441,442,443,444,
51,462,463,464,465,466,467,468,469,470,471,472,473,474,475,476,
93,494,495,496,497,498,499,500,501,502,503,504,505,506,507,508,
25,526,527,528,529,530,531,532,533,534,535,536,537,538,539,540,
57,558,559,560,561,562,563,564,565,566,567,568,569,570,571,572,
89,590,591,592,593,594,595,596,597,598,599,600,601,602,603,604,
21622,623,624,625,626,267,628,629,630,631,632,633,634,635,636,
53,654,655,656,657,658,659,660,661,662,663,664,665,666,667,668,
85,686,687,688,689,690,691,692,693,694,695,696,697,698,699,700,
17,718,719,720,721,722,723,724,725,726,727,728,729,730,731,732,
49,750,751,752,753,754,755,756,757,758,759,760,761,762,763,764,
81,782,783,784,785,786,787,789,790,791,792,793,794,795,796,797,
14,815,816,817,818,819,820,821,822,823,824,825,826,827,828,829,
46,847,848,849,850,851,852,853,854,855,856,857,858,859,860,861,
78,879,880,881,882,883,884,885,886,887,888,889,890,891,892,893,
10,911,912,913,914,915,916,917,918,919,920,921,922,923,924,925,
42,943,944,945,946,947,948,949,950,951,952,953,954,955,956,957,
74,975,976,977,978,979,980,981,982,983,984,985,986,987,988,989,
1005,1006,1007,1008,1009,1110,1111,1112,1113,1114,1115,1116,
,1130,1131,1132,1133,1134,1135,1136,1137,1138,1139,1140,1141,

,1205,1206,1207,1208,1209,1210,1211,1212,1213,1214,1215,1216,
,1230,1231,1232,1233,1234,1235,1236,1237,1238,1239,1240,1241,
,1255,1256,1257,1258,1259,1260,1261,1262,1263,1264,1265,1266,
,1280,1281,1282,1283,1284,1285,1286,1287,1288,1289,1290,1291,
,1305,1306,1307,1308,1309,1310,1311,1312,1313,1314,1315,1316,
,1330,1331,1332,1333,1334,1335,1336,1337,1338,1339,1340,1341,
,1355,1356,1357,1358,1359,1360,1361,1362,1363,1364,1365,1366,
,1380,1381,1382,1383,1384,1385,1386,1387,1388,1389,1390,1391,
,1405,1406,1407,1408,1409,1410,1411,1412,1413,1414,1415,1416,
,1430,1431,1432,1433,1434,1435,1436,1437,1438,1439,1440,1445,
,1459,1460,1461,1462,1463,1464,1465,1466,1467,1468,1469,1470,
,1484,1485,1486,1487,1488,1489,1490,1491,1492,1493,1494,1495,
,1509,1510,1511,1512,1513,1514,1515,1516,1517,1518,1519,1520,
,1534,1535,1536,1537,1538,1539,1540,1541,1542,1543,1544,1545,
,1559,1560,1561,1562,1563,1564,1565,1566,1567,1568,1569,1570,
,1584,1585,1586,1587,1588,1589,1590,1591,1592,1593,1594,1595,
,1609,1610,1611,1612,1613,1614,1615,1616,1617,1618,1619,1620,
,1634,1635,1636,1637,1638,1639,1640,1641,1642,1643,1644,1645,
,1659,1660,1661,1662,1663,1664,1665,1666,1667,1668,1669,1670,
,1684,1685,1686,1687,1688,1689,1690,1691,1692,1693,1694,1695,
,1709,1710,1711,1712,1713,1714,1715,1716,1717,1718,1719,1720,
,1734,1735,1736,1737,1738,1739,1740,1741,1742,1743,1744,1745,
,1759,1760,1761,1762,1763,1764,1765,1766,1767,1768,1769,1770,
,1783,1784,1785,1786,1787,1788,1789,1790,1791,1792,1793,1794,
,1808,1809,1810,1811,1812,1813,1814,1815,1816,1817,1818,1819,
,1833,1834,1835,1836,1837,1838,1839,1840,1841,1842,1843,1844,
,1858,1859,1860,1861,1862,1863,1864,1865,1866,1867,1868,1869,
,1881,1882,1883,1884,1885,1886,1887,1888,1889,1890,1891,1892,
,1906,1907,1908,1909,1910,1911,1912,1913,1914,1915,1916,1917,
,1931,1932,1933,1934,1935,1936,1937,1938,1939,1940,1941,1942,
,1956,1957,1958,1959,1960,1961,1962,1963,1964,1965,1966,1967,
,1981,1982,1983,1984,1985,1986,1987,1988,1989,1990,1991,1992,

A.L.

MARTHA COLBURN
Born 1971, Gettysburg, Pennsylvania; lives in New York, New York, and Amsterdam, The Netherlands

An artist, musician, and self-taught filmmaker, Martha Colburn has developed her distinctive style of exuberantly colorful animated collage over the last ten years. She began making films using found footage after she acquired a number of discarded classroom films from a library. Living in Baltimore throughout the 1990s, she released six records and collaborated with numerous musicians and artists, including Yamatsuka Eye and Jad Fair. Among her most recent projects is a music video for the band Deerhoof.

Colburn delves into the vast repository of images from advertising and popular culture, drawing on found movies, clippings from magazines, posters, and books. Her kinetic manipulations, made using traditional cutout and paint-on-glass animation, hold a distorted mirror to the image industries' finished blandness and unlock an undercurrent of sex and violence. In *Evil of Dracula* (1997), a riotous assault on conventional depictions of femininity, Colburn borrows the central trope from vampire soft porn and transforms a series of pleasantly pretty photo models locked in frozen smiles into fang-bearing bloodsuckers.

Cosmetic Emergency (2005), her first work made on 35mm film stock, mines similar territory as Colburn uses the tactile possibilities of handmade animation to explore the contemporary obsession with youth, beauty, and cosmetic surgery. In the beginning sequences, she slathers her appropriated images with paint, gradually peeling away layers from the grotesquely altered faces—bruised, bandaged, or scarred—to reveal underlying pictures of wholesome faces derived from pulp fiction covers. Commenting on the peculiar fact that the United States military provides free plastic surgery to its personnel, in another sequence she applies the animation technique to cartoonishly heroic pictures of soldiers in combat gear. The steely faces morph into skulls, and uniformed male bodies turn into stately, bodacious women. In the final segment, Colburn draws parallels between the historicity of beauty standards and the timeless quality of painting itself. She depicts and puts into motion a series of details from old-master-looking paintings, honing in on smoothly painted skin areas or the cracked surfaces of oil on canvas to once again revel in the lavish painterliness of her own medium.

HH

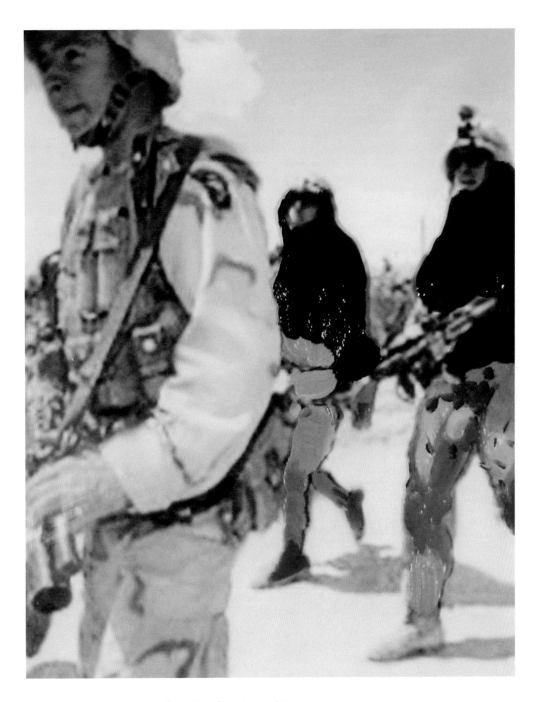

Still from *Cosmetic Emergency*, 2005. 35mm film, color, sound; 8 min.

DAN COLEN
Born 1979, Leonia, New Jersey; lives in New York, New York

"A brick wall in a school yard, a teenage symphony for god, a friend's black leather couch that I brought many late nights to a close on, America's southern landscape, Brancusi, a Styrofoam wall, a loft above a garage, a vampire's picnic, New Jersey backyards, news, mews, pews, brews, stews, and dues." Such a litany reveals some of the potent inspirations for painter and sculptor Dan Colen's aesthetic of charmed excess. More specifically, this torrent of allusions refers to a sculpture the artist made for the 2005 group exhibition *Bridge Freezes Before Road*. Derived in part from a detail of Jeff Wall's photograph *The Vampire's Picnic* (1991), it consisted of a stagelike platform populated by discarded and crafted objects, including a mangled chair with a large sign declaring "DRUGS," a truck tire, and a monstrous B-movie-style cockroach prop; the entire piece was shored up with heavily graffitied wooden planks to create a tableau of degradation. Looking like a piece of scenery from a theatrical production of William Burroughs's *Naked Lunch*, Colen's mise-en-scène of trash lay somewhere between an evocation of somebody else's squalid reality and an intoxicating fiction.

Recalling one of Gordon Matta-Clark's "building cuts" or a Robert Rauschenberg combine, *Secrets and Cymbals, Smoke and Scissors (My Friend Dash's Wall in the Future)* (2004) presents an extracted apartment wall that has become a kind of shrine. Covered with consumer packaging, cutout photographs, stickers, missing-child flyers, and front pages from the *New York Post* and other tabloids with shrill headlines relating to Saddam Hussein and the war in Iraq ("DEAD MAN," "FAIR GAME," "WAKE UP!"), the wall disgorges the detritus of New York City in a mass of conspiratorial evidence and global media vengeance, a terrorism of connectedness, or a psychological profile-in-waiting.

Colen's series of "candle paintings," begun in 2004, similarly revel in a haunted surplus. Each painting faithfully copies the same animation cell from a Disney movie—*Pinocchio*, perhaps—showing, in close-up, a tabletop tableau of an inkwell and quill, dancing figurines, a bottle, and a recently extinguished candle in its holder. As if troubled by a mischievous spirit who mocks the technical virtuosity and visual charm of the work, the smoke of the smoldering wick casts itself in the shape of a different offhand phrase or insult in each painting: "holy moly," "blow me," "so long," or simply "fuck."

MA

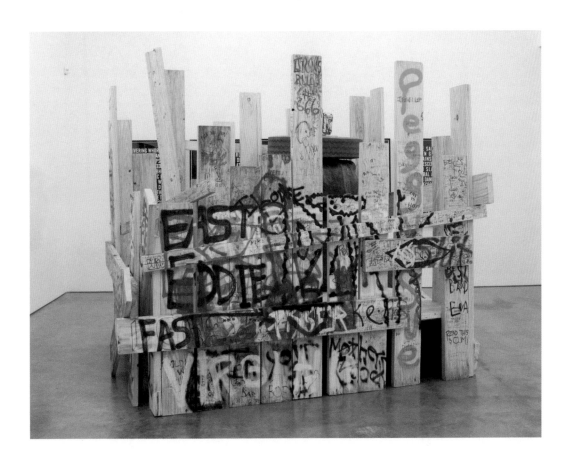

Untitled, 2004–5. Papier-mâché, Styrofoam, felt, oil paint, wood, and steel, 96 x 108 x 96 in. (243.8 x 274.3 x 243.8 cm).
Collection of Frank Cohen Museum of Contemporary Art, Manchester; courtesy Peres Projects, Los Angeles

ANNE COLLIER
Born 1970, Los Angeles, California; lives in New York, New York

Anne Collier's clinical, deadpan photographs draw on the legacy of West Coast Conceptual and Minimalist art, which she inflects with her own particular neuroses. Unlike the slick, good-time city of her predecessors, such as Robert Irwin and Billy Al Bengston, Collier's Los Angeles is more about the seven thousand miles of alienating hot freeway driven by the unhinged protagonist of Joan Didion's 1970 novel *Play It as It Lays.* Collier was educated in Southern California and appropriates certain tropes of the region's Light and Space aesthetic. However, her complicated insertion of herself into her photographs—which are often refracted through autobiography, obsessive-compulsively grouped, or literally splintered and digitally manipulated—marks her departure from the mostly male, self-confident Los Angeles canon.

Side 1/ Side 2 (2004) depicts the two sides of a boxed set of self-help cassette tapes, which Collier found in a thrift store, labeled ANGER, FEAR, DOUBT, APATHY, ANXIETY, DISCIPLINE, DISCOURAGEMENT, GUILT. Except for these words and the outline of each tape, the photographs are almost blank; in their sparsity they closely resemble Joseph Kosuth's or Mel Bochner's early Conceptual work of the 1960s. However, the diptych's excessively formal composition implies a sense of personality excised from Kosuth's or Bochner's drier offerings: the lack of shadows and the whiteness of the surfaces bring to mind a sanitized hospital environment and suggest a certain compulsion toward order and cleanliness on the part of the artist/listener.

Collier has described her works as "deflected self-portraits," and in the case of *Side 1/Side 2*, she interrogates her own compulsive tendencies. A more concerted self-examination is pursued in works such as *Eye* (2004), a digital manipulation of a close-up of the artist's eye in which a tiny repetition of it appears as if emerging from her pupil. This perceptual trick causes the real eye to look grotesquely misshapen—made strange. The same fractured self-image is made literal in *Mirrorball* (2004); here her eye and other fragments of her body are reflected in the mirrored panes of a disco ball. Such refractions aim to abnegate and subvert her identity, but in the end, the attempt fails, perhaps intentionally, when faced with the cool assuredness of Collier's self-examination.

ESM

Spill, 2005. Chromogenic color print, 46⅜ x 34¾ in. (117.9 x 88.3 cm). Private collection; courtesy MARC FOXX, Los Angeles

TONY CONRAD
Born 1940, Concord, New Hampshire; lives and works in Buffalo, New York

A pioneering musician and filmmaker, Tony Conrad's work has expanded the very definition of his disciplines' boundaries for more than forty years. Whether working in music, film, video, performance, painting, or sculpture, he roots his practice in a fundamentally political stance: as he states, "The job of an artist is to discover laws to violate that haven't been made yet." From 1962 to 1965, Conrad played with John Cale, Angus MacLise, La Monte Young, and Marian Zazeela as the Theatre of Eternal Music. The group broke new ground in creating what they termed "Dream Music"—Minimalist compositions based on drones and individual tones that dispensed with written scores and the musical scale used in Western music since the eighteenth century.

Transposing his interest in exploring harmonic relationships to a visual medium, Conrad made his first film, *The Flicker*, in 1966. In it, rapidly alternating frames of pure black and white flash on the screen at varying rates. Projected over the course of 30 minutes, the film's resulting stroboscopic effect is geared toward eliciting a direct physical response, or, as Conrad has described, "a hallucinatory trip through the unplumbed grottoes of pure sensory disruption."

Seeking to move beyond the perceived limitations of the period's Structural film-making, which was concerned with the apparatus and materiality of the medium, Conrad began to make a number of film objects in the early 1970s. He created these sculptural works by cooking, frying, or pickling film stock (a body of work he has recently revisited when he began pickling fresh batches of celluloid last year). The similarly irreverent paintings in the *Yellow Movies* series (1973) suggest movie screens; framed by a black border, they were made using various kinds of ordinary house paint in shades of white, yellow, and muted pastels.

Throughout the 1980s, much of Conrad's work was concerned with questions of authority, and he made numerous community-based videos that aired on public access television. Persistently crossing disciplinary boundaries, he continues to create short videos, musical compositions, and performances (including collaborations with Faust, Jim O'Rourke, and Charlemagne Palestine). A recent group of sculptures combines Conrad's parallel interests in mathematics and musicology, as in *Recomposing Galileo* (1998), a wood structure sculpture that maps the artist's assertion that "the first law of physics is based on music."

HH

Untitled performance, New York, 2005. 16mm film, canning jars, vinegar, vegetables, and pickling spices

CRITICAL ART ENSEMBLE
Founded 1987; based throughout the United States

Critical Art Ensemble (CAE) is an artists' collective that explores the intersections of art, technology, politics, and critical theory. Their projects take the form of interventionist actions, publications, films and videos, web-based initiatives, and instructional workshops. For twenty years, CAE has used these tactics to address biotechnology and biogenetics, the American health-care system, international pharmaceutical development, and advertising. Linked to the cultural phenomenon of "tactical media," defined as the critical use of old and new forms of media to address political issues, CAE's innovative model of protest creates platforms that provide information about government and corporate co-optation of global industries, therefore empowering the masses to reflect and react.

The performance project *Flesh Machine* (1997–98) addressed the human fertilization industry, its association with eugenics theories, and its increasing status in the capitalist marketplace. After attending an informational presentation performed by CAE members, viewers were invited to participate in a series of medical screenings that ultimately determined the potential market value of their genetic material. The *Tactical Gizmology Workshop* (2002), a collaboration with Beatriz da Costa, instructed participants in the creation of a digital graffiti tag—a tiny LCD screen programmed with text phrases that could be deployed into the cultural landscape as a "micro intervention," provoking a critical, reflective response to otherwise ordinary activities. In addition to creating a tool for social commentary, this project demystified electronic technology by teaching amateurs how to build and utilize an electronic device from scratch.

In *Free Range Grains* (2004), also a collaboration with da Costa, CAE empowered viewers to identify genetically modified food products that, despite restrictions, might have entered the global marketplace clandestinely. All information about the testing procedures was posted at the lab and online, thereby rendering the process transparent and available to anyone regardless of scientific expertise or credentials. This project created an inadvertent firestorm of controversy when a member of CAE was investigated for bioterrorism, although the bacteria in his possession were legal and benign. In a new video, CAE documents the piles of trash, including empty pizza boxes and plastic bottles, left in the artist's house by the local and federal investigators who had seized his property while determining whether it posed a health risk. The charges are still pending in a federal court, underscoring the importance of CAE's work in questioning and illuminating the complex, often veiled systems of information and economy that we have passively come to accept.

JM

Still from *Body of Evidence*, 2004. Video, color, sound; 4 min.

JAMAL CYRUS
Born 1973, Houston, Texas; lives in Houston, Texas

Jamal Cyrus's practice is heavily influenced by the history of the civil rights movement of the 1960s, including its subsequent collapse in the 1970s into splintered movements and the appropriation of its styles by mainstream culture. In 2005, as part of his work incorporating found album covers, Cyrus created a fictional 1970s record label called Pride Records, complete with an invented history. In Cyrus's telling, Pride Records was closely monitored by the FBI for releasing records deemed subversive by the agency. The FBI eventually coerced the label into releasing counterrevolutionary disco music, thereby neutralizing its ability to affect social and political change. This fictionalized narrative echoes the real evolution of disco in the United States, which is often seen as a capitulation to mainstream consensus in contrast to the more outspoken radical black music of the 1960s and 1970s.

The Dowling Street Martyr Brigade, "Towards a Walk in the Sun" (2005), "released" on Pride Records, is a collage made on top of an album cover of Cream's *Disraeli Gears* (1967). The psychedelic imagery has been partially obscured by a black-and-white cutout of a group of marching black militants, clenched fists held aloft, carrying a coffin that represents writer and poet Henry Dumas's mythological "Ark of Bones," commemorating those lives lost in racist acts (Dumas himself was killed in a confrontation with New York Transit Authority police in 1968). The felt-tipped name of the record's previous owner is still visible at the top of the album, and the text "Towards a Walk in the Sun" has been printed in black and white across its bottom. Cyrus's placement of the marchers in the center of the photograph reworks the mild-mannered hippie imagery into a critical remembrance of racism in U.S. history.

Other signifiers of the civil rights movement and the black liberation movement appear in *Hands Off (package design prototype)* (2005), a hand-drawn design for "genuine anti-agent ointment." In addition to the pun on anti-aging cream, *Hands Off* invokes both the black beauty industry's involvement in the creation of skin whitening creams and, at the other end of the spectrum, the black pride slogan "Black Is Beautiful." The sales pitch on the container reads "Makes your black political acts appear counter-revolutionary," a reminder of how the FBI kept active surveillance on black civil rights leaders under the COINTEL-PRO (counter-intelligence program). Cyrus's sculptures, drawings, and collages create a defiant black aesthetic with which he offers his own version of African American history.

ESM

Cyrus is a member of Otabenga Jones & Associates, also in the 2006 Biennial.

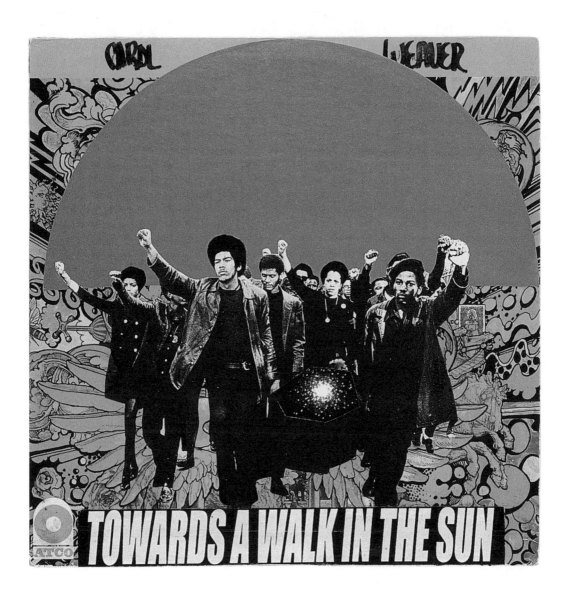

The Dowling Street Martyr Brigade, "Towards a Walk in the Sun," 2005. Collage on paper, 12�6/16 x 12½ in. (31.3 x 31.8 cm). Collection of the artist

MILES DAVIS
Born 1926, Alton, Illinois; died 1991, Santa Monica, California

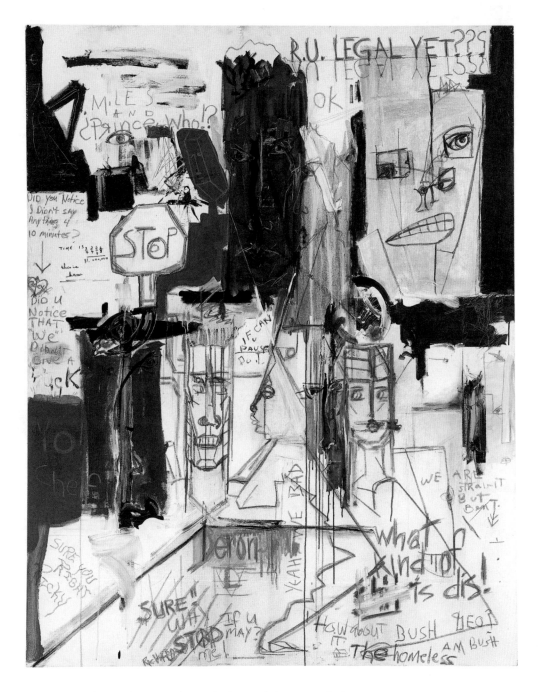

RU Legal, 1991. Oil on canvas, 36 x 50 in. (91.4 x 127 cm). Anonymous collection

of Fire

the House.

DEEP DISH TELEVISION NETWORK
Founded 1986; based in New York, New York

Deep Dish Television Network (DDTV) is the original alternative satellite network in America. Spawned from the nonprofit video collective Paper Tiger Television (established in 1981), DDTV's staff has been committed, for twenty years, to analyzing the mass media and advocating for grassroots social activism. Drawing inspiration from the legacy of underground video collectives in New York City during the 1970s, Paper Tiger and DDTV envisioned a cheap and fast way of bringing articulate critique into the public sphere by broadcasting nationwide on public-access cable networks. Today, DDTV collaborates with media production organizations dedicated to "resistance to the rampant tendencies toward repression, exploitation, isolation, alienation, and corporatization," including the Independent Media Center, Free Speech TV, and Pacifica Radio.

The availability of portable consumer-grade video equipment (and, later, of digital media) has allowed DDTV to demonstrate the democratic potential of the medium and to encourage an appetite for collective participation. Their productions (ordinarily 28 minutes long) stress process and message over product. Educators, journalists, activists, community organizations, academics, and students constitute the stars of the documentaries and reports—a roster of participants bent on posing questions, fighting disaffection, and confronting the biases and hidden agendas of the information and politics industries.

During the 1999 World Trade Organization protests in Seattle, videotapes were literally rushed by bicycle messenger to a DDTV satellite uplink. Every day, for five days, an hour-long program was picked up by community stations. DDTV had previously garnered wider attention with a pioneering ten-part documentary series produced during the first Gulf War in 1991. At a time when the only news coverage of the war on corporate channels was via formal military press conferences or human-interest stories of heroic troops, DDTV collaborated with independent producers from around the country to present the many voices of opposition to the war.

It is not without a withering sense of déjà-vu, then, that DDTV's twelve-program collection *Shocking and Awful: A Grassroots Response to War and Occupation* (2003–5) examines the latest violent and highly controversial actions in Iraq. With segments produced by some one hundred independent filmmakers and activist organizations, these broadcasts provide a damning account of the U.S. administration's boastful "shock and awe" military tactics. Subjects include the humiliation and dehumanization of the emergent neocolonial situation, the looting of museums in Baghdad, and ways the mainstream media has disguised its self-interest by downplaying the many demonstrations around the world against this "globalization at gunpoint."

MA

Still from *The Real Face of Occupation*, from *Shocking and Awful: A Grassroots Response to War and Occupation* series, 2003–5. Video, color, sound; 28 min. This image of an elderly hooded detainee in a house raid by U.S. troops in Sāmarrā was broadcast by DDTV before the Abu Ghraib revelations.

LUCAS DEGIULIO
Born 1977, Dearborn, Michigan; lives in San Francisco, California

Lucas DeGiulio creates small, delicate sculptures out of an assortment of found objects. He is less interested in creating recognizable everyday objects than in transforming familiar items into something fugitive and mysterious, and his works often stretch beyond sculpture to connect with his practice in other media.

Based in San Francisco, DeGiulio carefully pieces his works together from a vast repository of materials that he gathers as he moves through the city. A series of recent sculptures entitled *Scavenger Words* (2005–6) are crafted out of twigs that were collected and assembled with obsessive care into antennalike objects. One sprouts from a small terracotta flowerpot, the other from a base shaped like a flower bulb. These highly organic objects bear an ambiguous, almost ritualistic quality in their deliberate intersecting of lines and indecipherable patterns, which relate to the artist's drawings.

In *Can Barnacles* (2005), DeGiulio has covered an empty, slightly crushed soda can in barnacles, giving it the appearance of having been pulled out of the ocean. He highlights the object's movement from commodity to debris, and suggests an interest in processes of entropy and degradation, both natural and human-made, which point toward the work of Robert Smithson. Instilling value to what is commonly held as disposable, DeGiulio's work also connects with the assemblages of Bay Area artists of the 1960s, notably Bruce Conner.

Like Conner, DeGiulio informs his artistic practice with references to music and other popular cultural forms. In *Neil Young Globe* (2005), a globe emblazoned with a gurulike image of the rock icon rests on top of a tin can. DeGiulio performs with the Bay Area noise band Quadmoth, whose members wear handmade costumes and masks and whose performances rely equally on visual and sonic impact. In all of his various projects, DeGiulio suggests that there is mystery and beauty to be found in the most surprising of sources.

GCM

Can Barnacles, 2005. Aluminum can, barnacles, 4½ x 3 in. (11.4 x 7.6 cm). Collection of the artist

MARK DI SUVERO AND RIRKRIT TIRAVANIJA

di Suvero: Born 1933, Shanghai, China; lives in New York, New York
Tiravanija: Born 1961, Buenos Aires, Argentina; lives in New York, New York; Berlin, Germany; and Bangkok, Thailand

Although they are from different generations and their practices are located at opposite ends of the artistic spectrum, Mark di Suvero and Rirkrit Tiravanija share a belief in art's potential for effecting social change. Di Suvero's sculptures made from steel construction beams often contain elements that invite viewer interaction; in 1986 he founded Socrates Sculpture Park, in Queens, New York, as a place for young artists and the local community to work together. Tiravanija's practice also opens up the possibility for social dialogue. In the cooking events for which he is best known, he prepares Thai food for visitors; and in 1998, he established, with fellow Thai artist Kamin Lerdchaiprasert, "The Land," an experimental project in self-sufficient living in northern Thailand.

For the 2006 Biennial, di Suvero and Tiravanija collaborate to reconceive the *Artists' Tower for Peace*, first constructed in Los Angeles in 1966 to protest the war in Vietnam. Organized by the Artists' Protest Committee, the original tower was designed by di Suvero and erected on a vacant lot on the corner of La Cienega and Sunset boulevards. Dismantled and dispersed at the end of its three-month lease, today it is a largely forgotten event in the history of art and activism. The nearly 60-foot-high multicolored steel structure was an experiment in effective political protest that sought new ways to organize in a nonhierarchical fashion and to create a media spectacle. More than four hundred 2-foot-square artworks (participating artists included Elaine de Kooning, Leon Golub, Donald Judd, Roy Lichtenstein, and Mark Rothko, among many others) were displayed, democratically, on a 100-foot-long billboard wall that stretched around the tower. As an event, the tower became a target of organized attacks by angry opponents while also attracting wider media and public attention.

In many respects, *Peace Tower* (2006) remains true to the spirit of its predecessor: following Tiravanija's reconception of the project, di Suvero redesigned and constructed the steel tower, which rises out of the Museum's courtyard well; some 300 artists, including those involved in the original tower, were invited to contribute 2-foot-square panels to hang on the walls of the well and on the tower itself. *Peace Tower* provides an opportunity to step back momentarily from the bustle of the rest of the exhibition and to reflect on the wider social issues presented therein.

ESM

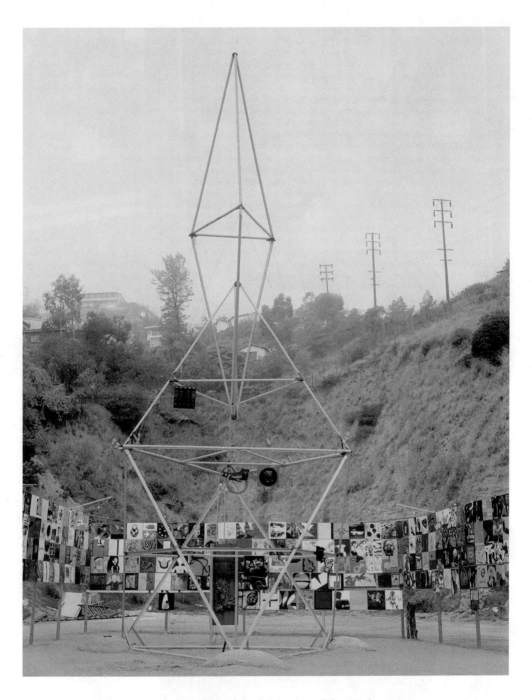

Artists' Tower for Peace, 1966. Steel and mixed media, 55 ft. (16.8 m). Installed Los Angeles

PETER DOIG
Born 1959, Edinburgh, Scotland; lives in Port-of-Spain, Trinidad and Tobago

Consisting of paintings, drawings, and prints—as well as a collaborative cinema project (see Studio Film Club, also in the 2006 Biennial)—Peter Doig's current practice is steeped in the culture of Trinidad, where he lived as a child and to which he returned in 2002. The hybrid social history of this Caribbean island and perceptions about its exoticism and remoteness inevitably come into play in Doig's intensely atmospheric works. "I'm interested in mediated, almost clichéd notions of pastoral landscape," the artist has said, "in how notions about the landscape are manifested and reinforced in, say, advertising or film. Yet at the same time, many of the paintings are rooted in my own experience." He operates in a range of pictorial modes and scales, encompassing imagery from art history, cinema, and tourist postcards while often reinventing and re-presenting his own figurative motifs. Like the work of his near-contemporaries Kai Althoff, Daniel Richter, and Laura Owens, Doig's paintings are at once ordinary and exotic, rational and hallucinatory.

Solitary figures appear like apparitions, hermits, or shamans throughout Doig's oeuvre. A red-nosed figure in a stovepipe hat and shabby frock coat is the seemingly anachronistic protagonist of *Metropolitain (House of Pictures)* (2004) and many other works referring to Honoré Daumier's painting *L'amateur d'estampes* (1863–65). A bearded man stares at us from a canoe in *100 Years Ago (Carrera)* (2002), a vision inspired by a scene from the 1980 horror movie *Friday the 13th*. Another hirsute loner (perhaps the same) is caught in midstride on a beach in a number of works, including *Pelican Man* (2004), transfixing us with his gaze like some neotropic Sasquatch.

Doig is interested in the different agendas played out in painting during the time before photography's invention or the advent of cinema, when paintings often held an aura of dramatic, suspended narrative. But this looking back does not fall into sentimentality. His deliberately indistinct, veiled handling of paint can lend his scenes the quality of half-recalled memory, and the recurring imagery conjures up a world that shuttles back and forth between an evocation of times past and a fantastic, dreamlike present.

MA

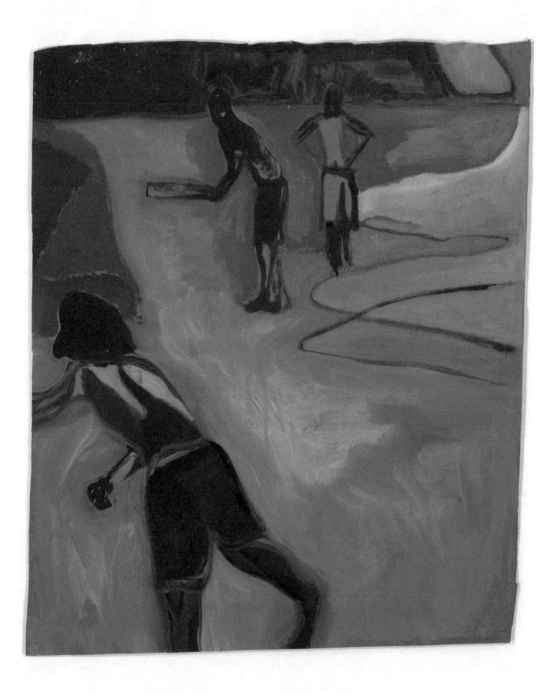

Paragon, 2005. Oil on paper, 26½ x 23 in. (67.3 x 58.4 cm). Private collection; courtesy Gavin Brown's enterprise, New York, and Michael Werner Gallery, New York and Cologne

TRISHA DONNELLY
Born 1974, San Francisco, California; lives in San Francisco, California

Trisha Donnelly bucks the convention that binds the exhibition to an expectation of being visible and presentable to viewers over a predetermined length of time. Her demonstrations occur unannounced and remain undocumented, at her insistence, and these unpredictable works are presented without explanation, creating an evasive mysteriousness that functions almost like a Hitchcockian "McGuffin." Just as that plot device twists the narrative of a film, thereby disrupting its temporal logic, Donnelly's works question the very nature and logic of the exhibition.

In an untitled work at the Cologne Kunstverein in 2005, Donnelly presented a grand, improvised organ work—created by an organist in collaboration with the artist—which was played only for a few minutes as the museum opened and right before it closed, thus marking the working day but also suggesting that the real goings-on might take place after hours. A single coughing sound was buried in the 20-minute recording. Visitors might be there at the wrong time and miss hearing it; or, they might hear it but think they'd imagined it.

Donnelly's silent untitled video (2005) appeases viewers' expectations only slightly more. Consisting of a frozen image of a taxidermied wildcat on a 10-minute loop, it shakes violently for 20 seconds every couple of minutes, as though the camera were convulsing. Neither medium nor message is explained, and although the convulsions suggest a potential narrative, none unfolds. This abrupt minimalistic aesthetic is also apparent in Donnelly's drawings, which often isolate a single element of an image, such as a sheet of cascading water cut off jaggedly in midair or a chinchilla's ear. Such truncated hints elude attempts to piece them together into coherence.

Donnelly's works, especially her demonstrations, contain certain extravagant elements. In an untitled piece for the opening of her debut solo exhibition in New York in 2002, she arrived unannounced and dressed in full Napoleonic costume on a white horse, dismounted, read a short proclamation, and then left. The act of withholding as much as possible from viewers so they appreciate all the more what little is released to them seems almost quaint in the context of our contemporary zoom-lens society. But Donnelly resists the expectation that art be quantifiable and lasting, favoring instead a carefully administered titillation.

ESM

The Grounding, 2004. Gelatin silver print, 48 x 47½ in. (122 x 121 cm). Collection of the artist; courtesy Casey Kaplan, New York

JIMMIE DURHAM
Born 1940, United States; lives in Berlin, Germany

Jimmie Durham's often-satirical art has changed gradually since he moved, in 1994, to Europe—or "Eurasia," as he calls the continent. He has departed from the explicitly ethnically coded vocabulary of his earlier sculpture, which often incorporated animal skulls and ethnographic references, though his work remains as politically caustic as ever. Throughout his career as a poet, theorist, editor, performer, sculptor, filmmaker, and American Indian Movement activist (he initiated the International Treaty Council in 1974), he has continually sought to address the exploitation of and disjunction with his Cherokee ancestry. As he has described: "There is a way my life is beautifully frustrating. I was raised a political activist and carver and a good fisherman and blacksmith. I label myself an artist for convenience."

Such cultural deals are struck in Durham's fable-like short film *La Poursuite du bonheur / The Pursuit of Happiness* (2003), in which one cannot help but see hints of autobiography. The setting is Arizona (though, in the tradition of Sergio Leone's "spaghetti westerns," it was filmed in Europe, in this case, Italy). A fictional Native American artist named Joe Hill, played by Albanian filmmaker Anri Sala, is seen wandering the desert picking up bones and trash for his art, which, according to Durham, might look "like the work of an American-Indian Julian Schnabel." He is soon discovered by an art dealer (played by gallerist Mario Pieroni), who hands him piles of cash, at which point the artist torches his trailer and moves to Paris. Like Peter Fischli and David Weiss's film *The Least Resistance* (1981) before it, *La Poursuite du bonheur* is a parable and a parody of the global art world and the path to success.

Durham's 2005 public sculpture *Particle/Wave Theory #2*, in South Hylton, England, is another exercise in displacement, this time through misplaced geology. He located a huge granite boulder—weighing almost three tons—and painted beady eyes and a smiling mouth on it. This rock character was then craned into position to sit in a 17-foot-long bright red fishing boat marooned on the bed of the river Wear. As the tide came in, the boat would become inundated with water until, at its highest point, all that remained above the surface was the tip of the boulder and its unblinking eyes. Summoning a dialogue between monumentality and impermanence, the irreverent boulder, like so much in Durham's dissident oeuvre, looks back at the viewer with an acute and humorous, yet potentially invective, look.

MA

Still from *La Poursuite du bonheur/The Pursuit of Happiness*, 2003. 35mm film, color, sound; 13 min.

KENYA EVANS
Born 1974, Sumter, South Carolina; lives in Houston, Texas

Kenya Evans's paintings and sculptures convey an intentionally didactic message about history's tendency to repeat itself. In their sampling of diverse references, these pseudohistorical collages, which combine texts from children's books with popular toys, and comics with Islamic proverbs, comment on the reductive simplicity of history books, while asserting their own critical analysis of the foundations on which the United States was built.

In the painting *Untitled (Overseer)* (2003), the canvas is neatly covered in trademarked cotton logos. A text reads: "Nearby stood the overseer. It was his job to see that the slaves did their work well. If they didn't, he used the big whip he always carried." The simplified text is made absurd by the illustration, which shows a slave on the ground with one arm raised in self-defense from an imaginary whip being wielded by a drooling sharklike Transformers robot. Evans's use of a cartoon character to represent the overseer might at first seem to trivialize the scene; however, the creature is mechanized—uncrushable—inferring the continued oppression of African Americans in contemporary society by the "machinery" of racism.

They Killed Raheem (2004) invokes the oppression of institutionalized racism. The sculpture consists of three flat vitrines joined together to form the shape of a boom box. Rose petals, the logo of the hip-hop group Public Enemy, and the lyrics of their 1989 song "Fight the Power," written on circular discs of paper, constitute the "speakers." "Fight the Power" is the title song of Spike Lee's 1989 film *Do the Right Thing*, in which the character Radio Raheem, who always carried his boom box on his shoulder, is killed by the police. Lee's film was a scathing critique of police brutality; Evans updates the critique by placing a plunger and the number 41 in the boom box's central vitrine, references to the cases of Abner Louima, who in 1997 was brutalized while in custody of the NYPD, and Amadou Diallo, killed in 1999 by NYPD officers, who fired forty-one rounds.

Evans is also a hip-hop musician, and his use of the medium—itself a repository of black experience and a primary means of black expression—in his artwork functions to create a multilayered juxtaposition of historical and contemporary situations, making it all too clear that little has changed.

ESM

Evans is a member of Otabenga Jones & Associates, also in the 2006 Biennial.

Nearby stood the overseer.

It was his job to see that the slaves did their work well. If they didn't,

he used the long whip he

always carried.

Untitled (Overseer), 2003. Acrylic, latex, marker, and graphite on canvas, 30 x 38 in. (76.2 x 96.5 cm). Collection of the artist

URS FISCHER
Born 1973, Zurich, Switzerland; lives in Zurich, Switzerland, and Los Angeles, California

Urs Fischer's artistic practice is founded on a consideration of the nature of substances, the act of making, and the unpredictable processes that can result from combining the two. With an extraordinarily wide range of materials—Styrofoam, clay, mirrors, fruit, wax, wood, glass, paint, sawdust, and silicone, to name a few—he resuscitates art historical genres such as still lifes, nudes, portraits, and landscapes in potent sculptures that reflect the complexity, wonder, and banality of everyday life. His works reverberate with material transformation and decay as well as with poetic internal collisions and contradictions that cause his sculptures to oscillate between seeming beautiful or ugly, elegant or awkward, graceful or burdened.

In a series from 2000, Fischer screwed together half a pear and half an apple, half a cucumber and half a banana, half an onion and half an eggplant. Each coupling was suspended from a single nylon string and left to decay, the forces of nature alternately attracting or repelling within each union. For his 2004 exhibition *Kir Royal*, he presented several recurring elements in his oeuvre—cats, chairs, female nudes, liquid drops, cigarette cartons, tea sets, and skeletons—spread throughout the space in various states of being and interaction. Three life-size female nudes in vaguely sexual poses, hand-sculpted from wax with several wicks embedded and then hand-painted, were set alight. Over the course of the exhibition, the figures melted away in hunks of barely discernable limbs and colored tendrils of molten wax that pooled onto the floor. *Memories of a Blank Mind* (2004) consists of a collection of handcrafted straight-back chairs, the "shadow" of which seems to be projected onto the wall behind them as if cast from a low-lying light source. In fact, this shadow is actually a large wood and mirror structure attached to the feet of the sculpted chairs in a gesture that upends expectations about reality, representation, scale, and perspective.

Bread House (2004) is a life-size cabin built from loaves of sourdough bread, expandable foam, and wood. The quaint alpine structure is set on an arrangement of Oriental carpets and inhabited by four young parakeets that haven't yet learned to fly. Over time the house decays, shedding crumbs on the floor and emitting a distinct, pervasive odor. As with all of Fischer's works, the meaning lies within the very substances and processes of its making, whereby ideas become material and materials take on a life of their own.

JM

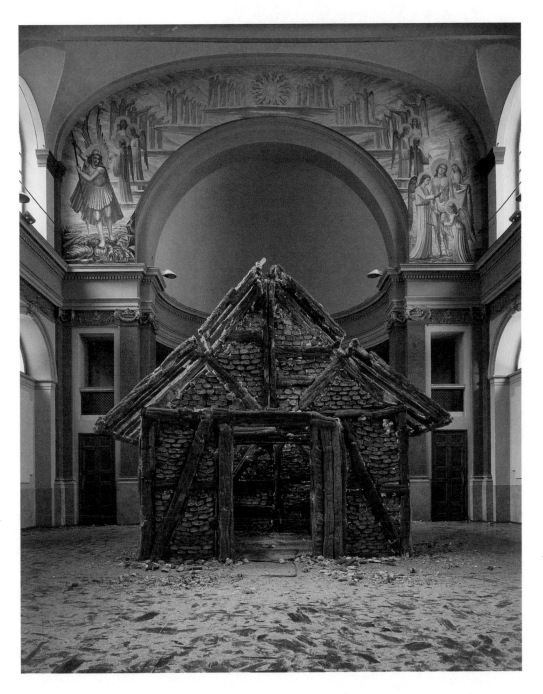

Bread House, 2004 (installation view, Fondazione Nicola Trussardi, Milan, May 2005). Bread, wood, screws, expanding foam, and light, 144⅛ x 209⅞ x 185⅞ in. (366 x 533 x 472 cm). Collection of Angela and Massimo Lauro; courtesy Galerie Eva Presenhuber, Zurich, and Gavin Brown's enterprise, New York

INSECTS ON A BOUGH

DAVID GATTEN
Born 1971, Ann Arbor, Michigan; lives in Ithaca, New York, and Brooklyn, New York

Over the past six years, David Gatten has worked on a cycle of films that take inspiration from the library of William Byrd II, an American colonial writer, planter, and government official. Sweeping in scope, Byrd's collection of about 4,000 volumes was one of the largest in early eighteenth-century North America and a conduit for introducing important works of European philosophical and political thought to the continent. Since happening upon Byrd's little-known title *The Secret History of the Line*, along with its better-known companion *History of the Dividing Line*, Gatten has delved into the Virginian's life in four films thus far (eventually the project will encompass nine films under the overall title *Secret History of the Dividing Line, A True Account in Nine Parts*). Focusing on specific volumes from the library, letters, and personal papers, Gatten's series probes the relationships between printed words and images, philosophical ideas, historical records, and biography. Throughout, his thematic concerns are realized in an array of cinematic processes and techniques, constituting a parallel survey of the medium's history.

The Great Art of Knowing (2004), the film most recently finished but forming part two in the overall series, refers to the seventeenth-century encyclopedia of the great polymath Athanasius Kircher (who, incidentally, invented the magic lantern, one of the precursors to the cinema). Whereas Gatten's first two films, *Secret History of the Dividing Line* (1996–2002) and *Moxon's Mechanick Exercises, or, The Doctrine of Handy-works Applied to the Art of Printing* (1999), were made almost entirely without a camera, the recent work contains scenes photographed on rich black-and-white reversal film. Opening with a sequence of outside shots, including the black wing feathers of a dead bird, dried leaves, and branches, the film shifts to the inside, depicting spines and pages from books. The contrast of disparate elements is continued in a series of excerpts from Byrd's "secret diary" and from his daughter Evelyn's letters to a lover of whom her father did not approve. Her intense longing and heartbreak stand in contrast to Byrd's resolutely unemotional chronicling of physical activity, studious research, and consumption of meals throughout the day. Magnified pages from Leonardo's notebooks, filled with illegible script, are shown about midway through the film, a passage that hinges on the moment when letterforms are read as image (the idea of secret writing weaves through the series as Byrd himself also wrote his diary in a hieroglyphic code). Between the enigmatic signs and the lines of writing by William and Evelyn emerges another narrative that is traced throughout in Gatten's continuing cycle: a story of hidden meanings, buried secrets, and the ghosts of the past.

HH

Still from *The Great Art of Knowing*, 2004. 16mm film, black-and-white, silent; 37 min.

JOE GIBBONS
Born 1953, Providence, Rhode Island; lives in Malden, Massachusetts

Since the 1970s, Joe Gibbons has fashioned a volatile, erratic, eminently untrust-worthy, and scathingly funny persona in his Super 8 films, Pixelvision works, and digital videos that blur the boundaries between autobiography and fiction. *Confessions of a Sociopath* (2002) presents a summary examination of the artist's professed self-destructive tendencies. Combining footage collected over three decades, Gibbons documents himself shooting heroin, shoplifting, being counseled by a parole officer, and being analyzed on a psychiatrist's couch. Dryly assessing his character's antisocial behavior, he plays on the comical contrast between his clean-cut appearance and the steadfast defiance of a conventional lifestyle. The recent sequel, *Confessions of a Sociopath 2* (2005), continues to plumb the abyss of the artist's psyche but turns the tables on the disciplinary institutions that enforce the parameters of acceptable conduct. Rather than presenting his character "as socially maladjusted and clinically disturbed," the film, according to Gibbons, "[makes] a case for the opposite perspective."

Mining Freudian territory in *Doppelganger Part 1* (2005), Gibbons plays a man who believes he is being followed by his double. Convinced that his life is in danger, the artist's alter ego is a man on the run, fleeing from one anonymous hotel to the next, from one country to another. The video unfolds like an absurdist spy thriller, as the man suspects the shadowy figure of his adversary in every window reflection and around every corner.

In the recent video *A Time to Die* (2005), Gibbons returns to his characteristic format of conducting intimate conversations between himself, the camera, and a third party. Playing an irascible hit man accosting autumnal flowers whose time has come to die, he crouches, holding a jackknife, near a yellow lily and snarls, "There's nothing more pathetic than a thing of beauty hanging on to its beauty after its prime" before ferociously whacking the blossoms from the stem. In his solitary monologues delivered to the camera, Gibbons continually skirts the darker recesses of the human mind, unveiling fantasies of power and violence with sardonic wit.

HH

Still from *Doppelganger Part 1*, 2005. Video, color, sound; 10 min.

ACTION

IMAGE

ROBERT GOBER
Born 1954, Wallingford, Connecticut; lives in New York, New York

Since the late 1970s, Robert Gober has been making objects, photographs, and large-scale installations that operate like faltering allegories shot through with anxious refrains. Diverse thematic concerns can be traced throughout his work, encompassing the iconography of Catholicism and the body, AIDS and perceptions of sexuality, childhood memories and ideals of the all-American family. Anomalous materials and incongruous scale often imbue Gober's objects with portentous meaning or suggest odd transfigurations. His wax torsos and limbs have an uncanny resemblance to pallid skin, for example, and his larger-than-life sticks of butter suggest an alternatively colossal reality. Drains and pipes appear regularly as cognitive triggers, surrogates for the conduits or orifices of the body, and water often seems to function as an agent of redemption or baptism, cleansing or drowning. Gober's 1997 mise-en-scène for the Los Angeles Museum of Contemporary Art included a concrete figure of the Virgin Mary run through with a bronze pipe and standing on a flooded storm-grate-cum-wishing-well. A 2005 chapel-like installation of works in New York featured a crucifix with a headless Christ-figure that cascaded water from its nipples into holes in the floor.

In *1978–2000* (1978–2000), Gober uses an almost forensic application of sequencing and erasure, and once again explores the agency of water—in this case, the sea. This work compiles rephotographed, grainy snapshots taken during a 1978 drive from New York City to Jones Beach and recent images, often appearing as overlays or insets, of beached flotsam near the artist's studio on Long Island. In this way, three entangled balloons might function, as the artist has suggested, as "stand-ins for human bodies and lungs" that, alongside the indelible plastic detritus, evoke a melancholy in which "these lost then returned objects knew another world that we'll never know anything about." In the central images of the sequence, a fragment of a newspaper clipping about a man who was murdered because he was believed to be gay, a published letter appearing to condone another homophobic killing, followed by an image of the Stars and Stripes reverberate to evoke a washed-up, washed-out American journey of callousness and tenderness.

MA

238

Detail from *1978–2000*, 1978–2000. Gelatin silver print, 25½ x 33¾ in. (64.8 x 85.7 cm). Collection of the artist; courtesy Matthew Marks Gallery, New York

JUMP
© MASON THATER 05
TEAM PHOTOS & T's
© TKM STUDIO 05

60

DEVA GRAF
Born 1974, Lafayette, Indiana; lives in Arizona

In her multimedia sculptures and installations, Deva Graf considers notions of hybridity, wholeness, and the nature of sculptural space. She combines figurative and abstract elements in a manner that alludes to and confounds the history of modernist sculpture, particularly its conventions of display, and creates charged psychological encounters.

Graf began investigating the viewer's experience of figurative sculpture in a series of grotesque humanoid and zoomorphic forms placed on pedestals to focus our attention on these objects of "curiosity." In *Untitled Figure* (2003), a sculpture in the shape of a rabbit's head is partially sheathed in a Stussy-brand T-shirt. The relationship between the rough purple head and its smooth purple base refers to the history of early modernist sculpture and its object-pedestal dialogue. This formalism is wedded to a specific evocation of fashion and culture of the recent past in the form of the T-shirt. This combination of disparate sources leads to a condition that Graf describes as "extra-wholeness."

Following a desire to shift the effect of her work from singular excess to composed unity, Graf moved her figures off the pedestals and into installation formats that both responded to and activated the architectural space of the gallery. In *The Space Between Us* (2004), she used a variety of strategies to charge the space. Several sculptures, including a tree stump and a man's head with a candle sprouting from its top, sat directly on the floor. In one corner of the room, at floor level, was a small wall drawing entitled *black hole*, which consisted of concentric black lines moving gradually closer together until they formed the illusion of a dark hole. The adjacent corner was highlighted by *When You Look Into the Ovoid the Ovoid Looks Back at You*, a large triangular piece of mirror on a sculptural base wedged between the two walls and framed above by an expansive, arching line of black ink. In this case, viewers were directed to the gallery's architecture and then back to themselves, caught in the act of looking.

Graf further explores this experience of reflection and space in a recent series of works on paper, *Mirror Photocopy I* (2005) and *Mirror Photocopy II* (2005). These eerie black images are created by photocopying a 12-by-12-inch mirror in an endless "Möbius strip" of reflection. Rather than viewing this act as a nihilistic gesture, she considers these works to be neutral surfaces of pure reflection, an apt metaphor for all human interaction whereby "human beings are engaged in similar endless simultaneous acts of perceiving the world and also being perceived by the world."

GCM

Untitled Figure, 2003. T-shirt and mixed media. 60 x 8 x 8 in. (152.4 x 20.3 x 20.3 cm). Collection of Lorelei Stewart and Andreas Fischer

DTAOT: COMBINE (DON'T TRUST ANYONE OVER THIRTY, ALL OVER AGAIN), 2005

Dan Graham, with Tony Oursler, Rodney Graham, Laurent P. Berger, and Japanther

In 2004, Dan Graham revisited and rewrote a project he had conceived in 1987 to be a live rock puppet show. Along with Sandra Antelo-Suarez, he brought together a group of artist friends, Tony Oursler, Rodney Graham, and Japanther, and a team of others in a unique collaboration entitled *Don't Trust Anyone Over Thirty: Entertainment by Dan Graham with Tony Oursler and Other Collaborators* (DTAOT).

The narrative of *DTAOT* revolves around Neil Sky, a young rock musician (based on Neil Young and Sky Saxon). Sky, having started teenage riots in Sunset Strip, campaigns for lowering the voting age to fourteen and, eventually, after lacing Congress's water with LSD, becomes the youngest president of the United States. Everyone over thirty is sent off to reeducation camps, where they are given copious amounts of LSD, and things are hunky-dory until Sky's adopted son, Dylan, aged eight, topples Sky and takes over.

DTAOT's satirical history of America's preoccupation with youth and how its manifestation during the psychedelic era as youthful hippie rebellion, epitomized in the slogan "Don't trust anyone over thirty," turned in on itself is distilled into a small-scale, intimate performance. As Rodney Graham has commented, "America was always responsible for youth culture in relation to the rest of the world.... In the time period when this work takes place, ideals were still in place above money, and the theme loosely traces this decline: from utopia to market."

One of the motifs of that doomed utopian moment in the 1960s was the concept of communality and collaboration. Like the hippie generation it satirizes, *DTAOT* is striking in its refusal to be defined by a single medium or structure. It also changes and evolves as it is presented in different situations. *DTAOT* defies all attempts to categorize, authorize, and finalize itself, or its subject. In the end, in this revolutionary spirit of rock, punk, and psychedelia, the final collaborator is the audience.

DTAOT: Combine (Don't Trust Anyone Over Thirty, all over again) (2005) is an installation version of *DTAOT* that premieres in the 2006 Biennial. The installation, which contains many of the same structural elements as the live performance—a purple carpet, benches, curtain, and proscenium stage area—includes a new two-channel video by Tony Oursler and a selection of conceptual drawings and collages by Dan Graham, Oursler, and Berger in an installation structure designed by Berger. On the proscenium arch wall, two overlapping projectors create random live combinations of images and double exposures on the screen, combining notations, instructions, and scripts that create an experience of the spirit of late 1960s rock culture and the utopian communalism that characterized that hippie generation.

In the immersive environment, drawings on the walls are juxtaposed with Oursler's videos, including new footage of Japanther performing their songs, pretaped puppetry, and documentary footage of the 1968 student riots in cities around the world. A 5.1 surround soundtrack, designed by Bruce Odland, combines Japanther's songs, *DTAOT*'s narrative, and Rodney Graham's gently ironic theme songs, which are counterparts to Japanther's jagged postpunk anthems.

ESM/CI

Video by Tony Oursler; script, drawings, and notations by Dan Graham with Tony Oursler, Laurent P. Berger, and Japanther; installation design by Laurent P. Berger; recorded music by Rodney Graham; recorded performing band Japanther; sound design by Bruce Odland; puppets and direction by Huber Marionettes; props by Eugene Tsai; video props by Tony Oursler Studio; installation design by Laurent P. Berger. Script by Dan Graham with Teresa Seeman, Sandra Antelo-Suarez, Roger Denson, and Tony Oursler. Curator: Sandra Antelo-Suarez. Producer: TRANS>. Co-producers: Foundation 20 21, New York; Walker Art Center, Minneapolis; Thyssen-Bornemisza Art Contemporary, Vienna; and LAB/Voom HD Originals, New York

Tony Oursler, collage of images from *DTAOT: Combine (Don't Trust Anyone Over Thirty, all over again)*, 2005

RODNEY GRAHAM

Born 1949, Vancouver, Canada; lives in Vancouver, Canada

Rodney Graham emerged from the conceptually rigorous artistic community of Vancouver in the 1970s, alongside other theoretically inclined artists such as Jeff Wall and Ian Wallace. Graham's work fuses his strong grounding in literature and philosophy with a love of popular movies and music. A survey of his artwork might take us through a European tradition that links poet Stéphane Mallarmé and novelist Raymond Roussel with the artist Marcel Broodthaers, encountering along the way American pop-culture icons such as Jerry Garcia, Dr. Seuss, and Kurt Cobain.

Graham often explores the materiality of film and dissects cinematic apparatuses and processes. *Two Generators* (1984), the first of his films, and what he calls "lighting events," was shot at night on a single roll of 35mm film next to a fast-flowing river. As the generators of the title fire up, high-wattage studio lights illuminate the water for a few minutes but in the process drown out the sound of the river. *Coruscating Cinnamon Granules* (1996) also deals with qualities of illumination. It shows footage of the glowing sparks given off by particles of cinnamon as they are sprinkled on a heated spiral burner in a darkened room and is screened in a specially constructed kitchen-sized cinema. *Rheinmetal/Victoria 8* (2003) consists of a series of luxurious static shots of a vintage German typewriter that becomes dusted and eventually buried in snowlike flour. The film is projected using a monumental Cinemeccanica Victoria 8 projector, which provides the clattering soundtrack as these two obsolete technologies go head-to-head.

Torqued Chandelier Release (2005) likewise centers on a single object: a crystal chandelier suspended from a twisted cable that unwinds and spins back and forth before coming to a rest. The film was shot and is projected at 48 frames per second, double the usual speed, to offer the eye twice the fidelity of a normal cinematic image. Graham was inspired by Isaac Newton's famous experiment with a spinning bucket of water, which led to his theories about relative motion, as well as by a scene from the 1952 swashbuckler film *Scaramouche* in which Stewart Granger narrowly avoids being skewered by a falling chandelier. In order to make the subject larger in the frame, *Torqued Chandelier Release* was shot with the camera on its side and the projector, too, is placed on its side. In this way, the format breaks from the usual cinematic horizon line, allowing Graham to explore, as he says, a "'portrait' rather than 'landscape' oriented cinema."

MA

Torqued Chandelier Release, 2005 (installation view, Donald Young Gallery, Chicago). 35mm film, color, silent; 5 min.
Projected at 48 fps on a Kinoton PK-60E/PC high-speed electronic vertical formatted film projector with endless loop
system. Projector dimensions: 68 x 64 x 30 in. (172.7 x 162.6 x 76.2 cm). The Art Institute of Chicago

LOCAL

they BOTH LOST.

CASTLE FO

FOR RE

the END

PRINCESS

CASTLE

MONSTER

PRINCE

HORSE

CREDITS

the MONSter
his CAMEL-

In the ForEST
there bu A HANDSOME

A LA
CA

Once upon a
time

a
Once
fairy
tale
mor

HANNAH GREELY
Born 1979, Los Angeles, California; lives in Los Angeles, California

Hannah Greely re-creates disarmingly lifelike everyday objects such as beer bottles, doormats, and ladders, which she transforms through her use of incongruous materials to, as she describes, "change the common into something uncommon." In *Alice* (2004), she attaches a fly to a beer bottle by a piece of reinforced string so it hovers in midair as if about to land for a sip; a sleeping dog morphs out of a doormat made from coconut fiber in *Muddle* (2004); and the rickety ladder of *Assembly* (2001), constructed from newspaper, becomes a resting place for hordes of insects. In its hyperreality and its combination of the mundane and the bizarre, her work resembles that of contemporaries such as Frank Benson and Matt Johnson, as well as their predecessor Charles Ray. She and Johnson are also among a number of artists currently working in Los Angeles whose sculptural practice emphasizes a return to objecthood and away from room-size installation. This "thingness" prompts an appraisal of the surprise value that is latent in everyday objects.

Greely's distinctive slant on the exploration of objecthood comes through in her sculptures' narratives, with their implied threat of violence or blatant absurdity. *Silencer* (2002) depicts a toddler, made of cast urethane rubber, in a diaper putting its head under the hood of a jacket. The addition of large eyes on the hood gives the sculpture a cartoonish aspect, but this anthropomorphization also heightens the anxiety that the coat might actually swallow the child, which is reinforced by the toddler's bowed, kneeling, and seemingly defeated pose.

The narrative suggested by *Rascal* (1999) is equally bewildering. A dog with eighteen legs carries two diminutive figures on its back. The dog's legs appear to wobble, as if the weight of these tiny passengers is proving challenging. Greely instills her sculptures' narrative with haptic qualities, what she calls their "tactile materiality." The dog is made of oil-based clay, which smudges and smells, making it an unstable material for a sculpture—and thus extending the visual pun into the sculpture's very make up as well. Rationality and surreality collide in Greely's work, with strangely compelling results.

ESM

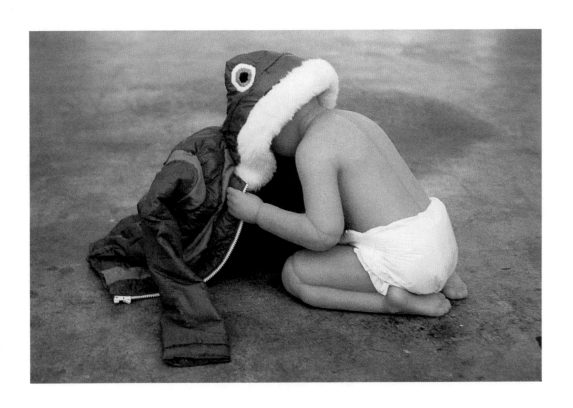

Silencer, 2002. Urethane rubber, nylon. 36 x 24 x 18 in. (91.4 x 61 x 45.7 cm). Collection of Dean Valentine and Amy Adelson

They Fought Like Hell

A Monster
Dwelt

RENT

CENTURY

PRINCESS FOR RENT

FOR RENT

MARK GROTJAHN
Born 1968, Pasadena, California; lives in Los Angeles, California

Mark Grotjahn's paintings and drawings are informed by strategies that grow out of his interest in Pop art, appropriation, and especially Conceptual art from the early 1970s. In a body of work from the mid-1990s, Grotjahn meticulously copied handmade signs he found in neighborhood restaurants and bodegas throughout the Bay Area and Los Angeles, and then would offer his copy to the owner in exchange for the original. In a gesture that upended expectations about authorship and collaboration, Grotjahn exhibited the actual sign while his copy was displayed at its point of origin.

In his more recent series of "perspective" drawings and paintings, flat planes of densely applied colored pencil or paint radiate from a series of vanishing points that are set slightly askew along vertical, and sometimes horizontal, axes. In *Untitled (colored butterfly white background 6 wings)* (2004), multicolored bands of vibrant color splay out from points set along three distinct vertical pencil lines; the effect recalls both the wings of a butterfly and light radiating from a prism. Although the surface is resolutely two-dimensional, the work takes on an illusionistic, three-dimensional quality owing to Grotjahn's use of the centuries-old convention of aligning two or more vanishing points along a central axis to create depth. The rigorous formality of Grotjahn's composition gives way to fluttering movement, as the wings appear to pull forward or recede back.

The method by which Grotjahn determines the color and placement of his marks is both formal and idiosyncratic. The colors are drawn at random from groups presorted according to their ability to "hold together" visually; the radiant areas are placed by intuition. The result is a dynamic abstraction that appears analytical by design but with a compelling undercurrent of expressionism. In fact, beneath some of these surfaces lies another painting: Grotjahn sometimes begins his composi- tions by painting humorously grotesque visages and gestural grounds, which are then covered up by his abstractions. Combining the analytical approach of such artists as Frank Stella and Sol LeWitt with a process uniquely his own, Grotjahn offers visual experiences of pure color and surface while investigating the systems that drive creative production.

JM

Untitled (White Butterfly), 2005. Oil on linen. 75 x 49 in. (190.5 x 124.5 cm). Walker Art Center, Minneapolis

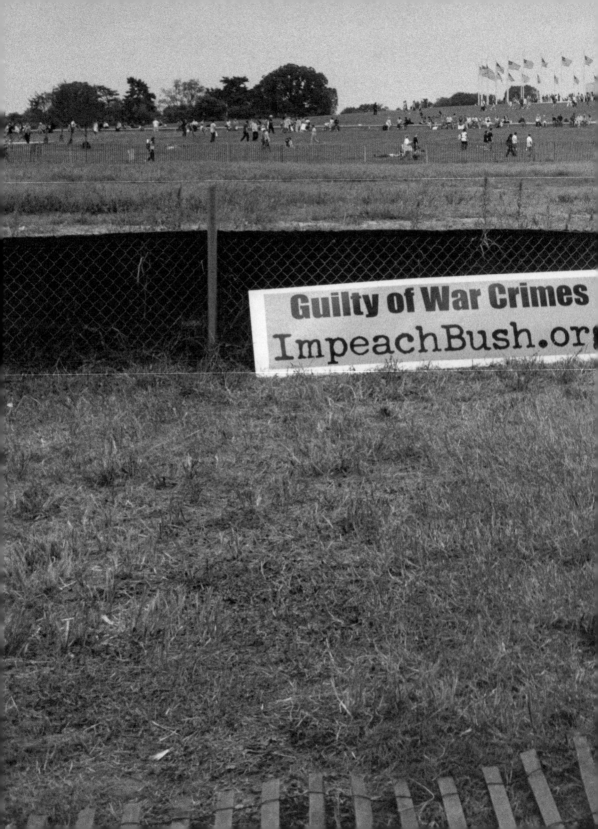

Guilty of War Crimes
ImpeachBush.org

JAY HEIKES

Born 1975, Princeton, New Jersey; lives in Brooklyn, New York, and Minneapolis, Minnesota

Jay Heikes's drawings, sculptures, videos, and installations are visual manifestations of the artist's attempt to purge himself of past cultural obsessions and influences in order to create a new space for artistic freedom. In many of his works, he appropriates and alters images from sources such as obscure MTV videos, cult films, and underground album covers to comment on the relationship between word and image, cultural stereotypes, and personal narrative.

To make the sculpture *Candle* (2002), Heikes cut out the lyrics from the Sonic Youth song of that name from pieces of denim, felt, and wool, in the form of exaggerated and elongated gothic font styles. He then laid the words out on top of one another on a low plinth. The layered arrangement obscures the text beyond legibility, creating an expressionistic composition in which the words return to pure form, emptied of content and significance.

For his 2002 exhibition *Kill Yr Idols*, which consisted of a trilogy of works, Heikes covered two walls of a gallery with photocopies depicting real and fictional personalities, including Sharon Tate, Laura Palmer (from David Lynch's television series *Twin Peaks*), and members of the British band Joy Division. These were sketched over with black ink and erased in spots with bleach. Alternately recalling drawings by high school students passing time in study hall and the grainy spectacle of Warhol's "disaster" paintings, the installation served as a kind of storyboard for Heikes's personal mythology in which a system of signs is corrupted by formal tactics that ultimately render them meaningless yet free them for multiple interpretations.

Heikes continues this process of formal corruption in his most recent work. However, instead of trafficking in pop cultural references, he employs a generic joke to serve as a metaphor for creative struggle. *So There's This Pirate ...* (2005) and *Return of the Parrot* (2005) present a series of stills taken from a video of the artist laboriously retelling a joke about a pirate and a parrot. Single images that relate key aspects of the joke are photocopied in large format, drawn over or erased by the artist, then installed like a running narrative on the wall. Less overt than Richard Prince's joke paintings and akin to the performances of comedian Neil Hamburger, the work embodies the kind of futile humor that succeeds because it fails. Through an elaborate process of translation—from verbal recitation to video presentation to visual re-presentation—the point of the joke becomes lost, an allusion to Heikes's perpetual fear of losing control over his work and his ability to communicate.

JM

So There's This Pirate… (Still 1300), 2005. Tempera, marker, and graphite on photocopy, 30 x 40 in. (76.2 x 101.6 cm). Private collection

63

DOUG HENRY
Born 1954, Las Vegas, Nevada; lives in Los Angeles, California

Influenced by the work of Conceptual artists such as John Baldessari, Jack Goldstein, Bruce Nauman, and William Wegman, Doug Henry began making films as a student at the Otis Art Institute in the late 1970s. *Measuring* (2004) is a humorous riff on some characteristics of that period's video art, especially its concern with systems of classification and measurement and its preoccupation with performative, repetitive actions. In the film, an actor is shown with a standard tape measure; as he repeatedly pulls the metal tape out of its green plastic casing, he flatly states, "This is eleven inches," "This is two inches," "That's six inches," and so forth. "I remember Baldessari, in a talk, saying something to the effect that he was interested in [art] that was simple, not simple-minded," Henry has said, "My recent work is something of an inversion of that idea."

Henry's recent short films, each consisting of a single scene or action, are deadpan exercises in reduction. In the 8-second-long *Not Afraid of Bob* (2003), a young man agitatedly stomps along a suburban California sidewalk. Suddenly, he turns around, addressing an unseen adversary behind him, and yells "I'm not afraid of you, Bob!" *Mickey Mouse Ears* (2003) shows the same actor approaching his parked car, loading a bag into the trunk, and getting behind the wheel. As he drives off, two decals stuck on the rear windshield frame his head with the shape of the iconic ears.

Henry sets up a satirical contrast between his films' scant subject matter and their proficient production values: often shooting on 16mm film, he cuts back and forth between different camera angles in the style of dramatic commercial productions. Set in unremarkable suburban yet recognizably Southern California environments and featuring a recurring cast of ordinary characters, his films present a humorously absurd vision of what it's like to live in proximity to the movie industry's superficial glamour. Exploring ideas of depth and surface, Henry's recent work inverts the notion that formal appearance disguises content. Instead, he seeks to create an experience in which "appearance is meaning."

HH

Stills from *Eatin' Pizza v1.0*, 2004. Video, color, sound; running time variable

PIERRE HUYGHE

Born 1962, Paris, France; lives in New York, New York

Pierre Huyghe explores the territory of reality and fiction, creating a site of convergence for interpretation, representation, and transformation. His work incorporates film, objects, and staged events such as celebrations, puppet shows, and musicals to address how we construct and translate experience. Although the final artwork often takes the form of a projected image, Huyghe's primary interest lies in the production of situations.

The Third Memory (1999) presents a reenactment of the 1972 bank robbery in Brooklyn that inspired Sidney Lumet's 1975 film *Dog Day Afternoon*. Huyghe's version is performed by the actual robber, John Wojtowicz, according to his recollections of the event and is paired with clips from both the fictionalized film version and newsreels of the heist that were aired live at the time. In the final installation, as multiple perspectives—both formal and philosophical—of the event are presented, reality and fiction become entangled in a representation of memory.

Huyghe's exhibition *L'Expédition Scintillante* (2002) translated a hypothetical journey to Antarctica into distinct temporal experiences meant to convey sensory aspects of such an expedition—melting ice, flashing colored lights, falling snow. This imagined experience became real in the project *A Journey That Wasn't* (2005). Inspired by tales of uncharted islands emerging from the melting ices of the Antarctic shelf, Huyghe embarked on an actual expedition to Antarctica with a handful of artists in search of an elusive white creature rumored to inhabit an unnamed island. Once discovered, the island served as a base for experimentations meant to facilitate contact with the animal. A machine set on the icy shore translated the island's topography into a musical score. This soundtrack served as the centerpiece for a musical equivalent of the expedition staged, and filmed, at Wollman Rink in Central Park in October 2005. In *A Journey That Wasn't*, footage from the re-creation—a negative version of the Antarctic landscape, with black ice, an albino penguin, and a forty-piece orchestra—is united with documentation from the original expedition. The resulting single film projection creates a new territory of reality where fact, fiction, and representation become one.

JM

A Journey That Wasn't is a project of the Public Art Fund.

Still from *A Journey That Wasn't*, 2005. Super 16mm film and high-definition video transferred to high-definition video, color, sound. Filming in Central Park, New York, a project of the Public Art Fund. Collection of the artist; courtesy Marian Goodman Gallery, New York and Paris

DOROTHY IANNONE
Born 1932, Boston, Massachusetts; lives in Berlin, Germany

Since the 1960s, Dorothy Iannone has been making vibrant paintings, drawings, prints, and objects depicting male and female figures in states of physical union and ecstasy. These works narrate the artist's life in intimate detail and, departing somewhat from the dominant feminist discourse of the 1960s, emphasize personal freedom and spiritual transcendence through complete devotion to, and union with, a lover.

In 1967, Iannone met the artist Dieter Roth in Reykjavík, Iceland. They fell immediately in love and began an intense seven-year relationship that became the primary subject matter of her artwork (the two remained close friends until Roth's death in 1998). Iannone's artist's book *An Icelandic Saga* (1978–86) illustrates in vivid detail her journey to Iceland and fateful encounter with Roth, her decision to leave her husband and comfortable life in the United States, and her move to Reykjavík to begin her new life.

Her paintings during that period convey the couple's everyday life and activities, with primacy given to the sexual aspect of their relationship. The abstract patterning in *At Home* (1969) provides a two-dimensional map of the couple's home, replete with plants, shelves full of books, and furniture. In paintings such as *I Begin to Feel Free* (1970), Iannone depicts herself and Roth in a number of sexual positions, the colors and patterns of their bodies echoed in the abstract forms that surround them. The titles of these paintings, suggesting intimate words spoken between the lovers, are inscribed on their bodies. Although they allude to timeless themes of love and spirituality, Iannone's paintings were immediately read as politically radical in the European art world of the 1970s. She famously pulled her works from a 1972 group exhibition in Berlin after the organizers attempted to censor imagery they found offensive.

Although painting remains her primary medium, Iannone has also incorporated time-based media into her work. In the large painted box *I Was Thinking of You III* (1975/2005), a video monitor serves as a surrogate head and shows the artist's face as she reaches orgasm. She has also made audio-based painted boxes that play the sound of her singing and music by members of the German band Kraftwerk. Such works lend immediacy to the states of ecstasy and spirituality so prevalent in Iannone's work.

GCM

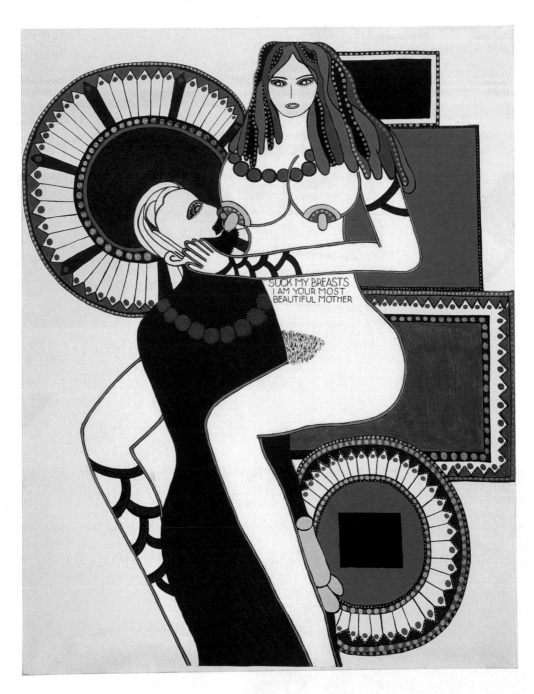

Suck My Breasts I Am Your Most Beautiful Mother, 1972. Acrylic and canvas collage on canvas, 74 13/16 x 59 1/16 in.
(190 x 150 cm). Private collection

orientering

MATTHEW DAY JACKSON
Born 1974, Panorama City, California; lives in Brooklyn, New York

Matthew Day Jackson's work takes the form of antimonuments that turn a critical eye on our cultural icons to address the romanticization of America's past, current political events, and environmentalism. Inspired by the Russian Constructivist notion of "art for the proletariat," Jackson employs materials scavenged from his past, his studio, and culture at large as well as imagery culled from American history, Native American mythology, and art history. Each element, whether material or symbolic, carries a significance at once personal and universal. When brought together, they create a narrative structure that illuminates the artist's belief in the redemptive possibilities of seemingly outdated ideals.

Jackson constructed *Sepulcher (Viking Burial Ship)* (2004) to mark his own symbolic death at the age of thirty, when he bid farewell to his previous attitudes toward creative expression. The hull is handcrafted from wood that once provided the support for Jackson's sculptures. Its sail takes the form of a Mondrian abstraction, stitched together from the artist's discarded T-shirts bearing the names of punk bands he once listened to and iconography of things he once believed in. In a reversal of the ritualistic role such vessels played in ancient cultures, as carriers filled with provisions for the deceased in the afterlife, *Sepulcher* provided the artist a means to cast aside the detritus of unproductive ways of thinking and in the process create something new.

Eleanor (2005) is a portrait of an exemplary public figure in American history: Eleanor Roosevelt. Using yarn, stained wood, feathers, and tooled leather, Jackson depicts this twentieth-century champion of social justice and humanitarian causes as a radiant being whose soul and ideals carry a lasting, regenerative power.

Chariot (The day after the end of days) (2005–6) transforms an icon of the American west, the Conestoga wagon, into a contemporary means of alternative transportation that resuscitates the ingenuity of the pioneer spirit. Pieced together from discarded wood and industrial plywood, with running gear borrowed from a Polish hay cart, this hybrid vehicle offers an innovative solution in the face of the stark realities of our dwindling natural resources. Jackson's individual brand of environmentalism heralds a new frontier in which creativity and resourcefulness emerge as our most valued currency.

JM

Eleanor, from *American Martyr* series, 2005. Spiked leather, yarn, scorched wood, stained wood, wood-burned drawing, polymer clay, abalone, mother-of-pearl, and panther taxidermy eyes, 120 x 96 in. (304.8 x 243.8 cm). Collection of Astrup Fearnley; courtesy Perry Rubenstein Gallery, New York

Imagine you're . After exile,

glance . see a lamp

against it. so moved

taped voices a

a dense Asian city, lost in a

between

right channel.

sang the periodic table acco

miniature cheese mandolin

grocery store,' narrates

all a r

remain misty.'

perfect crisis'. a 'nerv

the capacity

to

tru

CAMERON JAMIE
Born 1969, Los Angeles, California; lives in Paris, France

Cameron Jamie's work—a blend of video, sound, performance, photography, and drawing—deals with European and American history and culture, in particular their dysfunctional manifestations. His sharp critical gaze often focuses on ritualistic practices in popular culture, and his intricate work has its background in the artist's own folklore and mythologies. Using American suburban culture as a case study, he analyzes how the structures of mythology are shaped and shared, and the extent to which they participate in the creation of individuals' fictional worlds and fictional selves.

BB (2000) was filmed after a long investigation of the backyard-wrestling phenomenon in Southern California, in which teenage boys imitate the moves of their favorite wrestling stars with equal measures of athleticism, sexuality, violence, and aimlessness. For two years Jamie followed groups of young people in the San Fernando Valley, shooting videos, going to their wrestling shows, and integrating himself into their community. Eventually, he abandoned the video footage he'd made and shot *BB* in black-and-white Super 8 film with no sound and edited it in-camera. He added a soundtrack—the timeless, demented, slow, forceful music of The Melvins (who have accompanied the film in live performances)—creating a dreamlike state and reinforcing the nightmarish spectacle of the backyard ritual. In *BB* Jamie takes the documentary format to a new level, to what he has referred to as a purgatory state—a middle ground that, in his view, is perfectly embodied in the very notion of the suburb. *BB* is one of a trilogy of films that explores quasi-macabre folk rituals. Another film, *Kranky Klaus* (2002–3), looks at a Christmas ritual in rural Austria involving a shaggy creature known as the Krampus, which visits villages to punish those who have misbehaved. Ominous and intense, these films examine folk ritual and theater as an outlet for people to comment on their own culture and to express fantasies and ideas about themselves.

Death and resurrection, fact and fiction, and a twisted cultural memory of patriotism, Catholicism, and European history pervade Jamie's film *JO* (2004), which centers on the figure and iconic power of Joan of Arc, the martyr-heroine of the artist's adopted country of France. The film presents an intense transatlantic nightmare in which the saint became the inspiration for a type of deep-cooked french fries sold in fast-food stalls in the San Fernando Valley during Jamie's youth. In it, we witness an annual 400-year-old historical reenactment in Orléans, France, in her honor; an extreme right-wing nationalist rally and ceremony held at the statue of the saint in Paris, and a competitive hot-dog-eating contest at Coney Island. Force-fed and apocalyptic in its analysis of cultural bankruptcy, *JO* suggests the mythology of martyrdom as an analogy for the damaged, half-digested, and macabre cultural forms of the present.

MA/PV

Study for Kranky Klaus, 2002. Gelatin silver print, 10¼ x 14 in. (26 x 35.6 cm). Collection of the artist; courtesy Bernier/Eliades Gallery, Athens

NATALIE JEREMIJENKO/BUREAU OF INVERSE TECHNOLOGY

with Phil Taylor, Laura Kurgan, Daniel Perlin, and other intelligent creatures
Jeremijenko: Born 1966, Mackay, Australia; lives in New York, New York, and San Diego,
California; Bureau of Inverse Technology: Founded 1991

Natalie Jeremijenko uses new technologies in her art to develop alternative possibilities for the technological future and an institutional critique aimed at demonstrating the powerful role of technology in contemporary life: scripting our actions, directing our attention, and dramatizing our lives. In large-scale public experiments, "spectacles of participation," and video and media installations, she employs robotics, genetic engineering, and digital, electromechanical, and interactive systems to visualize data and facilitate natural systems (rather than virtual ones). Her devices are characterized by an "architecture of reciprocity," in contrast to technologies that further surveillance and asymmetrical power and control.

Tree Logic (1999) consists of six live trees that Jeremijenko planted in containers and suspended upside down, some twenty feet off the ground, in a courtyard at MASS MoCA in North Adams, Massachusetts. Over time, the inverted trees will manifest a growth pattern that challenges our assumptions about the "natural" shape of a tree, determined as it is by the tendency to grow away from the earth, toward the sun.

In the ongoing *One Tree(s)* project, which she began in 1999, Jeremijenko cloned a hybrid fast-growing, fruitless walnut tree, exhibited the sapling clones (which in fact looked quite different from one another) in a number of arts venues around the country, and then planted them in pairs throughout San Francisco. Despite common assumptions that genetic cloning produces identical physical traits, these trees dramatically prove otherwise, as each clearly takes on individual characteristics in response to the social and environmental factors of the area in which it grows. *One Tree(s)* contradicts the concept of genetic determinism and enables individuals to actually see shifts in their environment through the physical effects of those social and environmental changes on the trees planted in their community.

For the Birds (2005) is part of a larger project, *OOZ*, in which the artist reverses the concept of the zoo to produce new interactions between humans and animals. Bird perches installed in live trees are equipped with sensors; when a bird lands on one, it triggers lights and audio tracks instructing people to dispense food and water, share abundant resources, or perform other activities. Over time, the birds will learn that they can affect humans and will adapt to this form of communication, allowing them a means to convey some of their desires to the human population below.

JM

Goosing_ 7714: a folorn leda [robotic goose 5.6] piloted by humans ashore experiences social rejection from her biological counter-parts from *OOZ Goose translation database*, February 15, 2004. Robotic goose, goose control system, uncaged feral geese in urban setting, and database of annotated audio and video clips, using php scripting, MySQL database on Apache webserver, dimensions variable. Collection De Verbeelding art landscape nature, the Netherlands

66

DANIEL JOHNSTON
Born 1961, Sacramento, California; lives in Waller, Texas

Daniel Johnston has been writing and recording music for more than twenty-five years, earning considerable acclaim within the American music underground, and beyond, for his stripped-down yet highly ebullient lyricism. In the early 1980s, he began distributing his homemade cassettes, recorded in his parents' basement, to passersby on the streets of Austin, Texas. A prolific songwriter, his lyrics focus on a range of familiar American themes, including the joys and pains of love, the exploits of comic book characters such as Jack Kirby's Captain America, and the allure of rock and roll.

Each of Johnston's albums has been accompanied by examples of his unsettling drawings. These works are populated by a number of recurring symbolic characters that play out the struggles and triumphs of Johnston's life (he suffers from manic depression). Some of these, such as Captain America and the Devil, are clear signifiers of good and evil. Others are recognizable only within Johnston's personal lexicon, for example, Jeremiah the Frog, who symbolizes innocence. Johnston often portrays himself as a boxer with the top of his skull missing and out of which other creatures and visions emerge.

The world depicted in Johnston's drawings serves as a personal map of American culture, in which the iconographies of religion and popular culture are meshed. In *Rock and Roll* (2003), Captain America yells the title of the work as he punches the swastika-inscribed head of his comic-book nemesis, Red Skull. In the background, Satan looks on menacingly. The drawing references a historic battle between the forces of democracy and fascism to evoke the artist's own internal struggle and conflicts within contemporary culture at large. As a relentless collector of American popular culture in all its forms, Johnston both reflects and personalizes the moral and social tensions that are contained within.

Johnston has noted that his drawings often become source material for his songs, and their idiosyncratic style is in keeping with the lo-fi musical aesthetic he helped popularize. Like the characters in his songs, the creatures in his drawings play the guitar and long for the love of beautiful women. Johnston's art and songwriting are parallel and interconnected expressions of his psyche that resound with fundamental human longings and struggles.

GCM

Goodnite, 2005. Color marker on card stock, 8½ x 11 in. (21.6 x 27.9 cm). Collection of the artist

LEWIS KLAHR

Born 1956, New York, New York; lives in Los Angeles, California

Armed with scissors, paper, ingenuity, and a camera, Lewis Klahr animates the secret life of images. His method is simple, practically archaic: clipping images from vintage comic books and magazines, he arranges his materials on the floor of his garage, films them on 16mm film, then edits the footage into kaleidoscopic pseudonarratives. Through this primitive collage technique, Klahr practices a subtle and mysterious form of cultural archaeology, literally sifting through stacks of faded pop culture in search of lost narratives, suppressed potentials, and trapped significance.

The cutout animation *Pony Glass* (1997) is emblematic of the allusive, synecdochic nature of Klahr's work as well as its enthusiasm for unveiling covert meanings. In the subversive spirit of Situationist comics, in which the original contents of word bubbles were replaced by revolutionary rhetoric, Klahr hijacks the discourse of pulp images. *Pony Glass* performs a cut-and-paste *détournement* on Jimmy Olsen, the squeaky-clean cub reporter from the *Superman* comics who now becomes a figure wracked with sexual anxiety.

Klahr has enacted similar procedures on pornography (*Down Are Feminine*, 1994), fashion magazines from the 1940s (*Altair*, 1994), contact prints from the 1960s (*The Aperture of Ghostlings*, 2001), and baseball cards (*Soft Ticket*, 2004). The unique tenor of Klahr's animations owes a great deal to his eclectic use of music, from the ballads of Frank Sinatra to the propulsive avant-garde compositions of Glenn Branca.

Klahr often conceives his films in cycles or series, as in the eight-film *Picture Book for Adults* (1983–85) and the twelve-film *Tales of the Forgotten Future* (1988–91). His latest, *The Two Minutes to Zero Trilogy* (2003–4), was gleaned from a comic-book adaptation of *77 Sunset Strip*, a popular TV detective drama that aired from 1958 to 1964. In three films of decreasing length, Klahr splinters the original narrative almost beyond recognition, narrowing the focus to evocative shards of visual information. With its forefronting of the material surface (Benday dots and newsprint) and intuitive, artisanal montage, *The Two Minutes to Zero Trilogy* suggests a film noir collaboration between Roy Lichtenstein and Guy Maddin. Yet the beguiling tone, at once winsome and melancholy, is distinctly Klahr's, a signature effect of his unexpectedly moving aesthetic.

NL

Still from *The Two Minutes to Zero Trilogy*, 2003–4. 16mm film, color, sound; 33 min.

JUTTA KOETHER
Born 1958, Cologne, Germany; lives in New York, New York

Jutta Koether's restless energy translates into a prolific body of work that is at once affirmative and nihilistic. Although she writes and performs, frequently in collaboration with fellow artists and musicians, she is foremost a painter. Rather than hanging her paintings according to the conventions of the "white cube," however, Koether contextualizes her paintings within an "expanded field" by affecting a number of physical interventions in the space. In recent exhibitions these have included placing a silver exercise ball at the installation's center; painting the walls silver; putting shiny mylar-strip curtains at the gallery's entrance; and adding strobe lights. These strategies for obstructing and instructing the viewing experience demonstrate Koether's relentless interrogation of the conditions in which painting is produced and viewed.

Ladies of the Rope (Version 2) (2003–4) presents a blank face outlined by its hair; a single red thread hangs down one side of the canvas. Entangled in the hair is a quotation by Guy Debord comparing the spectacle (which he defines in his 1967 book *The Society of the Spectacle* as the saturation of contemporary society with images) to an opium war, "which unleashes a limitless artificiality in the face of which all living desire is disarmed." This iconography of decadence appears in collage elements in other works from this series of black paintings, in which liquid glass holds together a jumble of glittery party debris, chains, fake dollar bills, and New York tourist souvenirs (Koether moved from Cologne to New York in 1995).

Through her construction of an unresolved dialectic between nihilism and desire in *Ladies of the Rope* and elsewhere, Koether works toward a new (feminist) subjectivity that refuses any fixed, and thus easily typecast, identity. Her series *Hysterics* (2000) depicts outlines of female heads bearing only token facial characteristics on muddied background swirls of washed-out color. Some faces are crossed out; others have eyes with big bags under them; and in some cases, a blaze of light bursts from their center. Resisting easy interpretation, these frazzled-looking representations defy sexualized glamour, while leaving open the question of what might arise in its place.

In *Das Wunder* (1990), the words THE WONDER THE WONDER IS AS ALWAYS are painted in German in block letters across the canvas. The words are obscured within frenetic, colorful swirls that radiate outward from the painting's center. Here, as in all Koether's work, the wonder is simultaneously denied and celebrated.

ESM

Very Lost Highway, 2005 (installation view, Galerie Daniel Buchholz, Cologne). Installation with drawings, paintings, and miscellaneous media, dimensions variable. Collection of the artist; courtesy Galerie Daniel Buchholz, Cologne

The Family art

Barceloneta P.R.

ANDREW LAMPERT
Born 1976, St. Louis, Missouri; lives in Brooklyn, New York

In his triple capacities as filmmaker, programmer, and archivist, Andrew Lampert engages film as a tactile, proximate entity to be handled with delicacy and care. Against the production and exhibition of the moving image as large-scale spectacle for mass consumption, Lampert is devoted to small-gauge cinema (16mm, Super 8), fragile forms (home movies, found footage), and the most intimate contexts for presentation. *For Plastic Man* (2004) is an 8mm "projector performance" intended for an audience of one; after receiving a personal invitation, the lone spectator experiences the work in the privacy of Lampert's apartment, where the artist oversees the projection and sound.

The performative, improvisational aspect of Lampert's "expanded cinema" practice is further modulated by his ongoing collaboration with experimental cellist Okkyung Lee. From an archive of Super 8 and 16mm portrait footage of the musician, Lampert has culled a variety of single- and multiple-screen works, including *#6 Okkyung* (2004) and *Okkyung Duet* (2004–5); the latter can be screened by itself or incorporated into a live performance with Okkyung on the cello, accompanied by as many as seven simultaneous projections. "This is an improvisation," Lampert says of the work, "and the projectors are my instrument." By manipulating the frame rate, the cine-soloist creates percussive effects of shadow and light, and, through the use of multiple projections, approximates polyphonic musical structures.

As befits an artist with keen musical sensibilities, Lampert is highly conscious of duration. "Time," he says, "is the motif in one way or another with most of my works. Not just duration but the breakdown/disturbance/questioning of linear and 'fixed' time." The triple-screen installation *Varieties of Slow* (2005) lists its official running time as "indeterminate." The Super 8 image consists of a several books on a shelf, whose titles constitute a punning thematic index: "time," "still," "light," "review," "Muybridge." Projected at a rate of three frames per second, three reels of this still life (one in black and white, one in color, and one with a red filter) follow in a sequence that "is meant to be performed for days, weeks, and months at a time: the ultimate slowing down."

NL

Still from *Varieties of Slow*, 2005. Triple-projection film and performance, dimensions variable. Courtesy Public Opinion Laboratory, New York

esidency

LISA LAPINSKI
Born 1967, Palo Alto, California; lives in Los Angeles, California

Lisa Lapinski's imaginative sculptures incorporate mainstays of their genre—wood and wire, cement and clay—as well as painting, photography, drawing, and more unconventional materials such as ornate wallpaper, nail salon advertisements, boxed foodstuffs, and Snoopy figurines. Her work often resonates with narrative meaning deriving from philosophical, historical, and psychological sources. For example, a recent installation, *Analysandom* (2003), alluded to the emotionally charged environs of a psychiatrist's office; a 2001 installation of sculpture contained objects that referenced the North African journeys of French poet-turned-mercenary Arthur Rimbaud. Lapinski's sculptures are intricately crafted and formally compelling. Yet through her unexpected combinations of imagery and materials—both playful and foreboding—viewers are drawn to attempt a deciphering of the uncertain narratives.

Nightstand (2005) was inspired by the iconography of Shaker gift drawings depicting religious ecstasy. Permitted during a brief mid-nineteenth-century revivalist interlude, such visionary drawings departed from the prosaic functionality of Shaker furniture. Lapinski conjoins these opposing aesthetics in what she calls "a piece of Shaker furniture that would appear to be an artifact of frenzied religious experience." The very structure of *Nightstand* reflects this sense of manic energy, and the piece requires apprehension from several vantage points. The drawers of the four walnut sewing chests that form its base are open, revealing other drawers nesting inside. Elaborate multicolored patterns of wood caning and framed reproductions of Hungarian-born French artist Gustave Miklos's Art Deco bird sculptures jut out in parallel and perpendicular configurations, sleek stand-ins for the folksy birds that appear in Shaker gift drawings. Workaday materials are interwoven with elements of whimsy: wooden stars of David and trapezoids are attached as decorations to the otherwise staid sewing chests; three jewelry display hands are laced with a gold costume necklace running through their fingers; a vibrant painting of a cape-clad female skeleton traversing a swamp accompanied by a frog adds a particularly incongruous touch.

Lapinski imports materials and histories to generate new forms: "I don't think any material dies," she has commented. The components of her sculptures lead double lives—as discrete objects with their own pasts, and as interconnected parts of the artist's sculptural constellations, in which histories collide and meanings multiply.
LP

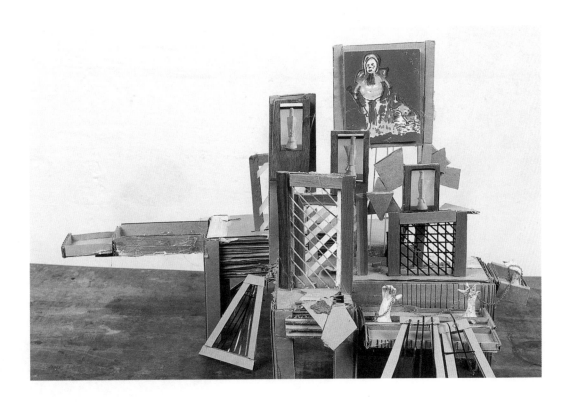

Sketch model for *Nightstand*, 2005. Mixed media, dimensions variable. Collection of the artist; courtesy Richard Telles Fine Art, Los Angeles

LIZ LARNER
Born 1960, Sacramento, California; lives in Los Angeles, California

Liz Larner's work, which ranges from diminutive objects to large-scale installations, reconfigures the traditional roles that form and color have played in the practice of formalist sculpture. Whereas color has historically been used to reinforce form, in her sculptures it takes on a more active role, functioning as the driving force in the viewer's engagement with the work. Her powerful use of color recalls the California Light and Space movement of the 1960s, in which heightened perceptual experiences manifested in real space are achieved through the generative use of color, or the way in which artist Ken Price applies color to his ceramic forms, effectively merging painterly and sculptural techniques.

In *Two or Three or Something* (1998–99), steel armatures welded together in the form of a collapsing cube are covered with watercolor paper washed in pale and vibrant yellows. These tones and the work's linearity evoke a fluidity and softness uncharacteristic of steel, thereby serving an almost counterintuitive structural role. The forced perspective and gestural quality of the form emphasize a relationship to drawing that is present in many of Larner's sculptures.

Untitled (2001) merges two primary and ostensibly opposite sculptural forms: the cube and the sphere. Developed with the aid of a computer animation program that morphed a sphere into a cube then spun it back into a sphere again, this hybrid manifests the various contradictory physical states such a metamorphosis would entail. Its dynamic green and purple surface, covered with the kind of iridescent paint favored by hot-rod enthusiasts, reflects different hues on each of the multitude of planes and adds to the sense that the object is caught in a moment between stasis and development.

RWBs (2005) is a red, white, and blue thicket of aluminum tubing, wire rope, batting, fabric, and ribbons. Demonstrating the power of color to evoke particular emotions and symbolic references, the work teems with associations tied to American culture—from patriotic parades to the vast rows of decorative banners that festoon used-car lots—and it is evident that these particular hues, in combination, cannot be separated from the political and nationalistic connotations they inspire. Larner's skill in recalibrating the forces within sculpture—color and form, stability and instability, movement and stasis—creates a new awareness of the material world and our own interaction with the complex objects that populate it.

JM

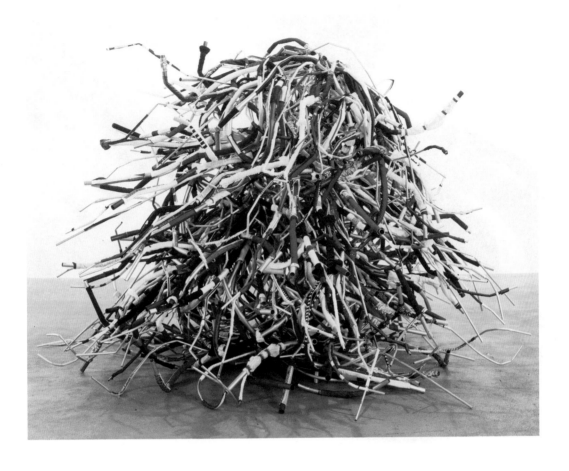

RWBs, 2005. Aluminum tubing, batting, fabric, ribbons, wire rope, padlocks, and keys, 82 x 117 x 117 in.
(208.3 x 297.2 x 297.2 cm). Collection of the artist; courtesy Regen Projects, Los Angeles

HANNA LIDEN
Born 1976, Stockholm, Sweden; lives in New York, New York

In Hanna Liden's photographs, figures with their faces obscured populate wide and desolate landscapes. The sky is almost always gray, giving the photographs a flatness that causes the stunning Scandinavian landscapes against which the figures are posed to look equally staged. Invoking the iconography of pagan rituals, the figures are either hooded or wear masks—death's-heads or gargoyles, which the artist makes herself. However, except for their masks, they look strangely normal; they wear jeans and sneakers or, when portrayed nude, their bodies are white and soft. Liden slyly acknowledges this incongruity: in one snowy forest scene, *Bus Stop* (2002), a shadowy figure waits by a bus stop that looks completely out of place within the striking chiaroscuro effect of the white snow on the dark trees.

Liden's photographs purport to be an anthropological documentation of postapoca-lyptic tribes living in the Scandinavian forests; but by adding contemporary figures and a thwarted narrative to her sumptuous landscapes, she also offers a version of the painterly sublime that avoids the genre's tendency toward romanticism. In *Lake with Fire* (2003), three hooded walkers in the foreground trudge in silhouette alongside a vast lake. The pallid sky is reflected in the water; evergreens loom on the other side; the bottom edge of the scene is licked by flames, which run the length of the photograph. The fire adds a threatening note to this otherwise near-pastoral idyll, but Liden provides no clues as to its relation to the rest of the scene—the flames could be a trick of the light or a product of our imagination.

Liden also makes kaleidoscopic black-and-white collages from the rejected images she calls her "failed photographs" in which the disorientating effect of her imagery is refracted and intensified. Both the collages and the photographs tap into a con-temporary Gothic trend in American art, a tendency often rooted in the psychology of the suburbs but which in Liden's work is firmly situated in the great outdoors. In this way, she updates a long tradition of the sublime in nature with her own wry sensibility for masquerade.

ESM

Swamp Walkers II, 2005. Chromogenic color print, 30 x 40 in. (76.2 x 101.6 cm). Collection of the artist; courtesy Rivington Arms, New York

JEANNE LIOTTA
Born 1960, New York, New York; lives in New York, New York

Jeanne Liotta was trained in theater and performance, working with groups such as the Living Theatre and Alchemical Theatre in the 1980s, and developed her interest in live performance and projected media in artistic collaborations with Bradley Eros (as Mediamystics) and the art rock band Circle X. In films, videos, performances, photographs, and installations made independently since 1995, Liotta continues to probe themes of existence and transcendence while inquiring into the ephemeral nature of her media.

In a number of hand-treated films, she explores the surface and materiality of celluloid, setting them into metaphoric relationship with organic processes of decay and regeneration. *Loretta* (2003) is a cameraless photogram animation with a moody score by Carlo Altomare that includes fragments of an opera. To make the film, Liotta placed a 35mm photographic negative of a female figure on top of raw 16mm stock and then flashlit it, section by section, creating evocative black silhouettes. The woman, an actress, had been photographed by Liotta during a live theatrical performance, and the film reanimates her gesticulating body while frames showing snippets of the film stock's sprocket holes or edge lettering dissolve and materialize against a hand-tinted background of blazing yellow.

Liotta is also a researcher for the Joseph Cornell collection at Anthology Film Archives in New York and is currently at work on a book devoted to the artist's films. Perhaps not coincidentally, her most recent body of work takes inspiration from astronomy and celestial phenomena, recurring themes in Cornell's work. Liotta's *Eclipse* (2005) consists of footage documenting a lunar eclipse in November 2003. She filmed the event from the roof of her building on Super 8 Kodachrome stock, which she subsequently hand-processed. In the film, a brief sequence of the darkened moon traveling through the frame from the bottom left corner to the top right is repeated several times while scratches and streaks on the hand-treated stock glow in luminous tones of orange and yellow on dark brown. Liotta notes that the work was conceived in the spirit of Aristotle's Lyceum, "a school for the study of all natural phenomena pursued without the aid of mathematics, which was considered too perfect for the application on the imperfect terrestrial sphere." Her filmic "translation" of the celestial alignment captures a fleeting, evocative moment while conveying its cyclical nature, which both predates and follows any individual act of human perception.

HH

Stills from *Eclipse*, 2005. 16mm film, color, sound; 3:30 min.

MARIE LOSIER
Born 1972, Boulogne, France; lives in New York, New York

Marie Losier's work is steeped in cinephilia. In early videos, she inserted herself into appropriated movie classics, performing the titular role of Carl Theodor Dreyer's *The Passion of Joan of Arc* (1928) and as the Elliott Gould character in Ingmar Bergman's *The Touch* (1971). Her penchant for camp theatricality, extravagant dress-up, and the glamour cinema's early years is also evident in a group of prints and photographs in which she assumes the identity of a fictional silent film star named Loula Nasaroff. Losier's more recent films form a series of whimsically idiosyncratic portraits of such underground luminaries as George Kuchar, Mike Kuchar, and Richard Foreman.

In *Bird, Bath and Beyond* (2003), a shot of filmmaker Mike Kuchar in a space animal-like costume is superimposed on an aquatic background; he recounts various anecdotes, in voice-over, including one about his childhood parakeet, Lulu, a bird that would run on a spinning turntable as though using a treadmill. Filmed in black and white, the work emulates the look of silent movies, interspersing short passages of old-fashioned cutout animation and overlaying pieces of humorous text. The elder Kuchar brother, George, is the subject of *Electrocute Your Stars* (2004). Opening with a montage sequence of footage from a B-horror movie, the film presents the bare-chested Kuchar being sprinkled with confetti and fanned with leafed branches as well as reading a comic book while wearing a retro swim cap. Throughout, he delivers commentary on nature and the weather, cannibalism, and the perils of filming actors in showers.

In *The Ontological Cowboy* (2005), Losier trains her nostalgic lens onto Richard Foreman, the renowned playwright and director of the Ontological-Hysteric Theater based in New York City's East Village. She films the three principal actors (dressed in period garb and heavy makeup) from Foreman's play *King Cowboy Rufus Rules the Universe*, a raucous production about a dandyish Englishman who dreams of becoming king of the universe. Through Losier's cinematography and editing, their live performance is fragmented, slowed down, and turned into her own silent-movie rendition. Foreman is interviewed, from offscreen, in his book-filled home and on the set, where he reflects on various aspects of his work in theater, having himself become an inhabitant of Losier's cinematic universe.

HH

Still from *The Ontological Cowboy*, 2005. 16mm film, black-and-white and color, sound; 13 min.

FLORIAN MAIER-AICHEN

Born 1973, Stuttgart, Germany; lives in Cologne, Germany, and Los Angeles, California

Florian Maier-Aichen's photographs oscillate between landscapes of incredulous sublimity and depictions of uncannily plausible catastrophes. Whether a Technicolor vision of a Malibu beach enshrouded in a pallid, rosy haze or a scene of a capsized cargo ship suspended laterally in a pixilated expanse of cobalt blue water, his images evince a preoccupation with making the familiar strange through effects of color, light, and composition.

Dissolving the difference between veracity and artifice, Maier-Aichen's work betrays a position at odds with the so-called Düsseldorf School surrounding the influential German photographers and teachers Bernd and Hilla Becher. Maier-Aichen did not study with the Bechers and in fact left Germany to study in Los Angeles, in part to divorce himself from the mandates of dispassionate formalism and social documentation advocated by them. Though he eschews their emphasis on the realistic depiction of functionalist architecture and the non-sites of modern industrialism, he nonetheless retains the looming monumentality of their images. But Maier-Aichen's photographs convey surreal constructions of place rather than objective articulations of it.

His works are not typologies but singular, subjective visions. In a recent series, bridges torque and veer into the ground. *Untitled (Long Beach)* (2004) and *Untitled (Tenaya Lake)* (2004) offer dramatic vistas that likewise play with the possibilities inherent in digital technology. Taking sites that have been frequently photographed by amateurs and professionals alike, Maier-Aichen produces fresh spectacles that transmogrify these recognizable locations into backdrops for unnamed narratives that invite our speculation. About Yosemite—and Tenaya Lake specifically—the artist has observed that it resonated for him as a "science-fiction scene without the spaceship."

Untitled (2004) produces another paradoxically staged reality. It is a faux-nocturne, an image that takes day for night. The foreground landscape anchors the view and provides the "stage set" for the computer-drawn stars. Here, as elsewhere in Maier-Aichen's work, a self-consciousness about the history of photography and the role of burgeoning technology within it allows for apertures of allusive power that are abetted by, but ultimately allowed to transcend, their technical means.

SH

Untitled (Long Beach), 2004. Chromogenic color print, 71½ x 92½ in. (181.6 x 235 cm). Private collection; courtesy Blum & Poe, Los Angeles

MONICA MAJOLI
Born 1963, Los Angeles, California; lives in Los Angeles, California

Monica Majoli's figurative paintings from the early 1990s to the present have depicted scenes of sexual fetishism—painstakingly actuated self-portraits with dildos or claustrophobically populated representations of S&M encounters between men. But she focuses less on the transcription of physical experience than on the suggestion of its most obdurate, if ineffable, psychological aspects and ramifications. Investigating themes and rituals of identity, intimacy, and mortality, Majoli's work is both a site for catharsis and an admission of its irresolution. A painting such as *Untitled* (1990), a small panel showing a slice of a woman's scarred pelvis, paradoxically implies intractable psychic distance that is unmitigated by corporeal proximity.

With the technical precision of a Northern Renaissance master, Majoli, in her earlier works, lavished attention on decidedly nonorthodox, sexually explicit scenes that are undeniably contemporary yet nonetheless betray a multitude of historical and religious references. These range from the invocation of Bernini's ecstatic Saint Teresa and David's beatific *Death of Marat* in her *Untitled* (1990) to more generalized tropes of masochistic Christian iconography, such as the martyrdom of the saints.

In her more recent series, Majoli has traded the factureless exactitude of oil paint for the runny swells of watercolor and gouache. She has also forsaken self-portraiture and depictions of friends in favor of more universal forms, while at the same time abandoning the diminutive scale of the earlier oils for a larger format. In her ongoing *Rubbermen* series, begun in 1999, Majoli loosely renders men donning multilayered rubber fetish suits. These garments function as a kind of second skin, a prosthesis that both envelops and redoubles the contours of the bodies they contain, implying at once protection and suffocation, restriction and pleasurable abandon. Because the rubbermen's faces and the details of their physiognomy are occluded through their encasement, their forms, often suspended and hanging from trees, become anonymous sites of identification and disavowal. Just what is our relation to them? Their isolated vulnerability and muffled presence imply and even mirror our own, while the rubber skin stresses and performs the impossibility of seeing, literally and metaphorically, inside even those who are closest to us.

SH

Hanging Rubberman #3, 2004. Watercolor and gouache on paper, 51 x 96 in. (129.5 x 243.8 cm). The Museum of Modern Art, New York, The Judith Rothschild Foundation Contemporary Drawings Collection

YURI MASNYJ
Born 1976, Washington, D.C.; lives in New York, New York

Yuri Masnyj creates densely populated yet intricately spare drawings that juxtapose and continually recontextualize elements culled from graphic design, architecture, art history, and the artist's imagination. Convolutions of line produce figurative and abstract elements, including disembodied eyes, linear slashes, concentric circles, prisms, chairs, wall units, and representations of framed paintings. It is on the space of Masnyj's page that these fragments of culture—high and low, artistic and popular, autonomous and commercial—can be assembled as collections in miniature, like modern *Wunderkammers* turned inside out.

Masnyj works from the position that the history of art has been radically domesticated and dispersed across a broadly diluted range of cultural practices and sites. He is critical, for instance, of the ways the lofty social and political ambitions of the Russian Constructivists have been drained of effect in their recapitulation as now-empty formal structures to be appropriated for mere decoration. Masnyj questions the viability and philosophical coherence of such modernist practices: "I take the position that the visual culture my generation inherited is a kind of flotsam and jetsam—the product of an exponential deconstruction." This deconstruction "took a mortar and pestle to the avant-garde but left art and design in splintered fragments."

Masnyj's work explicitly pillages the debris of our contemporary landscape, suggesting that the already small distance between the yard sale and the museum exhibition has perceptibly diminished. At stake in his reworking of such templates is not an attempted return to some imagined utopian past, but an expressionistic performance of present anxiety. Drawings such as *A Collision Point, In a Blind Run,* and *Climbing the Hole* (all 2005) attest to his calculated dynamism and deeply unsettling vision. In his installation for the 2006 Biennial, Masnyj pushes into three dimensions, filling the gallery with architectural panels, "aesthetic objects," and graphic elements. Constituting a drawing in space, the work challenges the boundaries between media and, in the process, invites us into a fictive world in ruins that has all the ambiguities of our real one.

SH

Climbing the Hole, 2005. Graphite on paper, 35¾ x 48 in. (90.8 x 121.9 cm). Collection of the artist; courtesy Metro Pictures, New York

T. KELLY MASON AND DIANA THATER
Mason: Born 1964, Hollywood, California; lives in Los Angeles, California
Thater: Born 1962, San Francisco, California; lives in Los Angeles, California

Distinctions between art and music—always hazily fluid in LA—were definitively sundered in T. Kelly Mason and Diana Thater's first collaboration, a five-hour "live performance for audio and video" titled *The future that almost wasn't* (1996–2000). Carried out with numerous guest artists and musicians, it included six video projectors and fourteen video decks showing sequences of images—from news footage of the Black Panthers to clips of Esther Williams swimming to excerpts from Fluxus films—as well as live-mixed video stills drawn from television, advertising, and the artists' own work. Prerecorded and live-mixed music emanated from turntables, keyboards, drum machines, and computers. This technical and stylistic profusion stemmed in part from the diversity of the pair's own practices. Thater's large-scale "neo-structuralist" video installations of the past fifteen years feature multichannel projections and colored gelatins applied to the architecture of the exhibition space, and take up themes ranging from the mediation of nature by culture to the influence of abstraction on animation. Mason was trained as a composer and musician and has used floral arranging, aerial photography, and urban planning as points of reference in his "communicative sculptures," while his text-based works probe the fault lines of linguistic signification.

Their joint projects explore alternative social spaces afforded by the overlapping of art and technology. Though keyed to a contemporary production that has resolutely renounced medium specificity in favor of expansive mixed-media installations, their work also bespeaks the legacy of early Performance art. Like much work from the late 1960s and early 1970s, Thater and Mason's collaborations blur the parameters of authorship, encourage communal viewing, and emphasize the intersection of experimental music, art, and technology.

The film *JUMP* (2004) presents twenty teenagers jumping rope in syncopation and trying to keep pace with a live band that plays four stylistically different versions—from a straight cover to a Mexican ranchero take—of Bob Dylan's "Subterranean Homesick Blues." Thater and a crew shot *JUMP* from 360 degrees, and Mason, who accompanies the band on bass guitar and vocals, recorded and mixed the music and designed the participants' textual T-shirts; both artists edited the footage in styles ranging from classical Hollywood streamline to jarring jump cuts. "Subterranean Homesick Blues" opens D. A. Pennebaker's film portrait of Dylan, *Don't Look Back* (1967)—a seminal moment in the history of music and its convergence with performance for the projected image.

LP

Production still from *JUMP*, 2004. 16mm film, color, sound; 16 min.

CHAOS ... CONFUSION ... DISORDE
DERANGED ... LAWLESS ... SICK ...
MORBID ...

DOMINANT, PREDOMINANT, PREVA
CONTROL, DOMINEER, TYRANNIZE
VAPOR, REALM ...

MASS, AGGREGATE, TOTALITY, LU
HEAP, MASSACRE.. CARNAGE.. BUT
[OF HUMAN BEINGS] ... SLAUGHTE
MASSIVE, PONDEROUS ... BULKY ..
HUGE ... CUMBERSOME ... MASSY .

... DEMISE ... DECEASE ... DEATH ..
... DISSOLUTION ... DYING ... MORT
... EXPIRATION ... MORT ...

TERRORE NELLO SPAZIO
by Steven Parrino

NOXIOUS, INJURIOUS BANEFUL, U
NOISOME, NUCLEUS, NUISANCE PI
PEST, BANE, INFLICTION, BORE, OF
NULL, INVALID, NUGATORY, NULL
ABROGATE, CANCEL, REPEAL, COU
NUMB ... DEADENED, UNFEELING,
BENUMBED

CORROSIVE, MUSHROOMCLOUDS
VAST ... IMMENSE ... MONSTROUS
EXTENSIVE ... IMMEASURABLE ...
COLOSSAL

ILLUMINATE ... FICTITIOUS, UNREA
OSTENSIBLE, ARTIFICIAL ...
VERITY... UNREALITY, PHANTASM
PHANTOM

ADAM MCEWEN
Born 1965, London, England; lives in New York, New York

In his sculptures, paintings, and installations, Adam McEwen deploys a series of interventions that jolt us temporarily out of our indifference, owing to over-exposure, toward the signs that dominate our daily lives. Although McEwen's text paintings situate his work in relation to artists such as Richard Prince, Ed Ruscha, and Christopher Wool, his conceptual practice links him more closely to Andy Warhol. Like Warhol, McEwen excavates our obsession, in a tabloid-dominated culture, with the lives—and deaths—of public figures and celebrities.

In *Untitled (A-line)* (2002), McEwen presents a life-size image, scanned from a 1945 photographic "souvenir" print, showing the lynched bodies of Benito Mussolini and his mistress strung up by their feet. But he has rotated the image 180 degrees, causing the lovers to be upright, reaching for the sky in a sort of grotesque ecstasy of death, which simultaneously deflates and heightens the horror of the image. In a series of faux obituaries of, among other celebrities, Nicole Kidman, Macaulay Culkin, Jeff Koons, and Bill Clinton, McEwen wrote or commissioned near-pitch-perfect newspaper obits, which he formatted on a computer and then photocopied, enlarged, scanned, and printed as large-scale photographs. The one detail missing from them all, however, is the cause of death, thus robbing these portents of a key element of their significance and effect. According to McEwen, his obituaries are "homages to their subjects, all of whom are unable finally to control their (real/fictional) personae as they spin out into the world."

As the text painting *Untitled* (2003) reads: "I hate you / you because / you make me / me hate you." Thanks to the slick delivery of McEwen's artistic predecessors, we are used to reading text in paintings in expectation of a punch line; therefore, on first viewing, McEwen's repetitions, which appear at the end of one line and the beginning of the next, go unnoticed. This type of sardonic self-reflexivity can also be seen in *Untitled (Dead)* (2002), an exact replica of a generic storefront sign, but which reads "Sorry We're Dead." Others from the same series read "Fuck Off We're Closed" or "Sorry We're Sorry," conveying more genuine sentiments, perhaps, than the ever-present through-clenched-teeth nicety of "Sorry We're Closed."

ESM

Jeff Koons

Artist whose controversial work included a 40-foot high puppy made of more than 70,000 live flowers

JEFF KOONS, the artist who has died aged 49, was responsible for some of the most provocative and iconic artworks of the last twenty-five years.

Among his meticulously produced sculptures were an enormous puppy made entirely of living flowers, a series of tanks in which basketballs were suspended as if by magic, and a life-sized depiction in porcelain of the pop singer Michael Jackson, along with his pet chimp Bubbles.

Koons preached an art for the masses. Armed with such slogans as 'Banality as Saviour' and 'Embrace Your Past', he overturned notions of good and bad taste by interweaving high art production methods with the most devalued and kitsch baubles.

These emblems of consumerism ranged from brand-new Hoover vacuum cleaners to inflatable toys to a host of gaudy, hand-carved souvenirs. In Koons' hands they became the keys to an astute and sophisticated critique of contemporary culture.

The direct descendant of Marcel Duchamp, inventor of the "readymade", and Andy Warhol, the master of pop iconography, Koons presented to the world a persona of sometimes bewildering sincerity. Seeing himself as a facilitator rather than as artist in the more conventional sense, he employed a small army of assistants to fabricate his works. Shiny, immaculately made and often very expensive - both to produce and to purchase - the results spoke eloquently of materialism, sentimentality, desire and death.

Coming to prominence in the early 1980s, Koons and his work were seen by many as the embodiment of the times – a double-edged compliment, as that decade was increasingly dismissed for its materialistic excesses. At the height of the artist's first run of success, when he was said to have earned more than $2.5 million through three simultaneous exhibitions in different cities, the critic Robert Hughes declared, "The art world is very sick."

Koons was accused variously of being a cynic, a faker and a peddler of shock effect – the last, particularly, after his 1991 show entitled 'Made in Heaven', which consisted of highly explicit large scale images and blown-glass sculptures of the artist having sex with his wife at the time, the Italian hard-core adult film actress known as Cicciolina.

But the consistent thread running through his work was a deep understanding of the human desire for unattainable perfection, which he identified as being at the heart of pornography and sex, in the seduction of a highly polished surface or in the amniotic suspension of a basketball in a tank of water.

His sculpture 'Rabbit' (1986), a 40-inch high representation of an inflatable toy bunny, flawlessly cast in gleaming stainless

Koons (1998): work spoke eloquently of desire, sentimentality and death

steel, has a dense, packed quality which from its first appearance qualified it as one of the most enigmatic and compelling artworks of its time. The art market concurred in 2003, when one of three examples exchanged hands for $1.8 million.

Taking the banal promises of advertising and marketing at face value, Koons invented an artistic language which was all the more powerful for its unsettling ambiguity. Like many artists before him, he held up a mirror to society; Koons' mirror was just that much more intensely reflective.

The son of a furniture-store owner, Jeffrey Koons was born on January 21 1955 in York, Pennsylvania, where he lived until the family moved to the suburbs when he was five. He began taking art lessons at the age of seven; at eight he was appending the signature 'Jeffrey Koons' to his copies of Old Masters, which his proud father would display in his store, and which before long were selling for several hundred dollars.

After high school Koons enrolled at the Maryland Institute of Art in Baltimore. During his first year there he traveled to New York City and spent an entire day visiting art galleries with Salvador Dali, having boldly telephoned the Spanish artist-showman at his hotel after seeing him in the newspaper.

Koons received his BFA in 1976, following a year as a visiting student at the Art Institute of Chicago, where he came under the influence of the artist Ed Paschke. Soon afterwards he moved to New York City, and within two weeks he had a job manning the membership desk at the Museum of Modern Art.

His few years there were to become legendary, as he cultivated a series of outlandish outfits with which to attract museum-goers to the membership booth: aiming for the "outrageous but not offensive", his outfits included paper bibs, a pencil moustache (after Dali), two ties worn simultaneously, loud polka-dot shirts, a sequined jacket and an inflatable flower which he would wrap around his neck. He sold five

times as many memberships as any other sales person.

During this time Koons was beginning to experiment with his earliest serious artworks, combining inflatable toys, flowers, Plexiglass and mirrors. In 1980 he left the museum, became licensed to sell mutual funds and took a job at First Investors Corporation, thus financing his breakthrough sculptures of vacuum cleaners encased in Plexiglass boxes.

His first New York show was in the window of the New Museum in 1983, when he displayed several new vacuum cleaners; the show was titled 'The New'. He continued to make and exhibit pieces from the series, now combining them with cigarette and car advertisements housed in lightboxes.

But Koons was disappointed with the way his career was going, and in 1983 he returned to his parents' home, now in Sarasota, Florida. When he moved back to New York he took a job as a commodities broker at Smith Barney, and began

to concentrate in earnest on producing his work (his favourite commodity, he once said, was cotton; when asked why, he replied, "I'm an artist, and cotton is soft").

From this point on Koons' career showed an unusual sense of structure, each exhibition comprising a discrete body of work, distinguished by title, mood and materials, much in the manner of a series of advertising campaigns.

'Equilibrium' (1985, at the gallery International with Monument) included his basketball sculptures, along with cast bronzes of floatation devices such as a life jacket. 'Luxury and Degradation' (1986) consisted of stainless steel copies of products associated with liquor consumption, such as 'Travel Bar' and a seven-car 'Jim Beam Train', flanked by mechanically printed ink-on-canvas Frangelico liqueur advertisements.

'Statuary' (1986), exhibited as part of a group show at the gallery of renowned dealer Ileana Sonnabend, alongside work by three of Koons' long-time friends, Peter Halley, Ashley Bickerton and Meyer Vaisman, was followed in 1988 by 'Banality'.

Koons was as concerned with the underneath of a sculpture as he was with the top. During the mid-1990s his notorious perfectionism came close to bankrupting him, when he sent large works intended for a show entitled 'Celebration' back to the fabricators because the finish on the stainless steel casts was under par.

Rumours circulated that his career was finished; but in typical fashion, Koons responded with an acclaimed series of large paintings which drew as much from current popular iconography as from the history of pop art.

When the sculptural works for 'Celebration' finally appeared, in the form of such pieces as 'Balloon Dog' (20xx), an enormous red, polished steel replica of a dog made from balloons, they confirmed that the artist was once again at the top of his form.

Koons would pay a price for the erasure of the line between his personal life and his art when, in 1994, following their separation, Cicciolina debunked to Italy with their young son Ludwig. The situation dismayed the artist; he later said that many of his sculptures were intended to let his son know that he was thinking of him.

Koons was the subject of numerous retrospectives at museums and institutions around the world. His 'Puppy' has been installed outside the Sydney Opera House, in New York City's Rockefeller Centre, and outside the Guggenheim Museum, Bilbao.

Jeff Koons married, first, Ilona Staller (marriage dissolved); they had a son. He married secondly, in 2003, Justine Wheeler; they had two sons. He also had a daughter from an earlier relationship.

Untitled (Jeff), 2004. Chromogenic color print, 52¾ x 37 in. (134 x 94 cm). Private collection; courtesy Nicole Klagsbrun Gallery, New York

WHOLESOME,

AGUE,.

FENSE ...

FY, INVALIDATE,

NTERMAND,

NSENSIBLE,

F BLACK NOISE,

.. HUGE ...

NORMITY...

L ... SPURIOUS,

.. SIMULATION,

... DISCOMFORT ...

LL ... DISEASED ...

LING, SWAY, RULE,

LORD IT, SWAGGER,

P

HERY

HAVOC,

IMMENSE,

LITY ...

TAYLOR MEAD
Born 1924, Grosse Point, Michigan; lives in New York, New York

Poet, performer, actor, and painter Taylor Mead has been defying the establishment for over half a century and remains one of the brightest stars of the American underground. A force within the Beat movements in both San Francisco and New York, he began writing and performing his particular brand of raunchy, irreverent, and often hilarious poetry in the early 1950s. He made his first film, *The Flower Thief*, in 1960 with San Francisco underground filmmaker Ron Rice. Inspired by Robert Frank's 1959 Beat classic *Pull My Daisy*, which was narrated by Jack Kerouac and featured poets Gregory Corso, Allen Ginsberg, and Peter Orlovsky, *The Flower Thief* follows the sprightly Mead as he wanders through the oceanfront arcades and smoke-filled poetry cafes of bohemian San Francisco. Breaking down the boundary between art and life with its impressionistic, improvised style, the film has been hailed by film theorist P. Adams Sitney as "the purest expression of the Beat sensibility in cinema."

By 1963 Mead had made his way to New York City where, as a downtown celebrity in his own right and a fixture on the East Village poetry circuit, he was introduced to Andy Warhol and became known as one of his most accomplished actors. Between 1963 and 1969, Mead starred in numerous Warhol films, including *Tarzan and Jane Regained ... Sort Of* (1963), *The Nude Restaurant* (1967), *Imitation of Christ* (1967), and *Lonesome Cowboys* (1969). As a tongue-in-cheek rebuttal to a letter published in the *Village Voice* complaining about its coverage of tedious avant-garde films (such as "films focusing on Taylor Mead's ass for two hours"), Warhol and Mead made *Taylor Mead's Ass* (1964), an hour-long silent film of Mead performing with just his rear end. He has appeared more recently in Rebecca Horn's *Buster's Bedroom* (1991), Jim Jarmusch's *Coffee and Cigarettes* (2003), and as the subject of William A. Kirkley's documentary *Excavating Taylor Mead* (2005), which captures the octogenarian superstar's antics in the Lower East Side as he fights eviction from an apartment filled with ephemera from his extraordinary life.

Mead continues to publish poetry and performs weekly at the Bowery Poetry Club in New York City, captivating audiences with his wry, dramatically vivid comments on sex, death, genius, and his own unique celebrity.

JM

Taylor Mead, photographed by Bryce Lankard

"Life is very much about rule-br
Otherwise history would just sta
along and break the rules and tr
things in a different way. Even if
a sense of exploration. You explo
interest you, but you are also ex

JOSEPHINE MECKSEPER
Born 1964, Lilienthal, Germany; lives in New York, New York

Josephine Meckseper's installations, photographs, and films explore, as Nicolas Garait has described, "the questionable links the media establishes between images of political news, the fashion industry, and advertising." In *The Complete History of Postcontemporary Art* (2005), she assembles everyday objects (a stuffed rabbit, stockings, a toilet plunger) and imagery related to protest culture. Deconstructing the media's strategy of mixing advertising and editorial content, she exposes how we have become consumers not only of products but also of news and politics. In displays that recall ethnographic museums, her work sets up absurdist juxtapositions that reflect and absorb the interrupted desires created by the ideally lit shop window at midnight, where consumption is temporarily deferred and the projection of ownership meets the transgressive impulse toward looting.

Meckseper's attention to the ways in which the subcultural is canned and sold back to an accommodating public often takes form in mock displays and serious pastiches (she was, for example, the editor and publisher of the conceptual magazine *FAT* from 1994 to 2000). She has constructed store windows and counters filled with wares, offering up haute-couture imagery alongside depictions of present-day protests captured on film by the artist. Constructivist paintings and manifestos from fictitious underground cells hang behind mannequins wearing Palestinian scarves. Lacy stockings are set alongside handmade rugs, while revolutionary slogans—such as "End Democracy/ That Festival of Mediocrity: Vote Communist 2008"—fluctuate between seeming equally powerful and pat. In this way, activist procedures and aesthetics—from modes of group protest to ad hoc accoutrements, including signage and clothing—can be suddenly emptied of substance, becoming elements of style in their own right.

In recent works, she investigates the particularities and generalities of decades of protest. Having previously made photographs and films of protests in Berlin and New York, she documented the September 2005 rally in Washington to end the war in Iraq. Her use of Super 8 film represents the shifts in the time-coded representation of the evolving antiwar movement. The degradation of the film stock—from the clearer, more animated imagery shot in New York to the grainier and more grave images from Washington—drives the associative referent further into the collective memory of past wars and their opposition; at the same time, the accumulative evidence, in the protesters' "formal" visual language, of the consequences of the present war creates a condition whereby, according to Meckseper, "the mediated styles of oppositional consumerism, politics, and their rhetoric are flattened and forced to organize around their detached symbols like the ready-made that sits in its vitrine next to a padded modernist museum bench, co-perpetuating their histories of the radical old newness."

JB

The Complete History of Postcontemporary Art, 2005. Mixed media in display window, 63 x 98½ x 23⅝ in. (160 x 250.2 x 60 cm). Collection of the artist; courtesy Elizabeth Dee, New York

ing, about confrontation.
still. Someone has to come
or whatever reason, to go about
s a simple sense of adventure,
concepts and things that
ring inside of yourself."

Ed Paschke

1939 - 2004

MARILYN MINTER

Born 1948, Shreveport, Louisiana; lives in New York, New York

Marilyn Minter has been considering representations and ramifications of glamour for the last thirty years, but it is worth considering just what is connoted by the word. Minter, it seems, defines this concept by the book, or at least intuitively leans toward its etymological truth, which aligns glamour with magic spells and illusory attractiveness—never with fictional ideas that propose glamour as some kind of natural condition. All of which is to say that Minter has been plumbing the depths of (al)chemical beauty (and its breakdowns) for a very long time.

In one of her earliest series of work, a group of black-and-white photographs from the late 1960s, Minter went right to the source—her own mother. Snapping pictures of her aging, substance-abusing, bedridden parent, Minter captured the queasy day-to-day undoings and recastings of physical appearance. Obsessed with tasks of pruning and priming, Minter's mother, clad in nightgown and propped with pillows, refused to let even a stray eyebrow lay seed. The photographs, at once gorgeous and grotesque, made nearly everyone who saw them so uncomfortable that the artist hid them away in a drawer for the next three decades.

In conjunction with her practice of photography, Minter makes paintings (enamel on metal), showing a special interest in Photo-Realist methods of representation. Culling imagery from cooking shows, porn videos, and beauty advertisements, the artist posits a visual continuity between seemingly disjunctive sensual experiences. By intentionally conflating the pleasures of cuisine and cunnilingus, Minter renders straightforward yet ambiguous images that shore up the constructed nature of their meanings.

In Minter's hands, a lobster tail is apt to become infinitely sexier than a penis, and the accoutrements of beauty will never ensure perfection. In recent works, she paints hyperrealistic images that look more photographic than photographs, and snaps photographs that look utterly painterly. Choosing models whose race and gender are open to interpretation, Minter hones in (literally and figuratively) on the imperfect trappings of high couture in large-scale color photographs and paintings that at once magnify, fetishize, and abject their subjects. Plumped, rouge-stained lips drip with slimy egg yolk; the glittered eye of a model is accompanied by a peach-fuzzed face; the wearer of studded Christian Dior pumps has apparently been doused in mud, and dirt infiltrates every crease of her perfectly manicured feet. The ambivalence in Minter's works does not leave us any less seduced by them: we simply have a harder time cleaning up and simplifying the true nature of our much more complicated desires.

JB

Stepping Up, 2005. Enamel on metal, 96 x 60 in. (243.8 x 152.4 cm). Private collection; courtesy Salon 94, New York

205

A superbely painted and rare 'famille-rose' 'peony' Vase *(tianqiuping)*, seal mark and period of Yongzheng, the shouldered globular body enveloped by sprays of peony, the flowers in iron-red, pale pink, yellow and white with overlapping diaphanous petals delicately shaded and highlighted in differing tones, some centred with yellow stamens, supported on slender curved stems with large prolific leaves in tones of apple-green and torquoise to distinguish the topside and underside of the leaves, mingled with sprays of prunus with pink blossoms and buds and a flowering, twisted bough of magnolia extending up the cylindrical neck, the shoulder with two butterflies and a bee hovering in mid-air, detailed in minutely pencilled *grisaille* strokes, the countersunk base inscribed in underglaze-blue with the mark in seal script
52 cm., 20½ in., condition report available

HK$4,000,000–5,000,000
(US$512,820–641,030)

清雍正　粉彩牡丹芝蘭粉蝶紋天球瓶
　　《大清雍正年製》款

MOMUS
Born Nicholas Currie, 1967, Paisley, Scotland; lives in Berlin, Germany

Momus has been producing pop albums in a variety of musical styles since the 1980s. His lyrics are often darkly humorous, with descriptions of sexual fantasies and futuristic societies, reflecting the artist's sophisticated wit and carefully constructed persona. More recently, his ongoing interest in the relationship between narratives, sound, and space (both mental and physical) has carried over into a series of videos and gallery-based performances in which he reconfigures storytelling traditions.

In *I'll Speak, You Sing* (2005), Momus collaborated with Japanese artist Mai Ueda in a three-week-long gallery performance in New York. For five hours each day, Momus sat hunched over a computer mixing prerecorded sound with stories he composed on-site, while Ueda could be found wandering the gallery, occasionally accompanying the sounds with her own improvised vocals. The performers never directly addressed the viewers, whose experience of the work was based both in the observation of the performers' interactions and in the active construction of "mental soundscapes" produced by the laptop, the singing, and the narrated stories.

In an earlier performance, *Folktronia* (2000), Momus likewise inhabited a gallery space and constructed tales, this time in an installation meant to recall an Appalachian mountain village. Some stories were taped on the spot and then offered for sale, and others lived on through retelling by visitors who had listened to them firsthand. In both cases, Momus sought to confront viewers directly with a fusion of folk forms and digital technology. Though similar interests were at work in the conception of many of his albums, the physical proximity between artist and viewer in the gallery performances has allowed Momus to transform his fantastic narratives into orally transmitted myths that unfold in real time.

For the 2006 Biennial, Momus takes on the role of the Unreliable Tour Guide. Wearing a costume and equipped with a portable sound system, he leads visitors on improvised tours of the exhibition that go beyond description into the realm of imagination. The freely invented, "unreliable" content of his tours opens up new possibilities for experiencing the art, shaped by Momus's unique ability to weave a tale.

GCM

I'll Speak, You Sing, 2005. Performance with Mai Ueda. Courtesy Zach Feuer Gallery, New York

MATTHEW MONAHAN
Born 1972, Eureka, California; lives in Los Angeles, California

An exploration of the human figure—its insides and outsides, beauties and gro-
tesqueries—unites the diverse work of Matthew Monahan. His large-scale transfer
drawings, executed by incising carbon paper with a pencil, fork, or palette knife,
are reminiscent of blueprints: architectural structures, abstract designs, and human
bodies are densely arrayed on the surface like intricate cross-section diagrams. The
precise, finespun subtlety of these drawings finds its counterpoint in Monahan's
wildly inclusive sculptural assemblages, made of beeswax, floral foam, and encaustic
and bedecked with glitter, hardware, twine, wire, and small objects (a tiny paint-
brush, a five-dollar bill). The sculptures reference a profusion of sources, including
Buddhism, the occult, robotics, classicism, and modern design: one figure alludes
to the modeling in ancient Greek sculpture, and another recalls a voodoo doll.
The artist speaks of "a brutal materiality edging toward spirituality" in his work,
and indeed, despite the gory, inside-out features of many of his forms—some
heads are bound, others spill brains or sprout tumorlike growths—Monahan's
installations often resemble totems or small altars; redemption is proposed by
way of abjection. Other sculptures are formed out of charcoal drawings of human
heads on muslin, bolstered with plastic, wood, and drywall. Some of these "folded
paper" works, evoking the Futurist sculpture of Umberto Boccioni, appear to be,
on first glance, wholly abstract; but slowly a face begins to cohere—bulging eyes,
an outsized nose, a gouged slash of a mouth.
Monahan conceived his recent solo exhibition in New York as an "excavation"
of his studio. He arranged his work in seemingly aleatory groupings that defied
conventions of regularized placement and open space in traditional museological
practice. Some sculptures were raised high up on plinths, out of viewers' sight lines,
and others were arranged in tightly packed clusters in vitrines and on pedestals—a
reconfiguration of gallery space at once startling and perfectly suited to the raffish
unconventionality of Monahan's work.
LP

Installation view at Anton Kern Gallery, New York, 2005

Smoke Break

JP MUNRO
Born 1975, Inglewood, California; lives in Los Angeles, California

JP Munro paints elaborate scenes of epic battles, opulent feasts, orgiastic celebra-
tions, and pagan rituals. His distinct approach to genre painting borrows heavily
from a vast array of historical sources, ranging from Greek mythology to Chinese
antiquity, and of artistic styles from Eugène Delacroix to Salvador Dalí. Often frozen
in a moment of high tension, Munro's scenarios take on a decidedly cinematic air,
one that balances highbrow elegance and lowbrow kitsch. The combination of these
multifarious elements results in psychologically fraught compositions that form
a unique pastiche, distinctly contemporary in appearance and sentiment. Munro
relishes the enigmatic and avoids clearly articulating or resolving any potential
narrative, preferring to let viewers work through the mystery and uncertainty his
paintings evoke.

Torture Garden (2004), a large three-panel oil painting, was inspired by Octave
Mirbeau's nineteenth-century French novel of the same name. Munro depicts in
elaborate detail a garden in China—with lush vegetation, fantastical flora, and
delicate pagodas—described by Mirbeau as a place where torture was revered
as an art form. Enveloped within this gorgeous landscape are contorted, writh-
ing bodies bent over torture devices and dangling from ropes. They are painted
with the distinct sandstone pigment with which Munro often depicts his figures,
rendering them statuelike, as if excavated from ancient ruins. In *The Vision of St.
Eustace, Master Hunter* (2005), he limits his typically ornate compositional style to
a single figure: a majestic stag from whose skull sprouts a cross—the very vision
that compelled Eustace to convert to Christianity. Munro's version contains the
additional element of Christ nailed to the Cross, his flesh tinted the same color as
the highlights on the stag's horns.

The Marseillaise (2005), an oil study for a future painting, captures a cast of young,
muscled, nude French revolutionaries poised for an impending battle. On their
faces, the figures display an expression of determination mixed with trepidation
in anticipation of the grave consequences revolution incurs. Munro often exhibits
studies alongside his more fully developed works as a means to celebrate an element
of painting that, in historical traditions, did not have the same import. In this work,
Munro combines references to two histories, that of the French Revolution and that
of the painting study, to comment on burgeoning ideas and unfulfilled promise.
JM

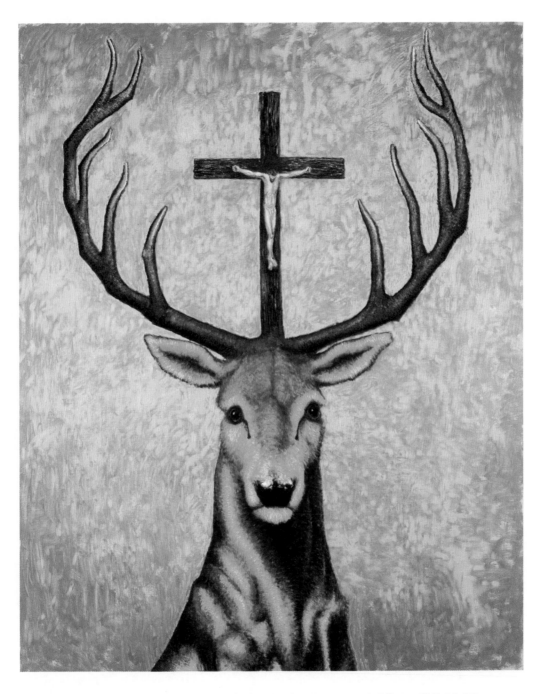

The Vision of St. Eustace, Master Hunter, 2005. Oil on linen, 60 x 48 in. (152 x 121.9 cm). Collection of Sadie Coles HQ, London

JESÚS "BUBU" NEGRÓN
Born 1975, Barceloneta, Puerto Rico; lives in San Juan and Barceloneta, Puerto Rico

Although many Conceptual practices imply a dearth of labor, in their emphasis on the idea over its transcription into physical form, Jesús "Bubu" Negrón's mode of Conceptualism strives for something different. Predicated as much on physical endurance as on humor, his site-specific interventions wed personal politics of resistance to poetic structures and often form the basis for creating a sense of community through artistic collaboration.

For *Abra de las Collilas (Homenaje a Angito)* (Cigarette path [homage to Angito]) (2002), Negrón collected cigarette butts from all over San Juan to construct an elegiac monument to a deceased bartender by meticulously placing them in cracks in the paved alley outside the bar where the man had worked. The "refuse" was promptly removed by the government (with a giant street-cleaning vacuum), but the cigarettes nonetheless functioned as an ephemeral memorial that temporarily reclaimed and rendered intimate an otherwise public, even dispassionate, site.

Movement supplants stasis in Negrón's 2003 performance-documentary *La Promesa* (The promise). The artist took his mother's wheelchair on a pilgrimage of art and alcohol, traveling from Puerto Rico to Mexico and drinking at every bar between the airport and the contemporary art center Ex Teresa Arte Actual in Mexico City, thus enacting a secular *via crucis* that raises questions of familial duty as well as cultural identity. Such themes are also suggested by Negrón's 2004 project *7 días en Igualdad* (Seven days in Igualdad). The artist returned to the specificities of place—in this case, the village of Añasco, Puerto Rico—in an effort to bring visibility to a dying community. Once marked by a flourishing sugar industry, the region saw its factories close some thirty years ago, followed by the impoverishment of its people. Negrón worked with local participants to light the chimney of an abandoned sugarcane processing plant, twenty-four hours a day for a week. The resulting smoke indexed not production but concerted social action and the reconsolidation of kinship. Indeed, the project continued long after its ostensible conclusion, with the organization of festivals and musical events. In this way, the piece fostered porosity between art and life, productively instantiating a form of historical memory without forsaking possibilities for the present moment.

SH

Brite Bikes, 2005. Reflective tape on bikes, marathon. Courtesy Galería Comercial, San Juan

KORI NEWKIRK
Born 1970, Bronx, New York; lives in Los Angeles, California

Kori Newkirk makes multimedia paintings, sculptural installations, and photographs that explore the formal properties of materials, the politics of identity, and the artist's personal history. Although cultural references emerge in his recurring use of pomade and plastic pony beads, both used to style black hair, as well as the color white, with its connotations of race and pristine environments, the symbolic possibilities of these elements are always matched by their formal elegance.

The World and the Way Things Are (2001) is a curtain of glossy multicolored pony beads strung along strands of braided synthetic hair suspended close together from a thin strip of metal installed against the wall. The beads are arranged in a pattern that depicts two ranch houses along a cul-de-sac in a typical suburban neighborhood. The suburban portrayal is further emphasized by the curtain's resemblance to the beaded room dividers popular in the 1970s. While easily discernible from a distance, the curtain's image breaks down into sculptural abstraction upon closer viewing. Straddling media as well as references to black and white culture, the work combines allusions to blackness with images of a presumably white American landscape, embodying Newkirk's experience as a black child growing up in a predominantly white rural area in upstate New York. *Glint* (2005), a four-sided curtain of nighttime scenes from both urban and suburban settings, is suspended from the ceiling, allowing the viewer to circumnavigate the form. The ability of these works to be recognized, all at once, as painting and sculpture, representation and abstraction, reveals the complex territory in which Newkirk's art operates, where stereotypes can be shattered as easily as parting a curtain.

In a series of untitled wall drawings he completed for the Museum of Contemporary Art in Cleveland in 2004, Newkirk used pomade to shape enlarged imprints of his fingerprints across the walls of the gallery. This marker of identity was rendered black against the stark white walls, creating a surface of convergence for race, identity, color, and the body. The color white moves from the background to the foreground in a series of installations Newkirk began making in 2003. For one exhibition, he covered the gallery floor with a thick dusting of artificial snow. Dozens of small great white sharks were sculpted in encaustic and embedded in a back wall in the formation of a giant snowflake, while an 8-foot-long white fiberglass shark rested on the floor, its mouth open to reveal a set of teeth made of glass icicles. The overt reference to "white" is thus tangled with notions of purity, coldness, isolation, menace, and beauty in a landscape emblematic, for Newkirk, of all the "whiteness" that endangers him.

JM

Glint, 2005. Artificial hair, pony beads, aluminum, and dye, 92 x 84 x 48 in. (233.7 x 213.4 x 121.9 cm). Museum of Contemporary Art, San Diego

TODD NORSTEN
Born 1967, Sunburg, Minnesota; lives in Minneapolis, Minnesota

Todd Norsten makes self-consciously homespun paintings and works on paper that reveal a fundamental curiosity in his approach to materials and techniques. His images are often steeped in the climate and vernacular of the Upper Midwest—specifically, his native Minnesota—articulating an attitude of nostalgia and diligence that is often characterized as reflecting "traditional," transcendental American values. Norsten deciphers contemporary contexts in which such ideals are routinely but often duplicitously invoked, whether in debates about the separation of church and state, as seductive material for commercial culture, or as the bedrock of partisan politics in the United States.

In his paintings from the mid-1990s, Norsten navigated the threshold of abstraction. Reducing painting and drawing to their barest essences, he made chordlike progressions of line and form to create expansions and contractions of surface and space. In *ALLSOMENONE* (2003), a suite of intaglio prints with chine collé, his expert technical restraint results in blushes of dots and forms that look like tree rings or fungus spores and clusters of lines that evoke traps or birdcages.

The painting *Grandma Moses Ain't Shit* (2005) shows a tiny homestead almost lost in a blizzardlike expanse of white paint. The title proffers a mocking commentary on the celebrated folk artist known for her nostalgic pictures of "old-timey" rural life in America. Norsten's take on suburban vernacular recalls the style of home-made roadside signs, as in an untitled painting of 2005 in which two Halloween jack-o'-lanterns rest on a field of white that evokes the stripped-down aesthetic of modernist painting. *Son Jesus Loves You Still* (2005), whose blurry lettering was created by partially scraping back white paint to reveal a black underlayer, is a deliciously ambiguous excavation of unabashed down-home evangelism.

In a recent series of small, scathing drawings, Norsten's cultural anthropology trains its focus on the current White House administration. These faux-naive drawings with handwritten inky texts present imagined scenarios in which high-ranking administration officials—including Secretary of Defense "Rummy" and Vice President "Cheney" caricatures—spout incendiary proclamations, frat-house humor, and unsubstantiated accusations. The buckled paper expresses a petulant hastiness and ill preparation. In their almost childlike disregard for "grown-up" representation, these edgy drawings adumbrate a political system where complex, portentous topics appear to be handled in a willfully ham-fisted way.

MA

Untitled (Bucket of Blood), 2005. Gouache on paper, 15½ x 12½ in. (39.4 x 31.8 cm). Collection of the artist; courtesy Cohan and Leslie, New York

JIM O'ROURKE
Born 1969, Chicago, Illinois; lives in New York, New York

Jim O'Rourke has recently begun to focus on filmmaking after an intense, and intensely varied, career in music. Trained as a composer and musician, he has recorded more than ten solo albums and participated—as a musician and/or producer—on dozens of additional projects, collaborating with, among others, Tony Conrad, John Fahey, Beth Orton, and the bands Wilco and Sonic Youth. O'Rourke's inventive guitar improvisation extends from quiet, bare-bones acoustics to deafening atonal drones, and his work testifies to an eclectic array of influences, from classical sources to electronic music.

Door is a three-channel video installation created in 2005, based on music that O'Rourke made about fifteen years earlier. At that time, he was not wholly satisfied with the recordings; he set them aside in a box and forgot about them. He rediscovered them in 2003, and, as he explains, "with time, and the dissipation of youthful obsession, I came to some kind of peace with them." In the installation, three close-up images of a door are rear-projected on three walls of an enclosed room and, similar to much film and video art from the late 1960s and early 1970s, the architecture is integral to the experience of the work. As one shifts position in the space, different frequencies of the soundtrack become audible, and the film's images fall in and out of sync with the music. The effect of this layering, as O'Rourke offers poetically, is one of "slow continuous change, and if distracted for a moment, you will find yourself somewhere else upon your return."

LP

Still from *Door*, 2005. Three-screen video installation, color, sound; 20-min. continuous loop. Collection of the artist

OTABENGA JONES & ASSOCIATES
Founded 2002; based in Houston, Texas

Otabenga Jones & Associates is an organization founded by Otabenga Jones and whose other members include artists Dawolu Jabari Anderson, Jamal Cyrus, Kenya Evans, and Robert A. Pruitt (the latter four are also in the 2006 Biennial, independent of the organization). The group works under the tutelage of Mr. Jones, who is named after Ota Benga, the African Pygmy brought to the United States in 1904 and later exhibited at the Bronx Zoo, and this historical reference to the pseudoanthropological penchant for exhibiting Africans and other non-Western peoples in world's fairs and other such exhibitions of the time is an indicator of the group's intent. Their pedagogical mission, realized in the form of actions, writings, and installations, is to highlight the complexities of representation across the African diaspora; to establish a cross-generational aesthetic continuum stemming from the transatlantic experience; and, as they write in their mission statement, quoting from Sam Greenlee's classic satirical novel *The Spook Who Sat by the Door* (1969), "to mess wit' whitey."

In 2005, responding to an exhibition at the Museum of Fine Arts, Houston, titled *African Art Now: Masterpieces from the Jean Pigozzi Collection*, Otabenga Jones & Associates staged the action *Africa Is a Continent* (2005). The focus of their protest was the museum's exhibiting of African art without, in their view, due context, and in particular, its decision to present the personal choices of a Swiss collector as representative of the continent and its cultures. The group's members rallied outside the museum with placards stating "Africa Is a Continent" and "My Blacknuss [*sic*] Is Bigger Than Your White Box!" The threat implied by the rally, that it might lead to an invasion of the museum, is emphasized by the latter slogan's play on sexual stereotypes; however, the "white box" is also the Western canon that, according to the group's statement, "chooses to represent blackness in diluted form," thus extending the critique, in this instance, to the larger context of art history and representation.

The Art of Subversion (2005) is a project with yet another kind of intervention, this time inside the proverbial white box itself. It envisions a flea market, inside a museum, that sells bootleg DVDs and knockoff designer goods, mix tapes, and other merchandise of the sort found in contemporary urban street markets. Like David Hammons's 1983 snowball sale on a street corner in New York, *The Art of Subversion* comments on hustling as a subversive business strategy that fulfills a need left unaddressed by wider American society. Otabenga Jones & Associates articulate this tension between illegitimate activity and conformity to the structures of the market (hustling is, after all, capitalism in its purest form), and the group's interventions function as a type of institutional critique—challenging not only the constructs of race but also the ideology of the white cube.

ESM

We Did It for Love, 2005. Mixed media, dimensions variable. Collection of the artist

A bishop, sailing through remote waters, saw the captain of the boat pointing to a spot on the

Some say three hermits live on that island.

The bishop squinted his eyes but the sun shimmering on the water prevented him from seeing
They shifted course and soon arrived on the island. Sure enough, the bishop found three men,

Tell me, what are you doing to save your souls? And how do you serve God on this island?

We don't know how to serve God.
We only serve and support each other.

But how do you pray?

Three are ye, three are we, have mercy on us.

The bishop smiled, and began to teach them the prayer, Our Father. All day he labored,
remember more than one word at a time. Finally by nightfall they could repeat it back to him
The bishop was satisfied, and set sail from the island.
As night wore on, he watched the island gradually disappear from sight. He remained on the d
Suddenly, a light appeared on the horizon. As it quickly approached the boat, he was amazed
moving their feet. They soon reached the boat and called out with one voice:

We have forgotten your prayer. Please teach us again.

STEVEN PARRINO
Born 1958, New York, New York; died 2005, New York, New York

Steven Parrino's work in painting, drawing, sculpture, film, and video incorporates elements of Minimalism, pop culture, and Action Painting within a particular kind of nihilism that demonstrates the creative potential of destruction. Emerging from the East Village art scene of the late 1970s and early 1980s, Parrino embarked on a decades-long investigation of painting that stressed physical surface over pictorial representation. His "misshaped paintings," as he called them, are large-scale, mostly monochromatic canvases that were twisted or torn off their stretchers, then reaffixed in a dynamic, often violent action. Recalling the shaped canvases of Frank Stella, the slashed surfaces of Lucio Fontana, and even the elaborate drapery depicted in Baroque paintings, Parrino's works blur the line that separates painting from sculpture, gesture from form.

In *Process Cult* (2004), a black enamel-covered canvas has been twisted in on itself, its raw edges pulled into the picture plane as if disappearing into a black hole. Its highly reflective vortex, referencing the collapse of both space and time, is at once frightening and compelling. Collapse carried deep significance for Parrino, who credited Robert Smithson's notion of entropy as a major influence on his own endeavors to create a disruptive field through painting. In *Untitled* (2004), four hulking triangular stretchers have been upended, their sides draped in sagging folds of heavy black-painted canvas. Resting on a single point on the floor, the stretchers meet at a right angle, creating a form that is as passive as it is aggressive.

The stark formality and sustained tension displayed in Parrino's paintings are also present in his mixed-media drawings and collages. Populated by porn stars, murder victims, and cult heroes such as Billy the Kid, Bruce Lee, and Johnny Cash, these works create liminal spaces where narrative resolution is suspended in favor of creative interpretation. Their influence can be seen in the black-saturated, neo-Gothic sensibility of many younger artists working today.

All of these elements are part of a larger project that Parrino and fellow artist Jutta Koether (also in the 2006 Biennial), with whom he performed in the noise band Electrophilia, termed a "black system," in which "joyous nihilism" and converging creative forces lead to a new kind of artistic production.

JM

Untitled, 2004. Enamel on canvas, 102½ x 107 x 140 in. (260.4 x 271.8 x 355.6 cm). Estate of the artist; courtesy Team Gallery, New York

...nt horizon.

...thing. He was curious, and persuaded the captain to take him there.
...ding together holding hands.

...ig slowly, word by word, and all day they blundered, not able to
...heir own.

...after the crew had gone to sleep, recalling his day with the hermits.
...ee the three hermits, gliding across the surface of the water without

Adopted from an old Volgic Legend

ED PASCHKE
Born 1939, Chicago, Illinois; died 2004, Chicago, Illinois

Working in cyclical modes of abstraction and representation, Ed Paschke painted hundreds of faces over the course of nearly forty years. A childhood love of animation predisposed him to Pop art when it emerged in the early 1960s, and the subjects of his early portraits—ranging from movie stars and champion wrestlers to circus freaks—derived from tabloid magazines, trade catalogues, and television. He was linked to the Chicago Imagists, a group of artists in the 1960s who tapped outsider art and Surrealism as source imagery, though Andy Warhol's photo-based paintings would prove to be a more lasting touchstone for the artist. Yet Paschke departed from Pop's exuberant primary colors; his palette was—and remained—both darker and more psychedelic, spanning from fluorescent neons to garish, sickly hues. In the 1970s and 1980s, his portraits became more abstract: disembodied eyes and mouths took the place of faces, their silhouettes overlaid with abstract designs that borrowed equally from the fanciful Pattern and Decoration movement and the binary geometries of electronic media. In the last twenty years of his life, Paschke returned to recognizable subjects, executing portraits of mercurial historical figures both beloved and deplored—Abraham Lincoln and Elvis Presley, Adolf Hitler and Osama bin Laden—and in the 1990s, he revisited classic themes such as the Venus di Milo and Velázquez's portrait of Juan Pareja.

Paschke's late works veered back to abstraction, and in them military iconography (guns, insignias) is juxtaposed with Eastern religious motifs and brightly tinted facial features rendered in isolation. In *Legal Tender* (2004), a hat of the sort worn by commissioned officers in the armed forces tops an outline of a nose, at once suggesting a face and, in conjunction with cartoonish birds in the lower corners and horizontal lines spanning the painting's top edge, denying human presence. The heavily lidded eyes, large nose, and full lips pictured in *Bang Bang* (2004) also hint at, but don't cohere as, a discrete identity, and the work's mix of whimsy (its biomorphic yellow underpainting) and menace (the title phrase, which is super-imposed on the mouth) encapsulates the combination of pictorial precision and moody allusion that marked Paschke's production.

LP

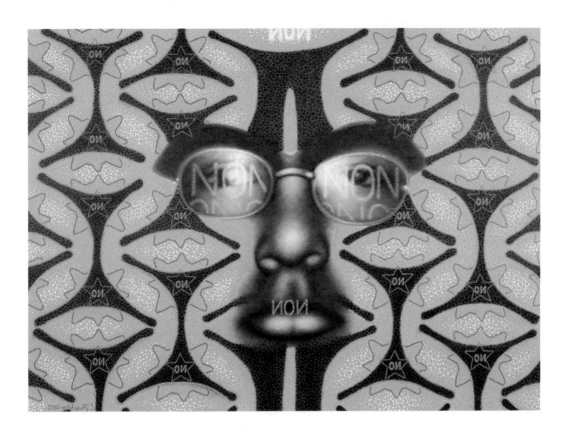

Non, 2003. Oil on linen, 36 x 50 in. (91.4 x 127 cm). Estate of the artist

MATHIAS POLEDNA
Born 1965, Vienna, Austria; lives in Los Angeles, California

Mathias Poledna's films and installations are situated in a tradition of Conceptual art practice that shares with artists such as Dan Graham and James Coleman an interest in modernity and the use of mass culture and historical memory as conceptual tools. Poledna meticulously re-creates as well as erases specific contextual information in his work—such as the background in his films, which leaves his subjects singled out or isolated against a blank space—thereby pointing to the ways in which the narratives of popular culture, and history itself, are constructed and mediated.

The 16mm film *Actualité* (2001) features a band in rehearsal trying to develop the structure of a song. The camera pans across and zooms in on details of their late 1970s appearance; the background is black, and the screen fades to black between each shot. The sequence is instantly accessible for its resemblance to historical footage in a documentary, except that here the performers are cast in their roles and the random musical patterns they emulate were created in a recording session with musicians associated with the postpunk period. However, even as Poledna participates in the construction of this highly mediated scene, he simultaneously draws attention to it: *Actualité* consists entirely of stops and starts, as the performers never quite manage to get it together. By effectively restaging the momentous event of a band attempting to arrive at a song, Poledna complicates—down to his own role in its creation—our relationship to historical memory and experience, and our experience of images in general.

Poledna's practice of both referring to and employing production processes of the culture industry is also evident in the mesmerizing 16mm film *Version* (2004), related in part to Maya Deren's 1948 film *Meditation on Violence*. Dancers glide across the screen against a black backdrop. Poledna has excised not only their surroundings but also the soundtrack, thus literally transporting each dancer into a world of his or her own. Although their movements have a vintage quality resembling motion studies in early film or the vernacular movements of a 1960s Judson Church dance performance, it is impossible to discern what they are dancing to or why. Occasionally the performers appear as if they might step into the synchronized pattern of a musical-like choreography, but as with the reconstructed rehearsal in *Actualité*, the moment of cohesion—and our own identification with the scene—is continually deferred.

ESM

Still from *Version*, 2004. 16mm film, black-and-white, silent; 10:10 min. Collection of the artist; courtesy Richard Telles Fine Art, Los Angeles; Galerie Meyer Kainer, Vienna; and Galerie Daniel Buchholz, Cologne

ROBERT A. PRUITT
Born 1975, Houston, Texas; lives in Houston, Texas

Robert A. Pruitt incorporates America's often unsettled race relations into the aesthetics of desire. His rereading of twentieth-century art, especially the ready-mades of Marcel Duchamp, in light of African American history and experience offers a commentary on the ongoing struggles of black Americans.

Low Rider Art (2004) presents a chrome bicycle wheel from a BMX stunt bike turned upside down on a stool—a "blackening" of Marcel Duchamp's *Bicycle Wheel* (1913). Whereas Duchamp's ready-mades brought into question the significance for art of new techniques of mass production, Pruitt suggests there may be an equally trenchant critique to be found in the easiness of it all for his (white) artistic predecessors. His establishment of an alternative critical position with relation to such art historical works demonstrates his self-proclaimed role as mediator between the world of high art and African American culture.

In a series of decorated handguns, Pruitt uncovers the subtext of violence in the relationship between large corporations such as Nike and their African American market. In *Just Do It!* (2004), which consists of a .38 caliber handgun with a small pendant of a basketball player hanging from the trigger guard, he distorts Nike's exhortative slogan as if to encourage whoever is holding the gun to pull the trigger. The gun is embellished with the iconic Nike swoosh and presented in an empty sneaker box, emphasizing how easy it is to acquire both items in the United States.

America's Most Wanted (2004), a prop gun decorated with rhinestones, references among other things Ice Cube's 1990 album *AmeriKKKa's Most Wanted* and points to the contradictions within gangsta rap's idealization of the outlaw—the desire to be both recognized and feared. The sculpture plays up the glamorization of violence while suggesting its fundamental ineffectiveness.

Pruitt follows through on this in *Throw Back* (2005), a Ku Klux Klan robe decorated with dark, hip-hop–inspired puns that deflate the object's historicized status as an icon of terror. "Burn Baby Burn," the mantra of the 1965 race riots in Watts, is emblazoned in boisterous graffiti lettering across the garment's back like some kind of gleeful reclamation, acknowledging the allure, yet ultimate ineffectuality, of violent protest.

ESM

Pruitt is a member of Otabenga Jones & Associates, also in the 2006 Biennial.

This Do in Remembrance of Me, 2005. Wood communion table, two iPod Minis, mixer, hair, wine, and various altar offerings, dimensions variable. Collection of the artist; courtesy Clementine Gallery, New York

Rock bottom

JENNIFER REEVES

Born 1971, Colombo, Ceylon (now Sri Lanka); lives in New York, New York

Jennifer Reeves is known for her expressive abstract films that probe the tactile surface of celluloid. She uses the virtually obsolete technology of an optical printer and in luminous works such as *The Girl's Nervy* (1995) or *Fear of Blushing* (2001) paints directly on the filmstrip. In the autobiographical *Chronic* (1996), she examines self-mutilation, setting the treated texture of the film into metaphorical relationship with lacerated skin. Invoking film noir and 1980s No Wave cinema, *Darling International* (1999) is an experimental narrative made in collaboration with MM Serra. Tracing the erotic exploits of several New York women, the film-makers star respectively as a commanding executive (Serra) and a boyish metal worker-cum-femme (Reeves) against the backdrop of nighttime Manhattan shot in luscious black and white.

The Time We Killed (2004), Reeves's first feature film, weaves the poetic visual language of her short films and bits of documentary footage into a personal, impressionistic narrative. Set in the period preceding the American invasion of Iraq, the film follows agoraphobic writer Robyn (played by real-life poet Lisa Jarnot), whose mental turmoil parallels the events taking place outside. As the country reels in the aftermath of the World Trade Center attacks, she increasingly shuts herself up in her Brooklyn apartment. "Terrorism got me out of the house, the war on terror drove me back in," she recalls in laconic voice-over. While the outside world filters in through the television and the muffled voices from neighboring apartments, Robyn retreats into memories of her childhood, old lovers, and a failed suicide attempt. Reeves shot interior scenes set in the present on crisp digital black-and-white video while recollections from the past were filmed on high-contrast 16mm, bleaching the images to stark black-and-white silhouettes. Empathetic but unsentimental, the protagonist is not a tragic figure (she continues to hold down writing assignments, and friends check in on her regularly) and her lachrymose musings are treated with sly wit. Using Robyn's withdrawal from the world to reflect on the country's isolationist retreat and the Bush administration's belligerent rush to war in the aftermath of September 11, Reeves injects *The Time We Killed* with a dose of seething and subdued anger.

HH

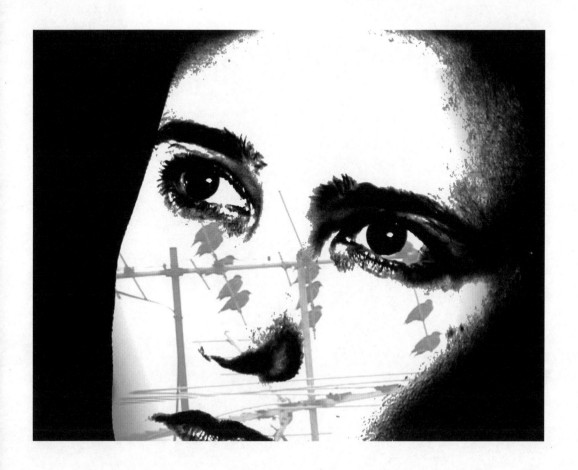

Still from *The Time We Killed*, 2004. 16mm film, black-and-white, sound; 94 min.

RICHARD SERRA

Born 1939, San Francisco, California; lives in New York, New York, and Cape Breton, Nova Scotia

For more than thirty years, Richard Serra has created sculptures and public installations known for their physicality and investigation of the qualities and processes of industrial materials, particularly steel and lead. Early sculptures consist of molten lead splashed into or cast from the juncture where walls meet the floor, and massive slabs of steel propped against one another, held in balance by the forces of gravity and weight. In his series of *Torqued Ellipses* from the mid- to late 1990s, enormous plates of rolled steel are twisted at various angles then abutted to create semi-enclosed spaces that induce a destabilizing experience of space, volume, movement, and time. His site-specific public sculpture *Tilted Arc* (1981) was the source of long-standing debates and legal proceedings that addressed the rights and sometimes conflicting interests of artists working in the public domain and the public itself.

Serra has always been politically engaged and has frequently voiced criticism of the role of government in the arts, media cooptation and dissemination, and right-wing political figures. In 1990, he produced an etching as a fund-raiser for Harvey Gantt, the North Carolina Democratic candidate running against Republican Senator Jesse Helms. For the 2004 presidential election, Serra produced two posters that were made freely available on the web. One depicts George W. Bush as the terrifying figure of Saturn in Francisco de Goya's macabre painting *Saturn Devouring One of His Sons*. The other, titled *Stop Bush* (2004), reminds us of the horrifying events at Abu Ghraib prison. Using thick oil stick (a favored medium in his drawing practice), Serra sketches one of the iconic images of contemporary torture—the anonymous hooded figure balanced on a box with arms outstretched and fingers wired for electrocution—that became immortalized throughout the world as a symbol of the U.S. military's abominable conduct in Iraq after the fall of Baghdad. *Stop Bush* was widely distributed not as an artwork, but, according to Serra, as a means to "get the message out."

JM

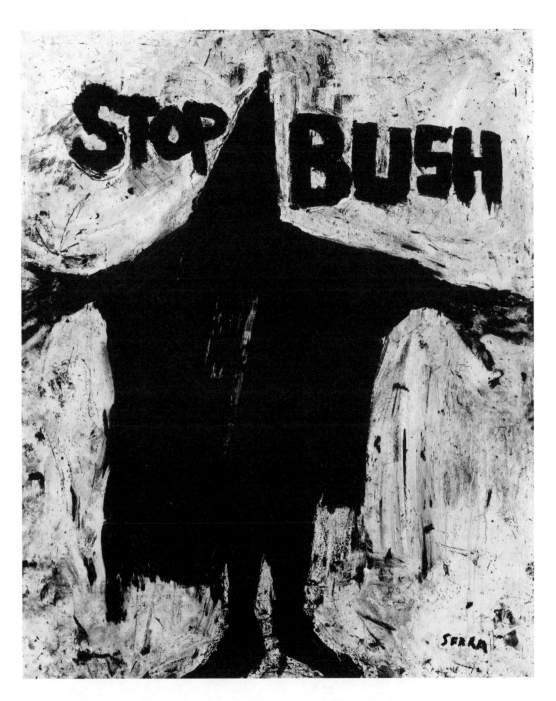

Stop Bush, 2004. Lithocrayon on mylar, 59¼ x 48 in. (150.5 x 121.9 cm). Collection of the artist

GEDI SIBONY
Born 1973, New York, New York; lives in Brooklyn, New York

Gedi Sibony's allusive sculptures are delicately constructed out of fragments of the built environment. His arrangements of assorted detritus—pieces of colored carpet, plywood, and contractor bags—are often audacious in their sparsity and evocative in their spatial composition. With a careful attention to material, color, and form, Sibony's work consistently engages the viewer in a physical recognition of the surrounding space and an awareness of the processes of construction. His installations take on a narrative quality as we move among the sculptures, reading their relationships to each other and to the architecture.

Disguised as Material Properties (2005) consists of four components arranged in one corner of a room. A black garbage bag is stapled to a door, which is propped against one wall. Against the adjacent wall, a cardboard box rests precariously, high above the floor, on four spindly stick legs; a clear piece of plastic lies casually underneath, stuffed through a hole cut in a piece of medium density fiberboard. In the center of the room, two small pieces of carpet (one upside down) come together so that one corner of each remnant rests against the other and points gently toward the ceiling. Like much of Sibony's work, the gesture is at once elegant, slyly humorous, and slightly melancholic in its almost accidental appearance. Although each piece has a distinct internal dialogue, the viewer is guided from one tenuous balancing act to the next, uniting the arrangement of objects in a subtle drama of structuring processes.

As the centerpiece of a recent installation, *Working Better Than It Was Before* (2005) emphasizes the potential of a largely blank space. It consists of a few faint traces of spray paint on a large white wall. As the viewer may come to realize, these reveal the edge of a now-absent piece of cardboard or wood placed against the wall as the mark was made. The work, relying solely on the traces of the artist's earlier action, creates a strong charge out of almost nothing. Rather than coming into being through a process of accumulation, *Working Better Than It Was Before* depends on the removal and, consequently, the absence of sculptural material. Using subtle moves and the simplest of materials, Sibony conjures a surprising psychological potency.

GCM

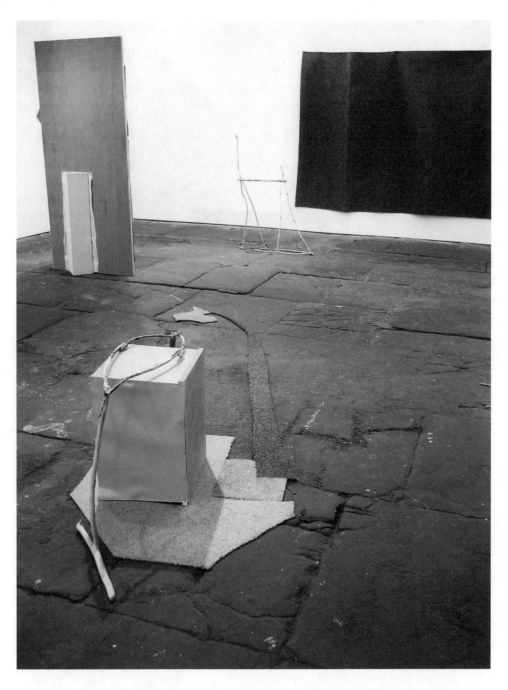

The Qualities Depend on Other Qualities, 2004 (installation view, Canada, New York). Sticks, carpet, vinyl, wood filler, medium density fiberboard, hollow-core door, and cardboard, dimensions variable. Collections of Carol and Arthur Goldberg, and Greg Miller

JENNIE SMITH
Born 1981, San Francisco, California; lives in San Francisco, California

A variety of creatures, both real and fantastic, populate Jennie Smith's graphite and watercolor drawings. Individual animals appear in small, delicately rendered compositions, while in larger drawings, they are assembled into formal structures suggesting narratives of collective action and ecosystems. In a series of small works entitled *Animal Its Habitat* (2004), a lone bird or fox, among other animals, is depicted with just its head emerging from small mounds. In the *Animals Slumber* series (2004), "all of nature's creatures" lie tucked in sleeping bags, surrounded by flowers and in a state of utter stasis, togetherness, and contentment.

When Smith gathers animals together, the drawings often become dynamic and evocative of the forces of entropy and social change. The large-scale *Kite Wars* (2004) presents a tangled mass of kites, which take on the likeness of a multitude of imagined creatures. Thin lines of string wind through and connect the kites, bunching some together in groups and allowing others to drift off solitarily. *Migration* (2003) provides an aerial view of a nomadic community on the move. Small tents in a variety of shapes are clustered together around campfires, and the linear forms that spread out across the blank landscape of the page trace the migratory patterns.

We'll Never Tell You Where We Have Gone (2004) is more explicit in its narrative of ecological awareness and social change. The work depicts a large spaceship igniting its engines for takeoff. As Smith describes the scene, "All of the animals of the world have recently held a meeting, making the decision to build an aircraft and take off to a new planet, bringing what was left of the earth's natural resources." This activity is portrayed in the densely patterned surface of the ship, which is overflowing with a variety of animals, plants, and other organic forms. In Smith's imagining, the animal kingdom saves itself from the reckless waste of resources as consistently practiced by humans. Although the animals in Smith's drawings might seem fanciful, their apparent emphasis on the value of cooperation, community, and dynamic change serves as a political message directed at contemporary society.
GCM

Animal Slumbers, 2004 (detail). Graphite and watercolor on paper, 15 x 17 in. (38.1 x 43.2 cm). Collection of the artist

DASH SNOW
Born 1981, New York, New York; lives in New York, New York

A boy shows off his magnum of Veuve Clicquot for the camera; a naked couple poses in a hotel room; a dog looks up from scavenging in the trash: Dash Snow's Polaroid photographs document his own life in New York's Lower East Side, a *vie bohème* that, in its excess, verges on the surreal. Like Ryan McGinley or Nan Goldin, who have also chronicled the downtown Manhattan scene, Snow takes a romantic approach and participates completely in the moments he documents, which ensures that his photographs do not collapse into voyeurism. In addition, he often contextualizes the photographs by showing them alongside large-scale installations that include found objects, newspaper clippings, and videos.

Although the Polaroids are taken in the heat of the moment—depicting life as it happens—Snow pays as much attention to their formal composition as to their content. Overtly nihilistic images are resuscitated by their colors, as in the bright red blood drenching the bleached white face of a friend after a fight. The exhibitionistic nature of some of the images poses the question: Did this happen for, or in spite of, the camera? Yet, in other examples, the content is more subtly provocative. One snapshot catches a mother and her young daughter, dressed as Easter bunnies, as they cross the street. The daughter grins widely at the camera; the mother looks unsure. This may seem like a ready commentary on the innocence of youth, but the mother's own awkwardness makes the confident daughter appear the adult. Snow also subjects the harsher realities of urban life to his eye for the disarmingly picturesque. In one image, a man is pushing a shopping cart full of junk across an intersection as he carries a large red cross on his shoulders.

Snow presents himself in the mythologized role of artist/outlaw, and another romantic theme evident in his work is an obsession with the precariousness of life. Polaroids are themselves a finite medium, and Snow's are often smudged and tarnished from being carried around in his pocket, echoing the fragility of the moments he captures, as invoked by the title of his 2005 exhibition *Moments Like This Never Last*.

ESM

Untitled (Dog in garbage), 2002. Digital chromogenic color print, 20 x 20 in. (50.8 x 50.8 cm). Private collection; courtesy Rivington Arms, New York

MICHAEL SNOW
Born 1929, Toronto, Canada; lives in Toronto, Canada

Since the late 1960s, Michael Snow has been a key figure in the development of structural and avant-garde film, producing works infused with a modernist sensibility that, with distinct humor and wit, distills the material elements and structural properties of the filmic medium. Also an accomplished composer, musician, painter, sculptor, photographer, and writer, Snow creates, in almost every medium, puns, paradoxes, and unexpected perspectival shifts that reveal our assumptions about perception and ultimately expand our experience of it.

His groundbreaking film *Wavelength* (1966–67) centers on the zoom as the framework for "a definitive statement of pure film space and time, a balancing of 'illusion' and 'fact' all about seeing." The 45-minute presentation of a forward zoom across an 80-foot loft is intercut with narrative events, light flares, negative and underexposed images, and colored gels. It is accompanied by the sound of a sine wave rising from its lowest to its highest tone. Snow revisited the film when he made *WVLNT (Wavelength for Those Who Don't Have the Time. Originally 45 Minutes, Now 15!)* (1966–67/2003) by dividing the original *Wavelength* into three 15-minute sections (sound and picture) and superimposing them in a shortened, simultaneous presentation.

Snow investigates the space of exhibition and the effect of context in *SHEEPLOOP* (2000), which presents a looping video of grazing sheep on monitors placed in the exhibition space but also in stairwells, the entrance foyer, and the restaurant, fracturing continuity and emphasizing the effect of placement on the viewing experience.

SSHTOORRTY (2005) investigates narrative and filmic layering by literally placing the story on top of itself (the title is derived from layering SHORT on STORY). A 3-minute scene of an artist delivering a painting to his lover, only to be confronted by her husband, was divided into two equal parts superimposed one on top of the other. Spatial and narrative grounds shift as the protagonists continuously encounter themselves going through the same actions they have just performed: the wife meets herself coming and going, turning her back on the men's quarrel as her ghostly imposition turns to watch it. The visual impact of Snow's gesture is surprising: characters multiply, depth is flattened, and colors are mixed into curious hues. Recalling his earlier double-sided film installation *Two Sides to Every Story* (1974), in which footage of a woman walking toward and away from the camera is projected on one side of a screen while the same footage shot from the opposite angle is projected on the other side of the screen, *SSHTOORRTY* creates a tautological exchange between form and concept that challenges the traditional linear viewpoint of cinema. As with all of Snow's work, it elicits a new way of seeing and engaging with the moving image that is one of the artist's most characteristic traits.

JM

Still from *SSHTOORRTY*, 2005. 35mm film and 16mm film transferred to video, color, sound; 20 min.

REENA SPAULINGS
Created 2004; based in New York, New York

Reena Spaulings is a fictional artist (and art dealer) created under the auspices of the New York gallery Reena Spaulings Fine Art, cofounded by John Kelsey and Emily Sundblad. Spaulings's work—which includes painting, sculpture, performance, and music—is made by a shifting group of collaborators, many of whom are represented by the gallery. By entering the art world in reverse—first forming a gallery, then becoming an artist—Spaulings confronts the problem of how to maintain integrity in an environment that is overwhelmingly under the sway of the market, both financially and creatively. Furthermore, her fictitious status questions the art-star system that operates in conjunction with this market.

Spaulings's first exhibition, in 2004, consisted of pages torn from a Michael Krebber catalogue and stuck on the walls of Reena Spaulings Fine Art; for the second (also 2004), a mirrored sign was placed above the gallery's storefront with the words ROBERT SMITHSON. In 2005, Spaulings exhibited *The One & Only* at Haswellediger & Company in Chelsea, which constituted an encroachment on another gallery and involved a proposal to change its name to Tsao-Kotinkaduwa and other formal impositions on the space. Thin steel pipes were removed from Reena Spaulings Fine Art and installed at Haswellediger, dividing the space in two. Painted flags, some covered in mussels and tar, hung from flagpoles topped by decorative eagles; one large brick-patterned flag was placed just inside the entrance to the gallery as if to obstruct access. Eagles and mussels were key imagery for the Belgian Conceptual artist Marcel Broodthaers, and Spaulings's use of them highlights his strong influence, particularly his problematization of such issues as art's exchange value and the sacred myth of artistic creativity.

Spaulings's recent "money paintings" are enlarged figurative and abstract renditions, made to scale, of various currencies, including a United Nations Relief and Rehabilitation Administration banknote; these banknotes were printed for circulation exclusively within the Lithuanian camps that housed displaced persons immediately after World War II. Other money paintings include *Swiss 20* (2005), a deliberately badly painted wash of purple and yellow depicting a Swiss franc, and *Black Ruble* (2005), in which a murky black sludge covers most of the painting, leaving visible some shapes that hint at the note's design elements and a small cluster of crudely drawn figures. Drawing a parallel with Marx's description of money as a "real abstraction," these paintings refer to their own unquantifiable, yet precise, market value—as well as to the social function of the artist, since Reena herself might be considered a real abstraction.

ESM

Flag, 2005. Nylon, adhesive letters, aluminum pole, and fittings, dimensions variable. Collection of the artist

RUDOLF STINGEL
Born 1956, Merano, Italy; lives in New York, New York

Rudolf Stingel's Conceptual paintings and site-specific installations deconstruct, in order to popularize, the processes of making art. In 1989, he produced an instruction manual on how to make abstract paintings and duly painted according to its formula for a decade. In another take on the notion of do-it-yourself artwork, Stingel often covers the gallery walls with reflective insulation boards. The first time he showed these silver "paintings," viewers scrawled all over them; but rather than seeing this as a defacement of his work, the artist responded by upping the ante. His wall coverings have since become increasingly baroque in terms of their decorative elements, thereby challenging viewers to reconsider their preconceived ideas about what constitutes a legitimate surface for graffiti.

Stingel has created a series of wall-to-wall carpets, which he views as paintings; however, they can (and are meant to be) walked on, demonstrating his determinedly functional approach to his work. In *Plan B* (2004), he carpeted one of the grand marble entrance halls of New York City's Grand Central Terminal with an incongruously chintzy blue-and-white-on-red floral pattern, recalling the use of cheap carpets to mute sound and hide stains within generic corporate architecture.

Stingel's populist leanings do not preclude an acknowledgment of his own collusion in a rarefied art world. In *Paula* (2005), he painted the floor and walls of Paula Cooper Gallery white, and hung a large portrait of the gallerist on the back wall like some sort of art world icon. In making the painting—a Photo-Realistic rendering of Robert Mapplethorpe's 1984 portrait of Cooper—Stingel first rephotographed the Mapplethorpe to capture the light glinting off its surface, thereby giving his painted version extra sparkle. The effect was to create, in Stingel's words, "a temple of Minimalism and its high priestess," but rather than simply providing a space for worship, he created an opportunity to reflect on the significance of that act itself as it pertains to complex mechanisms of the art market.

Stingel's latest series of paintings, black-and-white Photo-Realistic self-portraits, take a more pensive approach to artistic production. In *Untitled (After Sam)* (2005–6)—the reference is to Sam Samore, whom Stingel commissioned to take the photographs that are the basis for the paintings—the artist lies slumped on a bed, the despondency of both his pose and his expression possibly signaling a moment of creative crisis.

ESM

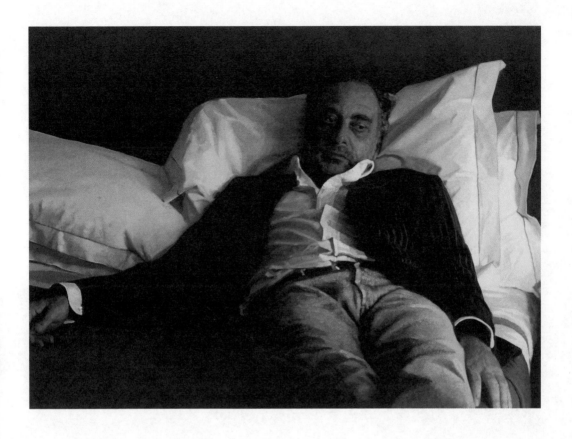

Untitled (After Sam), 2005. Oil on canvas, 15 x 20½ in. (38 x 52 cm). Private collection; courtesy Galleria Massimo de Carlo, Milan, and Paula Cooper Gallery, New York

ANGELA STRASSHEIM
Born 1969, Bloomfield, Iowa; lives in Minneapolis, Minnesota, and New York, New York

Before receiving her MFA from Yale in 2003, Angela Strassheim became certified as a forensic photographer. She did crime scene, evidence, and surveillance photography in Miami and, while working in New York, photographed autopsies. Her first exhibited work was a photograph of a naked woman on an unkempt bed who had committed suicide, and subsequent photographs feature a hospital X-ray room, a body in an open casket, and a bloody surgical saw. But many of Strassheim's vivid color photographs depict less dramatic, even banal, objects and figures, and she identifies her subject matter as "the Midwest and the middle-class American family with the dog, etc." Yet the lessons of forensics have lingered, and scientific detachment, meticulous symmetry, and clinical lighting pervade each of her images. The ropy blue veins in a close-up shot of an elderly woman's hands seem macabre even after we learn that they are those of the artist's grandmother.

Strassheim's crisply polished images seem on first glance to have nothing to hide, but discordant details soon emerge: the deformed toes of a woman wearing an immaculate negligee sitting on a carpeted floor, or the headline of a magazine cover on the desk of a distinguished-looking executive that reads, "God's Great Ambition." (Both works are from Strassheim's *Left Behind* series, photographs of her born-again Christian family in Illinois.) Conventional adult and child roles sometimes reverse: in one image, a diaper-clad toddler perches on a chair next to a bathtub, washing her mother's hair; in another, the child strikes a vaguely seductive pose on what appears to be an adult's bed. Other photographs carry a psychologically fraught charge, even if nothing is identifiably amiss in their domestic narratives. For example, a father combing his son's hair in front of a mirror is not especially unusual, but Strassheim's picture of the scene *feels* odd. It may be their nearly identical Sunday-best clothing, or the man's large hand clamping the boy's shoulder, or the son's doleful expression in comparison to the father's slightly stern one, or something else in the spare portrait that cannot be pinpointed. As in much of Strassheim's work, we sense darker motivations lurking behind the gleaming surfaces, rendering us witnesses to events that the participants would prefer to keep private.

LP

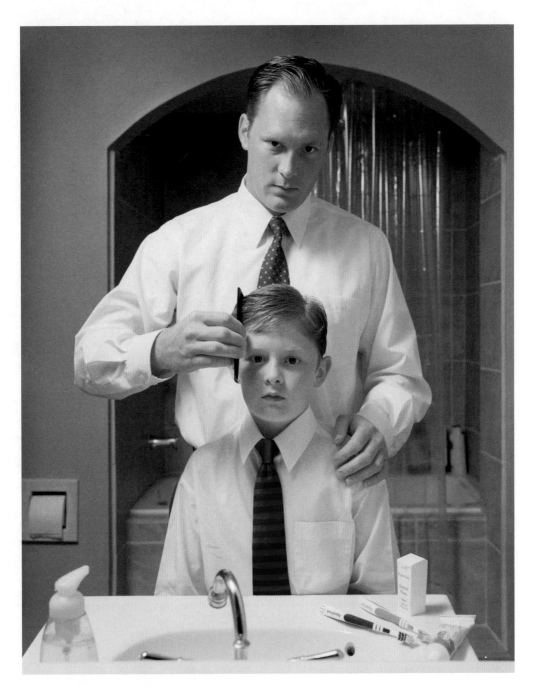

Untitled (Father and Son), from the *Left Behind* series, 2004. Digital chromogenic color print, 40 x 30 in. (101.6 x 76.2 cm). Collection of the artist; courtesy Marvelli Gallery, New York

ZOE STRAUSS
Born 1970, Philadelphia, Pennsylvania; lives in Philadelphia, Pennsylvania

In late September 2005, in the aftermath of Hurricane Katrina, Zoe Strauss traveled to Gulfport and Biloxi, Mississippi, where she spent most of her time with a group of doctors and nurses, distributing ice, water, and over-the-counter medicine to those affected by the disaster. While there, Strauss took dozens of photographs with her digital camera that are as arresting for their formal qualities as for the devastated land and lives they record. Some images verge on abstraction—a tangle of twisted window blinds in one shot occupies the whole field of the picture—but most bluntly document the damage wrought on humans and buildings. Volunteers pass bottles of water in a bucket brigade; piles of ruined belongings surround a leveled home; and the golden arches of a McDonald's sign are bent almost beyond recognition. Strauss has a keen sense of urban semiotics: a graffitied warning on a shuttered warehouse declares "Looters will be shot!" while the high-contrast gridded facade of an anodyne apartment building bears the poignant handwritten message "Mom Were [*sic*] OK."

The artist's extensive written descriptions of some of the Gulf Coast photographs reveal that Strauss spends considerable time getting to know her subjects and, indeed, social responsibility and artmaking are inseparable in all her work. She directs the Philadelphia Public Art Project, which aims to bring conceptually driven art to the southern reaches of the city, and exhibits her photographs in an annual installation under a stretch of Interstate 95 in South Philadelphia. Strauss also presents her images, taken mostly in Philadelphia, in slide shows; but she avoids the didacticism that often characterizes that format by accompanying the work with music from an iPod, ranging from jazz to hip-hop. Her photographs bear the stamp of 1960s documentary practice and seem at first glance to have the deadpan, detached aesthetic of 1960s Conceptualism, but without the "de-skilling" that often (allegedly) marked that work. Although many of her images have the casual feel of off-the-cuff snapshots, Strauss is particularly mindful of composition, color, lighting, and cropping, all in the service of conveying what she terms "the beauty and the struggle of everyday life."

LP

Mom Were OK, detail from *I-95* series, Gulfport, Mississippi, September 2005. Digital chromogenic print, dimensions variable. Collection of the artist

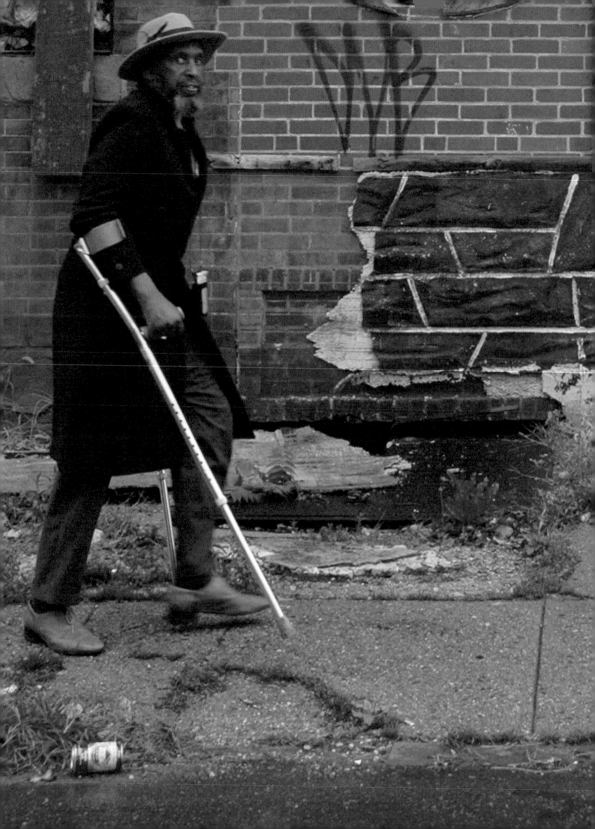

STUDIO FILM CLUB
Founded 2003; based in Port-of-Spain, Trinidad and Tobago

Every Thursday evening since early 2003, in the garagelike studio behind the Caribbean Contemporary Arts, a former rum factory in Port-of-Spain, Trinidad, Peter Doig and Che Lovelace have been presenting free screenings of movies they enjoy—from obscure international art-house films and classics of world cinema such as François Truffaut's *La nuit Américaine (Day for Night)* (1973) to Hollywood anomalies such as David Lynch's *Blue Velvet* (1986). American-style multiplex theaters showing blockbuster movies are beginning to infiltrate the cinema life of Trinidad, and Doig and Lovelace's passion is to reinvigorate the rich film culture of the island with weekly detours from the mass entertainment agenda. Studio Film Club's diverse, improvised program offers a refreshing, unpretentious, and hybrid conversation between art and life, cinema and social interaction.

The physical location and the atmosphere of the "cinema" are resolutely informal: the screen is a simple white wall; the windows are open to the elements; and the noises from the street drift in and mingle with the films' soundtracks. Spontaneous discussions can often go on long into the night, continuing the tradition in Trinidadian cinemas of audience members chatting back to the screen and giving advice to characters in an active and irreverent dialogue with the movies. The club's programming has also included live musical performances and a talk by the influential Trinidadian-born filmmaker Horace Ové.

To advertise each screening, Doig paints quickly executed posters that are often hung at the Studio Film Club while still wet. The bands of color and block lettering in his posters—for example, those accompanying Alejandro González Iñárritu's hard-hitting *Amores Perros* (2000) and Bud Smith's documentary *The Esso Trinidad Steelband* (1971)—recall the design conventions of hand-painted commercial signage seen throughout Trinidad. Doig sometimes incorporates motifs from his own painting practice, but most often the posters sample a key scene from the movie to which they refer.

The films that Doig and Lovelace show provide a broad spectrum of cinematic experiences. Their choices have frequently reflected on the context of the Caribbean as a production location as well as on the notion of Creole culture, as in the 1973 Jamaican gangster classic *The Harder They Come* or Trevor D. Rhone's *Smile Orange* (1974). During the 2006 Biennial, a number of films from Doig and Lovelace's Studio Film Club program will be screened at the Museum, and the duo will present selections from the Biennial film program to audiences in Trinidad.

MA

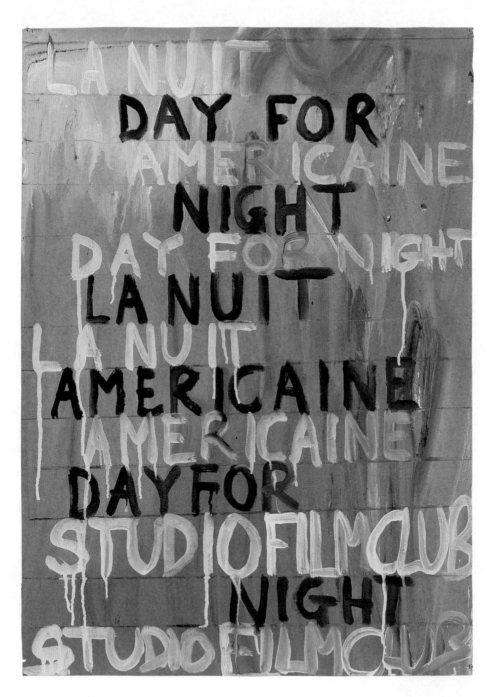

Peter Doig, *Day for Night*, 2005. Oil on paper, 33 x 23½ in. (84 x 59.7 cm). Private collection; courtesy Contemporary Fine Arts, Berlin

STURTEVANT
Born 1930, Lakewood, Ohio; lives in Paris, France

Sturtevant's work centers on questions of authorship, authenticity, and the ways art acquires meaning through institutional contextualization, criticism, and market valuation. Since the 1960s, she has meticulously re-created works by other artists, ranging from Pop stalwarts such as Jasper Johns, Claes Oldenburg, and Andy Warhol to Robert Gober, Felix Gonzalez-Torres, and Paul McCarthy. These projects have included repeating Johns's iconic *Flag* (1965–66) and reconstituting, in its entirety, Oldenburg's *Store* (1967). Warhol in particular recognized the collaborative rather than appropriative basis of her approach and even gave her one of his *Flower* silkscreens to use in creating her own canvases. When later quizzed about his own painting techniques, Warhol deadpanned: "I don't know. Ask [Sturtevant]."

Sturtevant's technique makes it almost impossible to tell the difference between her work and its source. Nevertheless, she maintains that the "brutal truth" of her works is that they are *not* copies: when she uses a Warhol silkscreen, she is creating not a Warhol but a conceptually "authentic" Sturtevant. She has described this paradox as "the push and shove of the work [which] is the leap from image to concept."

Sturtevant's installation for the Biennial, *Duchamp 1200 Coal Bags*, takes as its source Marcel Duchamp's pioneering ready-mades, which inaugurated an important thread of conceptually driven artmaking. She has fabricated a dozen of Duchamp's ready-mades and titled them accordingly, so that, for example, Duchamp's signed urinal, *Fountain* (1917), becomes Sturtevant's *Duchamp Fountain* (1973). The installation is littered with other replications of Duchamp works, including a snow shovel, a bottle rack, and a film of a female nude descending a staircase; the room is crowned by 1,200 distended burlap bags hanging from the ceiling.

Sturtevant's *Duchamps* confront our desire for legitimate and singular aesthetic events and complicate our expectations about originality. In making them, she deconstructs the mechanisms of art production and consumption, shifting the emphasis from objects to ideas and providing a space for critical reflection upon the various systems that convey meaning onto artworks.

SH

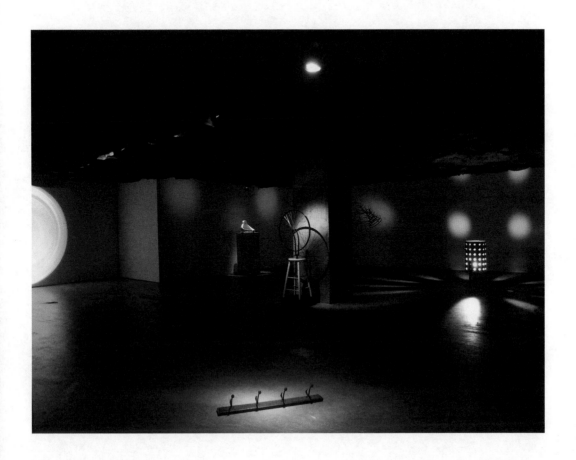

Push & Shove, 2005 (installation view, Perry Rubenstein Gallery, New York)

BILLY SULLIVAN
Born 1946, New York, New York; lives in New York, New York

Billy Sullivan's portraits and still lifes capture the fleeting moments in life that transcend the everyday. Since the late 1960s, he has chronicled in slide photographs the art, fashion, and celebrity scenes through which he travels. These images of the intriguing people and striking details that surround him often serve as source material for his paintings, pastels, and ink drawings. Buzzing with a tangible energy and fraught with an insider's intimacy, they depict the highs and lows of a life less ordinary.

The subjects of Sullivan's images include family members, friends, art stars, drag queens, actors, fashion models, lovers, and complete strangers. In the painting *Clarissa, East Hampton 1982* (2005), the curator Clarissa Dalrymple is shown kneeling on the floor, doubled over and leaning through an open sliding glass door. Her hair looks wet and her shoulders are bare. She wears an enigmatic expression—a mixture of fear, pain, grief, and reflection that stands in stark contrast to the bright sunlight that bathes her. Sullivan's gestural lines and sensitive, painterly touch infuse this frozen moment with a dramatic immediacy.

1969–2005 (2005), a slide work presented for the first time as part of the 2006 Biennial, consists of three separate yet contiguous slide projections. One grouping focuses on the beguiling figure of Sirpa—a lithe blonde luxuriating in a rumpled hotel room, alternately wrapped in gold lamé, lolling nude about the bed, or picking at a room-service breakfast. Another sequence is devoted to men, caught in an array of poses and moods that range from mischievous and provocative to thoughtful to aloof. The third is a mix of images from Sullivan's past and present, documenting decades of parties, fashion shoots, vacations, theatrical productions, solitary moments, and druggy decadence. Portraits of downtown scene-makers now deceased, including Cookie Mueller and Jackie Curtis, are mingled with a new crop of personalities such as Sophia Coppola and Skeet Ulrich. Sullivan's visual diary takes on the quality of cinematic stills or snapshots, recalling in its compelling mixture of eroticism and innocence the look and feel of Andy Warhol's films and Polaroids; here, too, people caught in profound or mundane moments of life are presented in all their poignant luminescence.

JM

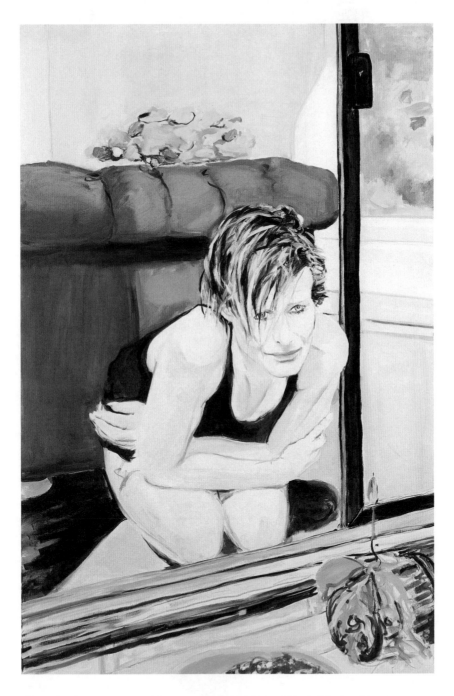

Clarissa, East Hampton 1982, 2005. Oil on canvas, 64 x 42 in. (162.6 x 106.7 cm). Collection of the artist; courtesy Nicole Klagsbrun Gallery, New York, and Regen Projects, Los Angeles

WAX JOEL

WAS CAMP
SAT SNOW
LADIES NITE
ENCHANTMENT Rec

PROD. SNDS.
ALAN DIAZ
SIR CHARLES
SWWTU
'SAT 29 OCT
BASIX PROM.

SFC
100
19 MAY
LAVENTILLE

SPENCER SWEENEY
Born 1973, Philadelphia, Pennsylvania; lives in New York, New York

Spencer Sweeney assumes the roles of artist, club owner, and musician to build a practice that falls intentionally between the cracks of any qualifiable genre. His explosively colorful collaged paintings and cartoonish drawings constitute one part of a larger body of work based on his persona. This places him within a tradition of artists, such as Martin Kippenberger, who, in cultivating outrageous personalities and shifting rapidly between artistic styles, sought an expanded room to maneuver not otherwise afforded by the gallery system.

For a recent solo exhibition, Sweeney suspended an NYPD police car (which he bought at auction) upside down from the ceiling of the gallery, surrounded by a series of psychedelic paintings. In one, *The Mother of Us All* (2005), vivid motifs compete for space: large sections of the canvas are blacked out; a burst of colorful scrawls originating in the top right-hand corner mutates into intestines, which crawl over the painting and drip to its bottom; and a black spiderweb billows at the painting's opposite corner. Many of the paintings resemble New York City's heavily graffitied surfaces, reinforcing the sense of anarchy evoked by the upturned police car (*Turning a cab back into a police car into a disco*, 2005). In place of an identification number, the vehicle bears the chemical equation for LSD; a disco ball and rotating colored lights are attached to its roof, turning the car into a chandelier—in fact, it will soon be installed in Santa's Party House, Sweeney's nightclub in Manhattan.

In an ongoing series of daily drawings that spans a suitably diverse array of images, Sweeney evinces a boundless disregard for consistency of style and form: one shows a woman with her legs spread, wearing only sweatbands and tennis shoes; the self-explanatory *Note to Mother* (2004) is a doodle-like collage; and numerous homoerotic diagrams portray nude male figures replete with angel wings, red high heels, and flowing hair in unabashedly absurd sexual positions. Their occasional preposterousness and their diaristic nature offer a live feed of the artist's thoughts and reinforce the contradictions that sustain Sweeney's ever-shifting practice.

ESM

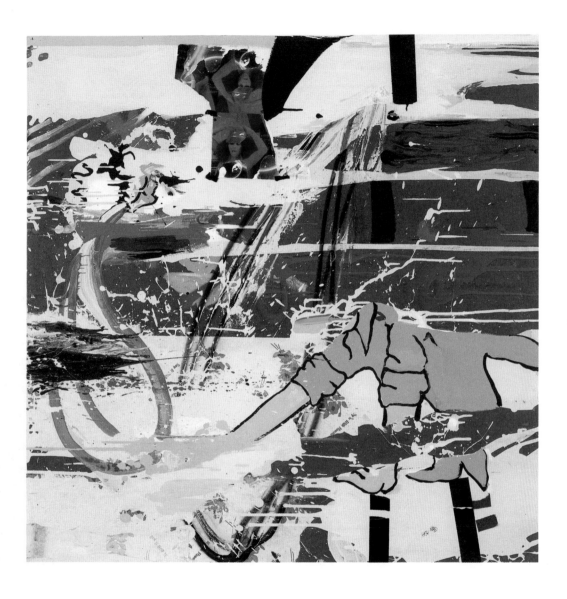

Fun, 2005. Oil on canvas, 48 x 48 in. (121.9 x 121.9 cm). Collection of Shane Akeroyd; courtesy Gavin Brown's enterprise, New York

SUCKED O

RYAN TRECARTIN
Born 1981, Webster, Texas; lives in New Orleans, Louisiana

Ryan Trecartin's video *A Family Finds Entertainment* (2004) is a carnivalesque, meandering narrative that chronicles the coming-out of a gay teenager named Skippy. Kicked out of his parents' house upon revealing his sexual preference, he attempts suicide, is run over by a car, and is ultimately "rescued" by a flamboyant coterie of "experimental people." The cast members—made up of Trecartin's family, friends, and the filmmaker himself (playing no fewer than five parts, including Skippy)—prance around inside a series of elaborate interiors (a style developed in his early videos from 2001 to 2003). Modeling an array of extravagant costumes, the characters include a drag diva, an androgynous dandy, a bespectacled "documentary video artist," and a group of men who are so masculine that their genitals cause them constant pain. In the spirit of filmmakers such as Jack Smith, George and Mike Kuchar, and John Waters, Trecartin orchestrates his burlesque parade of class and gender stereotypes as a hilarious send-up of conservative social and sexual mores.

Trecartin adds to the riotous visual overload with an array of digital effects: he finger-paints over faces or breaks the images up into a multitude of moving screens. To make his deliberately lo-fi and exuberantly over-the-top animations, Trecartin sifts through the detritus of images from popular culture, computer games, and advertising; in this way, his practice connects with recent tendencies is digital animation that encompass work by assume vivid astro focus and the artist collective Paper Rad, among others.

The characters in *A Family Finds Entertainment* ramble on in fake accents and deliver tangentially related monologues, often speaking directly into the camera. Despite the appearance of being ad-libbed, the work was completely scripted. In fact, what passes itself off as a loose, ad hoc production culminating in a noisy live performance by the real-life band XPPL (of which Trecartin is a member) was elaborately staged and carefully choreographed from start to finish. The video's faux naïveté, camp spectacle, and ironic mockery are thrown into relief with its sweeter underlying sentiment: in a happy turn at the end, Skippy finds salvation through the motley crew that is his adopted family, asserting the work's exhilarated appreciation of community.

HH

Still from *A Family Finds Entertainment*, 2004. Video, color, sound; 41:12 min. Collection of the artist; courtesy Elizabeth Dee, New York, and Q.E.D., Los Angeles

JT CONTENT

CHRIS VASELL
Born 1974, Grand Rapids, Michigan; lives in Los Angeles, California

In Chris Vasell's work, surface and depth are in perpetual play, a dynamic that results from his patiently laborious process. In large acrylic paintings and smaller, page-sized watercolors, he applies numerous washes of paint in successive overlays. These multiple, paper-thin layers render his canvases and works on paper at once seemingly translucent and compactly filled, as the edge-to-edge pictorial density is offset by a watery luminosity. Vasell's technique echoes that of 1960s Color Field painting: the smeary runs of paint and limpid washes of *Second Day* (2005) and *Bereshit* (2004), for example, evoke the stain techniques of Morris Louis and Helen Frankenthaler, and the nested rings of *Untitled (Concentric Circles Painting)* (2004) seem a direct nod to the preferred geometric icon of Kenneth Noland. But Vasell's palette—which includes hues that range from psychedelic acids to somber, metallic darks—betrays a contemporary sensibility, as does the expansive scope of his imagery: human forms are intermingled with landscape vistas, and areas of ornate patterning are juxtaposed with passages of amorphous abstraction.

Certain qualities in Vasell's paintings—the aqueous washes of *Second Day*, for example, or the warm hues and membranous layers of *Untitled (Cave)* (2004), apparently infinite in number—induce feelings of meditative calm. Others suggest existential narratives, however uncertain, with edges of menace. In *SELF (Landscape)* (2005), two disembodied eyes (one glassy, one half-closed) punctuate a desolately shadowed mountainscape, and in *Cephalic Isolation* (2005), a pair of eyes emerges from a spidery thicket of webbed lines. In Vasell's hands, the organs of vision have relinquished their perceptual abilities and become trapped and damaged. Indeed, the title of his recent solo exhibition, *Don't go outside they're waiting for you* (2005), hints at a sinister dimension to his preternatural images.

LP

Cephalic Isolation, 2005. Acrylic on canvas, 82 x 68 in. (208.3 x 172.7 cm). Collection of Dean Valentine and Amy Adelson; courtesy Blum & Poe, Los Angeles

FRANCESCO VEZZOLI
Born 1971, Brescia, Italy; lives in Milan, Italy

Francesco Vezzoli's work plays on a dark fascination with the luster and decadence of celebrity and the treadmill of fame and extends a whole tradition of artists, from Andy Warhol to Douglas Gordon, dealing in their work with Hollywood and cinema. Vezzoli has collaborated with charismatic, aging divas whose time in the limelight has past, as in his films *An Embroidered Trilogy* (1997–99), for which he sought out three Italian film idols from his childhood: Iva Zanicchi, Franca Valeri, and Valentina Cortese. Alongside his film work, and sometimes in them, Vezzoli practices needlepoint, embellishing black-and-white film stills of Edith Piaf or Maria Callas, for example, with stitched metal tears or sparkling eye shadow.

Vezzoli's practice merges a studied melancholy derived from Italian film directors such as Pier Paolo Pasolini and Luchino Visconti with the high-camp seduction of contemporary popular entertainment, with its constantly changing roster of pop stars, reality TV shows, and celebrity magazines. His film *Non-Love Meetings* (2004), inspired by Pasolini's *Love Meetings* (1964), presents a full-scale, glossy dating game show compered by Ela Weber in a Rome studio. Unscripted, actresses Catherine Deneuve and Antonella Lualdi, rock icon Marianne Faithfull, and popular Italian television personality Terry Schiavo each has to choose a "date" from a cast of suitors that includes a stripteasing bodybuilder, a transvestite, and a young lesbian. The members of the audience (including the artist) are invited to give their opinions. A similarly indulgent cocktail of sexual ribaldry, fame, and high- and low-brow genres marks Vezzoli's star-studded *Trailer for a Remake of Gore Vidal's "Caligula"* (2005). Filmed at a faux Roman palazzo in Bel Air, California, and featuring, among others, Milla Jovovich, Benicio del Torro, Helen Mirren, Courtney Love (as Caligula), and Gore Vidal (as himself), in costumes designed by Donatella Versace, this exhilaratingly bawdy teaser for a nonexistent remake sends up the excesses of movie trailers using one of the most excessive films in Hollywood's history. It revels in Emperor Caligula's notoriously wayward sexual appetite and the delirious controversy surrounding the 1979 semipornographic feature film. In Vezzoli's trailer, naked collared slaves are led about on leashes and gold-plated dildos are put into action for a promiscuous, orgiastic five-minute romp. As the titillating voice-over declares, "You can literally feel it coating you in the taboo!"

MA

Still from *Trailer for a Remake of Gore Vidal's "Caligula,"* 2005. 35mm film transferred to video, color, sound; 5:35 min.
Castello di Rivoli Museo d'Arte Contemporanea

89

KELLEY WALKER
Born 1969, Columbus, Georgia; lives in New York, New York

With a computer and a flatbed scanner, Kelley Walker turns squirts of toothpaste into colorful abstractions, photographs objects such as cutout cereal boxes, and scans archival images for reproduction; he then uses Photoshop to layer his scanned images in superflat collages or to enlarge them to make equally flat sculptures. This digitally induced leveling serves to critique the way in which the proliferation of images causes them to lose their historical content, becoming literally two-dimensional. In *Schema: Aquafresh plus Crest with Tartar Control* (2003), toothpaste is scrawled across a news photograph taken during the 1960s of a police dog savagely attacking a black civil rights protester. Walker's layering of the once-shocking with the mundane causes these images to inform each other—tartar control takes on sinister undertones, while the apparent erasure of the infamous image causes us to see it afresh—so that neither can be exempted from its historicity.

Walker is one of a generation of artists employing digital media to construct a critical examination of appropriation in art. He often sells his work on CD-ROMs, encouraging buyers to contribute their own manipulations to his images and to print (and proliferate) them as often as they like. This dispersive approach to circulation and distribution is part of Walker's adoption of the motifs of recirculation. He borrows the recycling logo itself to comment on the way in which images and trends resurface in art, as in contemporary society as a whole, becoming, in the process, in danger of losing their historical relevance. In the soft sculpture *Black Suede* (2005), the three-arrowed logo can either rest on the floor like a hearth rug or hang on the wall like a painting; Walker has also produced equally flat freestanding cardboard cutouts of the symbol.

Through his own recycling of media images, specifically those depicting police brutality during the civil rights protests of the 1960s, and his antagonistic mimicry of the production values of capitalism, by his own accounting Walker situates himself in dialogue with Andy Warhol, who created a body of work based on photographs of race riots. In another nod to Warhol, namely, his series of Rorschach paintings, Walker has created *Rorschach* sculptures made of mirrored plexiglass that impart both a brittle glamour and an incisive critique. Rather than letting the inkblots reveal aspects of our inner mental workings, our reflection—image—within the inkblots causes the collapse of their real purpose, enacting the victory of image over content.

ESM

Black Star Press (rotated 90 degrees); Black Press, Black Star, 2005. Milk chocolate and dark chocolate on digital print on canvas, 84 x 208 in. (213.4 x 528.4 cm). Carlos and Rosa de la Cruz Collection; courtesy Paula Cooper Gallery, New York

NARI WARD
Born 1963, Saint Andrew, Jamaica; lives in New York, New York

Nari Ward often reclaims discarded objects and materials found in the urban landscape to create sculptures and installations that evoke memories, experiences, and questions. In earlier bodies of work, he used plastic garbage bags, abandoned baby strollers, glass bottles, landscaping barrier cloth, and fire hoses to raise issues related to consumer culture, poverty, and race. More recent works incorporate oil drums, tar slabs, discarded doors, dried salted codfish, and old television sets to comment on immigration, religion, sex, and patriotism. His juxtapositions are often ambiguous, however, allowing for multiple, open-ended interpretations.

For *Amazing Grace* (1993), Ward retrieved more than 350 baby strollers from the streets of New York and installed them in a defunct Harlem firehouse. The strollers were bound together with thick coils of deflated fire hose, forming a shape reminiscent of a ship's hull. The hymn "Amazing Grace" played over a sound system, creating a reverent and poignant environment in a building that symbolizes an affirmation of life through salvation from fire.

While in residence at the Walker Art Center in 2000, Ward researched the local histories of Minneapolis's famous ice palaces, St. Paul's once-thriving African American Rondo neighborhood, and the distinct ice-fishing shacks found throughout the winter on Minnesota's frozen lakes. In response, he created *Rites-of-Way* (2000), an outdoor sculptural installation of scaffolding built according to the floor plan of a 1940s ice palace designed by African American architect Clarence Wigington. The scaffolding supported ice shacks, which held items donated from former residents of the Rondo community. Curtains of glass beads draped along the supporting pillars brought to mind the sparkle of ice and water. Literally and conceptually layered, Ward's project reclaimed lost histories in an evocative environment that viewers could physically navigate.

Glory (2004) addresses contemporary political events in a wry and disturbing way. Consisting of three battered oil barrels welded end to end, turned sideways, and split in half, the sculpture is opened to reveal the mechanisms of a tanning bed. Inside, there is a mesmerizing audio element appropriated from an English-language training CD for parrots. The glass surfaces of the bed have been covered with stars and stripes, enabling a user to burn the motifs of the American flag into his or her skin. Crowned by the seal of the United States of America, the contraption is the ultimate representation of heated post-9/11 nationalistic fervor. Like all of Ward's works, *Glory* raises questions about our history, our culture, what we cherish, and what we abandon.

JM

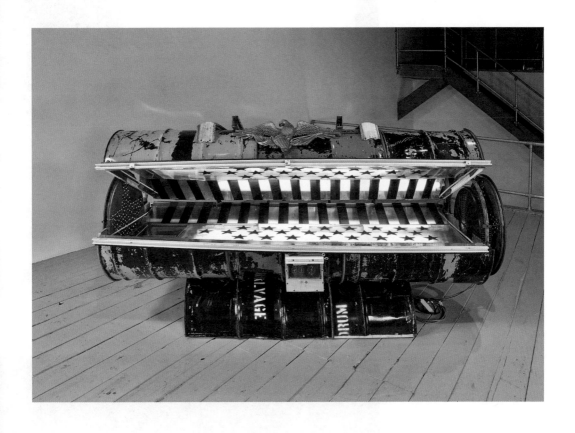

Glory, 2004. Oil barrels, ultraviolet and fluorescent lights, computer parts, plexiglass, fan, camera casings, audio element, towels, and rubber roofing membrane, dimensions variable. Collection of the artist; courtesy Deitch Projects, New York

photo by Sprague Hollander

CHRISTOPHER WILLIAMS
Born 1965, Los Angeles, California; lives in Los Angeles, California

Christopher Williams's work in photography, sculpture, performance, film, video, and graphic design is highly conceptual and often addresses hierarchies of power, object fetishism, and conventions of representation. For one triptych, he photographed a Kiev 88 camera, a cheap eastern European knockoff of a Hasselblad, in front three-quarter view, back three-quarter view, and profile in a commercial studio in Los Angeles; the camera used to take the photographs was of the highest precision quality; the photographs were developed using a rarefied color process—all resulting in three conspicuously glamorous, perfectly staged "headshots." The high-end technical treatment is at odds with the Soviet-era product that is being represented. The title, as in all of Williams's work, inventories its subject's history: *Kiev 88, 4.6 lbs. (2.1 kg) Manufacturer: Zavod Arsenal Factory, Kiev, Ukraine. Date of production: 1983–87. Douglas M. Parker Studio, Glendale, California. March 28, 2003 (Nrs 1–3).*

Like his titles, Williams's photographs are densely laden with references. In its attentive depiction and fetishization of a mass-produced object, *Kiev 88* recalls the artist's earlier series *For Example: Die Welt ist schön (First Draft)* (1993), ostensibly an impartial documentation of commonplace objects, but one filtered by the awareness that photography is inextricably implicated in capitalism's co-opting of desire. The model for this series was the 1928 book *Die Welt ist schön* (The world is beautiful) by German New Objectivity photographer Albert Renger-Patzsch, a photographic archive of close-ups of natural organisms, machinery, and mass-produced objects that brought out their similar patterns.

In Williams's latest series *Kodak Three Point Reflection Guide, © 1968 Eastman Kodak Company, 1968. (Miko laughing), Vancouver, B.C., April 6, 2005* (2005), the typically hidden device of the Kodak color bar is self-reflectively made visible. A professional model, wrapped in bright yellow towels that refer to Kodak's signature color, flashes the clean, fetishized smile of commercial advertising. He selected the model by following a casting call used by Jacques Tati for his 1967 film *Playtime*: "A girl about 20–25 years old, coy, a little awkward, but with intelligent eyes … most important is the reserved appearance, due to a good education." The artificiality of the image is belied by the slight imperfections in the model's skin; for Williams, leaving out the last step—the retouch—renders the image anthropological rather than commercial.

ESM

Kiev MC Arsat (Zodiak-8) 30mm f3.5, 1:3.5, Product Aperture f/3.5, Serial Number 870701, Medium Format Camera Lens, Douglas M. Parker Studio, Glendale, California. August 4, 2005, 2005. Black-and-white fiber print, 16 x 20 in. (40.6 x 50.8 cm). Collection of the artist; courtesy David Zwirner, New York

THE !STORM! THIS YEAR WAS =NON-FICTION=
THIS WAY WORLDAMAGE BRAINEWORD FUTURE
WAS>...TICKELISH AND FRIGHTFUL---BUT ALSO
=I WANT THE SOUTH POLE- ONTOP + SIDEWAY
=MELTING ART SO PAINTING AND SCULPT.
=HEY YOYO! MAKE A NEW POEM THE OLD ONE

?WHAT DID "WE" SAY ABOUT LIFE ON THE BIG
+WE SAID+, "THIS YEAR ANSWERED A
WILL. THE. PEOPLE WORLD. EVER E
JUST KIDDING-FINGERS CROSSED".

JORDAN WOLFSON
Born 1980, New York, New York; lives in New York, New York, and Berlin, Germany

Jordan Wolfson's films, videos, and installations propose art as a site with the potential for personal experience and communication—of doubts, expectations, and wonder. His works are composed with a generous conceptual and formal elegance that leaves itself open to the viewer's emotional and interpretive response.

Infinite Melancholy (2003) is a misleadingly simple-looking 4-minute animation projected on a large screen. It gives the impression one is soaring and diving over a white field defined by rows of black letters that spell out, again and again, CHRISTOPHER REEVE, the name of the actor who played Superman. The soundtrack consists of a pianist making unsteady progress through Rogers and Hammerstein's "Getting to Know You" (1951). The evocation of the late Reeve, who was paralyzed in a 1995 riding accident, is open to a variety of responses: we may find the work inspirational, mawkishly memorializing, ironically sentimental, or "infinitely" sad.

Dreaming of the Dream of the Dream (2004) is concerned with the authenticity of representation, memory, and alternate states of mind. Wolfson assembled more than one hundred cartoon clips depicting water—seas and waves, storms and cascades—and then spliced them together to make a 1-minute silent film loop that cycles through the course of a day, from sunrise to sunset. This film was conceived as a unique piece of celluloid, and as the ever-repeating day is projected over and over, it will eventually fade away: in viewing it, we contribute to its destruction.

Wolfson's film for the 2006 Biennial shows a man in a tuxedo, seen from his bow tie down, performing in sign language, and therefore re-silencing, the final speech in Charlie Chaplin's 1940 Nazi satire *The Great Dictator* (the complete text of the speech serves as the title of Wolfson's film). The speech is a rousing, utopian plea for mankind, and though ostensibly delivered by the Jewish barber (played by Chaplin) who has been mistaken for his dictatorial döppelganger, it represents a unique moment, one year before the United States entered into World War II, when Chaplin broke character to make a resolutely personal entreaty (it was coincidentally his first "talkie"). Wolfson's film also appropriates the aesthetics of Jørgen Leth's *The Perfect Human* (1967), made during another turbulent moment in history when many were pleading for something "impossible," namely, humankind living in harmony.

MA

Still from *I'm sorry but I don't want to be an Emperor—that's not my business—I don't want to rule or conquer anyone. I should like to help everyone if possible, Jew, gentile, black man, white. We all want to help one another, human beings are like that. We all want to live by each other's happiness, not by each other's misery. We don't want to hate and despise one another. In this world there is room for everyone and the earth is rich and can provide for everyone. The way of life can be free and beautiful. But we have lost the way. Greed has poisoned men's souls—has barricaded the world with hate; has goose-stepped us into misery and bloodshed. We have developed speed but we have shut ourselves in: machinery that gives abundance has left us in want. Our knowledge has made us cynical, our cleverness hard and unkind. We think too much and feel too little: More than machinery we need humanity; More than cleverness we need kindness and gentleness. Without these qualities, life will be violent and all will be lost. The aeroplane and the radio have brought us closer together. The very nature of these inventions cries out for the goodness in men, cries out for universal brotherhood for the unity of us all. Even now my voice is reaching millions throughout the world, millions of despairing men, women and little children, victims of a system that makes men torture and imprison innocent people. To those who can hear me I say "Do not despair." The misery that is now upon us is but the passing of greed, the bitterness of men who fear the way of human progress: the hate of men will pass and dictators die and the power they took from the people will return to the people, and so long as men die [now] liberty will never perish ... Soldiers—don't give yourselves to brutes, men who despise you and enslave you—who regiment your lives, tell you what to do, what to think and what to feel, who drill you, diet you, treat you as cattle, as cannon fodder. Don't give yourselves to these unnatural men, machine men, with machine minds and machine hearts. You are not machines. You are not cattle. You are men. You have the love of humanity in your hearts. You don't hate—only the unloved hate. Only the unloved and the unnatural. Soldiers—don't fight for slavery, fight for liberty. In the seventeenth chapter of Saint Luke it is written "the kingdom of God is within man"—not one man, nor a group of men—but in all men—in you, the people. You the people have the power, the power to create machines, the power to create happiness. You the people have the power to make life free and beautiful, to make this life a wonderful adventure. Then in the name of democracy let's use that power—let us all unite. Let us fight for a new world, a decent world that will give men a chance to work, that will give you the future and old age and security. By the promise of these things, brutes have risen to power, but they lie. They do not fulfill their promise, they never will. Dictators free themselves but they enslave the people. Now let us fight to fulfill that promise. Let us fight to free the world, to do away with national barriers, do away with greed, with hate and intolerance. Let us fight for a world of reason, a world where science and progress will lead to all men's happiness. Soldiers—in the name of democracy, let us all unite! Look up! Look up! The clouds are lifting—the sun is breaking through. We are coming out of the darkness into the light. We are coming into a new world. A kind new world where men will rise above their hate and brutality. The soul of man has been given wings—and at last he is beginning to fly. He is flying into the rainbow—into the light of hope—into the future, that glorious future that belongs to you, to me and to all of us. Look up. Look up.* Charlie Chaplin, "The Great Dictator" (1940), 2005. 16mm film, black-and-white, silent; 2:37 min. Collection of the artist; courtesy Perry Rubenstein Gallery, New York

VERY VERY (TALLY.

RTH APACOWICKWICK SIGHTING>

(WEIRD) AND, FUN.

YOUNG EQUATOR

PEE. MAYBE

OTHER FACER?

ARD QUESTION--

END.? YES.

=OUT OF TOWN=

THE WRONG GALLERY
Founded 2002; based in New York, New York

The Wrong Gallery—a tiny, yet influential presence in New York's Chelsea gallery district—consisted initially of nothing more than a glass door, always locked, with one square foot of exhibition space behind it. Founded by artist Maurizio Cattelan, curator and art critic Massimiliano Gioni, and writer and curator Ali Subotnick, the gallery does not represent artists or buy and sell artwork. Rather, it serves as an incubator for artistic experimentation, inviting a range of artists to create site-specific works within its space or to participate in a variety of interventions within the art world.

In its first three years of operation, the gallery presented works by Martin Creed, Isa Genzken, Paul McCarthy and Jason Rhoades, Elizabeth Peyton, and Tino Sehgal, among many others. It produced a graffiti project with Lawrence Weiner and, in collaboration with the Public Art Fund and curator Jacob Fabricius, a series of presentations featuring Fabricius wearing artist-designed sandwich boards in a pedestrian mall in Brooklyn. In 2003, it opened a second space, just down the block, that was nearly identical to the first, but with two square feet of exhibition space behind its locked glass door, and in 2005, a miniature Wrong Gallery opened at the Center for Contemporary Art in Kitakyushu, Japan. *The Wrong Times*, a newspaper featuring interviews with artists who have collaborated with the gallery, has been published in two editions since 2004.

Although its exhibition spaces in New York have closed, the Wrong Gallery lives on as an identity, a franchise, and a concept, manifesting itself within other organizations like a parasite. In October 2005, working as curators for the 4th Berlin Biennial for Contemporary Art, the Wrong Gallery team opened a counterfeit Gagosian Gallery in Berlin. Soon after, a 1:6 scale version of the Wrong Gallery was produced by Cerealart, so now anyone can be a gallerist. In December 2005, the gallery's signature glass door relocated to the Tate Modern, London, where it continues an independent program of exhibitions, behind the locked door, within the permanent collection galleries.

For the 2006 Biennial, the Wrong Gallery devised another intervention. *Down by Law* is an exhibition within the exhibition that explores the phenomenon and myth of the American outlaw. Putting together a portrait gallery of bad men and women, a parade of wrong behaviors, it mirrors some of America's darker moments and unlikely heroes. Whatever its form and wherever it appears, the Wrong Gallery persists as a free-spirited entity that challenges and transforms, with irreverence and humor, our experience of art.

JM

Down by Law, curated by the Wrong Gallery with Cecilia Alemani and Jenny Moore, includes work by more than forty artists, including several artworks from the Whitney's permanent collection.

The Wrong Gallery, 516A½ West 20th Street, New York

AARON YOUNG
Born 1972, San Francisco, California; lives in New York, New York

Aaron Young's performative actions, videos, and sculptures deal with art's capacity to aestheticize extreme behavior and the margins of culture. Influenced by Chris Burden's high-risk performance actions of the 1960s, Young is no clinical voyeur, but an accomplice within the scenarios he orchestrates, acutely aware that his motives are always implicated.

For his video *High Performance* (2000), Young hired a biker to do tire "burnouts" in a studio space at the San Francisco Art Institute. As the revved-up motorbike creates black circles of burnt rubber on the floor, the space is gradually engulfed in thick white smoke. In its displacement from a parking lot to a studio context, this extravagantly indulgent though otherwise unremarkable stunt becomes inflected with a curious formal elegance. Playing off two meanings of the word "performance," Young recontextualizes this high-powered motorbike as a tool of boisterous live drawing. *Good boy* (2001) likewise draws on a subculture of cultivated aggression. The video records a muscular pit bull terrier writhing in midair as it dangles from a leash by its powerful teeth, as if performing in some kind of a canine trapeze act; the dog's intimidating growls are accompanied by the owner's equally aggressive tauntings off screen

Young's exhibition *Tender Buttons* (2004) provided a crescendo to his practice involving staged events that aestheticize power. For almost an hour during the opening night of the show, a helicopter hovered outside the gallery, training a searchlight through the windows of the building onto the crowd inside. There, visitors watched this mock law-enforcement operation through multicolored aviator sunglasses provided by the artist.

The sculpture *"LOCALS ONLY!" (Bayonne, New Jersey)* (2006), one of a series of bronze rocks, responds in another way to the marking of a territory and the current climate of suspicion and fear. After casting the boulder in bronze, Young hired professional scenery artists to paint it so it would resemble boulders from a location in New Jersey characterized as a marginal, suburban "non-site" in several works by Robert Smithson. Young then spray-painted the phrase "Locals Only" across the rock, suggesting the kinds of barriers that people put up in their intolerance toward outsiders and steadfast defense of a territory. Young's work evokes a cultural and psychological hinterland within which lies an ever-present potential for violence, exploitation, and instability.

MA

"LOCALS ONLY!" (Bayonne, New Jersey), 2006. Bronze and acrylic paint, 42 x 30 in. (106.7 x 76.2 cm). Collection of the artist; courtesy Harris Lieberman, New York

PUBLIC ART FUND: A COLLABORATION WITH THE WHITNEY BIENNIAL
Susan K. Freedman, President, Public Art Fund

In 2002, the Public Art Fund and the Whitney Museum copresented the first-ever *Whitney Biennial in Central Park*, a series of installations that each drew direct inspiration from the park itself. A tradition was born. In 2004, our organizations collaborated on a new series of Biennial works in the park, expanding the venture to include performance and participatory events as well as sculpture. When Tom Eccles—curator of this project and former director of the Public Art Fund—met with Chrissie Iles and Philippe Vergne about the 2006 Whitney Biennial, their discussions immediately centered on Pierre Huyghe's *A Journey That Wasn't*, an exciting new commission that by its very nature would bring us back to Central Park once again.

Huyghe's proposal for the Biennial was a layered project that would ultimately take place at three moments in time and involve three components: the artist's actual journey to the Antarctic; the Central Park musical based on that journey; and a film made using footage shot on those two occasions. In February 2005, Huyghe, a group of artists, and ten crew members set sail on an Antarctic journey in search of an unknown island and an encounter with a unique and solitary creature. After an arduous trip across the icy seas—in which they endured violent winds, pack ice, and other severe conditions—Huyghe and his fellow travelers arrived at the island and ultimately made contact with the creature, an albino penguin.

The second part of the work brought that faraway journey back to New York, where a re-presentation was staged and filmed outdoors on October 14, 2005. From the outset, Huyghe envisioned this event taking place in Wollman Rink in Central Park, in the figurative and geographic heart of New York City. The artist's personal odyssey was thus reiterated as a public spectacle, with the world's most famous skyline forming a dramatic backdrop. The audience members became

not just spectators but extras in Huyghe's film, waiting and watching—just as the artist himself had done in the Antarctic—to see whether the mysterious creature would appear.

The presentation and filming of *A Journey That Wasn't* took place after a week of record-breaking torrential rains. Just before sundown, hundreds of people began lining up despite the ongoing downpour. In addition to curators, artists, and other familiar faces, there were many people who had simply come "to see the penguin." Huyghe had always described the event as being an equivalent rather than a re-creation. Indeed, as night fell and the orchestra members walked out to their island platform in the flooded ice rink, the weather conditions that had seemed like disaster all week suddenly became a natural, even magical, part of the work. It wasn't Antarctica, but it wasn't exactly New York either. Huyghe's spectacle of lights, atmosphere, and music lasted just under twenty minutes as the symphonic orchestra and soloist Elliott Sharp played composer Joshua Cody's extraordinary epic soundtrack based on the shape of the island. The smoke machines' fog blended with the night's mist to envelope the audience, camera crews, and orchestra alike. At the end of the show, some claimed to have seen the albino penguin while others said they hadn't. Like any adventure—and like any dream—its afterimage has lingered on and has become yet another aspect of Huyghe's multifaceted work.

Public Art Fund

CALIG

STAY

ADRIANA ASTI KAREN B
GERARD BUTLER BENICIO D
HELEN MIRREN MICHELL
TASHA TILBERG SPECIAL A

SPECIAL G
COURTN

COMING SOON TO A

FROM THE CREATOR OF

THE REIMAGINING OF A MOVIE

FRANCESC

GORE

WORKS IN THE EXHIBITION*

*as of January 2, 2006. A final list of works in the exhibition is available at www.whitney.org.

Dimensions are in inches followed by centimeters; height precedes width precedes depth.

JENNIFER ALLORA AND GUILLERMO CALZADILLA

Returning a Sound, 2004 • Single-channel video projection, color, sound; 5:42 min. • Collection of the artist; courtesy Galerie Chantal Crousel, Paris • Shown in a concurrent program at the Museo Fuerte Conde de Mirasol, Vieques, Puerto Rico

Under Discussion, 2005 • Video projection, color, sound; 6:40 min. • Collection of the artist; courtesy Galerie Chantal Crousel, Paris, and Lisson Gallery, London • Shown in a concurrent program at the Museo Fuerte Conde de Mirasol, Vieques, Puerto Rico

Untitled, 2006 • Single-channel video projection, color, sound. • Collection of the artist; courtesy Galerie Chantal Crousel, Paris, and Lisson Gallery, London

DAWOLU JABARI ANDERSON

Frederick Douglass Self-Defense Manual Series, Infinite Step Escape Technique #1: Hand Seeks Cotton, 2005 • Ink and acrylic on chocolate, butter paper, builder's paper, and craft paper, 43½ x 33½ (110.5 x 85.1) • Collection of the artist

Frederick Douglass Self-Defense Manual Series, Shovel Counter Whip Technique #1: Shovel Counter Whip, 2005 • Ink and acrylic on chocolate, butter paper, builder's paper, and craft paper, 43½ x 33½ (110.5 x 85.1) • Collection of the artist

Black History Month—Feel What the Excitement Is All About, 2005 • Ink and acrylic on butter paper, builder's paper, and craft paper, 68 x 52 (172.7 x 132.1) • Collection of the artist

"The Night Rider" Issue #4, 2005 • Ink and acrylic on butter paper, builder's paper, and craft paper, 68 x 52 (172.7 x 132.1) • Collection of the artist

KENNETH ANGER

Invocation of My Demon Brother, 1969 • 16mm film, color, sound; 11 min. • Collection of the artist

ICONS (Invocation of My Demon Brother), 1969/2004 • Suite of eight digital color prints, 18¾ x 25 (47.5 x 63.5) • Collection of the artist; courtesy Walter Cassidy, III

Lucifer Rising, 1980 • 16mm film, color, sound, 30 min. • Collection of the artist

Mouse Heaven, 2005 • Video, color, sound; 10 min. • Collection of the artist

Kenneth Anger's ICONS, 2006 • Installation of photographs, paintings, and ephemera, dimensions variable • Collection of the artist

DOMINIC ANGERAME

Anaconda Targets, 2004 • Digital video, black-and-white, sound; 12 min.

CHRISTINA BATTLE

buffalo lifts, 2004 • 16mm film, color, silent; 3 min.

following the line of the web, 2004 • 16mm film, black-and-white, silent; 4 min.

the distance between here and there, 2005 • 16mm, color, sound; 7:30 min.

migration, 2005 • 16mm film, color, sound; 5:30 min.

nostalgia (april 2001 to present), 2005 • 16mm film, color, sound; 4 min.

JAMES BENNING

One Way Boogie Woogie/27 Years Later, 1978/2005 • 16mm film, color, sound; 121 min.

13 Lakes, 2005 • 16mm film, color, sound; 135 min.

BERNADETTE CORPORATION

Pedestrian Cinema, 2006 • Video, color, sound; approx. 60 min.

VIDAL'S

VEZZOLI

"COMIZI DI NON AMORE"
...HAT SCANDALIZED THE WORLD

GULA

ING

ACK BARBARA BOUCHET

L TORO MILLA JOVOVICH

PHILLIPS GLENN SHADIX

PEARANCE BY GORE VIDAL

EST STAR

Y LOVE

THEATRE NEAR YOU

AMY BLAKEMORE

Miss Goodner, 1996/2005 • Chromogenic color print, 19 x 19 (48.3 x 48.3) • Collection of the artist; courtesy Inman Gallery, Houston
Dog in Snow, 2004 • Chromogenic color print, 19 x 19 (48.3 x 48.3) • Collection of the artist; courtesy Inman Gallery, Houston
Jude, 2004 • Chromogenic color print, 19 x 19 (48.3 x 48.3) • Collection of the artist; courtesy Inman Gallery, Houston
Little Garage, 2004 • Chromogenic color print, 19 x 19 (48.3 x 48.3) • Collection of the artist; courtesy Inman Gallery, Houston
Deer and Tepee, 2005 • Chromogenic color print, 19 x 19 (48.3 x 48.3) • Collection of the artist; courtesy Inman Gallery, Houston
Jill in Woods, 2005 • Chromogenic color print, 19 x 19 (48.3 x 48.3) • Collection of the artist; courtesy Inman Gallery, Houston

LOUISE BOURQUE

L'éclat du mal/The Bleeding Heart of It, 2005 • 35mm film, color, sound; 8 min.

MARK BRADFORD

Los Moscos, 2004 • Collaged paper on canvas, 125 x 190½ (317.5 x 483.9) • Collection of the artist; courtesy Sikkema Jenkins & Co., New York
Untitled, 2004 • Collaged paper on canvas, 108 x 144 (274.3 x 365.8) • Collection of the artist; courtesy Sikkema Jenkins & Co., New York

TROY BRAUNTUCH

Untitled (Shirts 1), 2005 • Conté crayon on cotton, 63 x 51 (160 x 129.5) • Collection of Michael Young; courtesy Friedrich Petzel Gallery, New York
Untitled (Shirts 2), 2005 • Conté crayon on cotton, 63 x 51 (160 x 129.5) • Collection of Alberto and Maria de la Cruz; courtesy Friedrich Petzel Gallery, New York
Untitled (Shirts 3), 2005 • Conté crayon on cotton, 63 x 51 (160 x 129.5) • Collection of Dirk Skreber; courtesy Friedrich Petzel Gallery, New York
Untitled, 2005–6 • Conté crayon on cotton, 51 x 79 (129.5 x 200.7) • Collection of the artist; courtesy Friedrich Petzel Gallery, New York

ANTHONY BURDIN

2006 • Installation

GEORGE BUTLER

Going Upriver: The Long War of John Kerry, 2004 • 35mm film, black-and-white and color, sound; 89 min.

CARTER

four cups, 2005 • Dye diffusion transfer print (Polaroid film) and blue acrylic ink, 3¼ x 4¼ (8.3 x 10.8) • Collection of Saatchi Gallery, London; courtesy HOTEL gallery, London
no title, 2005 • Blue and black acrylic ink, hand-marbleized paper, graphite and paper on paper, 32 x 36½ (81.3 x 92.7) • Collection of Saatchi Gallery, London; courtesy HOTEL gallery, London
no title, 2005 • Blue and black acrylic ink, hand-marbleized paper, graphite and paper on paper, 31½ x 36½ (80 x 92.7) • Collection of Saatchi Gallery, London; courtesy HOTEL gallery, London
no title, 2005 • Blue and black acrylic ink, collaged trees from the 1950s and early 1960s on paper, 31 x 36 (78.7 x 91.4) • Private collection; courtesy Salon 94, New York
no title, 2005 • Blue and black acrylic ink, graphite and paper on paper, 16½ x 20 (41.9 x 50.8) • Collection of the artist
no title, 2005 • Blue, white, and black acrylic ink and paper on paper, 16½ x 14 (41.9 x 35.6) • Private collection
no title, 2005 • Blue acrylic ink and paper on hand-marbleized paper, 16½ x 14 (41.9 x 35.6) • Private collection
no title, 2005 • Blue acrylic ink and paper on hand-marbleized paper, 16½ x 14 (41.9 x 35.6) • Collection of Pamela and Arthur Sanders
no title, 2005 • Dye diffusion transfer print (Polaroid film), 3¼ x 4¼ (8.3 x 10.8) • Collection of Saatchi Gallery, London; courtesy HOTEL gallery, London
prosopopoeia/stasis/landscape, 2005 • Blue acrylic ink, hand-marbleized paper, graphite and paper on paper, 37 x 31 (94 x 78.7) • Collection of Saatchi Gallery, London; courtesy HOTEL gallery, London

CAROLINA CAYCEDO
Daytoday, 2005–6 • Exchange project with website • Collection of the artist

THE CENTER FOR LAND USE INTERPRETATION
2005–6 • Touch-screen kiosk and printed material

PAUL CHAN
1ˢᵗ Light, 2005 • Digital animated projection onto floor, dimensions variable • Collection of the artist; courtesy Greene Naftali Gallery, New York

LORI CHEATLE AND DAISY WRIGHT
This Land Is Your Land, 2004 • Video, color, sound; 87 min.

IRA COHEN
Jack Smith as Electromagneto with Fly, 1970 • Chromogenic color print, 11 x 14 (27.9 x 35.6) • Collection of the artist
The Magician from The Grand Tarot—John Brockmeyer with Charles Ludlam's Ridiculous Theatre, 1970 • Chromogenic color print, 11 x 14 (27.9 x 35.6) • Collection of the artist

MARTHA COLBURN
Cosmetic Emergency, 2005 • 35mm film, color, sound; 8 min.

DAN COLEN
Untitled, 2005–6 • Styrofoam, papier-mâché, oil paint, plexiglass, and paper, 84 x 48 x 48 (213.4 x 121.9 x 121.9) • Collection of the artist; courtesy Peres Projects, Los Angeles
Untitled, 2005–6 • Styrofoam, papier-mâché, oil paint, plexiglass, and paper, 84 x 48 x 48 (213.4 x 121.9 x 121.9) • Collection of the artist; courtesy Peres Projects, Los Angeles
Untitled, 2005–6 • Styrofoam, papier-mâché, oil paint, and paper, 84 x 48 x 48 (213.4 x 121.9 x 121.9) • Collection of the artist; courtesy Peres Projects, Los Angeles
Untitled, 2005–6 • Installation of paintings. Plywood, molding paste, spray paint, and oil paint, dimensions variable • Collection of the artist; courtesy Peres Projects, Los Angeles

ANNE COLLIER
Cover (California Girl), 2004 • Chromogenic color print, 40 x 50 (101.6 x 127) • Collection of the artist; courtesy MARC FOXX, Los Angeles
Crying, 2005 • Chromogenic color print, 39 x 52 (99.1 x 132.1) • Collection of Madalyn and Stephen Tobias; courtesy MARC FOXX, Los Angeles
Despair, 2005 • Chromogenic color print, 37¼ x 45½ (94.6 x 115.6) • Collection of the artist; courtesy MARC FOXX, Los Angeles
Spill, 2005 • Chromogenic color print, 46⅜ x 34¾ (117.9 x 88.3) • Private collection; courtesy MARC FOXX, Los Angeles

TONY CONRAD
(P (RE (SERVE))), 2006 • Performance

CRITICAL ART ENSEMBLE
Body of Evidence, 2004 • Video, color, sound; 4 min.

JAMAL CYRUS

Africanismus #022564, 2005 • Book, hair, and bird, 4½ x 8½ x 5¼ (11.4 x 21.6 x 13.3) • Collection of the artist

The Dowling Street Martyr Brigade, "Towards a Walk in the Sun," 2005 • Collage on paper, 12⁵⁄₁₆ x 12½ (31.3 x 31.8) • Collection of the artist

Hands Off (Package design prototype), 2005 • Ink on paper, 13½ x 17 (34.3 x 43.2) • Collection of the artist

Lumpen Objekt, 2005 • Hair, tray, and spoon, 1¾ x 4⅛ x 7¼ (4.5 x 10.5 x 18.4) • Collection of the artist

Sharhonda and the Black Stone Queens, Me, My Shining Prince, and the Deep Black Sea, 2005 • Mixed-media collage on paper, 7 x 7¼ (17.8 x 18.4) • Collection of Valerie Cassel

MILES DAVIS

RU Legal, 1991 • Oil on canvas, 36 x 50 (91.4 x 127) • Anonymous collection

DEEP DISH TELEVISION NETWORK

Shocking and Awful: A Grassroots Response to War and Occupation, 2003–5 • Video, color, sound; series of 12 28-min. programs

LUCAS DEGIULIO

Yeast-in-Jar Holograms, 2004–6 • Gallon jugs, wood, and roots, dimensions variable • Collection of the artist

Can Barnacles, 2005 • Aluminum can, barnacles, 4½ x 3 (11.4 x 7.6) • Collection of the artist

Scavenger Words, 2005–6 • Sticks, glue, and terracotta planters, dimensions variable • Collection of the artist

Recent Scrapbook, 2006 • Book and collage in collaboration with Markus Lunkenheimer and Matt Wacker, 12 x 18 (30.5 x 45.7) • Collection of the artist

Untitled (After Dürer's "Samsom Rending the Lion"), 2006 • Plywood and ink, 96 x 48 (243.8 x 121.9) • Collection of the artist

MARK DI SUVERO AND RIRKRIT TIRAVANIJA

Peace Tower, 2006 • Mixed media, dimensions variable • Structure © Mark di Suvero • Courtesy Paula Cooper Gallery, New York

PETER DOIG

Stag, 2003–5 • Oil on canvas, 98⁷⁄₁₆ x 78¾ (250 x 200) • Private collection; courtesy Gavin Brown's enterprise, New York, and Michael Werner Gallery, New York and Cologne

Paragon, 2005 • Oil on canvas, 116⅛ x 78¾ (295 x 200) • Private collection; courtesy Gavin Brown's enterprise, New York, and Michael Werner Gallery, New York and Cologne

TRISHA DONNELLY

hedm!, 2005 • Two graphite-on-paper drawings, each 40 x 27½ (101.6 x 70) • Collection of Linda Pace; courtesy Casey Kaplan, New York

no title, 2005 • Digital video, color, silent; 10-min. loop

JIMMIE DURHAM

La Poursuite du bonheur/The Pursuit of Happiness, 2003 • 35mm film, color, sound; 13 min.

KENYA EVANS

Soo ... not so Super, huh?, 2002 • Acrylic on wood, 28 x 19½ (72.4 x 49.5) • Collection of the artist

Sometimes ..., 2002 • Acrylic, graphite, and silver marker on paper, 91 x 66 (231.2 x 167.6) • Collection of the artist

Zenith, 2003 • Wood, cotton, acrylic, latex, leaf, and polyurethane, 44 x 41½ x 30 (111.8 x 105.4 x 76.2) • Collection of the artist; courtesy Stolen Souls

URS FISCHER

The Intelligence of Flowers, 2003–6 • Installation holes in gallery walls, dimensions variable • Ringier Collection, Switzerland; courtesy Galerie Eva Presenhuber, Zurich, and Gavin Brown's enterprise, New York

Untitled (branches), 2005 • Cast aluminum, chains, candles, and motors, 244⅛ x 332⅝ x 234⅝ (620 x 845 x 596) • Private collection; courtesy Galerie Eva Presenhuber, Zurich, and Sadie Coles HQ, London

DAVID GATTEN

The Great Art of Knowing, 2004 • 16mm film, black-and-white, silent; 37 min.

JOE GIBBONS

Doppelganger Part 1, 2005 • Video, color, sound; 10 min.

A Time to Die, 2005 • Video, color, sound; 8 min.

ROBERT GOBER

1978–2000, 1978–2000 • Twenty-two gelatin silver prints, each 25½ x 33¾ (64.8 x 85.7) • Collection of the artist; courtesy Matthew Marks Gallery, New York

Untitled, 2005–6 • Wood, glass, and fabric, 25 x 20 x 20 (63.5 x 50.8 x 50.8) • Collection of the artist; courtesy Matthew Marks Gallery, New York

DEVA GRAF

Untitled Figure, 2003 • T-shirt and mixed media, 60 x 8 x 8 (152.4 x 20.3 x 20.3) • Collection of Lorelei Stewart and Andreas Fischer

Untitled Figure (Dinger), 2003 • Wood, unglazed porcelain, 108 x 10 x 10 (274.x 25.4 x 25.4) • Collection of Judy Ledgerwood and Tony Tasset

Rainbow Pyramid Candle, 2004 • Candle, concrete, and yarn, dimensions variable • Collection of the artist

When You Look Into the Ovoid the Ovoid Looks Back at You, 2004 • Mirror and ink, dimensions variable • Collection of the artist

Mirror Photocopy I, 2005 • Photocopy on paper, 24 x 18 (61 x 45.7) • Collection of the artist

Mirror Photocopy II, 2005 • Photocopy on paper, 24 x 18 (61 x 45.7) • Collection of the artist

DAN GRAHAM, WITH TONY OURSLER, RODNEY GRAHAM, LAURENT P. BERGER, AND JAPANTHER

DTAOT: Combine (Don't Trust Anyone Over Thirty, all over again), 2005 • Video by Tony Oursler; script, drawings, and notations by Dan Graham with Tony Oursler, Laurent P. Berger, and Japanther; installation design by Laurent P. Berger; recorded music by Rodney Graham; recorded performing band Japanther; sound design by Bruce Odland; puppets and direction by Huber Marionettes; props by Eugene Tsai; video props by Tony Oursler Studio; installation design by Laurent P. Berger. Script by Dan Graham with Teresa Seeman, Sandra Antelo-Suarez, Roger Denson, and Tony Oursler. Curator: Sandra Antelo-Suarez. Producer: TRANS>. Coproducers: Foundation 20 21, New York; Walker Art Center, Minneapolis; Thyssen-Bornemisza Art Contemporary, Vienna; and LAB/Voom HD Originals, New York

94

RODNEY GRAHAM

Torqued Chandelier Release, 2005 • 35mm film, color, silent; 5 min. Projected at 48 fps on a Kinoton PK-60E/PC high-speed electronic vertical formatted film projector with endless loop system. Projector dimensions: 68 x 64 x 30 (172.7 x 162.6 x 76.2) • Private collection; courtesy Donald Young Gallery, Chicago

HANNAH GREELY

Silencer, 2002 • Urethane rubber, nylon, 36 x 24 x 18 (91.4 x 61 x 45.7) • Collection of Dean Valentine and Amy Adelson
Last Stand, 2006 • Cow bones, epoxy, wood, paper, and nylon, 66 x 14 x 14 (167.6 x 35.6 x 35.6) • Collection of the artist

MARK GROTJAHN

Untitled (White Butterfly), 2005 • Oil on linen, 75 x 49 (190.5 x 124.5) • Walker Art Center, Minneapolis
Untitled (White Butterfly), 2005 • Oil on linen, 72 x 49 (190.5 x 124.5) • Private collection; courtesy Blum & Poe, Los Angeles
Untitled (Yellow White Butterfly), 2005 • Oil on linen, 67 x 50 (170.2 x 127) • Collection of David Teiger; courtesy Blum & Poe, Los Angeles
Untitled (Blue Face Grotjahn), 2005 • Oil on linen, 61 x 49 (154.9 x 124.5) • Collection of Dean Valentine and Amy Adelson; courtesy Blum & Poe, Los Angeles

JAY HEIKES

New Heaven Hook, 2005 • Cast aluminum, 84 (213.4) • Collection of the artist
Return of the Parrot, 2005 • Tempera, marker, and graphite on photocopies, 120 x 240 (304.8 x 609.6) • Collection of the artist

DOUG HENRY

Hey/What, 2003 • 16mm film, color, sound; 30 sec.
Mickey Mouse Ears, 2003 • 16mm film, color, sound; 36 sec.
Not Afraid of Bob, 2003 • 16mm film, color, sound; 8 sec.
Winners, 2003 • 16mm film, color, silent; 38 sec.

PIERRE HUYGHE

A Journey That Wasn't, 2005 • Super 16mm film and high-definition video transferred to high-definition video, color, sound. • Filming in Central Park, New York, a project of the Public Art Fund. Presented by Deutsche Bank and supported in part by Cultural Services of the French Embassy and by étant donnés: The French-American Fund for Contemporary Art, a program of FACE. • Collection of the artist; courtesy Marian Goodman Gallery, New York and Paris

DOROTHY IANNONE

Suck My Breasts I Am Your Most Beautiful Mother, 1972 • Acrylic and canvas collage on canvas, 74¹³⁄₁₆ x 59¹⁄₁₆ (190 x 150) • Private collection
Two Songs, 1972–2005 • "Long Ago in Antibes" and "Surabaya Johnny" • Ralph Hüttr, electric organ and Moog synthesizer • Emil Schult, guitar • Private collection
I Was Thinking of You III, 1975/2005 • Painted box, video, and monitor, dimensions variable • Private collection

MATTHEW DAY JACKSON

Chariot (The day after the end of days), 2005–6 • Two years of paintings, Polish hay cart, scrap wood, T111 plywood siding, yarn, scorched wood, wicker chair, broken skateboards, steel bucket from Jonestown, bronze, wood-burned drawing, twenty state flags, wool, abalone shell, and mother-of-pearl, 312 x 120 x 78 (792.5 x 304.8 x 198.1) • Collection of the artist; courtesy Perry Rubenstein Gallery, New York

CAMERON JAMIE

Kranky Klaus, 2002–3 • Video, color, sound; 26:10 min. Soundtrack by The Melvins. • Commissioned and produced by Artangel, London; courtesy Artangel, London

NATALIE JEREMIJENKO / BUREAU OF INVERSE TECHNOLOGY

For the Fish, 2006 • Custom electronics, sound, Hudson River water, and Hudson River fish, dimensions variable • Collection of the artist; courtesy Postmasters Gallery, New York

DANIEL JOHNSTON

Be a Movie Producer, 2002 • Ink and felt-tip pen on paper, 8½ x 11 (21.6 x 27.9) • Collection of the artist

God Bless America, 2002 • Ink and felt-tip pen on paper, 8½ x 11 (21.6 x 27.9) • Collection of the artist

Armageddon Could Happen, 2003 • Ink and felt-tip pen on paper, 8½ x 11 (21.6 x 27.9) • Collection of the artist

The Blessed Gift Has Bess Ignored Too Long, 2003 • Ink and felt-tip pen on paper, 8½ x 11 (21.6 x 27.9) • Collection of the artist

Die Satan Die, 2003 • Ink and felt-tip pen on paper, 8½ x 11 (21.6 x 27.9) • Collection of the artist

In Hell There Are No Friends, 2003 • Ink and felt-tip pen on paper, 8½ x 11 (21.6 x 27.9) • Collection of the artist

It's a Nightmare, 2003 • Ink and felt-tip pen on paper, 8½ x 11 (21.6 x 27.9) • Collection of the artist

Lonely Hulk, 2003 • Ink and felt-tip pen on paper, 8½ x 11 (21.6 x 27.9) • Collection of the artist

No Title, 2003 • Ink and felt-tip pen on paper, 8½ x 11 (21.6 x 27.9) • Collection of the artist

The Wages of Sin Is Death!, 2003 • Ink and felt-tip pen on paper, 8½ x 11 (21.6 x 27.9) • Collection of the artist

Look Out for the Vampires, 2003–4 • Ink and felt-tip pen on paper, 8½ x 11 (21.6 x 27.9) • Collection of the artist

Need to Be Inventive More, 2003–4 • Ink and felt-tip pen on paper, 8½ x 11 (21.6 x 27.9) • Collection of the artist

Victory at Sea, 2004 • Ink and felt-tip pen on paper, 8½ x 11 (21.6 x 27.9) • Collection of the artist

Lost Death, n.d. • Ink and felt-tip pen on paper, 8½ x 11 (21.6 x 27.9) • Collection of the artist

I wish to speak to my atto

- If you need my consent fo
other procedure, I will no
to my attorney.

- I will not waive any of my

Notice to Police Offi[cer]

- I do not wish to answer an[y]
speaking to an attorney.

LEWIS KLAHR
The Two Minutes to Zero Trilogy, 2003–4 • 16mm film, color, sound; 33 min., which includes the following:
Two Days to Zero, 2004. 23 min.
Two Hours to Zero, 2004. 9 min.
Two Minutes to Zero, 2003. 1 min. Music by Glenn Branca from "The Ascension" (1980). Commissioned by the 2004 International Film Festival Rotterdam "Just a Minute" program

JUTTA KOETHER
FANTASY NYC from Very Lost Highway to Whitney Biennial, or What do they want from me?, 2005–6 • Installation with paintings, drawings, and streamers, dimensions variable • Collection of the artist

ANDREW LAMPERT
Piano and String Quartet Piano and String Quartet, 2004 • Two audio CDs, duration variable
Varieties of Slow, 2005 • Triple-projection film and performance, dimensions variable • Courtesy Public Opinion Laboratory, New York

LISA LAPINSKI
Nightstand, 2005 • Walnut hardwood, polyurethane gel finish, paint, panel, canvas, photographs, cane, glass, feathers, hat form, screws and inserts, jewelry display hand, and necklace, 112 x 240 x 174 (284.5 x 609.6 x 442) • Collection of the artist; courtesy Johann König Gallery, Berlin, and Richard Telles Fine Art, Los Angeles

LIZ LARNER
RWBs, 2005 • Aluminum tubing, batting, fabric, ribbons, wire rope, padlocks, and keys, 82 x 117 x 117 (208.3 x 297.2 x 297.2) • Collection of the artist; courtesy Regen Projects, Los Angeles

HANNA LIDEN
Goat Girls, 2002 • Chromogenic color print, 30 x 40 (76.2 x 101.6) • Collection of the artist; courtesy Rivington Arms, New York
Black Sabbath, 2003 • Chromogenic color print, 30 x 40 (76.2 x 101.6) • Collection of the artist; courtesy Rivington Arms, New York
Hooves, 2003 • Chromogenic color print, 30 x 40 (76.2 x 101.6) • Collection of the artist; courtesy Rivington Arms, New York
Lake with Fire, 2003 • Chromogenic color print, 30 x 40 (76.2 x 101.6) • Collection of the artist; courtesy Rivington Arms, New York
Vampire Nude, 2003 • Chromogenic color print, 30 x 40 (76.2 x 101.6) • Collection of the artist; courtesy Rivington Arms, New York
Spinning Anti-Clockwise, 2004 • Chromogenic color print, 30 x 40 (76.2 x 101.6) • Collection of the artist; courtesy Rivington Arms, New York

JEANNE LIOTTA
Eclipse, 2005 • 16mm film, color, sound; 3:30 min.

MARIE LOSIER
The Ontological Cowboy, 2005 • 16mm film, black-and-white and color, sound; 13 min.

FLORIAN MAIER-AICHEN
Untitled, 2004 • Chromogenic color print, 48 x 61½ (121.9 x 156.2) • Private collection; courtesy Blum & Poe, Los Angeles
Untitled, 2004 • Chromogenic color print, 90 x 72 (228.6 x 182.9) • Private collection; courtesy Blum & Poe, Los Angeles
Untitled (Towards Burbank), 2004 • Chromogenic color print, 22½ x 27 (57.2 x 68.6) • Collection of Pete Franciosa; courtesy Blum & Poe, Los Angeles

MONICA MAJOLI

Hanging Rubberman #4, 2002 • Watercolor and gouache on paper, 51 x 78 (129.5 x 198.1) • Collection of Nancy and Stanley Singer; courtesy Gagosian Gallery, Los Angeles

Hanging Rubberman #2, 2003 • Watercolor and gouache on paper, 64 x 51 (162.6 x 129.5) • The Museum of Modern Art, New York, The Judith Rothschild Foundation Contemporary Drawings Collection

Study for Hanging Rubberman #1, 2004 • Watercolor and gouache on paper, 30 x 22 (76.2 x 55.9) • Collection of the artist; courtesy Gagosian Gallery, Los Angeles

YURI MASNYJ

The Fine Line, 2006 • Steel, plaster, wood, plexiglass, paper, graphite, house paint, joint compound, and fiberboard, 204 x 144 x 144 (518.2 x 365.8 x 365.8) • Collection of the artist

T. KELLY MASON AND DIANA THATER

JUMP, 2004 • 16mm film, color, sound; 16 min.

ADAM MCEWEN

Untitled (Bill), 2004 • Chromogenic color print, 52¾ x 37 (134 x 94) • Private collection; courtesy Nicole Klagsbrun Gallery, New York

Untitled (Jeff), 2004 • Chromogenic color print, 52¾ x 37 (134 x 94) • Private collection; courtesy Nicole Klagsbrun Gallery, New York

Untitled (Nicole), 2004 • Chromogenic color print, 52¾ x 37 (134 x 94) • Private collection; courtesy Nicole Klagsbrun Gallery, New York

Untitled (Rod), 2004 • Chromogenic color print, 52¾ x 37 (134 x 94) • Private collection; courtesy Nicole Klagsbrun Gallery, New York

TAYLOR MEAD

A Fairy Tale by Taylor Mead, 2005 • Eleven drawings, ink on paper, each 9 x 11 (22.9 x 27.9) • Collection of the artist

JOSEPHINE MECKSEPER

The Complete History of Postcontemporary Art, 2005 • Mixed media in display window, 63 x 98½ x 23⅝ (160 x 250.2 x 60) • Collection of the artist; courtesy Elizabeth Dee, New York

Tout va bien, 2005 • Mixed media in display window, 63 x 98½ x 23⅝ (160 x 250.2 x 60) • Collection of the artist; courtesy Elizabeth Dee, New York

Untitled (Life after Bush Conference/One-Year Anniversary of the Invasion of Iraq Protest, New York, 3/20/04), 2005 • Super 8 film transferred to video, black-and-white and color, silent; 7:07 min. • Collection of the artist; courtesy Elizabeth Dee, New York

Untitled (March on Washington to End the War on Iraq, 9/24/05), 2005 • Super 8 film transferred to video, black-and-white and color, silent; 8:50 min. • Collection of the artist; courtesy Elizabeth Dee, New York

MARILYN MINTER

Purple Haze, 2005 • Enamel on metal, 48 x 36 (121.9 x 91.4) • Collection of the artist; courtesy Salon 94, New York

Stepping Up, 2005 • Enamel on metal, 96 x 60 (243.8 x 152.4) • Private collection; courtesy Salon 94, New York

MOMUS

The Unreliable Tour Guide, 2006 • Performance

ers and Prosecutors:

questions without

icy now.

any search or for any

give it until I have spoken

constitutional rights.

95

MATTHEW MONAHAN

The Heckler and the Troubadour, 1994/2005 • Floral foam, beeswax, encaustic, pigment, $5 bill, wood, and charcoal on paper on canvas, cardboard, and dry wall, 64 x 79 x 24 (162.6 x 200.7 x 61) • Hort Family Collection

Twilight of the Idiots, 1994/2005 • Floral foam, beeswax, encaustic, pigment, quartz, studs, tape, foam, charcoal on paper, metal, wood, glass, and dry wall, 72 x 34 x 97 (182.9 x 86.4 x 246.4) • Collection of Adam Lindemann

JP MUNRO

Goebbels delivers total war speech, 2004 • Oil on panel, 20 x 30 (50.8 x 76.2) • Collection of China Art Objects Gallery, Los Angeles

Orgy Chamber, 2005 • Oil on linen, 16 x 24 (40.6 x 61) • Collection of Sadie Coles HQ, London

The Vision of St. Eustace, Master Hunter, 2005 • Oil on linen, 60 x 48 (152 x 121.9) • Collection of Sadie Coles HQ, London

JESÚS "BUBU" NEGRÓN

Picas y Museos (Picas and Museums), 2006 • Racehorse track with 24 wood horses, wood, metal, oil paint, Formica, bronze, and cloth, dimensions variable • Collection of César and Mima Reyes; courtesy Galería Comercial, San Juan

KORI NEWKIRK

Glint, 2004 • Artificial hair, pony beads, aluminium, and dye, 92 x 84 x 48 (233.7 x 213.4 x 121.9) • Museum of Contemporary Art, San Diego

TODD NORSTEN

Mary-Kate, 2005 • Oil on canvas, 66 x 52 (167.6 x 132.1) • Collection of the artist; courtesy Cohan and Leslie, New York

Something Pretty, Pretty Ugly, 2005 • Oil on canvas, 80 x 67 (203.2 x 170.2) • Collection of the artist; courtesy Cohan and Leslie, New York

Son Jesus Loves You Still, 2005 • Oil on canvas, 60 x 48 (152.4 x 121.9) • Collection of the artist; courtesy Cohan and Leslie, New York

JIM O'ROURKE

Door, 2005 • Three-screen video installation, color, sound; 20-min. continuous loop • Collection of the artist

OTABENGA JONES & ASSOCIATES

Untitled, 2006 • Site-specific installation, dimensions variable • Collection of the artist

STEVEN PARRINO

The Chaotic Painting, 2004 • Enamel on canvas, 72 x 72 x 72 (182.9 x 182.9 x 182.9) • Estate of the artist; courtesy Team Gallery, New York

NECROPOLIS (THE LUCIFER CRANK) for ANGER, 2004 • 16mm film, black-and-white, sound; 27 min. • camera: Amy Granat and Larry 7 • Estate of the artist; courtesy Team Gallery, New York

Process Cult, 2004 • Enamel on canvas, 84 x 14 (213.4 x 35.6) • Estate of the artist; courtesy Team Gallery, New York

Untitled, 2004 • Enamel on canvas, 102½ x 107 x 140 (260.4 x 271.8 x 355.6) • Estate of the artist; courtesy Team Gallery, New York

Untitled, 2004 • Graphite and ink on vellum, 12 x 9 (30.5 x 22.9) • Estate of the artist; courtesy Team Gallery, New York

Untitled, 2004 • Graphite and ink on vellum, 9 ½ x 12 (24.1 x 30.5) • Estate of the artist; courtesy Team Gallery, New York

Untitled, 2004 • Graphite and ink on vellum, 9½ x 12 (24.1 x 30.5) • Estate of the artist; courtesy Team Gallery, New York

Untitled, 2004 • Graphite and ink on vellum, 9½ x 12 (24.1 x 30.5) • Estate of the artist; courtesy Team Gallery, New York

Untitled, 2004 • Graphite and ink on vellum, 12 x 9 (30.5 x 22.9) • Estate of the artist; courtesy Team Gallery, New York

Untitled, 2004 • Graphite and ink on vellum, 19 x 12 (48.3 x 30.5) • Estate of the artist; courtesy Team Gallery, New York

Untitled, 2004 • Graphite and ink on vellum, 12 x 19 (30.5 x 48.3) • Estate of the artist; courtesy Team Gallery, New York

Untitled, 2004 • Graphite and ink on vellum, 12 x 19 (30.5 x 48.3) • Estate of the artist; courtesy Team Gallery, New York

Untitled, 2004 • Graphite and ink on vellum, 12 x 9 (30.5 x 22.9) • Estate of the artist; courtesy Team Gallery, New York

ED PASCHKE

Non, 2003 • Oil on linen, 36 x 50 (91.4 x 127) • Estate of the artist

Bang Bang, 2004 • Oil on linen, 20 x 24 (50.8 x 61) • Estate of the artist

Legal Tender, 2004 • Oil on linen, 50 x 60 (127 x 152.4) • Estate of the artist

MATHIAS POLEDNA

Version, 2004 • 16mm film, black-and-white, silent; 10:10 min. • Collection of the artist; courtesy Richard Telles Fine Art, Los Angeles; Galerie Meyer Kainer, Vienna; and Galerie Daniel Buchholz, Cologne, Los Angeles

Sufferer's Version, 2004 • 16mm film, black-and-white, sound; 6:20 min. • Collection of the artist; courtesy Richard Telles Fine Art, Los Angeles; Galerie Meyer Kainer, Vienna; and Galerie Daniel Buchholz, Cologne

ROBERT A. PRUITT

All Day I Dream about Senegal, 2002 • Conté crayon on butcher paper, 48 x 72 (121.9 x 182.9) • Collection of Rita Krauss

Glass Slippers, 2005 • Basketball shoes, broken glass, and beer caps, 5 x 10 x 11 (12.7 x 25.4 x 27.9) • Collection of Chris Erck; courtesy Clementine Gallery, New York

This Do in Remembrance of Me, 2005 • Wood communion table, two iPod Minis, mixer, hair, wine, and various altar offerings, dimensions variable • Collection of the artist; courtesy Clementine Gallery, New York

Throw Back, 2005 • Hood, robe, acrylic, and patches, dimensions variable • Collection of the artist; courtesy Clementine Gallery, New York

JENNIFER REEVES

The Time We Killed, 2004 • 16mm film, black-and-white, sound; 94 min.

RICHARD SERRA

Stop Bush, 2004 • Lithocrayon on mylar, 59¼ x 48 (150.5 x 121.9) • Collection of the artist

GEDI SIBONY

Their Proper Places the Entities from Which Partial Aspects Emerge, 2006 • Carpet, hollow-core door, medium density fiberboard, garbage bag, vinyl and plywood, dimensions variable • Collection of the artist

JENNIE SMITH

Kite Wars, 2004 • Graphite on paper, 42 x 120 (106.7 x 304.8) • Collection of the artist

We'll Never Tell You Where We Have Gone, 2004 • Graphite and watercolor on paper, 108 x 36 (274.3 x 91.4) • Collection of the artist

Untitled, 2005 • Graphite and watercolor on paper, 48 x 72 (121.9 x 182.9) • Collection of the artist

DASH SNOW
no title, 2006 • Mixed-media installation, dimensions variable • Collection of the artist; courtesy Rivington Arms, New York

MICHAEL SNOW
WVLNT (Wavelength for Those Who Don't Have the Time. Originally 45 Minutes, Now 15!), 1966–67/2003 • Digital video, color, sound; 15 min. • Collection of the artist; courtesy Jack Shainman Gallery, New York
Sheeploop, 2000 • Four-monitor video installation, color, silent; 15 min. continuous loop • Collection of the artist; courtesy Jack Shainman Gallery, New York
SSHTOORRTY, 2005 • 35mm film and 16mm film transferred to video, color, sound; 20 min. • Collection of the artist; courtesy Jack Shainman Gallery, New York

REENA SPAULINGS
The Hoods, 2006 • Awnings • Collection of the artist

RUDOLF STINGEL
Untitled (After Sam), 2005–6 • Oil on canvas, 132 x 180 (335.3 x 457.2) • Collection of the artist; courtesy Paula Cooper Gallery, New York
Untitled (After Sam), 2005–6 • Oil on canvas, 132 x 180 (335.3 x 457.2) • Collection of the artist; courtesy Paula Cooper Gallery, New York

ANGELA STRASSHEIM
Untitled (Father and Son) from the *Left Behind* series, 2004 • Digital chromogenic color print, 40 x 30 (101.6 x 76.2) • Collection of the artist; courtesy Marvelli Gallery, New York
Untitled (Fishtank) from the *Left Behind* series, 2004 • Digital chromogenic color print, 40 x 50 (101.6 x 127) • Collection of the artist; courtesy Marvelli Gallery, New York
Untitled (Grandmother in casket) from the *Left Behind* series, 2004 • Digital chromogenic color print, 30 x 40 (76.2 x 101.6) • Collection of the artist; courtesy Marvelli Gallery, New York
Untitled (Julia) from the *Left Behind* series, 2004 • Digital chromogenic color print, 30 x 40 (76.2 x 101.6) • Collection of the artist; courtesy Marvelli Gallery, New York
Untitled (Savannah on window) from the *Left Behind* series, 2004 • Digital chromogenic color print, 40 x 30 (101.6 x 76.2) • Collection of the artist; courtesy Marvelli Gallery, New York

ZOE STRAUSS
Untitled, 2000–2005 • Digital slide projection • Collection of the artist

STUDIO FILM CLUB
all paintings by Peter Doig
Van Dyke Parks Presents The Esso Trinidad Steelband, 2004 • Oil on paper, 33 x 23¼ (84 x 59) • Private collection; courtesy Contemporary Fine Arts, Berlin
Calypso Dreams, 2005 • Oil on paper, 28½ x 22¾ (72.4 x 57.8) • Collection of the artist
Carnival Roots, 2005 • Oil on paper, 28½ x 22¾ (72.4 x 57.8) • Collection of the artist
Crossing Over, 2005 • Oil on paper, 28½ x 22½ (72 x 57) • Private collection; courtesy Contemporary Fine Arts, Berlin
Day for Night, 2005 • Oil on paper, 33 x 23½ (84 x 59.7) • Private collection; courtesy Contemporary Fine Arts, Berlin
Osama, 2005 • Oil on paper, 28½ x 22¾ (72.4 x 57.8) • Collection of the artist

STURTEVANT

Duchamp Relâche, 1967 • Gelatain silver print, 11¹⁵⁄₁₆ x 9½ (30.3 x 24.1) • Collection of the artist; courtesy Perry Rubenstein Gallery, New York

Duchamp Nude Descendant un Escalier, 1968 • Video, color, silent; 8:23 min. • Collection of the artist; courtesy Perry Rubenstein Gallery, New York

Duchamp Bicycle Wheel, 1969/1973 • Assisted ready-made (bicycle wheel on stool), 53⅛ x 23⅝ x 13¾ (135 x 60 x 35) • Collection of the artist; courtesy Perry Rubenstein Gallery, New York

Duchamp Eau & Gaz, 1970 • Ready-made, glazed enamel on metal, mounted on wood, 7⅝ x 9⅞ (19.5 x 25) • Collection of the artist; courtesy Perry Rubenstein Gallery, New York

Duchamp L.H.O.O.Q., 1971/1990 • Printed image and graphite on canvas, 13⅞ x 11 (35.3 x 27.8) • Jedermann Collection, N.A.

Duchamp Fountain, 1973 • Ready-made (urinal), white porcelain, and acrylic paint, 12¾ x 16 x 18 (32.3 x 40.5 x 45.6) • Jedermann Collection, N.A.

Duchamp Trébuchet, 1973 • Ready-made (coatrack), metal, and wood, 5 x 39 x 6⅞ (12.7 x 99 x 17.5) • Collection of the artist; courtesy Perry Rubenstein Gallery, New York

Duchamp 1200 Coal Bags, 1973/1992 • Ready-made (coal bags), jute, 35⅝ x 23⅝ x 13¾ (90 x 60 x 35) • Collection of the artist; courtesy Perry Rubenstein Gallery, New York

Duchamp Coal Stove, 1992 • Assisted ready-made, 34½ x 21⅛ x 3⅞ (79.5 x 53.5 x 10) • Collection of the artist; courtesy Perry Rubenstein Gallery, New York

Duchamp Fresh Widow, 1992 • Enamel paint on wood, leather, and glass, 31¼ x 21⅛ x 3⅞ (79.5 x 53.5 x 10) • Collection of the artist; courtesy Perry Rubenstein Gallery, New York

Duchamp in Advance of a Broken Arm, 1992 • Ready-made (snow shovel), metal, and wood, 59⅞ x 18¼ (152 x 46.5) • Collection of the artist; courtesy Perry Rubenstein Gallery, New York

Duchamp Porte-Bouteilles, 1993 • Ready-made (bottle rack), metal, 20⅛ x 19⅝ x 19⅝ (51 x 50 x 50) • Collection of the artist; courtesy Perry Rubenstein Gallery, New York

BILLY SULLIVAN

1969–2005, 2005 • Three-carousel slide projection, color, silent; projected continuously • Collection of the artist; courtesy Nicole Klagsbrun Gallery, New York, and Regen Projects, Los Angeles

Clarissa, East Hampton 1982, 2005 • Oil on canvas, 64 x 42 (162.6 x 106.7) • Collection of the artist; courtesy Nicole Klagsbrun Gallery, New York, and Regen Projects, Los Angeles

PFW, 2005 • Oil on canvas, 64 x 42 (162.6 x 106.7) • Collection of Paul F. Walter; courtesy Nicole Klagsbrun Gallery, New York, and Regen Projects, Los Angeles

SPENCER SWEENEY

All That Jazz, 2005 • Oil on canvas, 48 x 50 (121.9 x 127) • Collection of the artist; courtesy Gavin Brown's enterprise, New York

Blood of a Poet, 2005 • Acrylic, spray paint, and mixed media on canvas, 80 x 63 (203.2 x 160) • Collection of the artist; courtesy Gavin Brown's enterprise, New York

Leon Russell Diptych, 2005 • Acrylic on canvas, diptych, 24 x 18 (61 x 45.7); 48 x 48 (121.9 x 121.9) • Collection of the artist; courtesy Gavin Brown's enterprise, New York, and Modern Institute, Glasgow

Roman Omen, 2005 • Acrylic on canvas with towel, 36 x 48 (91.4 x 121.9) • Collection of the artist; courtesy Gavin Brown's enterprise, New York

RYAN TRECARTIN

A Family Finds Entertainment, 2004 • Video, color, sound; 41:12 min. • Collection of the artist; courtesy Elizabeth Dee, New York, and Q.E.D., Los Angeles

CHRIS VASELL

Do (Last Exit), 2005 • Acrylic on canvas, 84 x 70 (213.4 x 177.8) • Private collection; courtesy Blum & Poe, Los Angeles

Equal is better than even, 2005 • Acrylic on canvas, 90 x 76 (228.6 x 193) • Collection of Danielle and David Ganek; courtesy Blum & Poe, Los Angeles

Christopher Williams

1. Kodak three point reflection guide © 1968 Eastman Kodak Company, 1968 2. Release 3. Release 4. Archäologie 5. Beaux Arts 6. Ethnographie 7. Théatre Vérité 8.Varieties 9. Mozambique 10. Tokyo 11. La Palma 12. Bruxelles 13. Release 14. Release 15. Release 16. Westkunst 17. The photographic industry that programmed the camera 18. The industrial complex that programmed the photographic industry 19. The socio-economic system that programmed the industrial complex 20. Christopher Williams 21. Couleur Européenne 22. Couleur Soviétique 23. Couleur Chinoise 24. Cartridge Replacement 25. Release 26. Release 27. Program: Views according to which this device and the various theories framing it will function for the artistic production the same way as the artistic production functions as advertising for the order under which it is produced. There will be no other space than this view according to which etc... 28. Cartridge Replacement 39. Release 30. Release 31. Release 32. Release 33. Release 34. Release 35. Release 36. Release 37. Reread this program again and again, become its author, correct it and repeat it, distribute it, and when we are all its authors, the old world will crumble to make way for... 38. Release 39. Release 40. 69, 70, 71, 72...

28. —

David Zwirner

525 West 19th Street
New York, NY 10011
Tel 212 727 2070
Fax 212 727 2072

www.davidzwirner.com

FRANCESCO VEZZOLI
Trailer for a Remake of Gore Vidal's "Caligula," 2005 • 35mm film transferred to video, color, sound; 5:35 min. • Castello di Rivoli Museo d'Arte Contemporanea

KELLEY WALKER
Black Star Press (rotated 180 degrees); Press Star, Press Black, 2006 • Digital print and chocolate on canvas, diptych: each panel 83 x 104 (210.8 x 264.2) • Collection of the artist; courtesy Paula Cooper Gallery, New York

NARI WARD
Glory, 2004 • Oil barrels, ultraviolet and fluorescent lights, computer parts, plexiglass, fan, camera casings, audio element, towels, and rubber roofing membrane, dimensions variable • Collection of the artist; courtesy Deitch Projects, New York

CHRISTOPHER WILLIAMS
Kodak Three Point Reflection Guide, © 1968 Eastman Kodak Company, 1968. (Miko laughing), Vancouver, B.C., April 6, 2005, 2005 • Chromogenic color print, 20 x 24 (50.8 x 61) • Edition of 10 • Collection of the artist; courtesy David Zwirner, New York, and Galerie Gisela Capitain, Cologne
Afri-Cola (Ashtray), Manufacturer: E. & A. Böckling, 6956 Neudenau, Germany, Date of Production 1980–1989, Douglas M. Parker Studio, Los Angeles, California, November 25, 2005 (Nr. 1), 2006 • Chromogenic color print, 20 x 24 (50.8 x 61) • Edition of 10 • Collection of the artist; courtesy David Zwirner, New York, and Galerie Gisela Capitain, Cologne
Afri-Cola (Ashtray), Manufacturer: E. & A. Böckling, 6956 Neudenau, Germany, Date of Production 1980–1989, Douglas M. Parker Studio, Los Angeles, California, November 26, 2005 (Nr. 2), 2006 • Chromogenic color print, 20 x 24 (50.8 x 61) • Edition of 10 • Collection of the artist; courtesy David Zwirner, New York, and Galerie Gisela Capitain, Cologne

Universal Travel Adaptor, Scorpio Distributors Ltd., Unit DZ, West Sussex, Great Britain, Product number TXR77000, Power Rating: 6A Max 125/250Vac, With Built-In Surge Protector, With Safety Shutters, Surge Status Indicator Light, 110Vac or 220Vac Light Indicator, Built-In 13A Fuse, Testing based on International Standard IEC 884-2-5 Witnessed by TUV, CE EMC Approval, Douglas M. Parker Studio, Los Angeles, California, December 15, 2005, 2006 • Gelatin silver print, 16 x 20 (40.6 x 50.8) • Edition of 10 • Collection of the artist; courtesy David Zwirner, New York, and Galerie Gisela Capitain, Cologne
Velosolex 2200 (Detail), Serial Number 3128819, Moteur antiparasité, Date of Production 1964, [from the property of Thi Minh Dam], Douglas M. Parker Studio, Los Angeles, California, August 15, 2005, 2005 • Gelatin silver print, 16 x 20 (40.6 x 50.8) • Edition of 10 • Collection of the artist; courtesy David Zwirner, New York, and Galerie Gisela Capitain, Cologne

JORDAN WOLFSON
Untitled (Frank Painting Company), 1966/2006 • Scraped and repainted wall • Courtesy Jack Frank and family
I'm sorry but I don't want to be an Emperor—that's not my business—I don't want to rule or conquer anyone. I should like to help everyone if possible, Jew, gentile, black man, white. We all want to help one another, human beings are like that. We all want to live by each other's happiness, not by each other's misery. We don't want to hate and despise one another. In this world there is room for everyone and the earth is rich and can provide for everyone. The way of life can be free and beautiful. But we have lost the way. Greed has poisoned men's souls—has barricaded the world with hate; has goose-stepped us into misery and bloodshed. We have developed speed but we have shut ourselves in: machinery that gives abundance has left us in want. Our knowledge has made us cynical, our cleverness hard and unkind. We think too much and feel too little: More than machinery we need humanity; More than cleverness we need kindness and gentleness. Without these qualities, life will be violent and all will be lost. The aeroplane and the radio have brought

us closer together. The very nature of these inventions cries out for the goodness in men, cries out for universal brotherhood for the unity of us all. Even now my voice is reaching millions throughout the world, millions of despairing men, women and little children, victims of a system that makes men torture and imprison innocent people. To those who can hear me I say "Do not despair." The misery that is now upon us is but the passing of greed, the bitterness of men who fear the way of human progress: the hate of men will pass and dictators die and the power they took from the people will return to the people, and so long as men die [now] liberty will never perish.... Soldiers—don't give yourselves to brutes, men who despise you and enslave you—who regiment your lives, tell you what to do, what to think and what to feel, who drill you, diet you, treat you as cattle, as cannon fodder. Don't give yourselves to these unnatural men, machine men, with machine minds and machine hearts. You are not machines. You are not cattle. You are men. You have the love of humanity in your hearts. You don't hate—only the unloved hate. Only the unloved and the unnatural. Soldiers—don't fight for slavery, fight for liberty. In the seventeenth chapter of Saint Luke it is written "the kingdom of God is within man"—not one man, nor a group of men—but in all men—in you, the people. You the people have the power, the power to create machines, the power to create happiness. You the people have the power to make life free and beautiful, to make this life a wonderful adventure. Then in the name of democracy let's use that power—let us all unite. Let us fight for a new world, a decent world that will give men a chance to work, that will give you the future and old age and security. By the promise of these things, brutes have risen to power, but they lie. They do not fulfill their promise, they never will. Dictators free themselves but they enslave the people. Now let us fight to fulfill that promise. Let us fight to free the world, to do away with national barriers, do away with greed, with hate and intolerance. Let us fight for a world of reason, a world where science and progress will lead to all men's happiness. Soldiers—in the name of democracy, let us all unite! Look up! Look up! The clouds are lifting—the sun is breaking through. We are coming out of the darkness into the light. We are coming into a new world. A kind new world where men will rise above their hate and brutality. The soul of man has been given wings—and at last he is beginning to fly. He is flying into the rainbow—into the light of hope—into the future, that glorious future that belongs to you, to me and to all of us. Look up. Look up. Charlie Chaplin, "The Great Dictator" (1940), 2005 • 16mm film, black-and-white, silent; 2:37 min. • Collection of the artist; courtesy Perry Rubenstein Gallery, New York

THE WRONG GALLERY
Down by Law, 2006 • Parasite exhibition

AARON YOUNG
IPO (30 Offerings), 2005 • Chrome, metal, masterlocks, U-locks, padlocks, rubber, and cable, dimensions variable • Collection of Michael and Ninah Lynne; courtesy Harris Lieberman, New York
"LOCALS ONLY!" (Bayonne, New Jersey), 2006 • Bronze and acrylic paint, 42 x 30 (106.7 x 76.2) • Collection of the artist; courtesy Harris Lieberman, New York

Pour la changer, alignez votre combinai

étapes 1-4.

GARDEZ VOTRE COMBINAISON

180°

INSTRUCTIONS:

The combination is now set at 0-0-0-0

To set your own personal combination:

1. Open the lock and rotate the shackle
2. Push down on the shackle until you h
3. Line up your new numbers with the n
4. Raise the shackle.

Your lock is now set to your personal co
To change your combination, line up yo
repeat steps 1-4.

STORE YOUR COMBINATION IN

INSTRUCTIONS:

Combinaison réglée à 0-0-0-0

Pour régler votre combinaison personne

1.Ouvrir la tige, la tourner à droite (180°
2. La maintenir enfoncée pour entendre
3. Maintenir la tige enfoncée et aligner
4. Relever la tige.

SCREENING AND PERFORMANCE SCHEDULE*
*as of January 2, 2006. The final schedule is available at www.whitney.org.

March 11–May 21, 2006
All programs take place in the Kaufman Astoria Studios Film & Video Gallery, Floor 2, unless otherwise noted.

PROGRAM 1
Back and Forth/Over and Out
T. Kelly Mason and Diana Thater, *JUMP*, 2004
Michael Snow
SSHTOORRTY, 2005
WVLNT (Wavelength for Those Who Don't Have the Time. Originally 45 Minutes, Now 15!), 1966–67/2003
Films with Music from China Haiti Jamaica North America • Selections by Mathias Poledna
Maya Deren, *The Very Eye of Night*, 1959
Mathias Poledna, *Sufferer's Version*, 2004
Program. • Selections by Christopher Williams
Part One:
Otto Mühl, *Grimuid*, 1967
Joris Ivens, *De Brug (The Bridge)*, 1928
Harun Farocki, *Ein Bild (An Image)*, 1983
Peter Kubelka, *Arnulf Rainer*, 1958–60
David Lamelas, *A Study of Relationships between Inner and Outer Space*, 1969
Yves Allégret and Eli Lotar, *Ténérife*, 1932
Jean Painlevé, *Les amours de la pieuvre (The Love Life of the Octopus)*, 1965
Jean Rouch, *Les maîtres fous (Mad Masters)*, 1955
Morgan Fisher, *Picture and Sound Rushes*, 1973
Part Two:
Otto Mühl, *Grimuid*, 1967
Carl Theodor Dreyer, *Storstrømsbroen (The Storstrom Bridge)*, 1950
Chris Marker, *Photo Browse*, 1985/1990
Tony Conrad, *The Flicker*, 1966
Joris Ivens, *A Valparaiso*, 1963
Peter Kubelka, *Unsere Afrikareise (Our Trip to Africa)*, 1961–66
John Baldessari, *Ice Cubes Sliding*, 1974
Luis Buñuel, *Las Hurdes, tierra sin pan (Land Without Bread)*, 1932

PROGRAM 2: VARIETIES OF SLOW
Andrew Lampert
Varieties of Slow, 2005
Piano and String Quartet Piano and String Quartet, 2004
Okkyung Duet, 2004–5

PROGRAM 3: IRA COHEN
Poet, photographer, and filmmaker Ira Cohen reads from his work. The program includes a special screening of his psychedelic film *The Invasion of Thunderbolt Pagoda* (1968).

PROGRAM 4: EXPERIMENTAL
With a Little Help from My Friends
Joe Gibbons, *A Time to Die*, 2005
Tony Conrad with Joe Gibbons and Louise Bourque, *The Producer*, 2005
Doug Henry
Not Afraid of Bob, 2003
Hey/What, 2003
Winners, 2003
Mickey Mouse Ears, 2003
Marie Losier, *The Ontological Cowboy*, 2005
The Flowers of Emulsion
Jeanne Liotta, *Eclipse*, 2005
Louise Bourque, *L'éclat du mal/The Bleeding Heart of It*, 2005
Christina Battle
nostalgia (april 2001 to present), 2005
the distance between here and there, 2005
buffalo lifts, 2004
Martha Colburn, *Cosmetic Emergency*, 2005
Serial Pleasures
David Gatten, *The Great Art of Knowing*, 2004
Lewis Klahr, *The Two Minutes to Zero Trilogy:
Two Days to Zero*, 2004
Two Hours to Zero, 2004
Two Minutes to Zero, 2003

lfway (180°).
r a click, and hold it firmly in place.
k.

bination.
previous combination with the mark, and

SAFE PLACE.

:

«click».
tre combinaison avec les traits.

n précédente face à l'arrêt. puis refaire les

N LIEU SÛR.

PROGRAM 5: JAMES BENNING

James Benning
13 Lakes, 2005
One Way Boogie Woogie/27 Years Later, 1978/2005

PROGRAM 6: POLITICS I

Deep Dish Television Network (DDTV) Part I
A selection from DDTV's independently
produced documentaries on the war in Iraq.
Pictures from Afghanistan
Dominic Angerame, *Anaconda Targets*, 2004
Siddiq Barmak, *Osama*, 2003
The Time We Killed
Jennifer Reeves, *The Time We Killed*, 2004

PROGRAM 7: (P (RE (SERVE)))

Tony Conrad, a pioneer of New York
Minimalism and microtonal music, presents the
premiere of his performance *(P (RE (SERVE)))*
(2006).

PROGRAM 8: TAYLOR MEAD

Warhol film legend Taylor Mead reads from his
poems. The program includes a screening of
Excavating Taylor Mead (2005), a documentary
film by William A. Kirkley.

PROGRAM 9: POLITICS II

This Land Is Your Land
Lori Cheatle and Daisy Wright, *This Land Is Your
Land*, 2004
Going Upriver
George Butler, *Going Upriver: The Long War of
John Kerry*, 2004
Deep Dish Television Network (DDTV) Part II
A selection from DDTV's independently
produced documentaries on the war in Iraq.

PROGRAM 10: STUDIO FILM CLUB

François Truffaut, *Day for Night (La nuit
Américaine)*, 1973
Abbas Kiarostami, *The Taste of Cherry (Ta'm E
Guilass)*, 1997

PROGRAM 11: STUDIO FILM CLUB CARNIVAL

Bud Smith, *The Esso Trinidad Steelband*, 1971
Peter Chelkowski, *Carnival Roots*, 2003
Geoffrey Dunn and Michael Horne, *Calypso
Dreams*, 2003
Christopher Laird and Nii Bampoe Addo,
Crossing Over, 1988

PROGRAM 12

Through a Glass Darkly
Steven Parrino, *NECROPOLIS (THE LUCIFER
CRANK) for ANGER*, 2004
Kenneth Anger
Mouse Heaven, 2005
Lucifer Rising, 1980
Invocation of My Demon Brother, 1969
Global Follies
Jimmie Durham, *La Poursuite du bonheur/The
Pursuit of Happiness*, 2003
Bernadette Corporation, *Pedestrian Cinema*, 2006

PROGRAM 13: THE UNRELIABLE TOUR GUIDE

The artist Momus appears at random times and
in random locations in the Museum to offer
improvised tours.

Toni Burlap emerged as a curator on the highway somewhere between Los Angeles and Tijuana in July 2005. Born of an *entente cordiale* between France and Britain, traditional rivals in the historic battle to control the territory of the United States, Burlap's curatorial approach is, in essence, collaborative. She has written extensively on gastronomy for the Michelin Guide and is finishing a PhD on Victor Hugo's later novel *Les travailleurs de la mer* (The toilers of the sea). She lives in the Channel Islands, where she is a guest lecturer at the University of Guernsey.

Johanna Burton is a critic and writer living in New York. She attended the Whitney Independent Study Program and is currently completing her PhD at Princeton University, where she is compiling a dissertation on appropriation. She has written numerous reviews and articles for *Artforum*, *Parkett*, and *Texte zur Kunst*, and is on the faculty of the Center for Curatorial Studies at Bard College.

Bradley Eros is an artist, experimental filmmaker, curator, writer, performer, and researcher based in New York. His work was shown in the 2004 Whitney Biennial; he has also screened work at the 2002 New York Film Festival, Anthology Film Archives, the Museum of Modern Art, New York, and Pacific Film Archives, Berkeley. He has curated projects at the Whitney Museum of American Art, Millennium, Ocularis, Anthology Film Archives, the New York Underground Film Festival, and the Robert(a) Beck Memorial Cinema at Collective:Unconscious and Participant Inc.

Lia Gangitano founded Participant Inc., New York, a not-for-profit art space, in 2001. She is a former curator of Thread Waxing Space, New York, where her exhibitions, screenings, and performances included *Spectacular Optical* (1998). As an associate curator at the Institute of Contemporary Art, Boston, she co-curated *Dress Codes* (1993) and *Boston School* (1995) and edited the publications *New Histories* (with Steven Nelson, ICA Boston, 1997) and *Boston School* (ICA Boston, 1995). She is the editor of the forthcoming anthology *The Alternative to What? Thread Waxing Space and the '90s.*

Bruce Hainley is a writer based in Los Angeles. He is associate director of graduate studies in Criticism and Theory at Art Center College of Design, Pasadena, a contributing editor of *Artforum*, and the author of *Foul Mouth* (Plainer Edition, 2006) and, with John Waters, *Art—A Sex Book* (Thames & Hudson, 2003).

Bernard-Henri Lévy is a writer and philosopher who lives in Paris. He is the author of many books, including *Barbarism with a Human Face* (HarperCollins, 1979), *Who Killed Daniel Pearl?* (Melville House Publishing, 2003), and *War, Evil, and the End of History* (Melville House Publishing, 2004). His articles "In the Footsteps of Tocqueville," first published in serial form by *The Atlantic Monthly*, are available with new material in his book *American Vertigo: Traveling American in the Footsteps of Tocqueville* (Random House, 2006).

Molly Nesbit is a professor of art at Vassar College and a contributing editor of *Artforum*. She is the author of *Their Common Sense* (Black Dog, 2000), *Atget's Seven Albums* (Yale, 1992), and a forthcoming book of essays. With Hans Ulrich Obrist and Rirkrit Tiravanija, she curates the ongoing project *Utopia Station.*

WAM

Siva Vaidhyanathan, a cultural historian and media scholar based in New York, is the author of *Copyrights and Copywrongs: The Rise of Intellectual Property and How It Threatens Creativity* (New York University Press, 2001) and *The Anarchist in the Library: How the Clash between Freedom and Control Is Hacking the Real World and Crashing the System* (Basic Books, 2004). Vaidhyanathan has written for many periodicals, including *American Scholar*, *The Chronicle of Higher Education*, *The New York Times Magazine*, MSNBC.com, Salon.com, openDemocracy.net, and *The Nation*. He is an assistant professor of Culture and Communication at New York University.

Neville Wakefield is a writer and commentator on contemporary art, culture, and photography. His work appears in numerous magazines, and he is the author of, among other books, *Postmodernism: The Twilight of the Real* (Pluto Press, 1988), *Fashion: Photography of the Nineties* (Scalo, 1993), and *Matthew Barney: The Cremaster Cycle* (Guggenheim Museum, 2002). Recent curatorial projects include the exhibitions *Power Corruption & Lies* (Roth Horowitz, 2004) and *Bridge Freezes before Road* (Barbara Gladstone, 2005). He is currently producing a series of pornographic films by artists, including Marina Abramovic, Matthew Barney, Marco Brambilla, Larry Clark, Gaspar Noe, and Sam Taylor-Wood, under the label *Destricted*.

LED

WHITNEY STAFF*

Carol Mancusi-Ungaro
Joel Martinez
Sandra Meadows
Graham Miles
Dana Miller
Shamim M. Momin
Victor Moscoso
Maureen Nash
Chris Neal
Colin Newton
Carlos Noboa
Kisha Noel
Darlene Oden
Richard O'Hara
Sarah O'Holla
Tamatha Ortega
Nelson Ortiz
Carolyn Padwa
Beverly Parsons
Christiane Paul
Angelo Pikoulas
Marcelle Polednik
Kathryn Potts
Linda Priest
Vincent Punch
Elise Pustilnik
Christy Putnam
Michael Raskob
Maggie Ress
Kristen Richards
Emanuel Riley
Felix Rivera
Jeffrey Robinson
Georgianna Rodriguez
Justin Romeo
Joshua Rosenblatt
Amy Roth
Jan Rothschild
Jane Royal
Carol Rusk

Doris Sabater
Angelina Salerno
Warfield Samuels
Galina Sapozhnikova
Stephanie Schumann
Julie Seigel
David Selimoski
Frank Smigiel
G. R. Smith
Joel Snyder
Stephen Soba
Karen Sorensen
Barbi Spieler
Jocelyn Splitter
Carrie Springer
Mark Steigelman
Minerva Stella
Nicole Stiffle
Emilie Sullivan
Elisabeth Sussman
Mary Anne Talotta
Kean Tan
Phyllis Thorpe
Robert Tofolo
James Tomasello
Limor Tomer
Makiko Ushiba
Ray Vega
Eric Vermilion
Cecil Weekes
Adam D. Weinberg
Marjorie Weinstein
John Williams
Rachel de W. Wixom
Sarah Zilinski

*as of November 1, 2005

PHOTOGRAPH AND REPRODUCTION CREDITS

foldout 44, Marianne Greber; foldout 83, Richard Kern, *Soft*, published by Universe, 2004; 31, Karim Kadim; 33, Gregory Bull; 37, © 2004 Karen Ocker; 43 top, Joe Cavaretta; 43 bottom, Lisa Nipp; 46 top, Karim Kadim; 46 bottom, J. Scott Applewhite; 51 top, Jerome Delay; 51 bottom, Eric Gay; 64, © Elizabeth Linden; 110, Geoffrey Clements, art © Jasper Johns/Licensed by VAGA, New York; 117, Geoffrey Clements. Courtesy Paula Cooper Gallery, New York, © Walker Evans Archives, The Metropolitan Museum of Art; 185, Lamay Photo; 203, © Marco Bakker; 207, Courtesy Barbara Gladstone Gallery, New York; 211, Karen Waltuch and Ted Conrad, © Tony Conrad 2005; 217, Erma Estwick © The Estate of Miles Davis; 223, Structure © Mark di Suvero, Photo © Charles Brittin; courtesy Paula Cooper Gallery, New York; 225, © Peter Doig; 233, Stefan Altenburger. Installation view, Fondazione Nicola Trussardi, Milan, 2005 © Urs Fischer; 245, Tom Van Eynde; 249, Joshua White. © Mark Grotjahn 2005. All Rights Reserved. Courtesy Blum & Poe, Los Angeles; 255, Xavier Veilhan; 265, Courtesy the Johnston family; 283, Joshua White. Courtesy Blum & Poe, Los Angeles; 285, Courtesy Gagosian Gallery, Los Angeles; 289, Sabrina McGrew; 293, © 1999 Bryce Lankard; 295, Blaise Adilon. © Biennale de Lyon 2005; 325, © 2006 Richard Serra/Artists Rights Society (ARS), New York; 343, Jochen Littkemann. Courtesy Contemporary Fine Arts, Berlin; 349, Ellen Page Wilson Studio; 353, Joshua White. Courtesy Blum & Poe, Los Angeles; 355, Matthias Vriens; 365, Jason Nocito

The *2006 Whitney Biennial: Day for Night* was curated by Chrissie Iles, Anne and Joel Ehrenkranz Curator of Contemporary Art, Whitney Museum of American Art, New York, and Philippe Vergne, deputy director and chief curator, Walker Art Center, Minneapolis, with the assistance of Lindsay H. Macdonald, Biennial coordinator, and Nicholas Anderson, Biennial intern; Gary Carrion-Murayari, curatorial assistant; Arianne Gelardin, researcher; Jarrett Gregory, Biennial assistant; Elizabeth Gwinn, Biennial intern; Henriette Huldisch, assistant curator of film and video; and Tina Kukielski, senior curatorial assistant.

The publication was produced under the supervision of the Publications and New Media Department at the Whitney Museum of American Art, New York: Rachel de W. Wixom, head of publications and new media; Thea Hetzner, associate editor; Jennifer MacNair, associate editor; Makiko Ushiba, manager, graphic design; Vickie Leung, production manager; Anita Duquette, manager, rights and reproductions; Joann Harrah, rights and reproductions assistant; and Anna Knoell, graphic design assistant.

Project Director: Mary DelMonico
Catalogue Design: Purtill Family Business
Editor: Michelle Piranio
Proofreader: Richard G. Gallin

Texts on the individual artists were written by:
Max Andrews (MA)
Johanna Burton (JB)
Gary Carrion-Murayari (GCM)
Suzanne Hudson (SH)
Henriette Huldisch (HH)
Nathan Lee (NL)
Emily Speers Mears (ESM)
Jenny Moore (JM)
Lisa Pasquariello (LP)

Printing and binding: Shapco Printing, Inc., Minneapolis, Minnesota

Printed and bound in the United States